DIALOGUES

Other Works by Edouard Roditi

APHORISMS
Life with God the Father
Redhill Press, forthcoming

BIOGRAPHY
Magellan of the Pacific
McGraw-Hill *and* Faber & Faber, 1972

CRITICISM
MAKERS OF MODERN LITERATURE SERIES
Oscar Wilde: A Critical Study
New Directions, 1947

MEMOIRS
Meetings with Conrad
The Press of the Pegacycle Lady, 1977

POETRY
De L'Homosexualité
Sedimo, 1962

Emperor of Midnight
Collected surrealist poetry
Black Sparrow Press, 1974

In a Lost World
Black Sparrow Press, 1978

New and Old Testaments
Red Ozier Press, 1983

New Hieroglyphic Tales: Prose Poems
Kayak Press, 1968

Poems 1928–1948
New Directions, 1949

The Temptations of a Saint
Ettan Press, 1980

Thrice Chosen
Collected poems on Jewish themes
Black Sparrow Press, 1981

The Wandering Fool: Poems of Yunus Emre
Translated from the Turkish
Cadmus Editions, 1985

STORIES
The Delights of Turkey
New Directions, 1977

DIALOGUES

Conversations with European Artists at Mid-Century

Edouard Roditi

Bedford Arts, Publishers
San Francisco

Published by Bedford Arts, Publishers
250 Sutter Street, Suite 550
San Francisco, CA 94108-4482

Library of Congress Cataloguing-in-Publication Data

Roditi, Edouard.
 *Dialogues: conversations with European artists at
mid-century* / Edouard Roditi.
 p. cm.
Previously published in 2 vols.: Dialogues on art,
published in 1960, and More dialogues on art, pub-
lished in 1984.
 ISBN 0-938491-26-1 (pbk.):
 1. Artists — Europe — Interviews. 2. Art,
Modern — 20th century — Europe. I. Roditi,
Edouard. Dialogues on art. II. Roditi, Edouard.
More dialogues on art. III. Title.
 N6758.R6 1989
 709.04 — dc20. 89-17575

Cover: Giorgio Morandi, *Still Life,* 1952.

*Art acknowledgments are included in the list of
illustrations on page ix.*

Editors: Gail Larrick and Stephen Vincent
Art management: Monica Garcia
Design: Jon Goodchild/Triad.
Typeset at TBD Typography, San Rafael, CA

DIALOGUES ON ART, the first collection of twelve
dialogues, was published in 1960 in London by
Secker and Warburg and in 1961 in New York by
Horizon Books. This collection was also published
in French and German editions. All editions of the
collection included an introduction and conversa-
tions with Marc Chagall, Marino Marini, Giorgio
Morandi, Joan Miró, Oskar Kokoschka, Barbara
Hepworth, Pavel Tchelitchev, Gabrièle Münter,
Eduardo Paolozzi, Josef Herman, Henry Moore,
and Fahr-el-Nissa Zeid. A new American edition,
awarded a 1982 Literary Award of the American
Academy and Institute of Arts and Letters, was
reprinted in 1980, with a brief additional introduc-
tion, in Santa Barbara, California, by Ross-Erikson.
In 1984, Ross-Erikson published MORE DIALOGUES
ON ART, a second collection of twelve dialogues. It
included an introduction and conversations with Vic-
tor Brauner, Carlo Carrà, Max Ernst, Leonor Fini,
Demetrios Galanis, Nicolas Ghika, Hannah Höch,
Mordecai Moreh, Ianni Tsarouchis, Jef Van Hoof,
Ossip Zadkine, and Alexander Zlotnik. All previous
editions are out of print.

 Several interviews included in the current edi-
tion were first published in periodicals, as acknowl-
edged below.

Brauner: *Art Voices*
Carrà: *Italian Quarterly*
Chagall: *Encounter* (London)
Ernst: *Arts Magazine* [abridged] (New York)
Hepworth: *The Observer* (London)
Höch: *Arts Magazine* (New York)
Kokoschka: *Arts Magazine* (New York)
Marini: *Arts Magazine* (New York)
Moore: *The Observer* (London)
Morandi: *Arts Magazine* (New York)
Münter: *Arts Magazine* (New York)
Zadkine: *The Observer* (London)

Contents

Illustrations

DIALOGUES

Introduction

The most newsworthy or famous artists are not necessarily the most eloquent or profound when they try to express themselves in words. Expressing themselves in the less familiar medium of language rather than visual images, and, in fact, in words rather than colors, forms or textures, the painter and the sculptor may seem, as they discuss their art, less explicit, more impersonal, than many a creative writer. Yet a relatively popular collection of interviews of leading contemporary authors, *Writers at Work*, proved that many authors are sheer determinists or defeatists, scarcely more conscious of the nature or purpose of their literary activity and of the tools and devices of which they dispose than electronic brains or chimpanzee painters. William Faulkner, for instance, seemed unwilling to see himself, in his creative activity, as anything but a pawn in the hands of a mysterious blind force. He has been chosen at random for the task of writing tales which someone else might just as well have written and which would inevitably have been written, sooner or later, had he refused, like the prophet Jonah, to accomplish his mission. On the technical aspects of his work, Faulkner is even less explicit. He accomplishes his tasks only with luck and the help of some whisky:

"Bourbon, you mean?"

"No, I ain't that particular. Between Scotch and nothing, I'll take Scotch."

Only in France, it seems, or among the American poets and novelists of the "beat generation," is one still likely to find, as one did so frequently a hundred years ago, writers and artists who as openly flaunt their addiction to opium, hashish, marihuana or other such keys to an artificial paradise. In America, Aldous Huxley offered himself as a guinea pig, in the interests of science, for experiments on the effects of mescalin. In France, Henri Michaux conducted similar experiments on himself, with infinitely more interesting results which, however, have been less widely publicized. Fun, it seems, must

now accept the limitations imposed on us by the law, or must find its justification as scientific research.

The successful writer or artist is no longer, as so often he was some time ago, an outcast, an enemy of Society, a *poète maudit* like Baudelaire, a *peintre maudit* like Modigliani. Oscar Wilde and even Soutine, in our generation, would be anachronisms. Too conformist to exhibit them in public as hideous warnings, we would condemn them to the mental home, to the concentration camp, to the self-imposed retirement of monastic life. Dylan Thomas, while still alive in our midst, was a pain in the neck; one almost wonders how he escaped the fate of Antonin Artaud and Ezra Pound. Those whom one threatens to intern, during their lifetime, in mental homes may well be revered, once dead, as saints, and Dylan Thomas and Antonin Artaud have thus become, in recent years, the objects of a public cult.

Most contemporary writers and artists play safe, when they discuss their work, and prefer to speak as if it were a craft, involving but the manual skills of an honest artisan. They can talk at great length about the kind of room where they feel at ease to create, about whether they walk up and down as they think, whether they prefer to scribble their ideas in bed, on the back of unanswered mail, or in the cheap copybooks of schoolchildren on the terrace of a Left Bank Paris café. In the case of a writer, such a discussion of the fads and superstitions of his particular *cuisine littéraire* may sound ingratiatingly familiar. The reader, similarly afflicted with all sorts of tics and inhibitions when it comes to mere letter writing, will tend to forget that a writer achieves distinction as an artist in spite of such finicky bad habits which he may share with others who are not called upon to create. An artist's genius consists to some extent in his ability to transcend bad habits, to overcome handicaps; a discussion of the clay feet on which the monument may rest,

however insecurely, cannot teach us much about it as a whole. The artist is indeed human, all too human, like our humble selves, but he should be gifted with some complementary daemonic powers that others generally lack.

The painter and the sculptor are handling materials and tools that are more cumbersome and less widely used than the writer's pen and paper or than the typewriter or word processor to which countless readers are likewise chained, eight hours a day, in their office work. One cannot imagine Barbara Hepworth chipping away at a large block of marble in her bed, with her tray of morning coffee thrust negligently aside, though Truman Capote may well have been able to write a whole novel in his dyspeptic morning moods, between breakfast in bed, phone calls and the long-delayed moment when he could finally pluck up enough courage to plunge into his bathroom before sauntering forth to face an alien or hostile world. Far more than any bedroom or study, the studio is a workshop, and the working habits of a painter or a sculptor are those of a craftsman, imposed on him by the nature of his tools and materials. A discussion of these working habits would lack the human interest of a similar discussion of a writer's working habits, its tone degenerating too easily into that of a "do it yourself" technical manual, full of useful hints about mixing colors of two different brands, or about welding techniques.

Nor has an artist's or a writer's ability to explain his working habits or his philosophy of art any necessary connection with the quality of his work. Of the *cuisine littéraire,* the working habits and philosophy of art of some of the greatest writers of all times, we know nothing, partly because such topics have become popular only within the last hundred and fifty years, partly too because, even today, many writers are more interested in creating than in observing the workings of the creative process. Paul Valéry, throughout his life as a writer, devoted several hours a day to the meditations which filled his journal and his notebooks. In France, this self-imposed discipline, even on such a scale, scarcely provoked much comment. But not a single Turkish writer of the past fifty years has been known to keep a journal, and one is surprised when one discovers, in America, the notebooks of Francis Scott Fitzgerald. Do we know how much wine Catullus had to drink

before he could compose one of his lyrics? How Virgil organized his days while he worked on the *Aeneid*? Did he write his *Georgics* in bed, or in odd moments of respite as he administered his own farms?

Among the greatest artists of the past even Rembrandt, one of the most introspective of all self-portraitists, neglected to leave us anything in writing but a few laconic letters in which he dunned a recalcitrant patron who had failed to pay the agreed sum for a completed commission. Sir Joshua Reynolds, on the other hand, has left us a literary *oeuvre* that reveals unsuspected complexities of aesthetic theory in his seemingly simple art; and Eugène Delacroix, as a writer, deserves inclusion in any study of the philosophy of Romanticism. Camille Pissarro, in his letters, discusses at length the scientific and social principles on which he founded, to a great extent, his own impressionism. The few letters of Jean-François Millet offer us a complete theory of Socialist realism. The letters of Vincent van Gogh are like the submerged part of an iceberg, revealing much that he refrained from expressing in his painting. The interviews published in the present volume seek to elucidate these broader aspects of each painter's or sculptor's beliefs rather than the more picturesque or gossipy details of their working habits. Some of the artists interviewed happen to be less inclined than others to philosophical meditation, more concerned with autobiographical explanations of their stylistic evolution.

In interviewing some of the leading painters and sculptors of our age, I have avoided, as far as possible, evaluating their work as "contributions" to a movement. Nor have I deliberately selected those painters and sculptors whom I personally believe to be indisputably the greatest living artists. These interviews are rather the fruit of a series of felicitous meetings that occurred in the course of years of travel undertaken mainly as a multilingual interpreter for international conferences. The choice of my victims was determined, to a great extent, by chance.

A copy of the German edition, *Dialoge über Kunst,* chanced to fall into the hands of the late Carl G. Jung. In *Man and His Symbols,* which Jung conceived shortly before his death, my interview with Marino Marini is quoted at considerable length: "A good deal may be learned

from a conversation that took place in 1958 between the Italian sculptor Marino Marini and the writer Edouard Roditi. . . ." Jung's book then concludes that "The conversation . . . explains the transformation of *sensory* art into abstraction that should be clear to anyone who has ever walked open-eyed through an exhibition of modern art."

Although the late Harold Rosenberg defined the book, in an article in *The New York Times,* as "the best of its kind," some critics in England and America nevertheless tended to view my first collection of interviews with misgivings. The main concern of such critics appears to have been my choice of artists. I have been asked why I chose to include, for example, Gabrièle Münter, whose name and work, as a companion of Kandinsky at the time of his decisive shift from figurative art to his earliest and more expressionist style of abstraction, were still scarcely known, except to a few specialists, beyond the frontiers of Western Germany. Why, too, had I included Josef Herman but failed to interview Picasso?

I always point out that Josef Herman reaffirmed certain beliefs in the social responsibility of the artist that had scarcely been touched upon by any other artists interviewed, whereas my interview with Joan Miró, who is certainly one of the more famous artists represented in my *Dialogues,* proved to be, however entertaining as a piece of sheer journalism, by far the least informative of those twelve conversations.

Critics and friends have often accused me of deliberately spoofing Miró by not seeking to offer a less flippant or snide version of our original conversation. When I translated my interview with Miró for publication in French, I therefore added to the introduction a quotation from a similar interview written and published in Spanish and with which I had meanwhile become acquainted. This interview was written by the great Spanish writer Don Camilo José Cela, of the Royal Academy of Spain, who happened to be, on the Balearic island of Majorca, one of Miró's neighbors and closest friends. In order to justify the contents and tone of my own conversation with Miró, I will summarize, in translation, this Spanish interview which was originally published in the periodical *Papeles de Son Armadans.* It proves conclusively that the most famous artists are not necessarily the most

brilliant or profound conversationalists, and that it was through no fault of my own that Miró failed, when I interviewed him in Paris, to come up to the expectations of some of my readers and critics.

In Don Camilo José Cela's Spanish text, one finds Miró making even more commonplace or absurd remarks than in my interview. Among other subjects of vital importance to an understanding of his art, Miró discusses at length with Cela the various vegetables and herbs that grow in his Majorcan garden, as if his listener were a visitor from another planet now hearing about onions, for instance, for the first time in his life. "There used to be onions," Miró reminisces, "in my father's garden." After which he goes on to explain how useful onions can be. Every vegetable or herb that Miró grows is then discussed in turn, each time with a detailed account of how Miró himself raises, prepares and eats it.

But the most breathtaking part of this whole conversation is Miró's highly personal theory of the miracle of an artist's inspiration. The floor of his new Majorcan studio, he carefully points out, consists of beaten earth, so that inspiration, surging from Mother Earth, can rise to the artist's mind through his feet and legs. Miró neglected, however, to tell Cela whether he stands there barefooted when he works. Floor boards, tiles, stone paving, linoleum and carpeting, too, must all hinder, it seems, the process of inspiration by preventing the direct contact of the artist's feet with Mother Earth, his only true source of inspiration. But how about leather or rubber soles? On this vital subject, we are left in the dark. I now seriously regret that I failed to encourage Miró to make any such revelations to me.

When I tried to interview Picasso, he proved to be so boastfully and disconnectedly garrulous that I preferred never to submit for publication a final draft of my notes of our conversation. When I interviewed Hans Arp, he was very sick and uncommunicative; he died a couple of months later.

I interviewed these various artists in English, French, German or Italian. If their speech seems at times monotonous, their diction impersonal and devoid of those tricks and twists and catch words that are the insignia of an individual turn of mind, this is to be attributed to my having

had to translate their French, their German or their Italian in an English style that remains inescapably my own. Besides, I have often inflicted, as an interviewer, my own preoccupations and terminology on those whom I was interviewing. A question inevitably determines, to a great extent, the terminology of the answer. Had a different interviewer approached each one of these artists, the whole book might have offered a greater variety of points of view, but it would also have lost much of its present unity.

Nor is this unity accidental — I mean that of a series of interviews in which a somewhat pedantic or monomaniac critic may have frustrated every attempt of his victims to transcend his own limited or compulsive preoccuations. My purpose, in attempting this task, was at first to clarify certain historical developments in the evolution of the art of our century. In interviewing Chagall, for instance, I was more interested in elucidating the facts of his Russian background and in discovering, at long last, how much credit should be attributed to the influence and the teachings of certain distinguished Russian painters of the turn of the century or of the Revolutionary era, than in hearing again about Chagall's evolution as a painter of the School of Paris. I knew that the artistic avant-garde of the former Tsarist capital, so little known today, had once been important, and that its painters had been in close contact with the Paris cubists, the German expressionists of Dresden and Berlin, the Blue Rider painters of Munich, and the futurists of Milan. In the case of Morandi, too, I was interested in verifying the facts of friendships and associations, so as to clarify his evolution, from his earlier *pittura metafisica* to his present style of nearly abstract still-life composition. Only by checking such facts can one discover the true history of an individual artist's stylistic development, obscured as this history has often been by the kind of art criticism which sets out to praise rather than to explain, to sell rather than to evaluate.

But I soon began to set myself a more ambitious purpose, too, for which I remain to a great extent indebted to my friend Tchelitchev. I found myself, as I edited his posthumous papers in the form of a dialogue, facing a task that is perhaps unique: that of bringing together, in one volume, a selection of the many

basic beliefs on which the philosophy of modern art is founded. Too often, books on modern art expound but an extremist point of view, valid only as a means of explaining or appreciating the work of a single artist or a single school or tradition. The writings of Mondrian and his apologists, for instance, are of no use to us if we wish to understand and evaluate the achievements of great Fauvist and expressionist painters such as Rouault, Matisse, Kirchner or Kokoschka. Kandinsky's theories will likewise appear nonsensical if applied to an analysis of the evolution of Max Ernst, and even André Breton's writings on surrealist art are not very helpful when it comes to explaining the workings of Paul Klee's mind. In explaining or justifying his own innovations, many a modern artist allows himself to be carried away by his own eloquence and begins to formulate norms which are often applicable only to his own works. I have tried, in these interviews, to discuss the relationship of each artist's work, as far as possible, to modern art as a general trend instead of obtaining, from each artist in turn, a kind of unilateral statement — I mean merely individual creed.

At the height of the Italian Renaissance, in 1538, a Portuguese humanist, Francisco de Ollanda, spent some time in Rome, in the immediate circle of Michelangelo's friends. On his return to Lisbon, he wrote in Portuguese a series of dialogues on art wherein he purported to expound the philosophy of the great master. For centuries, this little book was neglected by most scholars, who saw in it but another Renaissance pastiche of Plato's "interviews" of Socrates. It was published in Oporto in 1896 and only in recent years have a few scholars, among whom my former classmate Professor Robert Clements of New York University deserves special mention, taken the trouble to compare the opinions attributed to Michelangelo in these Portuguese dialogues and those that the master expressed elsewhere, in his own writings or in those of his Italian associates. It is now known that Michelangelo's philosophy of art has been very completely and faithfully expounded by his Portuguese disciple, in spite of the formal limitations imposed by the latter's choice of as rigid a literary genre as the neo-Platonist dialogue of the Renaissance humanists.

The twentieth century interview, as a literary

genre, borrows its conventions from the chatty and presumably informal journalism of our daily press, our radio and television programs. It remains, however, a genre as inescapably literary, though less formal or dramatic, as that in which Renaissance scholars once tried to revive the dialectical tradition of Plato's dialogues.

Nearly all my interviews are based on notes hurriedly scribbled in the course of actual conversations. As I redrafted these notes later for publication, I cheated no more than the average journalist who writes up his impressions of an interview. But a journalist generally cheats by highlighting the "informality" of such an interview, whereas I have cheated, perhaps, by overstressing the formal progression of our discussions. These are indeed dialogues rather than interviews, perhaps because I hoped to produce a work that might be less ephemeral than journalistic impressions of my meetings with painters and sculptors. Have I succeeded in writing a group of dialogues on art that might explain, in a hundred years or more, the problems, aims and beliefs of some of the artists of today?

EDOUARD RODITI

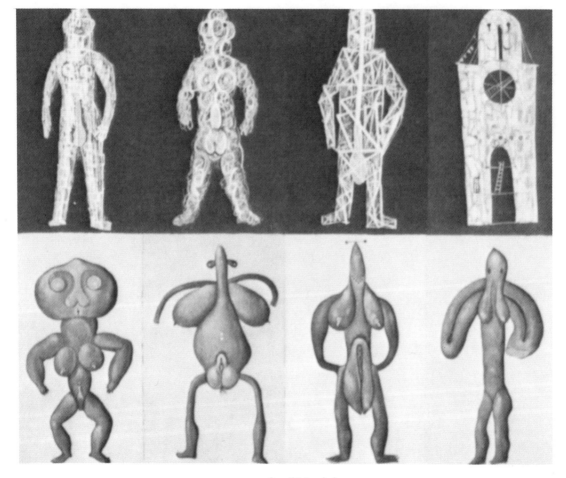

VICTOR BRAUNER, *Small Morphology,* 1934

Victor Brauner

1963

*S*uccess was slow in coming to the Rumanian-born Paris surrealist painter Victor Brauner. Whether in Europe or in America, Brauner remained for many years a favorite only of a few initiates, while Hans Arp, Salvadore Dali, Yves Tanguy, André Masson, Max Ernst or Joan Miró were already being launched on the international art market by more powerful dealers than those who, from time to time, were showing Brauner or his Ger-man-born colleague and contemporary Hans Bellmer beyond the frontiers of France. Only during the last few years of his life did Brauner's Paris shows prove regularly to be major events in the art world. In 1963, at the Galerie du Point Cardinal in Paris, a somewhat selective Paris exhibition of works illustrating various periods in Brauner's evolution since about 1930 finally consolidated his international reputation as a major surrealist, in fact as a painter of much the same kind of importance as Max Ernst. It was on the occasion of this show that I chanced to meet Brauner one afternoon in the gallery. In the course of our exchange of memories and news of various common friends, I suggested to Brauner that I interview him.

Though Brauner always remained faithful, by and large, to the spirit of surrealism as it had first been expressed in its heyday four decades earlier, he often produced works which at a first glance might no longer appear to be typically surrealist. Their style, subject or general character indeed can remind us sometimes of the art of the American Indian or of the native sculptors of Melanesia. Some of the near-human figures that haunt so many of Brauner's works thus have the appearance of totems borrowed from some collective tribal subconscious rather than from the dream world of an individual westerner. A few days after our meeting in his gallery, I visited Brauner in his studio apartment on the heights of Montmartre and was then free to question him mostly on his relationship, past or present, with the surrealist movement and its official doctrine.

E.R.: Do you consider yourself, in your work, a typical or orthodox surrealist?

BRAUNER: No, because there has never really existed a style of art that one might call typical of orthodox surrealism. Even André Breton admitted this. His most important critical work on the subject is quite properly entitled *La Peinture et le Surréalisme*, not *La peinture Surréaliste*. When he wrote it, we were all aware of the existence of a kind of art that reveals close affinities with the literary or ideological preoccupations of the surrealists, but this art can never be as strictly surrealist as, for instance, surrealist poetry.

E.R.: To what kind of art are you referring?

BRAUNER: Breton was already quoting to us the names of some painters of the past as prophets or precursors of surrealism, but it would scarcely be reasonable to claim Jerome Bosch, Arcimboldo, Gustave Moreau or even Giorgio De Chirico as real surrealists. I would prefer to say that such artists tended, in much of their work, to choose somewhat esoteric subjects because these helped them in their search for symbols or archetypes which correspond, so to speak, to the prehistory, in the evolution of human awareness, of those preoccupations which finally became typically surrealist. Such an art of the past offered us exciting possibilities of experience and of self-expression, as it also does today, and that is why I too first joined the surrealist group in spite of the contradictory nature of some of its doctrines or assumptions. Perhaps I was even attracted to surrealism for ethical rather than for aesthetic reasons.

E.R.: Would you care to define the general theory of surrealist art as you might conceive it?

BRAUNER: It can never be formulated very strictly. In any case, surrealist art occupied from the very start a somewhat marginal or tangential position in relationship to the previous evolution of modern art. Surrealism has never imposed any specific technique or style, as cubism, Fauvism or expressionism did. Surrealism was always more concerned with

1

*"Whenever I face a fresh canvas, I feel like a new man
and become an utter stranger in my own eyes."*

subject matter, expecting it to reveal the artist's individual subconscious or to allow us to recover forgotten archetypes from a kind of collective unconscious.

E.R.: What are these archetypes? Are you referring to those types of human experience that supply, as Jung has suggested in his writings, the basic elements of mythologies and religious beliefs?

BRAUNER: Yes, I suppose so, but a surrealist artist remains, in this respect, more isolated and individualized than primitive or religious man, even if his archetypes may coincide with those of primitive art or religion.

E.R.: Would this mean that the surrealist artist is, in a way, detribalized — I mean alienated from any social context of collective beliefs that he may happen to share with others as a group rather than as individuals?

BRAUNER: Yes, because the surrealist artist has chosen to commit himself to a more strictly individualistic kind of experience which is more experimental in a subjective sense than any initiation ceremony, for instance, to the religion of a group. A surrealist artist must seek isolation in order to discover his archetypes, whereas primitive man, to achieve the same ends, allows himself to be initiated into the collective beliefs of his community, which participates in his experiences. As soon as I become aware of my own loneliness and of my own more strictly subjective world, all my personal ties to a group — even to the surrealists — cease to function.

E.R.: Would this explain why the surrealist group, in the few decades of its history, has already excluded or excommunicated as heretics so many of its writers and artists who had at first appeared to be orthodox?

BRAUNER: There is certainly some contradiction between the ideological ties that unite the surrealists as a group and the very nature of surrealism as a kind of individual experience which remains strictly personal and reveals

itself generally as a kind of heresy, in fact as a deviation from the official beliefs of the group.

E.R.: Then how has surrealism managed to survive nevertheless, as a doctrine or group, for more than four decades?

BRAUNER: In a civilization as confused and violent as ours, surrealism can appear at first to mean something relatively clear and stable, but this meaning shifts and changes and is always "other," much as the imagery of our dreams must also change as years go by, reflecting in a way the shifting physical appearance of the world of daily life in which we live and from which our dreams borrow so many of their symbols. If only as a group or school, surrealism has thus revealed to its adepts a great variety of forms of expression, or devices, in the field of subjective experience, and this is particularly true of surrealist poetry and narrative. But surrealist art can also involve the painter, whose tools and materials are so much more cumbersome than a writer's, in solving problems of technique which are not necessarily of a secondary nature, I mean different from his more purely subjective preoccupations. And this is where I find myself less in agreement with some of the younger surrealists who are still grouped around Breton. They seem to be bound to him by obligations, in their attitudes and behavior, which are often of a more ideological, political or social nature than strictly artistic. Their actions may thus seem to be spontaneous, but are really dictated to them by collective deliberations and decisions. As for me, I cannot bear any such limitations to the absolute freedom that I need as an artist, so that I can no longer allow myself to become involved in any such collective action. Besides, surrealism is no longer as active at the level of artistic creation as it once was — I mean as a movement — in fact, many of the more creative new representatives of surrealist art are not even members of the orthodox or official surrealist group.

E.R.: How would you define your own aims

now — as a solitary individualist at this level rather than as a member of a group?

BRAUNER: I still feel that I have, as a creative artist, some problems of my own to solve in my work. For this, I need my full freedom of action. In any case, I have never made any effort to become integrated as a member of any group or society, whatever its structure and beliefs. For a long while, I have felt free to try my hand at anything. I'm no longer at all bound or committed to any style or school of art. Besides, like any other artist today, I can choose among a profusion of technical means and styles such as no other period in art history has ever yet offered. As an artist, I am accepted as I happen to be, without feeling at all obliged to remain faithful to whatever I may already happen to have been.

E.R.: Do you believe that nonformal abstract art can offer an artist a new kind of freedom?

BRAUNER: In theory perhaps, at least as long as it relies on chance to suggest meanings for its formlessness. In practice, however, it generally concerns itself with such problems only superficially and soon degenerates into a style of decoration that lacks any more articulated system of beliefs, thought and emotion. In any case, such terms as figurative and nonfigurative or formal and nonformal suggest very superficial categories. An artist such as Paul Klee understood quite properly that he had to try his hand at any style that occurred to his mind, and this is how he managed to leave some works that are figurative and others that are nonfigurative — but all of them equally typical of his very personal genius.

E.R.: So you would not advise an artist to seek too personal a style to which he would remain rigidly faithful in all his work?

BRAUNER: Certainly not. The modern art market requires that an artist specialize and, in the long run, repeat himself too. But what he then produces may no longer illustrate what remains indispensable to him as artistic expression — I mean a sense of adventure, of discovery and perhaps even of danger, of the risk of really making the wrong choice and of losing or destroying himself as an artist. Whenever I face a fresh canvas, I feel like a new man and become an utter stranger in my own eyes. When one faces this mystery of becoming and of self-discovery and self-expression as an artist, one can no longer rely very much on what one has already achieved. But this is also why I can never have very clear long-range plans. I do not want to become a specialist in any strictly limited style or range of subject matter, though I may actually find myself more often preoccupied by some problems or symbols than by others. Nor would I really be able to be such a specialist, even if I wanted. But this problem, fortunately, has never arisen in my life, and this may well be why I continue to feel the need to work and to create, as if I had never yet created anything in the past which I can still recognize as wholly my own.

At the time of this brief interview, Brauner was seriously ill and easily tired. I refrained from making any heavy demands on his attention or his memory. As we parted, he agreed, however, that we should soon meet again for a more extensive discussion of his work and his beliefs. This second discussion, alas, never took place. A few weeks later, Victor Brauner was no longer of this world. I had been the last to importune him with an interview.

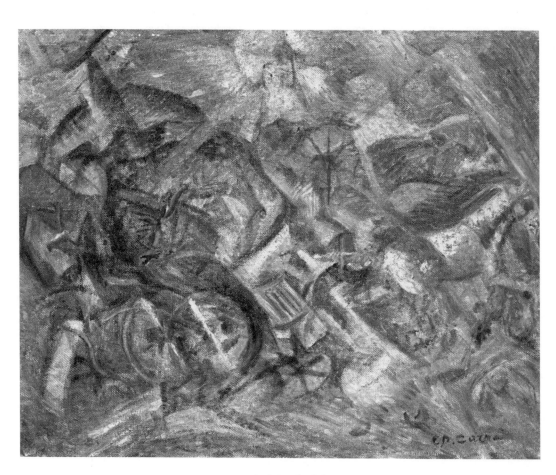

CARLO CARRÀ, *Jolts of a Cab*, 1911

Carlo Carrà

*U*ntil a few years ago, relatively little was known outside of Italy, except by special-ists, about the two phases in the evolution of modern painting which remain strictly Italian contributions to the art of the twentieth century: futurism and pittura metafisica. Only one painter who had been a major figure in both movements was still alive—Carlo Carrà. Though now rarely mentioned in the same breath as Picasso, Matisse or Modigliani, Carlo Carrà at one time failed only by chance to become the object of the kind of Barnum & Bailey publicity whereby some Paris dealers have managed since 1920 to market the works of major painters whom they represent exclusively, making their names almost household words as widely known as brands of patent medicines or detergents. In the autobiography he published in Italian, Carrà indeed relates how in 1914 Picasso's Paris dealer, Henri Kahnweiler, offered to handle his works too on almost the same terms as Picasso's:

"When my friend Guillaume Apollinaire men-tioned to me the possibility of obtaining a contract whereby all my paintings would be marketed by the dealer Kahnweiler, I asked him not to include the customary clause requiring that the artist reside in Paris. In the course of the discussions which were expected to lead up to the signing of the contract, I continued to insist on being allowed to spend at least six months of each year in Italy. The agreement was expected to be in force as of September of that year, but it was never applied in practice as war was declared on the first of August. After the war, other proposals of the same kind were made to me by vari-ous Paris dealers, but I continued to reject them; by that time I was deeply convinced that it was my des-tiny to remain in Italy, where my activity, whether as painter or as critic, was in my opinion more useful than in any other country. This attitude of mine was later criticized, and some people have even declared that I accepted a great sacrifice by remaining in Italy, a country that still offered in those years less scope to an artist than France. I write all this today,

in 1942, not so much in order to boast, but rather because it might still be of some significance."

Some twelve months after I had been there for my conversation with Marino Marini, I found myself again in Milan for a few days. The weather was as cold and foggy as on my last visit, the streets as inhospitable, the museums as deserted and as permeated with the city's oddly un-Italian smog. In the course of a chat with the proprietors of the Galleria del Miglione, I was told that Carrà was in Milan; when I expressed my desire to meet him and interview him, a phone call sufficed to make an appointment. The next morning, at eleven o'clock, Carlo Carrà and his wife received me in the large apartment they shared with their only son in the center of the city, a few hundred yards from where Marino Marini lived.

Born in February 1881, Carrà was already about to celebrate his seventy-ninth birthday. Though afflicted with a deafness that made it difficult for him to converse with strangers, he was hale and hearty and boasted to me that he still drew or painted every day. His lively and intelligent wife assisted him throughout our interview, repeating my questions whenever my somewhat peculiar Italian made it difficult for him to detect by lipreading what I was trying to say. As on the occasion of my conversation with Marino Marini, I was pleasantly surprised to observe how comfortably, in terms of traditional middle-class amenities, the major painters and sculptors of Milan live. One somehow feels that art in Italy remains as respectable a profession as medicine or law, and that the artist is no marginal Bohemian as elsewhere in the western world but an integrated member of an established order. Though Milan may have had in the latter half of the nine-teenth century its Scapigliatura, which imitated for a while the mannerisms of the Bohemians of Paris, it still seemed to be a city where the long hair, dirty blue jeans and unwashed necks of the existentialists of Paris and the beatniks of Greenwich Village, Chelsea or Bloomsbury had no place.

Not that Carrà's immediate physical appear-ance, his "presence" as a personality, were at all

"In my pittura metafisica, *I . . . sought to strip physical reality
of its accidental trappings, to reduce it in a way to the
same basic structures as in my* arte antigraziosa, *but then
to reconstruct it and to enrich and expand its meaning in
terms of a timeless reality."*

those of a middle-class professional man. On
the contrary, his habits of dress and speech, his
gestures, the beret that he wore on his head even at
home — all proclaimed his faithful allegiance to a
pattern of life adopted in his early youth. Then, as
a journeyman artisan earning wages by decorating
walls and ceilings, he had also been active — either
in Italy, Paris or London — in those Italian anar-
chist circles that specialized in concocting home-
made infernal machines and organizing attempts
on the life of every European crowned head. The
earlier chapters of Carrà's published memoirs are
full of descriptions of his meetings and disagree-
ments with other anarchists. In London, for
instance, at the turn of the century he was living in
Soho on Dean Street with a group of Italian anar-
chists whose real-life activities have also been
described, with some poetic license, in a couple of
novels by Joseph Conrad and stories by Robert
Louis Stevenson. Among these anarchists, Carrà
even knew Recchioni, who spent some years in
prison after having tried to throw bombs in the
House of Commons but was then allowed to remain
in England and to prosper as a respectable coal
merchant. When Italy's King Umberto I was assas-
sinated in Monza in 1900, Carrà and his friend
Mario Tedeschi shocked many of their anarchist
friends in Soho by adopting an entirely novel stand:
as humanitarians and pacifist anarchists they
declared in a leaflet drafted, printed and distributed
in London's Italian colony that kings were human
beings and had a right to live like all other
men. Royalty, they believed, should be deposed,
not exterminated.

This one incident — far more than any references
to the works of Bakunin and Marx or to actual
meetings with Kropotkin during his London
exile — gives Carrà's published memoirs the pecu-
liar flavor of the political, literary and artistic
Bohemia in which he lived, whether in Milan,
Paris or London, during the decade that preceded
his meeting with F. T. Marinetti and Umberto
Boccioni and their founding in Italy of the futurist

movement. Nor were those years of Carrà's
activities as a journeyman-decorator and an
anarchist quite fruitless in terms of his later career
as a creative artist. On the contrary, one must be
aware of his earlier preoccupations in order to
understand fully his major futurist masterpiece,
Funeral of the Anarchist Galli. Though first exhi-
bited — shortly after it had been painted in 1912 —
only in the great Paris, Berlin, London and St.
Petersburg futurist exhibitions, this composition
records the artist's memories and impressions of an
incident in which, in 1904, he had been personally
involved: the funeral of the anarchist Galli, killed
in the street fighting provoked in Milan by the gen-
eral strike. In his memoirs, Carrà describes the
incident as follows:

"Galli's corpse was transported to the Musocco
Cemetery, where the funeral was expected to
take place, according to police instructions, within
the area of the square opposite the entrance to the
cemetery. In order that these instructions be
respected, cordons of cavalry troops blocked all
roads that led toward the city. But the anarchists
decided to resist these orders and appeared in pro-
cession at the entrance of the broad Sempione
Street, suddenly marching toward the troops, which
charged them with unexpected violence. Quite by
chance, I found myself in the very center of the
ensuing fray. I could see, opposite me, the bier,
all covered with red flags; it was being tossed some-
what stormily on the shoulders of the pall bearers.
I could also see the horses rearing, the clash of
lances and the poles of the bier, and I felt that the
corpse was likely to fall at any moment onto the
pavement, to be trampled underfoot by the horses.
I was so much impressed by this scene that, on
returning home, I made a drawing of all that I had
witnessed. This record of an intensely dramatic
scene later inspired me to declare, in the technical
manifesto of futurist painting: 'We must place the
spectator in the center of the composition.'"

E.R.: Your memoirs begin with a detailed

description of your life as an artisan — a journeyman-decorator — rather than an artist. I was surprised as I read the earlier part of your book to find so few references to any ambition to become a creative artist. Does this mean that you might have been quite content to remain a decorator of walls and ceilings?

CARRÀ: To understand my reluctance in those years to embark on the career of a creative artist, you must realize that Italian art, toward the end of the nineteenth century, had sunk to almost unbelievable depths of degradation and meretricious corruption. There seemed to be absolutely no connection between the political, economic and social life of Italy and its artistic production. Italian art had ceased to be at all creative and had degenerated into a kind of export industry; it turned out masses of genre paintings and landscapes that could be purchased by tourists as souvenirs of a few days or weeks of carefree holiday spent in Naples, Florence, Rome or Venice. Many of these paintings represented picturesque beggars, fisherfolk, peasants or gondoliers — but always smiling, attired as if for a fancy ball; the artist refrained from ever expressing in his work any pity for the human degradation and the suffering implied by so much poverty.

While all these now-forgotten painters of landscapes and genre scenes were prospering, Italy's few serious nineteenth century artists remained doomed to poverty and obscurity. Our *macchiaioli* painters, for instance, deserve to be as world famous as their French impressionist friends and contemporaries; but even today, Fattori, Lega, Costa, Signorini, Cabianca and their associates are scarcely known beyond the frontiers of Italy. As the twentieth century was about to dawn, this great crisis in Italian art became even more acute. Young Italian painters of real talent and serious intent — such as Zandomeneghi, Boldini and De Nittis — emigrated to Paris and became disciples of the French impressionists. Contemporary Italian art — as it was represented in the academies, where we could study, in publicly sponsored exhibitions or in commercial art galleries — could only disgust and discourage us. Giovanni Segantini was already dead; the melancholy moods of his divisionist Alpine landscapes were a thing of the past. The sculptor Medardo Rosso had chosen the path of

exile and lived in splendid isolation in Paris. Everywhere in Italy one could find only expressions of bad taste and pretentious ignorance, examples of a kind of mania for painting as if with brown sauces and mustards, in a frenzy of negation of all the traditions of good Italian painting. Leonardo Bazzaro, and others whose names need no longer be remembered, ruled the roost, producing works that were ugly, undistinguished and brutish. It really looked as if professional artists were trying to compete, at the level of a degraded gastronomy rather than of art, with the greasy hashslingers of tenth-rate soup kitchens. But even this dreadful state of affairs was not yet shocking enough to rouse the so-called art critics of Milan, Florence, Venice, Rome or Naples from their journalistic stupor. Nobody seemed willing or able any longer to formulate any valid artistic principles, and Bazzaro was praised in hyperbolic terms by Italian critics who had the effrontery to mention him in the same breath as some of his most deservingly distinguished foreign contemporaries.

Exhibitions in those days had walls plastered with the works of painters whose names have now quite properly been forgotten. In Milan, even the memory of our own local Bohemia, the *Scapigliatura* of a few decades earlier, seemed to have vanished. Among those few who claimed to be interested in modern art, only Tranquillo Cremona — a decent but somewhat conventional painter and contemporary of Fantin-Latour and the French Second Empire — was still seriously discussed as if he represented, with his *sfumato* effects of fifty years earlier, the last word in experimental technique and style. A young man such as I, who felt no inclination to sacrifice his talents on the altar of the Golden Calf, could scarcely be expected in such an atmosphere to feel attracted toward those Italian circles that claimed to be heir to the great traditions of creative Italian art. As long as I decorated ceilings and walls, I was at least earning a decent livelihood without prostituting my talents.

E.R.: Do you believe that these early years of training as a decorator have influenced your later style as a painter?

CARRÀ: I probably owe to my training as a decorator an intense awareness of the aesthetic and emotional values of space and perspective

as well as a lasting faith in the values of certain laws of proportion and composition. In those years around 1900, most Italian painting was cluttered with unnecessary detail that the painter threw in without any regard for proportion or composition, as if to give the customer his money's worth merely in terms of an inventory of all the different things depicted. As a decorator I was relatively free, though in a much humbler craft, from this crass bad taste and materialism which corrupted Italian painting. In a way, the decorators who painted skies on ceilings and floral designs on walls were much more faithful to the basic principles of the great periods of Italian art than the genre painters who delighted in painting blind Neapolitan organ-grinders with trained monkeys performing tricks on their organs, or groups of cardinals drinking wine together in a room that looked like a sacristy.

E.R.: Does that mean that, until you became a regular art student at the Brera Academy in Milan in 1906, you steadfastly refrained from allowing yourself to express or reveal any ambition as a painter?

CARRÀ: On the contrary, I devoted much of my spare time to painting, but I practiced it as a kind of secret love, something that transcended a mere hobby. In 1901, for instance, I painted two portraits, one of my uncle and one of my aunt, which you can see on the wall here. They may be less skillful in terms of sheer technical knowledge and ease than the works that I painted much later, but I feel that they already reveal many characteristics of the color harmonies and texture that were destined to become typical of my more mature style.

E.R.: Yes, these very early works of yours are already characteristic in many respects of your later style. It would be difficult to point out from a study of these two portraits, and of some of your much later works, what you might still be said to owe to your years of schooling in the Brera Academy.

CARRÀ: I really doubt whether I learned anything there except to despise almost all that I was being taught to admire and imitate. We were already a small group of young art students who began to feel the need to attempt something that might infuse new life into the decayed corpse of Italian art. We spent much of our time every evening at the Café del Centro

formulating wild diatribes against all the art that enjoyed any popularity in Milan. We felt that we were "moderns" as opposed to representatives of a corrupt and decadent tradition. But we still had no clear idea of our aims and were content to know that we desperately wanted to discover some new approach to art.

E.R.: When did you begin to formulate the principles of a modern Italian art?

CARRÀ: It was in 1909 that Boccioni, Russolo and I first met Marinetti. He was living at the time in slightly exotic and decadent luxury in an apartment decorated mainly with Oriental rugs, vaguely reminiscent of the settings in which Dorian Gray might have lived. On the occasion of that first meeting we spent several hours discussing the desperate state of Italian painting and soon agreed to publish a manifesto calling upon all young Italian artists to free themselves from the lethargy which seemed to asphyxiate all our legitimate aspirations. The next day Boccioni, Russolo and I met in a café in our neighborhood and began to draft the text of our appeal. It was a difficult task and we devoted most of the day to it. That same evening we met Marinetti again, prepared the final draft, and brought it to the printers. Within the next few days several thousand copies of it were distributed. Futurism had come into being. At first it was but a battle cry, scarcely a systematic program. We hoped to rally to our banner all those who were dissatisfied with the existing climate of Italian art, all the rebels and potential rebels. It was in subsequent discussions and manifestos that we began to formulate the real theory of futurism. We began, for instance, by ridiculing the many merely commercial specializations of Italian painting, its categories of painters of mountain landscapes, seashore views, lakeshore views, et cetera.

E.R.: I once met a woman in Munich who proudly announced to me that she was the daughter of a famous painter of ducks, a man from around 1900 who had prospered by painting and selling only views of a corner of a populous duck pond.

CARRÀ: In Milan, a similar situation had developed. Italian artists seemed to have agreed to divide the whole visible world among themselves, each one of them claiming to be the sole lord and master of some corner of a duck pond.

If another artist dared to trespass on this private domain of subject matter, there would be a duel — if not a legal battle.

E.R.: Would it be correct to state that one of the purposes of futurism was to proclaim that the whole visible world was again accessible to all artists, and that it was the style of an artist rather than his subject matter that constituted his private domain?

CARRÀ: Certainly, and that is why our futurist manifesto provoked such furious resistance, such rage and gnashing of teeth. It was as if we had formulated a communist theory whereby all the vested interests of private property in subject matter were to be abolished overnight. We had set out to expropriate, so to speak, all the duck painters and goose painters and turkey painters of Italy.

E.R.: Futurist painting thus distinguished itself both by its novel style of design, color and composition, and by the variety of subjects that each futurist painter treated.

CARRÀ: Your second point is illustrated by the title of the paintings that I, for instance, exhibited in Paris at the Bernheim Jeune Gallery in the first big futurist show that was seen abroad: *The Funeral of the Anarchist Galli, Jolts of a Cab, The Movement of the Moonlight, What the Streetcar Told Me, Portrait of the Poet Marinetti, Girl at a Window, Crowd Leaving a Theater, Woman in a Café, Street with Balconies* and *The Milan Railway Station.* I had specialized as neither a portraitist nor a painter of genre scenes of women in cafés, nor crowd scenes, cityscapes or moonlight scenes. I had the courage to try my hand at all of them.

E.R.: How would you now define the elements of the latent unity of style or purpose in your first futurist compositions?

CARRÀ: In the beginning, we were all to some extent dominated by Marinetti's formulations of our latent impulses. He was a great publicist, and futurism certainly owed much of its international success to his ability to express our aims in words and to publicize them, as well as to his untiring energy. Marinetti somehow hit on the idea of presenting simultaneously in a single image a number of different moments or aspects of an action, and this led us all to concentrate for a while on a kind of motion study or synthesis, in a single picture, of various images or views of our subject matter. You can

see this aspect of futurism in my *Funeral of the Anarchist Galli* in which the scene is depicted from the point of view of a spectator who chanced to be in the midst of the fray and who then formed a composite, remembered image of different moments or aspects of the scene that he had witnessed. But I was never as passionately interested in these problems of motion and simultaneity as some of my futurist friends, and I soon began to formulate a kind of dissident and more painterly futurism of my own — I mean a style of art that relied less on philosophical or nonvisual notions of reality.

E.R.: How would you describe this dissident futurist style of your own?

CARRÀ: It was a gradual development, a transition that can be observed if one studies my more important works of those years in chronological order, though one should also allow for hesitations and occasional returns to the style of an earlier picture. It would be simpler to define only the last stages of this dissident futurism, when it had almost ceased to be at all orthodox. Perhaps as a result of certain cubist influences that reached me from Paris, perhaps also because of the intensely verbal nature of Marinetti's notions of futurism, I became increasingly interested in a kind of futurism that I called *dipinti paroliberi* — I mean abstract compositions of lettering and whole words organized freely so that their meaning suddenly dawned on the spectator like imperatives surging out of the picture.

E.R.: In a way, these *dipinti paroliberi* might be said to have much in common with certain recent subliminal experiments in advertising, when a word is flashed onto a screen so fleetingly that the spectator cannot read it consciously but remains subconsciously influenced by its meaning.

CARRÀ: Experiments in aesthetics often achieve the same results as similar experiments in psychology. But my *dipinti paroliberi* or *mots en liberté* were not really intended to illustrate a new artistic program; they represent rather a personal venture in a realm of typographical composition which also attracted other artists between 1910 and 1920, including Picasso and Braque among the cubists, Larionov and Goncharova among our Russian colleagues and, of course, after 1917 Max Ernst and a number of Dadaists.

E.R.: When do you feel that you definitely ceased to be a futurist?

CARRÀ: My *arte antigraziosa* period probably reveals my real break with futurism. Around 1914 I began to be weary of the excitement of futurism, of its atmosphere of endless discussion, constant manifestos and random collective action. I somehow felt the need to react in a more consistent and personal way, in a more concentrated style, against the degraded, pretty art that we had set out to revile. My experiments in *arte antigraziosa* represent a somewhat expressionist concession to the plastic values of the objects depicted, a return to an awareness of line and volume. By deliberately deforming the object, I wished to strip it of any accidental prettiness that might detract from a sense of its basic structure.

E.R.: Your *arte antigraziosa* has sometimes been compared to the earlier experiments of Larionov, who, around 1912 in Russia, invented a kind of *art brut* that anticipates all that Dubuffet has been credited with inventing since 1945. Were you consciously inspired, as Larionov had been, by popular art — I mean by the drawings of children and illiterates that one often sees scrawled on the walls of buildings?

CARRÀ: I suppose there exists some relationship between *arte antigraziosa* and this kind of popular art, but I was seeking above all to reduce the object depicted to its basic elements of significance. I wanted my pictures to communicate a meaning rather than exert an appeal by pleasing as mere subject matter. At the same time, I was trying to rediscover those basic principles of composition that had once guided Giotto, Paolo Uccello, Masaccio or Piero della Francesca, so that the beauty of a picture resides in its composition and proportions, not in its subject or its pleasing colors. As soon as I felt that I had rediscovered these principles, I abandoned *arte antigraziosa* and allowed myself more freedom. This was around 1916 and 1917, when I first began to experiment in *pittura metafisica*; within a short while, Giorgio De Chirico and Morandi joined me in these experiments and in 1917, just before I was mobilized in the Italian army, Serge de Diaghilev visited me here in my studio and purchased for his collection *La Femme Prodige*, one of my earliest experiments in *pittura metafisica*.

E.R.: Could you define the purposes and philosophy of *pittura metafisica*?

CARRÀ: I can only define what I had personally set out to achieve. Chirico, of course, was composing his pictures in a similar idiom, often using the same elements as I, but with a slightly different purpose in mind, with aims that were more literary or lyrical, less pictorial and plastic. But I was trying to achieve a formal synthesis with metaphysical implications of a reality perceived in meditation or in dreams. This led me to invent allegories which I allowed myself to represent only in terms of classical forms. I excluded from my compositions everything that could not be made explicit in terms of form, whereas Chirico still allowed his forms to suggest ideas that were not made explicit within the limits of the picture.

E.R.: Were you at all aware of the writings of Sigmund Freud when you set out on this venture of *pittura metafisica*?

CARRÀ: I had of course heard of Freud, but I was scarcely acquainted with his doctrine. If you want to discover the literary sources of *pittura metafisica*, you must seek them elsewhere, in the eighteenth century philosophy of Giambattista Vico. I had met Benedetto Croce in Naples; he had suggested that I read Vico, and it was in Vico's writings that I found a philosophical statement that expressed my own intimate conviction as an artist: "Physical reality is not true reality; true reality is the metaphysical reality of reality." I interpreted this as meaning that the objective world achieves its true reality *in conspectu aeternitatis*, as an allegory of its accidental physical reality of the moment, and never in this physical reality of which we first happen to be aware. In my *pittura metafisica*, I therefore sought to strip physical reality of its accidental trappings, to reduce it in a way to the same basic structures as in my *arte antigraziosa*, but then to reconstruct it and to enrich and expand its meaning in terms of a timeless reality.

E.R.: I have often felt that the importance of your contribution to *pittura metafisica* has been shockingly neglected abroad. When André Breton and the surrealists discovered around 1920 the work of Giorgio De Chirico, they failed to inform us about your work and that of Morandi.

CARRÀ: Jean Cassou is the only foreign critic who in recent years has stressed the importance of my contribution to *pittura metafisica*. But

my earlier experiments in futurism, in *dipinti paroliberi*, in *arte antigraziosa* and in *pittura metafisica* had not remained unnoticed in Paris and elsewhere when I was called to duty in the Italian army in the First World War. On the contrary, Diaghilev and Apollinaire and many others had already been lavish in their praise and encouragement. But that was the Golden Age of modern art. We were still a small group of pioneers, the Paris cubists and Fauvists, the Italian futurists, the London vorticists, the Blue Rider group in Munich, the expressionists in Berlin and Dresden, Larionov and his friends in Russia. Nationalism was quite unknown to us, and we were all friends, each ready to recommend the others to the few gallery owners, collectors and critics likely to be interested in our work. After the First World War, we found ourselves committed in each country to an absurd patriotism. It had become unpatriotic for a Paris painter, even if he were foreign-born, to know anything about contemporary German art or to praise the work of an Italian artist. Overnight, Picasso seemed to have forgotten all about Kandinsky, Chagall behaved as if he had never heard of Larionov, and only a few personal friends of mine in Paris could remember any of my pictures.

E.R.: I remember one particular passage in your memoirs that is very revealing in this respect — I mean the chapter on Apollinaire and Picasso, where you write about your friendship with Serge Jastrebzoff, the Russian cubist who signed his pictures with a pseudonym — Serge Férat — and who illustrated the first editions of some of Apollinaire's works. You describe there a world that seems now almost legendary, the world of Diaghilev's heyday with his Russian ballet and of the famous *Soirées de Paris*, the periodical that Férat and Apollinaire edited. I was particularly amused as I read your memoirs by your description of your accidental meeting with Trotsky, whose group of Russian political exiles used the same printer as Férat. It is difficult for us to realize now what a small and compact world it was, this Europe before 1914.

CARRÀ: It was also for the artist a much better and more liberal world. A foreign artist who chose to settle in Paris before 1914 was not expected by his French colleagues and critics to become a sort of convert to French traditions of art — I mean a renegade as far as his own native artistic background was concerned. But I began to detect the first symptoms of this nascent nationalism in the Paris art world as early as 1914.

E.R.: A kind of Iron Curtain then separated Italy from France throughout the fascist era, and nobody in Paris, London or New York in those years was interested any longer in knowing about contemporary Italian art. Had you decided to live in Paris, after 1920, rather than in Milan, do you believe that your work would now be more widely appreciated abroad?

CARRÀ: Perhaps, but I do not regret having decided to remain in Italy. I feel that I have not wasted my time here, whether as an artist, teacher or critic. Of course, during the years of fascism, I had to learn to paint more conventional pictures, if only in order to avoid the kind of controversy that might have involved me in dangerous political discussion too. But I feel that the more conventional style that I adopted after 1922 was a necessary concession and no betrayal. In some of the later paintings that are hanging here on the walls, I am sure that you will recognize the same basic principles of composition and proportion as in my works of the *pittura metafisica* period and as in the masterpieces of Piero della Francesca, Masaccio and Uccello which have always inspired me. In this painting of 1949, *Il Gran Lombardo*, for instance, I have sought to express in more modern terms the art of Uccello's representations of horsemen.

In a way, my paintings of the past thirty years have remained on the whole less personal, less individualistic than my work had been before 1920; but this is also because I have been concerned, above all, with solving problems that were less individual or personal than those of the majority of my contemporaries. Instead of trying to discover the essential nature of Carlo Carrà, I have been investigating the essential nature of Italian art. Had I lived in Paris, I would probably have been tempted to pursue my experiments along the paths of individualistic self-expression. But I feel that grave dangers await the artist who ventures too far along these paths. Flattery and success soon lead him to believe that every idea that occurs to him must be an original expression of his unique genius. I remember warning Picasso as early as 1914,

"You are ruining yourself here [in Paris]!" Now when I see some of his works of recent years, I realize how right I was. For all his virtuosity, Picasso seems to me to have lost, except in his drawings, those human qualities that must endow all art with some meaning, even in the eyes of relatively simple people. I have now been painting for almost sixty years. The mere fact that some of my latest works often are so very much like some of my earliest is proof in my eyes of the basic sincerity of my efforts. The circle is now . . . about to be closed.

It is always deeply moving to hear a man who is well advanced in years speak contentedly of his past in terms of a life that has been full, leaving him no regrets, no frustrations. Between 1910 and 1920, Carlo Carrà painted a number of masterpieces that should ensure him a lasting celebrity. As I left him and his wife, I could not help but ponder the lines of T. S. Eliot's great poem from Four Quartets: *"In my beginning is my end. . . ." But it was in the middle of the path of his life that Carrà, in my opinion, like Dante, created his greatest works.*

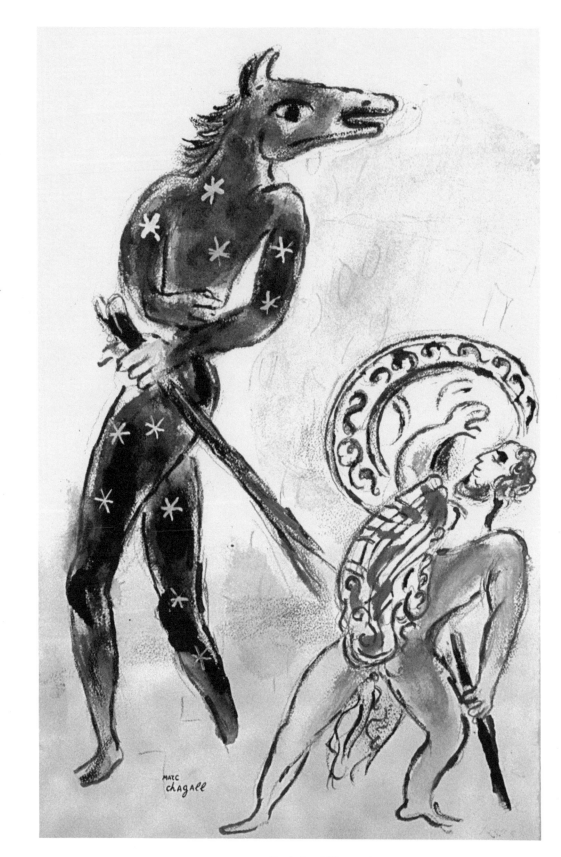

MARC CHAGALL, *Daphnis et Chloë,* 1958

Marc Chagall

*O*n the walls of the Paris apartment, in the Île Saint Louis, that Chagall had recently acquired as a home away from home for occasional visits to the French capital, I was surprised to find, as samples of the master's work, only a few posters of recent exhibitions, pinned up here and there as in the rooms of an art student who cannot yet afford original works of the painters whom he admires. Though I had known Chagall for many years, this was the first time that I had not been with him in a large crowd. I had met him the first time, around 1930, at a Montparnasse café table, at the Dôme. He was there with a group of artists and intellectuals from Central and Eastern Europe. Unless my memory betrays me and I have confused in a single evening my recollections of several such Montparnasse meetings, Chagall was in the company of the sculptor Ossip Zadkine, of the great Yiddish novelist Scholem Asch, of the Soviet publicist Ilya Ehrenburg, of the German film and theater producer–director Erik Charell, whose Congress Dances *and* White Horse Inn *were then recent successes, and of a number of others who came and went, all through an evening spent around a couple of café tables where one spoke French, Russian, German and Yiddish. I now remember, it seems, only the celebrities among those who came and went. I was then one of the youngest contributors to* transition, *not yet twenty years old, and quite thrilled to find myself in such brilliant company.*

Later, I met Chagall again in New York, where he was a refugee during the war years. Again, I have recollections of much coming and going, in an apartment on Riverside Drive where everyone spoke French, German, Russian or Yiddish besides English. There were painters and poets there. Zadkine was again present, with the poets Yvan and Claire Goll, who had just begun publishing in New York, with Alain Bosquet, the magazine Hemisphères, *to which many refugees from Montparnasse and American friends from Greenwich Village contributed.*

That night, in the apartment on the Île Saint

Louis, I was almost alone with Chagall. There were only five of us: Chagall, his wife Vava, whom I had known, long before their marriage, in prewar Paris and Berlin, the photographer André Ostier, the art dealer Heinz Berggruen and myself. At first, we exchanged news of old friends who are now scattered far and wide: Since 1939, each one of us has indeed lost sight of many of those who had once been in our prewar Montparnasse crowd and, since 1945, of many whom we had known later in wartime New York. After a while, Chagall suggested that I accompany him into the next room where I could interview him more quietly. To be more at ease, he lay down on a big blue divan bed, leaving me seated almost behind him. As he began to answer my questions, I felt as if I were psychoanalyzing him. The flow of his memories was often so torrential that I found it difficult to note all that Chagall said. As he spoke, he stared at the blank white wall ahead of him, as if it were a screen on which he could project and visualize his recollections.

E.R.: At what age did you paint your first picture or first begin to draw?

CHAGALL: I have never known when I was really born. Officially, I was born in 1887, which explains why my seventieth birthday has now been celebrated wherever I have friends, for instance in the New York Museum of Modern Art, which staged a special show of my graphic work on that occasion. But am I really a septuagenarian? In spite of my gray hairs, I often feel much younger. Besides, my parents may, as was frequently done in those years in Tsarist Russia, have cheated about the exact date of my birth. If they managed to prove that I was four years older than my next brother, they could obtain my exemption from military service by claiming that, as oldest son, I was already contributing toward the support of my family.

Chagall seems to be tempted to wander off into family memories such as those that he has already told us in his published autobiography rather than answer my question more specifically. Like a

15

*"I was seeking a true liberation, not a liberation of the imagi-
nation or the fantasy alone, but a liberation of form too."*

*stubborn analyst who has met with resistance in his
patient, I try to bring him back to the point.*

E.R.: Did your family encourage your ambi-
tions to become an artist?

CHAGALL: In our little provincial ghetto,
among the petty traders and craftsmen that my
family knew, we had no idea of what it meant to
be an artist. In our own home, for instance, we
never had a single picture, print or reproduc-
tion, at most a couple of photographs of mem-
bers of the family. Until 1906, I never had
occasion to see, in Vitebsk, such a thing as a
drawing. But one day, in grade school, I saw
one of my classmates busy reproducing, in
drawing, a magazine illustration. This particu-
lar boy happened to be my worst enemy, the
best student in the class and also the one who
taunted me the most mercilessly for being such
a *schlemiel,* because I never seemed able to con-
centrate or to learn anything in school. As I
watched him draw, I was completely dumb-
founded. To me, this experience was like a
vision, a true revelation in black and white. I
asked him how he managed such a miracle.
"Don't be such a fool," he replied. "All you need
to do is to take a book out of the public library
and then to try your luck at copying one of the
illustrations out of it, as I am doing right now."

And that is how, *Chagall added after a pause,*
I became an artist. I went to the public library,
selected at random a bound volume of the illus-
trated Russian periodical *Niwa,* and brought it
home. The first illustration that I chose in it and
tried to copy was a portrait of the composer
Anton Rubinstein. I was fascinated by the num-
ber of wrinkles and lines in his face that seemed
to quiver and to live before my eyes, so I began
to copy it. But I was still far from thinking of
art as a vocation or a profession. At most, it was
still but a hobby, though I already began to pin
up all my drawings, at home, on our walls.

E.R.: One of Soutine's biographers writes
that this Russian–Jewish artist's parents
had been horrified and had even beaten him

when he had first expressed his ambition, as a
boy, to become a painter. Did your family and
their friends, in the ghetto of Vitebsk, react
as strongly to your choice of this hobby as
Soutine's family in their small-town ghetto?

CHAGALL: My father was a devout Jew and
perhaps understood that our religion forbade
us to create graven images and, in the opinion
of the more orthodox Rabbis, even to reproduce
any living creature. But it never occurred to
any of us that these little pieces of paper might
be what was thus so solemnly forbidden. And
that is perhaps why nobody, among my relatives
and my friends, was at all shocked, at first, by
my new hobby.

Then, one day, another classmate of mine, a
boy who came of a family that was wealthier
than ours and more cultured, dropped by, at
our home, and chanced to see some of my draw-
ings pinned to the wall of the room where I
worked and slept. He was most impressed by
my drawings and proclaimed enthusiastically
that I was a real artist. But what did this strange
word mean? I had always been somewhat lazy
in my studies, a bit absentminded and unwilling
to concentrate or to learn. At home, nobody
ever asked me what trade or profession I might
want to study. My family was very poor, and
the poor cannot afford the luxury of a vocation.
On the contrary, boys with a background like
mine are generally glad to accept the first job
that comes their way, as soon as they are old
enough to work. Besides, I could scarcely
imagine, at that time, that I would ever be able
to do anything useful in life. At best, I might
qualify for some unskilled job, like my father,
who found it hard to make both ends meet on
his meager salary as a warehouseman for a
wholesale dealer in pickled and salted fish. Still,
this mysterious word "artist" might mean a
somewhat better opening for me, in my life,
and I began to ask my classmate what it meant.
In his explanation he mentioned the names
of the great artists of Tsarist Russia, men like

Riepin and Verestchaguine, painters of portraits of famous men or of vast historical scenes that were frequently reproduced at that time in such magazines as those where I picked the models for my own drawings. But I had never paid any attention to the names of the artists whose works were reproduced in *Niwa*, and nobody in my family had ever mentioned them to me.

Be that as it may, my madness became apparent for the first time that day. I now knew that I had a vocation, even if my own father still had no idea what this profession that I had chosen might really mean. As for me, I already understood that it would at least mean my having to attend some school and obtain a diploma there. That day, my mother was baking bread in the kitchen when I interrupted her to discuss my new plan. But what I said about being an artist made no sense at all to her, and she almost told me to go climb a tree.

E.R.: Was it in Vitebsk that you managed to obtain your first training as an artist?

CHAGALL: Yes, but it was no easy task for me to find a teacher. I had to run all over the city before I found a place where I might study my new trade. After enquiring everywhere, I finally found the studio of Pen, a provincial portrait painter who also taught a few pupils on the side. I then begged my mother to accompany me on my first visit to the master, much as I might have asked either of my parents to come and discuss with some craftsman under what conditions he would accept me as an apprentice. But my mother preferred to consult an uncle of mine beforehand, a man who read newspapers and thus enjoyed, in our family circle, the reputation of being a cultured man of the world. This uncle then mentioned the same names, as examples of all that being an artist could mean, as my classmate. But he also added that men like Riepin and Verestchaguine had talent, something that had never yet occurred to any of us. My mother decided, however, on the spot that she would allow me to study art if Professor Pen, who certainly knew his own business, expressed the view that I had talent. All this must have taken place in 1907 and, if I remember right, I must have then been scarcely seventeen years old.

E.R.: What were your impressions, on your first visit to Pen's studio?

CHAGALL: When we got there, my mother and I, the master was out, on some errand downtown. But we were greeted by one of his pupils, who was busy in a corner of the studio, drawing something or other. I had brought along, under my arm, a whole bundle of my own drawings, to show them to the master. When my mother saw, in Pen's studio, so many fine portraits of bewhiskered generals, their chests all bright with medals, and of the wives of local gentry, with their opulent and much bejewelled bosoms, she experienced a moment of hesitation. "My poor boy," she sighed, "you'll never manage to make the grade." She was ready to turn back and to drag me home again in her wake. I was still so timid that I held tight to my mother's skirt, whenever we left our part of town, as if I were a child and afraid of losing her in the crowd.

But my mother lingered on in Pen's studio, admiring the master's works and questioning his pupil about the chances of a future that this strange trade might offer a promising beginner. The young Bohemian answered her questions somewhat laconically, making a great show of his worldly cynicism. Art, he explained, isn't a trade that implies keeping a shop and selling one's wares. At this point, Pen returned to the studio from his errands in town. Immediately, I produced my drawings and began to show them to him. My mother asked him if I had any talent. Pen answered evasively that there was "something" in my work. But these few words of appreciation sufficed to convince my mother, and I was enrolled on the spot as one of his pupils.

I did not attend Professor Pen's classes very long. I soon understood that he could only teach me a kind of art that had little in common with my own aspirations. These were each day becoming more conscious and clear to me, though they still consisted in knowing what I didn't want to paint rather than what I really wanted to achieve. Still, old Pen was kind enough to realize what sacrifices my studies implied for my poor family, and he soon offered to teach me free of charge. My progress was, however, so rapid that, in 1908, I was already able to move to St. Petersburg and enroll there in the Free Academy where Léon Bakst taught.

E.R.: Wasn't Bakst already a close friend of Serge de Diaghilev and one of the most gifted

and famous designers of sets and costumes for the Russian ballets?

CHAGALL: Yes, Bakst was one of the leaders of a group of St. Petersburg artists that was known as *Mir Iskusstva*, the World of Art.

E.R.: What was your own style of painting, when you first came into contact with Bakst and his school?

CHAGALL: All my works of this first period of my professional life as a painter are now lost. I suppose you might have called me, at that time, a realist–impressionist, as I was still following a trend that had been introduced in Russia by a number of our teachers who, on their return from Paris, had begun to spread among their friends and pupils a few vague notions borrowed from Pissarro and Jules Adler, from Sisley and Bastien Lepage.

E.R.: How did it happen that all your early works of this period are lost?

CHAGALL: When I first arrived in the Tsarist capital, I was very short of money and, one day, discovered a frame-maker — his name was Antokolsky, like the famous Russian sculptor — whose shop window was full of photographs and of framed pictures that he seemed to have on sale there for various painters who were also his customers. I managed to overcome my natural timidity sufficiently to bring all my work to this man Antokolsky and to ask him if he thought he might be able to sell any of it. He told me to leave him my work and to come back in a few days, allowing him time to think it over. When I returned a week later, it was like a scene from a Kafka novel. Antokolsky behaved as if he had never seen me before and claimed that I had never left him any pictures. As for me, I had of course neglected to ask him for a receipt. I even remember his asking me: "Who are you?" In any case, I couldn't sue him in court as I was living illegally in the Russian capital, without the special permit that was still necessary for most Jews.

E.R.: It looks very much as if Antokolsky had been, in his unpleasant way, your first real patron, in fact the first to appreciate the market value of your work. He probably made a lot of money when he sold your pictures a few years later.

CHAGALL: Perhaps, but I have never been able to trace any of the pictures that I left with him, so I often wonder whether he ever sold them.

E.R.: Was it in St. Petersburg that you finally weaned yourself away from your earlier realist–impressionist style?

CHAGALL: Yes, though not at once. One of the first pictures that I painted in the Tsarist capital was a copy of a landscape by Isaac Levitan.

E.R.: Isn't Levitan considered a great Russian impressionist master? He was a friend, if I remember right, of the writer Anton Chekhov, who mentions him frequently in his diary and in his letters and had a Levitan landscape hanging above his desk.

CHAGALL: Yes, we all considered Levitan a great man, in those days, and I was fortunate enough to meet in St. Petersburg several of his friends and patrons as well as some friends of the painter Serov. I saw many of the works of these two Russian impressionist masters in private collections. At that time, being a Jew, I needed a special permit to reside in the capital and, having failed to obtain this permit, I was unable to register as a student in the National Academy of Fine Arts. That is why I had to go to the Free Academy, where I studied, among others, under Bakst and Roehrich. . . .

E.R.: Roehrich subsequently emigrated to the United States. I remember visiting, some twenty years ago, a Roehrich Institute in New York, on Riverside Drive. It was full of Roehrich landscapes, some of which struck me as pretty ghastly, and the whole place reeked of theosophy, or was it anthroposophy. . . ?

CHAGALL: But Roehrich had once been, in Russia, a very serious painter and a much respected innovator. It was to Roehrich that Diaghilev gave the job of designing the original sets and costumes for Stravinsky's *Rite of Spring*. At that time, Bakst, Roehrich and Alexandre Benois were the leaders of a kind of Russian art nouveau or *Jugendstil*. . . .

E.R.: Wasn't Benois the grandfather of Peter Ustinov?

CHAGALL: Yes, that whole family is very gifted, and several members of it have become famous, especially in theatrical work. When I first came to St. Petersburg, Bakst, Benois, Roehrich and their friends of the *Mir Iskusstva* group were trying to achieve a synthesis of new trends, which reached them mainly from Paris and from Vienna, and of certain elements of traditional Russian folk art, especially the

somewhat more exotic or oriental folk art of Southern Russia and of the Caucasus. They thus contributed very much toward the success of the early Russian ballets.

E.R.: Many of the Russian modernists, even Kandinsky and Goncharova, were at one time disciples of the *Mir Iskusstva* group. I saw last summer, in the Amsterdam Stedelijk Museum's Exhibition of Art of the year 1907, a huge painting by Kandinsky that still looked like a Bakst design for a theater curtain.

CHAGALL: I'm not at all surprised. But Bakst and his friends remained, on the whole, true to a very aristocratic and refined, even somewhat decadent, conception of art, whereas Levitan and even Riepin advocated a kind of Populist art that had some Socialist implications, suggesting a return to the earth and to the life of the Russian people. I felt attracted to this Populist impressionism rather than to the pure impressionism, after the manner of Sisley, of some Russian painters, such as Grabar, who had studied in Paris. Still, I always had my own notions about this Populism too.

E.R.: Yes, I don't suppose anyone has ever dared to place you among those Socialist realists whose paintings are often but illustrations to doctoral dissertations in the field of comparative sociology.

CHAGALL: On the contrary, I have always tried to remain within the general tradition of a kind of folk art and, at the same time, of all great art that also appeals immediately to the less sophisticated, to the people. That is why, in Russia, I was a great admirer of the traditional art of the icon painters. There is often something quite magical and unreal about the plastic values and the colors of icons. They suddenly light up before our eyes, in the darkness of a church, like flashes of lightning. One can well understand how it has been believed that many of these ancient icons were not created by the hands of man but had appeared miraculously from heaven.

E.R.: Another Russian painter, Vladimir de Jawlensky, who was a close friend of Paul Klee, was also a great lover of the art of the ancient painters of icons.

CHAGALL: Jawlensky? What a wonderful painter! He was one of those who encouraged me most when I was having such a hard time in St. Petersburg. Later, he often wrote to me from Munich. I was so pleased, in the last few years, to see that Jawlensky's art is at last receiving the attention that it has long deserved.

E.R.: So it was in St. Petersburg that you experienced your first contacts with the modern art movement. . . .

CHAGALL: Yes, but I was also busy discovering there some of the treasures of the city's museums. And it was in St. Petersburg that I began painting my first series of self-portraits.

E.R.: I have had occasion to see recently one of these self-portraits that have now become so rare. It hangs in Oxford, in the home of one of my friends. To me, it has always seemed, in its composition and coloring rather than in its actual texture, to be somewhat inspired by the early self-portraits of Rembrandt, perhaps because you depict yourself wearing a kind of beret, not unlike the one that Rembrandt wears in one of his self-portraits.

CHAGALL: How strange! I was very far, in those days, from thinking of Rembrandt. Most of the Russian painters whose work I knew were addicted to the color harmonies which you find so somber. It was only later, when I came to Paris, that I learned at last, as other Russian painters did too and as van Gogh had also learned earlier, to appreciate all the wonders of light and of color.

E.R.: I remember reading somewhere that Bakst had already encouraged you in St. Petersburg to try your hand at brighter color harmonies and to allow yourself greater freedom as a colorist.

CHAGALL: Perhaps, but Bakst had also learned much of his art in Paris and, in any case, I began to follow his advice only after 1910—that is to say, after my arrival in Paris.

E.R.: How did you manage your first trip to Paris?

CHAGALL: Bakst had originally wanted me to take on the job of his assistant Anisfeld, who helped him paint the sets for Diaghilev's ballets and was about to leave him. I don't remember how it came about that this plan did not materialize and that I somehow failed to go to Paris with Bakst and the ballet company. It was finally the lawyer Vinaver, who was also a member of the Russian Parliament or Duma, who offered me the money for my first trip. Vinaver had been, ever since my arrival in St. Petersburg, my first and most faithful patron.

He had several of my paintings in his collection, where I was very proud to see them hang close to works by Levitan and Serov.

E.R.: The American painter Zev tells me that his great-uncle had also been one of your early patrons in the Tsarist capital.

CHAGALL: Zev? Certainly. I even mention the old gentleman in my book *Ma Vie*. But I had no idea that the nephew of my friend Zev was an American painter.

Anyhow it was Vinaver who, one day, suddenly offered to pay for my trip to Paris and to transfer to me each month a sum of forty rubles, which I used to go and collect from the Crédit Lyonnais on the Boulevards. So I left Russia all alone, and full of misgivings. I was already in love, in those days, with Bella, who lived with her parents in Vitebsk. But her family felt that I was too poor to be considered a desirable son-in-law, and even the German frontier officials, when they boarded our train to inspect our passports and our baggage, viewed me suspiciously and asked me, *"Haben Sie Läuser?"* [Do you have lice?]

E.R.: What were your first impressions of Paris?

CHAGALL: I seemed to be discovering light, color, freedom, the sun, the joy of living, for the first time. It was from then on that I was at last able to express, in my work, some of the more elegiac or moonstruck joy that I had experienced in Russia, too, the joy that once in a while expresses itself in a few of my childhood memories of Vitebsk. But I had never wanted to paint like any other painter. I always dreamed of some new kind of art that would be different. In Paris, I at last saw as in a vision the kind of art that I actually wanted to create. It was an intuition of a new psychic dimension in my painting. Not that I was seeking a new means of expression, in a kind of basically Latin realism like that of a Courbet. No, my art has never been an art of mere self-expression, nor an art that relies on the anecdotes of subject matter. On the contrary, it has always been something essentially constructed, in fact a world of forms.

E.R.: Is that why you immediately associated with the Paris cubists?

CHAGALL: No, the experiments of the cubists never interested me very deeply. To me, they seemed to be reducing everything that they depicted to a mere geometry which remained a new slavery, whereas I was seeking a true liberation, not a liberation of the imagination or the fantasy alone, but a liberation of form too. If, in one of my pictures, I placed a cow on a roof, or a tiny little woman in the middle of the body of a much larger one, all this should never be interpreted as an anecdote. On the contrary, it all seeks to illustrate a logic of the illogical, a world of forms that are *other*, a kind of composition that adds a psychic dimension to the various formulae which the impressionists and then the cubists have tried.

E.R.: André Breton and the surrealists have often claimed that you had been ten years ahead of their movement, and that you had, as early as 1912, begun to obey the dictate of the kind of automatic painting that they advocated around 1920 in their earliest manifestos.

CHAGALL: No, this argument is entirely unfounded. On the contrary, I always seek very consciously to construct a world where a tree can be quite different, where I myself may well discover suddenly that my right hand has seven fingers whereas my left hand has only five. I mean a world where everything and anything is possible and where there is no longer any reason to be at all surprised, or rather *not* to be surprised by all that one discovers there.

E.R.: One of my friends, the Israeli art critic Haim Gamzou, claims that you are the Breughel of Yiddish idiom and folklore, and that he has himself identified over a hundred illustrations of popular Yiddish idioms and proverbs in details of your work.

CHAGALL: But I have never consciously set out to illustrate these idioms and proverbs as Breughel once did, nor have I ever systematically composed a painting in which every detail illustrates a different proverb. All the idioms and proverbs that I may have illustrated have actually become popular because thousands of ordinary men and women use them day by day, as I too have done, to express their thoughts. If a man driving a horse cart uses these metaphors and similes, there is nothing literary about his language. And if I, the son of a humble worker of the Vitebsk ghetto, also use them, this is still no reason to argue that my art relies on anecdote. Does the mere fact that I have become an artist make my work literary as soon as I express myself, perhaps unconsciously,

as did all those who surrounded me in my child-hood?

E.R.: Not at all. But other critics have also claimed that much of your earlier work borrowed its themes, or at least many of its details, from the writings of the great Yiddish humorists Sholem Aleichem and Peretz.

CHAGALL: Of course, I had read some of the works of these writers, but I have never been much of a reader and I feel that, on the contrary, I have probably used the same sources, in popular Jewish humor and folklore, as these writers who, after all, came from communities very much like the one where I was born and spent my childhood.

E.R.: And what do you think of the critics who claim that they have detected in your works the influence of Hassidic mysticism?

CHAGALL: It is true that all my family belonged to a Hassidic community and that we even had, in Vitebsk, a famous Hassidic *Wun-derrebe*, a miraculous rabbi. But I doubt whether anyone can reasonably pretend that my work is essentially an expression of mystical faith or even of religious belief. Mysticism and religion, of course, still played an important part in the world of my childhood, and they have left their mark in the work of my mature years, too, as much as any other element of the life of the ghetto of Vitebsk. But I have now discovered other worlds, too, and other beliefs and disbeliefs. . . .

E.R.: What artistic circles did you choose to frequent when you first came to live in Paris?

CHAGALL: One of my earliest and closest friends was the poet Blaise Cendrars. With Guillaume Apollinaire, the poet and leading theorist of the cubists, I was much less at ease, though he was always very friendly and helpful. In those days, I had a studio in La Ruche, that legendary colony of broken-down studios where so many famous artists have lived. Modigliani was one of my neighbors. He was then doing more sculpture than actual painting.

E.R.: But you must have found many other Russian artists living in La Ruche.

CHAGALL: No, I think I was then the only Russian painter there. Soutine moved in later. When I was preparing, in 1914, to go back to Russia, via Berlin, Soutine came one day to ask me if I would allow him to rent my studio as a subtenant while I was away.

E.R.: Was Soutine already as odd, as uncommunicative and as careless of his appearance as he has generally been described?

CHAGALL: I always found poor Soutine rather pitiful. Anyhow, I was not prepared to sublet my studio to anyone and, the day I left for Berlin, I secured the door, which had no lock, with a rope, like a parcel. I had no idea, at the time, that I would return to La Ruche only in 1922.

E.R.: What had made you decide to go to Berlin in 1914, just before the outbreak of the First World War?

CHAGALL: Apollinaire had mentioned my work several times to Herwarth Walden, the organizer of Berlin's Sturm Gallery shows. Walden often came to Paris, in those years, to pick new talents whom he could exhibit in Germany. The German poet Ludwig Rubiner and his wife Frieda had also recommended me to Walden. The Rubiners, who were wonderful and devoted friends, were then as frequently in Paris as in Berlin, and many Paris artists owed their German successes to the Rubiners, who were indefatigable propagandists for modern art. Well, one day Walden asked me to let him exhibit some hundred and fifty of my oils and gouaches. I had already exhibited once in Berlin, in the 1913 Herbstsalon, where the collector Bernhard Koehler had purchased my *Golgotha* that now hangs in the New York Museum of Modern Art. So I went to Berlin, in 1914, to take a look at my exhibition in Walden's Sturm Gallery. Actually I stopped in Berlin only a few days, on my way back to Russia, where I planned to see Bella again and hoped to persuade her family to allow her to marry me and to return with me to Paris. We would then have stopped again in Berlin, on the way back, to collect the money that Walden might have obtained for me as a result of sales from my exhibition. But war was declared, and I was able to return to Berlin, and on to Paris, only after the War and the Russian Revolution. By that time, Walden had already sold all of my hundred and fifty paintings and gouaches, but the currency inflation was raging in defeated Germany and the money that Walden had obtained for my work was no longer worth a cent.

E.R.: So it was the second time that you had seen all your work of a whole period sold without your being able to collect any money for it. It was almost like a repetition of the Antokolsky

fiasco in St. Petersburg, except that, this time, your paintings did not simply disappear into thin air. If I remember right, many of the works that Walden had sold for you are now in important public and private collections. I saw some of them in Amsterdam, among those that the Stedelijk Museum exhibits in a whole room of your works.

CHAGALL: Yes, but the Stedelijk also owns many of my works that come from other sources too. But a third unpleasant surprise of this kind awaited me in 1922, when I returned to Paris and tried to go back to my studio in La Ruche. I had expected to find it exactly as I had left it, though with the dust of nearly a decade accumulated on all my pictures and other possessions. Instead I was greeted there by new tenants. In my absence, all my belongings and my works had been moved out and sold, and I was never able to salvage anything.

E.R.: In a BBC talk that was reprinted in *The Listener,* Mania Harari reported, on her return from a trip to Moscow a couple of years ago, that she had still been able to see there quite a number of works which you had painted in Russia between 1914 and 1922. During those years of war and of Revolution, were you able to concentrate much on painting?

CHAGALL: Oddly enough, those years were among the most productive of my whole career. On my return from Paris, I found the atmosphere, in Russia, much more encouraging than before 1910, especially in certain Jewish circles that I had known before my first trip to Paris. Collectors had become far more open-minded, and there were more of them too.

E.R.: I suppose you also found that, in the eyes of younger artists, you already enjoyed considerable prestige as an established master. . . .

CHAGALL: Perhaps. . . .In Moscow, I met at that time an outstanding and very successful engineer, Kagan Chabchay, who bought some thirty paintings of mine, which he planned to donate, with works by other artists, too, to a Jewish Museum that he was sponsoring. But the Revolution came before this project had materialized, and Kagan Chabchay, in 1922, still owned all his private collection. It had not yet been nationalized, and he allowed me to bring back to Paris, so as to exhibit them there, all the paintings that he had purchased from me.

E.R.: Three of those pictures from the former Kagan Chabchay collection came up for sale in December 1958 in the Paris Salle Drouot. It appears that they have a somewhat curious history.

CHAGALL: Yes. On my return to Paris, in 1922, Kagan Chabchay's refugee relatives claimed that he had authorized them to sell the paintings which he had loaned to me, in order to raise money for themselves. So I allowed them to go ahead with these sales, until the Soviet authorities intervened and seized the last three pictures in order to sell them, it seems, on behalf of other heirs, who had remained in Russia, since Kagan Chabchay had meanwhile died. These three pictures, as a consequence of litigation that was then delayed by the Second World War, remained impounded by the Court for close on twenty years.

E.R.: And when they were at last sold in Paris the heirs, whether the money went to those who had emigrated or in theory to those who had remained in Russia, obtained some twelve million francs, a far larger sum than they would have obtained by selling their three pictures in 1922.

CHAGALL: But I had sold them originally to Kagan Chabchay for a sum that would amount to a few thousand francs today.

E.R.: Mania Harari also reports that she met in Moscow a private collector who owns, even today, some thirty of your works, which he has managed to purchase more or less secretly in recent years.

CHAGALL: That is quite possible. I left many works in Russia, most of them in the homes of friends who generally owned small collections that were not nationalized. Many of these collectors or their heirs, I suppose, subsequently sold these paintings on the Free Market, which is a kind of flea market in Soviet Russia.

E.R.: Only recently, I was told by another traveller who had returned from Moscow that he knew of about a dozen such private collectors of modern art who had managed, even during the Stalinist era, to purchase unobtrusively on the Free Market some very valuable works by French impressionist masters, Picasso, Matisse and other foreign artists, as well as works by yourself, by Larionov and other Russian or formerly Russian modernists who have long been banned as "formalists" by the official Soviet apostles of Socialist realism. Still, your own

work has not always been banned in Soviet Russia and, if I remember right, you even enjoyed some official support during the earlier years of the Revolution.

CHAGALL: Yes, I enjoyed the patronage of Lunatcharsky, who was the first Soviet Commissar for Education. It was he who nominated me local Commissar for Fine Arts in my native city, in Vitebsk. I was then responsible for all artistic activities in that region, and was thus able to provide Vitebsk with what I had missed there twenty years earlier — I mean a real Fine Arts Academy and a Museum.

E.R.: Were you able to attract to Vitebsk many of your fellow artists from Moscow and Leningrad?

CHAGALL: It was fairly easy, and nearly all those whom I approached accepted to come. Food supplies were then far more plentiful in Vitebsk than in bigger cities, and I also offered all artists complete freedom. The faculty of my Academy thus included many of the great names of the Russian artistic avant-garde. Nearly all schools of modern art were represented there, from impressionism through to Suprematism.

E.R.: We are not very well acquainted, in Western Europe and in America, with the various schools of contemporary Russian, from Rayonnism to Suprematism and Constructivism. The Suprematists, I believe, were somehow connected both with Mondrian's *De Stijl* group in Holland and with the Dadaists of Zurich, Berlin and Paris.

CHAGALL: Yes, the Suprematists and the Constructivists maintained contacts, throughout the revolutionary years, with advanced groups in Western Europe.

E.R.: But did all these artists, representing such different trends, cooperate harmoniously in your Vitebsk academy?

CHAGALL: On the contrary, our academy very soon became a veritable hotbed of intrigue. To begin with, my old friend Pen, who had been my first instructor, was mortally offended because I had neglected to offer him immediately an important position on the faculty. But I was anxious to avoid introducing, at the very start, too academic an element in our teaching. Pen got his revenge by painting a parody of a famous picture of the German symbolist Arnold Boeklin, the author of *The Isle of*

the Dead. In this parody, Pen depicted himself on his death bed, and gave the devil who had come to fetch his soul a face that was quite recognizably mine. Later, I asked Pen to join our faculty too. But it was with the Suprematists that I had the greatest trouble.

E.R.: Was the founder of the Suprematist school, Casimir Malevich, also on your faculty?

CHAGALL: Yes, but the Constructivists had not yet broken away from the Suprematist group, and I thus had both Malevich and El Lissitzky on the Vitebsk faculty. Even Pougny, who was also a Constructivist before he emigrated to Paris, was there with his wife: they both taught courses in applied art. But Malevich was the leader of this whole group. He had started painting as an impressionist, until 1906, and had then been one of the first Russian Fauvists.

E.R.: I saw a very fine Fauvist painting by Malevich in the Amsterdam Exhibition of the art of 1907, and Larionov subsequently told me in Paris that Malevich, after going through a cubist phase, too, had then exhibited in 1913, in one of the Rayonnist shows in Moscow.

CHAGALL: When I first met Malevich in 1917, he had already begun to preach his Suprematist doctrines.

E.R.: The Galerie Denise René, in Paris, recently showed a few abstract works of his Suprematist period. They are very closely related to the work of Mondrian and of the Dutch abstract painters of *De Stijl*.

CHAGALL: Actually, it was Lissitzky who, among the Suprematists, gave me the most trouble. At that time, he was still relatively unknown and, before committing himself exclusively to Suprematism and later to Constructivism, had first attracted the attention of several of my own patrons by handling Jewish themes in a style that was not unlike my own.

E.R.: Some of Lissitzky's early works on Jewish themes turn up even today in German auctions. Because they are so much like early works of your own and are likewise signed, as you did too at one time, in Hebrew script, they are usually listed in German auction catalogues under your name.

CHAGALL: I suppose there are no longer many art experts in Germany who can decipher Hebrew script. But Lissitzky and I were not the only artists in Russia to handle such themes and

to sign our work, at that time, in Hebrew script. There was also Issachar Ryback, who died relatively young and has left us some very fine works. He was one of the most gifted in our group of artists who were then seeking to formulate a specifically Jewish style of art. In the early years of the Revolution, the various national groups in Soviet Russia were at first encouraged to develop schools of art of their own, and quite a number of Jewish artists thus happened to pursue, for a while, the same aims. It was with Ryback, Nathan Altman, Lissitzky, Rabinovich and Tischler that I came to work in Moscow for the Jewish National Theater, for the Habbimah and for the Kamerny Theater. But most of my theatrical designs were considered too fantastic for use on the stage, and Meyerhold, Tairov and Vatchangov never used them. Only Granovsky ever had the nerve to use any of my designs. I also painted some panels to decorate the foyer of the Jewish National Theater in Moscow.

E.R.: How did you manage to find time to found and direct your academy and museum in Vitebsk and to work concurrently for the theater in Moscow?

CHAGALL: Well, as they say in Yiddish, you can't be dancing at the same time at two different weddings, and I could scarcely be both in Vitebsk and Moscow. As long as I was director of the Academy, I had little spare time to paint. At all times, I was busy raising funds to meet our expenses, scaring up supplies of all sorts, or visiting the military authorities to obtain deferments for teachers or pupils. So I came and went, and also inspected all schools in the area where any art classes were taught, and was constantly being called to Moscow for conferences with the central authorities. While I was away from Vitebsk, impressionists and cubists, Cézannians and Suprematists, whether on the faculty or among the students, used to engage in a kind of free-for-all behind my back. One day, when I returned to Vitebsk from Moscow, I thus found, across the façade of the school building, a huge sign: *Suprematist Academy*. Malevich and his henchmen had simply fired all the other members of the faculty and taken over the whole Academy. I was furious. I handed in my resignation at once and set out again for Moscow, in a cattle car, as the railroads had no other rolling-stock available even for travellers on official business. . . .

E.R.: But surely your friends in Moscow refused to accept your resignation.

CHAGALL: On the contrary, when I called at the Ministry of the Commissar for Education, I was told I had already been fired. A whole file of denunciations and affidavits was produced, and I was told that some of the Suprematists had accused me of being authoritarian and uncooperative and of a whole lot of other crimes. Reports of all this reached Vitebsk, and the students staged a protest as a result of which I was reinstated, though not for very long. My Suprematist colleagues continued to intrigue against me and I then arranged to move to Moscow, where I began to free-lance, working mainly for the Jewish Theater until I returned to Berlin and Paris in 1922. Not only did I now have more time to paint, but I even managed in Moscow to write my book *Ma Vie*, which was subsequently published in Paris in 1931.

E.R.: Did the Suprematists and Constructivists continue to persecute you in Moscow?

CHAGALL: From 1920 on, the various advance-guard schools of art began to feel more pressure to toe the party line of Socialist realism. Even David Sternberg, Falk, Altman and the other disciples of the impressionists and of Cézanne who still headed the National Academy of Fine Arts no longer dared open their mouths when the theorists of Socialist realism condemned as bourgeois or formalist all the styles of art which they admired.

E.R.: So you actually left Russia, in 1922, as a political refugee, since you would have been persecuted, had you remained there, as a representative of a school of art which the Stalinists had banned.

CHAGALL: Well, I had already had just as good political reasons to emigrate in 1910, so that it would be more correct to say that I left Russia, on both occasions, for purely personal and artistic reasons. I have chosen to live in France because I have always felt that France is my real home, because only in France, and especially in Paris, do I feel truly free as a painter of light and color. I have already stated to you that Russian painters, in my opinion, have but rarely managed to develop a real sense of color in their own country.

E.R.: Yet all of Paris and of Western Europe had raved about Bakst's sense of color, before the First World War, and about the brilliance of

the sets and costumes of Diaghilev's Russian ballets.

CHAGALL: True, but Bakst and the other artists who worked for Diaghilev had all studied in Paris or been pupils of Russian painters who had returned to their native land after studying with the great impressionists. Besides, there is a great difference between the use of color in the applied arts, especially on the stage, and in easel painting. The light, in a theater, is not of the same kind as the light that we find in nature, or in a room where a picture hangs on a wall. That is why an artist who works for the stage can allow himself more violent contrasts of color than on a canvas, where there is no movement of actors or of dancers to relieve the tension of these contrasts, and no spotlights to stress suddenly a detail while leaving the rest, for the time being, in the shadow. A canvas requires a kind of harmony of light and of color, a more integrated unity than that of a stage set. Now that I have been working on the designs for a new production of Ravel's *Daphnis and Chloë* ballet for the Paris Opera, I find myself constantly concerned with these problems.

E.R.: On your return to Paris, after spending all the years of the War and of the Revolution in Russia, you surely found it difficult, at first, to integrate yourself again in the Paris art world.

CHAGALL: Perhaps. . . . But I did not come directly from Moscow to Paris. Instead, I stopped for a while in Berlin, where I found myself, in those difficult years of inflation and of the birth pangs of the Weimar Republic, in an atmosphere that was not unlike that of the early years of the Russian Revolution. Besides, I met in Berlin a number of Russian friends, from Leningrad, Moscow and even Vitebsk, who had likewise emigrated, if only for a while.

Berlin had become, right after the First World War, a kind of vast clearinghouse of ideas where one met all those who came and went from Moscow to Paris and back. Later, I found for a short while a similar atmosphere on the Paris Left Bank, in Montparnasse, then again in New York during the Second World War. But in 1922, Berlin was like a weird dream, sometimes like a nightmare. Everybody seemed to be busy buying or selling something. Even when a loaf of bread cost several million marks, one could still find patrons to buy pictures for several thousand million marks which one had

to spend again the same day, in case they might become valueless overnight. In the apartments around the Bayrischer Platz, there seemed to be as many theosophical or Tolstoyan Russian countesses talking and smoking all night around a samovar as there had ever been in Moscow and, in the basements of some restaurants in the Motzstrasse, as many Russian generals and colonels, all cooking or washing dishes, as in a fair-sized Tsarist garrison town. Never in my life have I met as many miraculous Hassidic rabbis as in inflationary Berlin, or such crowds of Constructivists as at the Romanisches Kaffeehaus.

E.R.: I'm sure that Lissitzky had already converted to Constructivism whole groups of German disciples of *Neue Sachlichkeit,* and that his PROUN designs, as he called them, were as well known as the MERZ constructions of the German Dadaist Kurt Schwitters. If Lissitzky had remained in Berlin, the style that he had helped to create and to popularize might well have earned him a fortune, a few years later, as an industrial designer in Western Europe and in America. But he chose to return to Soviet Russia and, after 1928, even Henryk Berlewi, who had been one of his closest friends, ceased to receive any news from him. I have been told that Lissitzky was then exiled to Siberia under the Stalinist regime and died there in the most abject poverty. Ilya Ehrenburg was more fortunate or more clever in adapting himself after his return to Soviet Russia from his years of exile in Western Europe. . . .

CHAGALL: When I was a refugee in New York during the Second World War, I often thought of all those whom I had known in Vitebsk, in St. Petersburg, in Moscow, in Paris and in Berlin, all those who had been less fortunate than I and who had not managed to escape from the horrors of persecution and of war.

E.R.: There is a very poignant quality in many of the works that you painted in New York during the war. Your memories of Vitebsk and of Paris seemed to haunt you, and your visionary renderings of the past became more tragic or apocalyptic, less elegiac or humorous than those of your other periods. . . .

At this point, Madame Chagall interrupted our conversation, reminding the master that he had an appointment with the dentist. With the agility and

speed of an acrobat, he rose from the couch and was suddenly standing in the middle of the room. When Madame Chagall asked him, as he slipped into his jacket, whether he had enough money on him to pay his cab fares, he became a clown, of the same rare quality as Charlie Chaplin or Harpo Marx, felt all his pockets and replied: "Yes, yes, but where are my teeth?" Then, feeling his jaw, he added: "Oh, they are still there!" In a twinkling, he was gone.

Two days later, I returned to submit to Chagall the first draft of my manuscript and check with him the many dates and details that I had hurriedly noted as he spoke. He was surprised to see how much I had recorded of all that he had said. I explained to him that my experience as a conference interpreter had taught me, without ever using shorthand, to take extensive notes while listening to a speaker. From time to time, as he read my text, he corrected a few words, added a detail, changed a date. When he had approved the whole interview, he concluded: "The poet Mayakovsky used to say to me in Moscow: 'My dear Chagall, you're a good guy, but you talk too much.' I see that I have not improved with age. . . ."

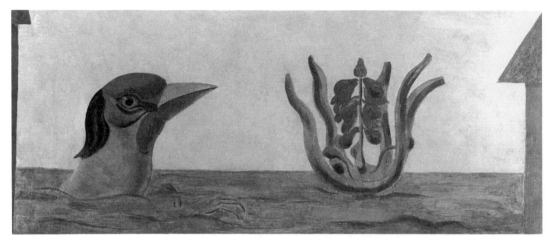

MAX ERNST, *Detail of a Surrealist Mural in the Home of the Poet, Paul Eluard,* 1923

Max Ernst

When I left my hotel in Grasse one January morning to take the bus to Seillans in the hill country, where Max Ernst was expecting me, the sky was leaden gray and a cold wind was blowing in the streets. As we drove into the surrounding countryside, a few tiny snowflakes began to fall hesitantly over the fields of flowers destined to be preserved as essences and perfumes. Along a meandering highway that follows the contour of the increasingly alpine landscape of this area of Provence, we discovered as we penetrated farther inland a series of small fortified towns, surrounded by olive groves. The inhabitants of the ancient Roman cities of the coast had sought refuge here from the raids of the Barbary Coast pirates in the Middle Ages. Perched like eagles' nests on the hilltops, these towns, with their masonry composed of the same stone as the crags above which they rose, appeared to be some strange combination of nature and art, as if the hill had of its own accord gradually developed on its summit a cluster of habitable caves, leaving to man only the task of adding tiled roofs and, topping everything else, an occasional church tower. Beyond Fayence, the most populous of these hill towns, I finally reached Seillans shortly before lunchtime.

By now the sky had cleared and was rapidly becoming blue as the last clouds were scattered by an abating wind. But the mountain air was still cool in spite of the midday sunshine. Descending from the bus, I entered the nearest café to enquire how I could reach the house that Max Ernst had purchased a few years earlier. Nobody in the café appeared to have ever heard of Monsieur Ernst. I explained that he was an artist, very famous in Paris and throughout the world. "Artists, my good sir," I was told by a local cynic who spoke with a strong southern accent, "we see many of them come here, especially in the summer, and they all tell us that they are famous."

I explained that Ernst's wife, an American, was also a painter. Finally, one of these old gaffers realized whom I meant: "Ah, you're talking about Madame Dorothea, the wife of Monsieur Max.

Everybody here knows Monsieur Max. The boy will show you the way to his door."

With that, he summoned Ali, a little North African Arab who was carrying a loaf of bread, fresh from the next-door baker, that was almost as long as he was tall. The son of a former Berber Harki in the French Army in Algeria, the boy was born in France after his Loyalist parents had settled there as refugees from their native Kabylia when Algeria became independent.

Together, we walked through a maze of steep and narrow streets to the summit of the hill town. Unevenly paved with rough-hewn blocks of stone, most of these streets intermittently become staircases between the high walls of the houses that are built almost like fortresses. I had the impression of being a good thousand miles away from Cannes and the fashionable Riviera. I felt, in fact, as if I were in the ancient Byzantine city of Monemvasia, on the eastern coast of the Peloponese, or else in Sicily or Spain or Dalmatia — perhaps even in Morocco, since my guide had the same typically Berber features as the boys who once guided me in Chechaouen (the former capital of the Berbers of the Rif, who had revolted against Spain and established there their short-lived republic under the leadership of Abdelkrim).

The house that Max Ernst had purchased in Seillans was at the very top of the town, opposite a somewhat dilapidated old fortress that is still known as the Saracen Castle. From the windows of his studio on the top floor of his house, Max Ernst could contemplate, beyond the rooftops of Seillans, the whole valley that spreads out with its countless olive trees and cypresses as far as the distant hills.

Max Ernst was sunning himself on his doorstep when I arrived, much as if he had heard the bus from Grasse arrive and had calculated to the minute how much time I would take to climb from the bus stop through the whole town to his house. We had known each other on and off for many years, ever since the early thirties in Paris; we met more frequently in wartime New York, so that he greeted me briefly, almost as an old friend, then invited me into the house, where we began chatting in what appeared to be his

> "If I . . . have allowed chance to play an important part in the creation of a number of my works, I did this . . . in order to interpret these chance effects in my own manner . . ., in human terms and in the terms of my own dream world, which is certainly personal and no other man's dream world."

living room. At first I expressed some surprise at his choice of Seillans for his retirement. Didn't he find himself a bit too isolated here? He began to explain how he now found himself gradually spending more and more time in southern France, though he had never really planned to retire there.

After his doctor told him that he suffered from heart trouble, the Grand Old Man of surrealist painting began to reduce considerably the pace of his activities, which had previously been surprisingly productive. This was why he was spending much of his time in Seillans, though he first purchased the old house with the intention of modernizing it only enough to spend a few weeks there each winter in relative comfort, when it became too damp and cold in Huisme, in the Loire Valley, where he had settled some years earlier in a large country house with all modern conveniences.

At his Left Bank apartment in Paris, Max Ernst made a habit of staying only for a few days at a time, whenever an opening of a show of his work or some other business made his presence in the capital necessary. But now in Seillans, he seemed to feel no nostalgia for his older home in Huisme, though he had spent there some of the happiest and most peaceful years of his life.

"Ever since I first came here," Ernst said, "I have missed the sunshine and the dry mountain air as soon as I leave Seillans. I don't think it rains more in Paris or in Huisme than it did four or five years ago, but I seem to notice only now how often the weather can be gray and rainy in the river valley of the Loire and the Seine."

His wife, Dorothea Tanning, was also spending most of her year in Seillans, though now when I visited Max Ernst she happened to be in Paris in order to put the final touches to the paintings she planned to show in the coming spring. Max Ernst thus found himself spending most of the winter alone in their big house in Seillans — except for the company of their Tibetan dog, a kind of gigantic cream-colored Pekinese that one can recognize in many of Dorothea Tanning's paintings, and a

Spanish manservant who had already managed to teach this multilingual pet to understand his own Iberian idiom as well as the French, English and German of its masters.

ERNST: Right now, I'm no longer working very hard. There are times in my life when I feel more disposed to read, to meditate, to relax, or to chat with friends. Fortunately, I have a few friends here in the immediate neighborhood. The painter Peverelli lives all the year round in Seillans, and the writer Patrick Waldberg spends his summers across the street from me in a house that belongs to his wife's family. Actually, it was Patrick who first introduced me to Seillans and made me think of buying a house here. I might even have purchased that big castle, across the street. But it's too much of a barracks for my taste.

E.R.: Is it still for sale?

ERNST: No. For the last two years, it has been invaded during the holiday season by a crowd of youngsters who bought it for a song. When they're here, they make a great deal of noise, especially at night with their hi-fi playing jazz at all hours. Last summer, all of Seillans protested, but in vain. . . .I sometimes feel that I've recovered here a kind of lost innocence. I very rarely go to Grasse, Cannes or Nice, and whenever I chance to show my nose there, I hasten to come back to Seillans.

E.R.: Do you ever see Chagall in Venice?

ERNST: Never, though we used to be quite good friends when we were both refugees in New York during the war years. But here I never see any of the other artists who have retired to southern France — only Peverelli, whom I see regularly much as I see other immediate neighbors, as if he and I had nothing else in common.

It was time for lunch and Max Ernst suggested that we eat in the restaurant in the local hotel, some hundred yards away from his house. There he

ordered our menu with the refined taste of a true gourmet. Among other delicacies, he ordered roasted thrushes, tiny birds that feed on grapes in the vineyards; these made me feel as if I were participating in a kind of cannibal feast. Max Ernst indeed had the appearance and movements of a bird, and had long been aware of this, so that he chose quite early in his life as an artist the image of a bird as a kind of personal crest, often signing his letters to his friends with a sketch of a bird. For instance, he once gave to me a book of his work, and autographed it on the flyleaf with a personal dedication and a tiny sketch of a bird. But his birdlike appearance has somewhat changed in the course of the years. Thirty years earlier, his profile reminded me of that of a hawk. Now, he had rather the appearance of an eagle, a kind of philosopher–king, both regal and wise among all other birds. He was less quick in his movements, more royally relaxed.

Though still gifted with surprising artistic productivity, Max Ernst refrained now from working as feverishly as his custom had once been and allowed himself more time for relaxation, meditation and reading. He was always a great reader, much more widely read than most other major artists of his generation, such as Picasso, Matisse or Chagall. Like Hans Arp, Ernst was also a poet, expressing himself in verse either in French or his native German, but his readings in recent years had been French or English more often than German, though he still expressed himself in each of these three languages with equal ease.

In his choice of readings, he was guided by his great curiosity, and by his need to experience wonder as well as to learn and understand. A sense of chance and the mysterious thus played an important part as a source of inspiration in his creative work; however, he never succumbed to the kind of nebulous and willful obscurantism that mars the thought of André Breton and most other surrealists, who generally display an almost absurd prejudice in favor of all that is irrational. Max Ernst, on the contrary, always displayed an intelligent interest in the sciences and had recourse in his own thought to chance and a sense of the mysterious only when his reason failed to offer him a more plausible explanation of the phenomena that puzzled him.

ERNST: The better I know myself, the less I can understand, in the final analysis, the mysteries and chances that combine or conspire to bring about the creation of a work of art.

Suddenly I find myself where I wanted to go, but without knowing how I came there. In fact, I have generally reached my goal by a shortcut that had previously been unknown to me. I always owe to chance the revelation of such shortcuts, and that is why, in my work, I have so often relied on technical tricks, such as collage, rubbing or frottage and "drip and drool," which allow chance to be a source of inspiration. I consider all such technical tricks legitimate shortcuts that can lead me to the desired end.

E.R.: Is it true that in the war years in New York you were the first to adopt this technique of "drip and drool"? It consists, if I remember right, in allowing very liquid pigments to flow down a canvas so as to produce by chance a design that then suggests to you the basic elements of the subject of a composition.

ERNST: Yes, and Jackson Pollock and his friends who later became masters of the New York school of abstract expressionism all used to come to my New York studio to learn the trick of this short cut. But I never claimed to have invented anything at all truly novel. It remained in my eyes only a new way of more rapidly obtaining those kinds of stains or color in which — Leonardo da Vinci had once observed — a painter can discover subjects for his paintings and, by having recourse to chance, really provoke inspiration.

E.R.: So this technique proves only to be a practical adaptation to the ends of artistic creation of the psychological devices of the Rorschach test, in which one shows the patient a series of ink stains in order to ask him what these stains suggest to him and then to interpret the patient's answers much as one might interpret his dreams.

ERNST: Certainly, but it is the artist who subjects himself to this kind of Rorschach test. On the one hand, he encourages chance to produce these stains or designs while, on the other hand, he himself interprets what he sees in these stains in order to derive from them the subject of a painting.

E.R.: Most of the so-called Tachiste painters of recent years remain content with offering us these stains or chance patterns without ever interpreting them. Their paintings can thus reveal to us more about ourselves as spectators who seek to interpret them than about the artist who created them. Your point of departure

would be the actual goal at which most Tachiste painters stop.

ERNST: But I merely followed the example of Leonardo da Vinci who in his writings sought to correct what Botticelli had said about the landscape painter's art. Botticelli claimed that there was nothing much in it since one can also discover some very fine landscapes in patches of color that are produced by sheer chance, or in the natural veins of a stone. Leonardo observed that all such mysterious effects that we find in nature — such as the stains of humidity on an old wall — can suggest to us a landscape, a face or any other such subject for a work of art, but that the artist must then develop what he believes to have seen there so as finally to produce a work that is in fact his own. To two different artists, the same chance stain can suggest two entirely different works of art, and each one of these communicates to us some aspect of the style and psychology or inner life of the artist who created it rather than anything that might be peculiar to the old wall which first suggested this painting to him.

All of Ernst's works, even if they seem at first glance to be abstract or somewhat hermetic, thus refer at least to an idea, belief or memory that is not necessarily explicit in the painting as an object in itself. Often, the work's title, which may seem puzzling or poetic, offers us a verbal clue to the real meaning of the painting, which may not be fully explicit in visual terms within the physical limitations of the painting. Whether in English, French or German, Ernst invents these titles with a poet's verbal virtuosity and a gift for language which often has something in common with the inventive poetry of the absurd that we admire in the works of Lewis Carroll, but also with the verbal imagery of the lyrical poetry of Wallace Stevens or Paul Eluard. The relationship between the title of some of Ernst's works and the work itself is often of much the same nature as the relationship that exists between a caption and a cartoon which, without such a caption, would have something essential still lacking. In order to interpret correctly a number of Ernst's works, we need to know some of the artist's biographical data, such as his beliefs, dreams or hopes. This is true even of many of his more recent monumental sculptures. Though these sculptures may well suggest to us, in terms of sheer form, some affinity with Henry Moore's works, Max Ernst had studied American Indian art and folklore in the

course of the years that he lived in Arizona, and this made it possible for him, independently of any archaism in his choice of subject or style, to rediscover in himself that true fear which the forces of nature can inspire in the minds of primitive people; and we too can experience this fear if we first manage to liberate ourselves from so many rationalizations that repress it as if it had been buried alive in the very depths of our soul.

I was only seventeen when chance allowed me to experience my first conscious contact with the work of Max Ernst. In 1927, I happened one day to be leafing through a recent issue of transition, *the avant-garde, expatriate periodical the American poet Eugene Jolas was then publishing in Paris. One could read there some recent writings of James Joyce, Gertrude Stein and a whole galaxy of American expatriate poets and prose writers who had escaped from the Paradise of Prohibition in order to enjoy greater freedom in Europe. I too was destined to publish there a few months later my first poems in English; these were reprinted in book form only some four decades later in my volume* Emperor of Midnight, *after Allen Ginsberg, Gregory Corso and the beat generation poets of San Francisco had rediscovered my early writings and become aware of the astounding fact that I was still alive.*

Be that all as it may, I discovered in this issue of transition, *which is now so rare, reproductions of two Dada paintings by Max Ernst that have both become true classics of Dadaism. One of these paintings was* La Révolution dans la Nuit, *now reproduced in most books devoted to Ernst's work, and the other one represented a rather peculiar madonna that I subsequently saw reproduced very rarely. Composed and painted in a somewhat academic or idealistic style that might remind one of many manneristic masters of the late Italian Renaissance or of some German Nazarene or English pre-Raphaelite painters, she looked rather like one of those wooden lay figures that appear in the* pittura metafisica *masterpieces of Giorgio De Chirico. But Ernst's madonna struck me above all because, instead of tenderly embracing her child like any traditional madonna, she had angrily turned the infant Christ around on her lap and was about to spank him with her angrily raised hand; in fact, Ernst's madonna seemed to have been depicted in the act of spanking her child so thoroughly that he had already lost his halo, which was rolling away on the floor like a tiny toy hoop. Now I asked Ernst why one so rarely sees this painting*

on loan in any exhibitions or reproduced in any books.

ERNST: It has belonged for many years to the Belgian artist Victor Servanckz, who is unwilling to loan it to exhibitions or to allow it to be reproduced.

E.R.: Does he find it too sacrilegious?

ERNST: I doubt it, especially as he knows that the painting depicts actually one of my childhood memories rather than the Virgin and her child.

E.R.: What do you mean?

ERNST: I was born in 1891 in Brühl, a small town in the vicinity of Cologne — in the Rhineland, a region of West Germany that is, in fact, traditionally very devoutly Catholic. I was the second child in a family of seven children, and our father, Philippe Ernst, was a somewhat taciturn and conventional man whose profession was ideally adapted to his personality: he was a teacher in a special school for deaf mutes. In addition, he enjoyed a local reputation as a painter, especially in ecclesiastical circles of the Diocese of Cologne. He generally devoted his talent, with great application and a certain simple-mindedness, to painting still-life compositions and landscapes or copying religious paintings by the great masters; he often copied these from postcard reproductions, and he was frequently commissioned to paint copies for local churches. If I systematically set out to seek them, I would surely find some still in some village sacristy around Cologne or Bonn. But my father, in these copies, allowed himself some freedom, too. To the devils and the damned he always gave the features of his own personal enemies, but those of family members or his friends he gave to the saints, the angels and members of the Holy Family. I can remember one of his madonnas that was actually a portrait of my mother; my brother in Brühl still owns a small portrait of me dressed up as the child Jesus. I can also remember, in spite of being a child Jesus, having also been spanked by a mother who served similarly as a model for a madonna. Thus, the painting to which you just referred really represents one of my own childhood memories, but without being a faithful portrait of either my mother or myself.

E.R.: But it was considered very scandalous when you first exhibited it — in fact, almost as scandalous as Marcel Duchamp's famous reproduction of the *Mona Lisa* to which he had added a moustache and a beard and which he showed in a Dadaist exhibition under the French punning title *LHOOQ* (she feels hot in the arse).

ERNST: That is exactly the kind of scandalous misunderstanding that I had hoped to provoke. I revolted at a very early age against my conformist, provincial, Catholic and middle-class family background. I must have been barely ten years old when one day I saw my father act in a manner that immediately determined the peculiar nature of my revolt. As he often did, he had just sketched a little view of our garden. To give it a few finishing touches, he retired into the room that served as his studio. There he thought that a shrub which he had sketched in our garden now offended his sense of composition. Instead of simply suppressing this detail in his sketch, he rushed back into the garden to uproot and destroy the innocent shrub that offended his sense of order and art. In my eyes, this was a veritable crime against nature, committed in the name of authoritarian principles of art and order against which I immediately revolted, and my revolt soon became a deeply rooted faith in all those forces of nature, instinct, inspiration and even anarchic but creative disorder that society seeks, by means of regulations and restrictions, to constrain and repress or even to ignore and deny.

E.R.: You seem to have remained faithful to a few symbols of those mysterious forces. Some of these symbols appear again and again in your works, from your very beginnings right up to some of your latest paintings.

ERNST: Yes — in fact, birds, for example, as symbols of absolute freedom if only because they appear not to be subjected to the same laws of gravitation as we are.

E.R.: I often feel, too, that you suspect birds of enjoying a much greater freedom in general than our own — I mean in their behavior and even in their habits, as if they were not subjected to ethical constraints of the kind that might act as a deterrent, for instance, on their cruelty. I remember one of your paintings in which birds are attacking some children with a quite arbitrary but sublime cruelty.

ERNST: There's also an element in this, I must admit, of anthropomorphism. One can all too easily attribute to creatures of another species a

kind of freedom for which one envies them but which in reality they may not enjoy or be aware of. But in my work, birds are not the only symbols of this freedom I demanded for myself when I revolted against my father's faith in principles of order. In my dreams and fantasies, trees and forests played a very important part. I often hid in the woods of Brühl when I wanted to escape my family.

E.R.: In many of your paintings, a forest suggests the archaic background of some mysterious or supernatural action, and we can only guess or suspect, without however directly witnessing it, its real nature, which is perhaps druidic or legendary.

ERNST: It was on one of my adolescent escapades in the woods near Brühl that I once met the nymph Echo. At first, I could only hear her voice, but then I felt her presence so very unequivocally that I was later able to depict her as if I had actually seen her with my own eyes. I truly believe that we are able, thanks to our talents and visual gifts as painters, to recreate the physical appearance of what we first perceived only with other senses, much as a composer can recreate in terms of music what he may first have perceived only with his eyes.

E.R.: Yes, I can remember several of your paintings in which the nymph Echo is depicted. She seems indeed to have haunted your mind ever since you first met her in the woods of Brühl.

As we spoke, Ernst's face acquired in my eyes the appearance of some faun or other sylvan demigod of antiquity, some male companion, with a birdlike head, that would have once pursued such nymphs as Ernst had met and depicted. Max Ernst was now over seventy years old, but still had the lively gait and gestures of a kind of faun with birdlike features instead of the hindquarters of a he-goat, as classical mythology once described fauns. After lunch, as we walked together on the hills around Seillans, among the groves of olive and cypress, I felt as if I were in some classical landscape of legendary Arcady which this artist, a modern reincarnation of the Great God Pan, was inspecting as its landlord, but elegantly clad in tweed!

When Max Ernst was first discovering in his native Rhineland the mysterious powers of woods and forests, he was already destined to travel far and wide and to discover many other types of landscape before finally finding, in this landscape of

Provence where he appeared to be curiously at home, the serenity that he now enjoyed in his old age. In spite of the tensions of his early conflicts with his father, he had not been able to achieve his emancipation very readily and was still forced to remain several years at home in Brühl with his family, at least until he graduated from secondary school.

ERNST: My father wanted me to study law in order later to lead the quiet life of a good provincial middle-class husband and father like himself, but this was certainly not my own ambition. I nevertheless somehow learned how to strike a happy balance between necessity and my ideals. Instead of refusing to study at the university at nearby Bonn, I managed to achieve a compromise: I would register there as a student, but would study philosophy and psychology instead of law, perhaps in order to enter the teaching profession. The courses that interested me most at the university were those on nineteenth century philosophical idealism or on the poets and story writers of German romanticism. My readings of these philosophers of nature, such as Hamann and Schelling, then incited me also to study psychiatry rather than experimental psychology. Finally, I found myself picking my own choices among all the courses that were offered, but without ever considering very seriously an integrated program of studies that might have prepared me for a diploma or a profession. I was not alone, however, in developing this kind of interest in the German romantic authors of fantastic tales, such as Achim von Arnim, or of treatises on psychiatry that were mainly concerned with phenomena of a more or less hallucinatory nature. Little by little, I thus found myself becoming a member of a small avant-garde group of writers and artists who shared my tastes and interests and who adopted as a group the name of Young Rhineland.

E.R.: In Bonn or Cologne were there then any writers or artists whose talents were already recognized and who could guide you at all in your aspirations?

ERNST: In the years that immediately preceded the First World War, Cologne could boast of being the hometown of one major modern painter — August Macke. But he spent most of his time in Munich, where he distinguished himself as one of the most gifted members of the Blue Rider group, which Kandinsky had recently founded there. Macke nevertheless

frequently returned to Cologne, so that I was able to meet him several times, and I owe him all my first contacts with modern art.

I asked Ernst a number of questions about German expressionism and the various artists who were beginning to come to the fore in Germany before 1914. For Kandinsky, Ernst expressed great admiration, as well as for Klee, Alfred Kubin and August Macke. He added too that Jawlensky's work had interested him, but only because of its powerful sense of color. Of the expressionists of the Dresden School of Die Brücke *and of the Berlin School and of Northern Germany, Ernst mentioned only Emil Nolde.*

ERNST: He, too, was a true master colorist. But above all I appreciate his works that depict legendary or visionary subjects — I mean those in which he appears to have been working in much the same tradition as James Ensor and Georges Rouault. After all, none of these painters in the German avant-garde before 1914 has exerted on me a truly profound and lasting influence. It was only after the war — when I found in Munich, in an issue of the Italian art journal *Valori Plastici*, some reproductions of metaphysical canvases by Giorgio De Chirico — that I finally discovered my true direction. There I seemed to recognize something that had always been familiar to me, much as when a *déjà-vu* reveals to us a whole area of our subconscious dream world that one had previously refused, by an act of self-censorship, ever to see or to understand.

E.R.: I'm almost tempted to believe that you too then became a metaphysical painter, in a way an artist of much the same nature as Chirico, and that you have never ceased since then to be one. In other words, that you picked up around 1920, where Chirico himself had already begun to abandon just about then in order later to abjure it entirely, the style of *pittura metafisica* that he and Carlo Carrà and Morandi had first invented and that you subsequently developed and enriched in your own manner. But you have never ceased to renew and enrich your own style and thought, in such a way as to transform completely the kind of dream-world art that Chirico and his *pittura metafisica* colleagues had bequeathed to you. Had you been at all friendly, however, with any other painters before 1914, besides Macke?

ERNST: I was still too unsure of myself to try to become at all friendly with artists who had already achieved a name for themselves. In 1912, I went on a holiday to Paris. There I met by chance, at the Café du Dôme, the Bulgarian–Jewish painter Jules Pascin, who spoke very fluent German and associated in Paris in those years with a number of German or German-speaking artists. But I scarcely dared exploit this chance meeting, though Pascin proved to be very affable and, had I expressed the wish, might have introduced me to a number of other artists who, among his friends, had already achieved a certain degree of celebrity. Among these friends Pascin could number the sculptor Lehmbruck as well as Modigliani and Brancusi. I was unfortunately too shy to hang around the Dôme and the few other Montparnasse cafés where these artists habitually congregated. Instead, I preferred to wander around the picturesque older quarters of Paris and absorb their atmosphere, feeling indeed that I was discovering there the familiar or predestined setting of my true spiritual homeland. Before even coming to Paris, I had already painted in Cologne a kind of imaginary vision of Paris which I entitled *A Paris Street* and that proved to be a premonition of much that I was destined to discover with my own eyes.

E.R.: On your return to Germany, were you more active in the avant-garde circles in Cologne?

ERNST: It wouldn't be very exact to say that these avant-garde circles in the Rhineland offered me much opportunity to be very active and thereby to attract much attention. True, we had in 1912, in Cologne, the great Sonderbund international exhibition of modern art, which aroused as much controversy in the whole Rhineland as the famous Armory Show in New York. Actually, it included current works by more or less the same artists from Paris and other leading centers of modern art as the New York show. But the Rhineland, in those years, was a consumer's market for modern art rather than an outstanding producer. In Cologne, in Essen and elsewhere, there were more great collectors than artists who enjoyed much more than merely a local reputation. This, however, didn't deter our little group of young enthusiasts from developing a very keen interest in all new ideas that reached us from Paris and elsewhere, so that I was able, up to a point, to lead

the life of a committed artist (as one would say nowadays) in a number of little groups of pacifists, anarchists and other dissidents. And it was in these groups that I was fortunate enough to meet Hans Arp.

E.R.: What was he doing in Cologne?

ERNST: When I first met him, Arp had a job in an avant-garde art gallery. He was still quite a young man who affected a somewhat precious manner — that of a latter-day dandy in the Oscar Wilde tradition, but he was already remarkably well informed about everything of importance that was happening elsewhere in the world of art and letters, though he still remained somewhat disinclined to commit himself to any participation, such as mine, in political activities of any kind. It was only later, during the war in 1917 when he was living as a pacifist refugee in Switzerland, that the Zurich Dada group managed to convince him to take a political stand. He decided to participate actively in their activities, but I had lost all contact with him by then. He had managed, thanks to the ambiguity of his status as an Alsatian [from those areas of France that had been occupied since 1870 by Prussia], to escape to Switzerland and thus evade combat duty in the German army. As for me, I was dutifully serving in the Kaiser's army.

E.R.: If I remember right, it was during those war years that you first married, on the occasion of one of your home leaves. Your son, Jimmy Ernst, who is now a well-known American painter, was born, I believe, of this marriage.

ERNST: Yes, I was on leave when I married my friend Lou Strauss; this gained me an additional two weeks of leave for our honeymoon. But my first marriage lasted only until 1922. After that, Lou returned to a successful career as a journalist and we gradually lost sight of each other until she fled to France when Hitler came to power. From occupied France, poor Lou was later deported by the Nazis to a concentration camp where she perished.

E.R.: When you were demobilized at the end of the First World War, were you immediately able to pick up the thread of your abandoned prewar activities in the Rhineland avant-garde?

ERNST: No, it wasn't as easy as you might think. The Rhineland was occupied by several Allied armies, and all our activities and avant-garde publications were subjected to close scrutiny by the censorship authorities of the various occupying forces, which failed moreover to follow uniform principles and practices. In spite of the confusion that prevailed in the intellectual circles of occupied Cologne, I was nevertheless able to establish contact very soon with similar circles in Munich, Berlin and Zurich, but above all with the Dada groups in Berlin and Zurich.

E.R.: There still seems to be some disagreement among art historians about the specific character of each one of these various Dada groups. How would you — as a firsthand witness — distinguish, for instance, the Berlin Dada group from the Zurich and Paris groups?

ERNST: Their specific character depends both on their particular environment and on the individual personality of their various members. In Paris, for instance, Dada remained, above all, an artistic and literary movement — in fact a revolt against the formalism of the cubists and most of the French avant-garde before 1914. Already before 1914, Marcel Duchamp, who became a leader among the French Dadaists, attracted attention as a somewhat dissident cubist, and when Dada began to scandalize the Paris bourgeoisie as a revolutionary movement, Duchamp never committed himself to any specifically political doctrine. In Zurich, on the other hand, the Dadaists were nearly all pacifist foreign refugees: as political refugees in neutral Switzerland, they had to refrain from pursuing any more overtly political aims than those of pacifism. But in Berlin, the Dadaist group immediately began to attract attention on account of its overtly political activities. Without yet being wholeheartedly communist, it was revolutionary in that it was actively opposed to the existing order and included several communists.

E.R.: In fact, Dadaism could be said to have been basically more anarchist than communist.

ERNST: But it nonetheless remained communist in the eyes of the conformist middle class and the later Nazis, too, who viewed the Dadaists as dangerous cultural Bolshevists. Under the Nazi regime, all the surviving German Dadaists found themselves threatened and were forced to emigrate, with the notable exception of Hannah Höch, who managed to cover her tracks and withdraw into total obscurity and anonymity in a Berlin suburb. It would nevertheless be difficult to prove that Kurt

Schwitters, for instance, had ever been involved in any overtly political activity in Germany; yet he too found himself threatened and had to leave his home in Hanover and emigrate, first to Norway and, when Norway was occupied by the Germans, to England.

E.R.: Did you participate in any of the German Dadaist activities?

ERNST: Yes, up to a point—until 1922. But Dadaism was everywhere a movement that remained intrinsically too hostile to any kind of systematic doctrine or organization to be able to survive the chaotic years of war, defeat, revolution and inflation that gave birth to it and saw it prosper. All the way from Moscow to Paris and Barcelona, between 1917 and 1924, a whole series of manifestations of Dada occurred; in fact, there was even a small nucleus of Dadaists in New York. But all this was of a more spontaneous than consciously organized nature, and a few Paris Dadaists came to feel, in 1922, the need to develop a more systematic doctrine or philosophy which, thanks to André Breton, was first expressed in the *Surrealist Manifesto.*

E.R.: Some time ago, Harold Rosenberg suggested in *The New York Times* that surrealism is a discipline or path in the total meaning of a mystical order—in fact, a state of mind and a way of life rather than an organized doctrine. And he concluded that surrealism represents, above all, a movement of conscious revolt against the stifling of the life of the individual and of communities under systems of forms that now constitute the official culture of the more civilized nations.

ERNST: Yes, that's more or less true, though Harold Rosenberg, of course, is expressing there in his own terms what we were then thinking or feeling, but what we expressed—if at all—in entirely different terms.

E.R.: But in 1922 such a movement was inevitably destined to win your personal support.

ERNST: I even believe that I would still subscribe today to the basic tenets of surrealism, though since 1922 I have gradually lost, as others have, many of my illusions about the truly revolutionary and liberating nature of some more strictly political movements that in those years inspired great hopes among us. Nor would this mean that I have now become a convert to more conservative views. On the contrary, I would now count these more strictly

political movements among those that are essentially authoritarian and that any true libertarian must oppose.

E.R.: Would it be correct to say that surrealism came to you much as the mountain is said to have come to Mohammed, and that you never were a convert to surrealism?

ERNST: As early as 1921, I had met in the Tyrol a small group of future surrealists who came from Paris to spend part of the summer there. A year later, in August 1922, I decided to leave Germany to join them in Paris. This was my first experience of living illegally: I had no residence permit in France, and it was still practically impossible for me, as a German and a former enemy alien, to obtain such a permit so soon after the war.

E.R.: Were you immediately able to earn a living as an artist in Paris?

ERNST: If I hadn't had a few good and faithful friends, I might well have starved there. But I've already told Patrick Waldberg the more significant details of my life during my first years in Paris. It can all be found now in the fine book that he wrote about me and Jean-Jacques Pauvert published. Between 1922 and 1929, practically nobody was buying any modern art at all. To make both ends meet, I even had to work, together with the painter Grégoire Michonze, in a little workshop that produced what is called *articles de Paris*—I mean luxurious costume jewelry and souvenirs manufactured under sweatshop conditions.

E.R.: So the shops in the rue de Rivoli were selling to tourists trinkets that were authentic works by Max Ernst, though they were not signed by you. It might still be possible to find some of them at the flea market.

ERNST: But it would not be possible to distinguish those that I made from those made by Michonze or by the other wretched wage slaves who worked with us.

E.R.: The Paris surrealists, however, accepted you immediately in all their group shows.

ERNST: That wasn't much help. Until 1958, every show that I ever had, whether in Paris or elsewhere, was always a complete flop. My paintings of those years now sell—I admit, at very high prices, but I was then selling them, if at all, for any wretched sum I could get. Now I often see in an auction, going at an extravagant price, an old picture of mine that I once gave

away to a friend or that I had left on a commission with a gallery that later went bankrupt before selling it and without returning it to me. As for the books that I used to illustrate, they never really earned me a living. Printed in limited editions by publishers who generally had to close shop before making both ends meet, they sold very slowly or remained unsold for years on shelves of bookstores.

E.R.: In Germany before 1933, I knew a woman whom we called Mutter Ey and who tried very hard to sell your works in her little gallery.

ERNST: Dear old Mutter Ey became a gallery owner after feeding all the artists of Düsseldorf in her cake shop during the postwar years of famine and inflation. She continued to be of great assistance to me during my early Paris years. She managed to sell my paintings, often to the most unlikely people, but always at very modest prices.

E.R.: One of my friends, the Berlin painter Heinz Trökes, was, after 1945, still able to find two or three of these early paintings of yours which he purchased in the Rhineland from retired shopkeepers who had been friends of Mutter Ey but had never purchased any other modern art. As for me, until 1939 I knew mainly your collages and your illustrated books. I have an idea that the Paris surrealists understood, as early as 1922, that your collages express, with a technique that had never yet attained such perfection in Paris, a sense of mystery and the unpredictable — in fact, of the supernatural or super-real — which was in perfect harmony with their own preoccupations. In my own eyes, many of these collages or montages were something entirely novel, though many other artists soon began to imitate you and still do. The elements of these collages were cut out from old-fashioned woodcut illustrations of nineteenth century adventure stories, such as the novels of Jules Verne, or old magazines or catalogues of outdated mechanical or scientific inventions. By bringing together in an arbitrary manner these elements culled from the most unlikely sources, you managed to obtain surprise effects of much the same nature as those of Lautréamont's famous image, in which he speaks of the fortuitous encounter of a sewing machine and an umbrella on a dissecting table. Such a technique of provoking unex-

pected encounters encourages free association of ideas, of much the same nature as those provoked by some of the devices of psychoanalysis or by the cards in a Rorschach test.

ERNST: I generally left it to chance to suggest to me the first of these unpredictable juxtapositions, and these allowed me to associate freely as I progressed with the rest of the collage. Later, I obtained similar effects of free association when I had recourse to other methods or devices, such as frottage or rubbing or what was later called in New York "drip and drool." Everything that is fortuitous and can surprise us will stimulate our imagination, and as soon as we begin to wonder we begin also to think of ideas and subjects that reason alone would never suggest to us.

E.R.: Most nonfigurative or abstract artists have not gone beyond your point of departure, and remain content with your preliminary techniques of frottage, grattage (scraping), decalcomania — or "drip and drool." These effects of mere chance thus become the sole object of their work. For me, however, the mere technique or material of a work of art can never quite satisfy. True, they can suggest some free associations of my own, but I don't need to have recourse to anyone else for this kind of experience that I can provoke on my own initiative. In a work of art, I need to discover something of the artist's own dream world of free association in order to get to know and understand him better. Paul Goodman once said to me that you can only really know and understand people when you have witnessed how they experience an orgasm. In the moment of truth of an orgasm, people reveal themselves stripped of all the affectations and pretenses that otherwise conceal their real nature. In art, too, I guess there must be this kind of moment of truth when the artist reveals himself, whether consciously or unconsciously, in a realm that transcends the mere technique of his work. I have always admired you because I seem to experience this moment of truth so often when I contemplate your work. But I've already had occasion to discuss this with you when I interviewed you some years ago for *Arts Magazine*. . . . It was then that you also spoke to me of the theories of some painters of the German romantic movement.

ERNST: I suppose you mean Caspar David Friedrich.

E.R.: I remember that you were already professing your admiration for Friedrich in the early years of surrealism — in fact, before 1930. You remain the first major German artist in close to a hundred years to admit having been influenced by him. In the whole German avantgarde since Liebermann and the impressionists, I have found no reference to Friedrich until you began to bring his work to the attention of the surrealists. Your works, like those of Friedrich, often suggest an experience of a mystical or dream-world nature, but which generally lends itself more readily to expression in poetry or philosophical meditation or musings than in the visual arts. Friedrich states in his writings that the artist must close his eyes in order better to see with his spiritual rather than his physical eyes what he intends to depict. He will then be able to bring to light what he has visualized only in the depths of his own night, and the work of art that he thereby creates must act on the inner world of others who contemplate it in such a manner as to remain a finite and objective link between two subjective infinites: that of the artist and that of the spectator who contemplates his work. This whole theory made a profound impression on me, especially as I chanced in 1951 to spend a whole afternoon in the Walraf Richartz Museum in Cologne, studying its fine collection of Friedrich paintings, and the next day spent the whole afternoon in the nearby castle of Brühl, visiting an important retrospective of your own work.

ERNST: So you were one of the few visitors to that ill-starred exhibition that had been planned to celebrate worthily my sixty years in my birthplace! Of all my shows, it was certainly the most disastrous flop. . . .

E.R.: When I read the different texts that you've published on various occasions, I'm struck by the frankly erotic nature of your attitude toward art. Not that I mean that this attitude has anything in common with pornography, but rather with the sheer passion of love — I mean with what in Greek would be called *eros*. You seem to believe in a very close relationship between art and love, or perhaps rather between art and desire.

ERNST: It's because I paint only what I passion ately wish to witness with my own eyes — I mean as an object in the physical world, no longer as a subjective dream or vision within my own mind.

E.R.: And this brings us back to the ideas of Caspar David Friedrich to which I referred earlier — I mean to what a modern philosopher would call a reification of an idea or an ideal.

ERNST: Yes, in some respects, but also to the art if not the ideas of Max Klinger, too. It was this great turn-of-the-century German realist–symbolist painter whose prints in particular, with their nightmarish subjects, first suggested to me the style of my own collages. In order to create a painting of any kind of image, I must first conceive it in my mind and then desire so ardently to see it with my own eyes that this desire can be compared only to the desperate need that one might feel to see in one's own physical presence the loved one whose absence one desperately regrets. My relationship to my work is, as you quite properly said, of a frankly erotic nature, even if the actual painting or sculpture isn't in any way erotic. But I'm far from accepting the eroticism of André Breton, which I find too intellectualized; and that is one of the reasons why Breton and I ceased to agree, when I was no longer able to feel at ease in the somewhat puritanical and disembodied intellectualism of the more orthodox surrealists. I feel, at heart, a far greater affinity with the German romantics than many of the French surrealists, who are more at home in the intellectual world of Mallarmé and the French symbolists. I must nevertheless admit that the objects one can create — according to my philosophy that you call erotic — always remain, as reified dreams or desires, somewhat disappointing, and my friend Paul Eluard, the poet, once remarked in this context that he never really recognized what he loved in what he created.

E.R.: This disappointment illustrates the extent of what, in the philosophy of Plato, constitutes the difference between an ideal and its degraded manifestation in the material world of objects and realities. But this should never discourage an artist from attempting to communicate his ideals to us.

ERNST: Nor has it ever discouraged me, so that I still continue to create objects that are born of my intense desire to see in the real world the images that haunt my own mind.

E.R.: One aspect of these images that you create as objects has sometimes puzzled me. I have seen some of your paintings that are very large and some of your quite monumental

sculptures, but also some tiny pictures, no larger than postage stamps, little miniatures that you yourself have called "microbes." Yet your very large works never appear to me to be mere large-scale copies of something that might originally have been conceived on a more modest scale, nor do your microbes appear to be miniaturizations of something larger, though the actual subjects of both your larger works and your microbes may often have a lot in common. I mean that they all appear to be views of the same reality, in a kind of Gulliver's world in which the scale of things can vary according to the scale of the being that sees them, the latter being sometimes dwarflike and sometimes gigantic. I thus have the impression that the scale of each one of these different images of the same kind of world really depends on the scale of your own vision, as if you had sometimes dreamed you were a giant, but sometimes, too, that you were a kind of Lilliputian.

ERNST: The scale of each image I create depends truly on the scale of the previous vision that I've had of it, and I always hesitate to change the scale of this vision; I don't like to create on a large scale what I first visualized as very small, or vice versa. My microbes thus depict a world of the infinitely small. But all this, of course, would not apply to the kind of image that I create by having recourse to frottage or any other such technique which, according to the theories of Leonardo da Vinci, will suggest images to our imagination. I allow the images to be born of my materials according to the scale that these materials impose on me, since the materials dictate the subject to me.

E.R.: These explanations lead me to believe that your art is the fruit of a kind of dialectical game between the outside world and the artist's mind; sometimes this game produces a subjective image that must then be reified, but sometimes, too, an image is born spontaneously from your materials in order to be projected onto the screen of your mind that then develops and interprets it. And this offers us the elements of a kind of Hegelian interpretation of your true art. True, you once studied nineteenth century German idealist philosophy in Bonn, so that Hegelian interpretations of your activity as an artist would not be absurd. But the philosophical complexity of your art might well be the reason why in our age, when those whom Voltaire called the *terribles simplificateurs* often meet with surprisingly easy success, you on the contrary have had to struggle so hard and so long before being widely appreciated or understood. When you published your *Propos de Max Ernst* in 1959, you included an appendix in which you offered a chronology of your life and your more important shows, while insisting that nearly every one of these had been a resounding flop.

Let's now go back to your memories of the great years of surrealism. You told me that you first came to live in Paris in 1922. What were then your reasons for wanting to leave Germany?

ERNST: Circumstances have always played an important part in helping me come to a decision whenever I felt an urge to escape. In 1922, I needed above all a kind of change of air. By nature, I'm more impatient than anxiety-ridden, more curious of the future, sometimes of the past, too, than of the present. Postwar Germany, in those years, offered me only a present that no longer interested me at all, and I really felt myself called upon to participate elsewhere in activities that suited my temperament better than anything that I saw in my immediate surroundings, whether in the Rhineland or elsewhere in Germany, for instance in Munich or Berlin.

E.R.: From 1922 until 1940, did you participate in Paris in all the activities of the surrealists?

ERNST: Yes, insofar as these activities refrained from being at all political. My somewhat irregular situation as a foreigner, above all as a German, made it extremely unwise for me to engage in any political activity in France. Fortunately, in its early years, surrealism had not yet acquired the political character that distinguished it after 1930. True, we already shocked the bourgeoisie, which often believed that we were dangerous revolutionaries, perhaps because we managed to attract more attention and provoke more comment than other groups that were politically more active or dangerous. Later, when the surrealists became more seriously concerned with political problems, we took a firm and clear stand against Stalinist communism, and this brought about our group's first major crisis, when Louis Aragon, Paul Eluard and a few others abandoned us to join the Communist Party.

E.R.: It has been said that those who then remained faithful to André Breton and his "party line" of surrealism became Trotskyites or anarchists.

ERNST: It's true, up to a point. But we always stated that our conception of a surrealist revolution set us aims that were much more broadly libertarian than those of any more strictly political movement.

E.R.: So that Harold Rosenberg would be right in affirming that surrealism is basically a way of life. To put it in a nutshell, you were concerned with the ultimate liberation of man as an individual rather than with attaining any kind of collective activities or social goal.

ERNST: Yes, but we still had some collective activities as a group.

E.R.: Some of these group activities tended, however, to baffle the authorities or to provoke a scandal rather than to undermine or overthrow the established order. I remember, in particular, the scandal that arose when you eloped with Marie-Berthe Aurenche, whom you subsequently married. If her brother, the film director, Jean Aurenche, had used this episode as a story for a comedy, he would have been accused of borrowing gags for his film script from René Clair. . . .You revealed yourself, in spite of being a surrealist, as far more reasonable and balanced than the girl's very middle-class parents. Waldberg even tells how her mother always led her to believe that she was of royal blood and thus had every right to expect to become overnight Queen of France. And you, I guess, would then have been her Prince Consort. . . .

ERNST: It was all that nonsense rather than the supposedly bad influence of surrealism that finally made the poor girl lose her mind.

E.R.: After the disaster of this second marriage, you were often seen in the cafés of Montparnasse in the company of Meret Oppenheim. She is the Swiss surrealist artist, if I remember right, who first dreamed up the fur-lined cup that is now a surrealist classic. Salvador Dali was only following her lead when, a couple of years later, he shocked all of New York with his fur-lined bathtub displayed in a Bonwit Teller shop window on Fifth Avenue. But you were also seen very often in the company of Leonor Fini, who was also a surrealist painter.

ERNST: You sound as if you were now accusing me of crimes, or at least misdeeds.

E.R.: Certainly not. I'm simply trying to remember how I've always seen that the company you tend to keep is generally that of women who are not only very beautiful but also very talented or fanciful. Later, this procession of surrealist goddesses included Leonora Carrington, again a surrealist painter; then your marriage with Peggy Guggenheim, famous for her art collection, and finally your present marriage with the surrealist painter Dorothea Tanning. All this leads me to believe that these previous marriages and friendships were episodes in a quest that finally led you inevitably to Dorothea Tanning, who represents the attainment of an ideal toward which you were always tending.

ERNST: Yes, I'm now experiencing a kind of happiness that I feel I had longed for and sought.

E.R.: In this quest, as well as in your activities as an artist, chance has played an important part. In 1939, you were living in France with Leonora Carrington, who was English. At the time of the German occupation of France, the Vichy government interned you as an enemy alien and she had to flee to Spain after the Armistice. In her anxiety, she lost her mind and was interned in a Spanish psychiatric hospital until she was well enough to escape to Mexico, where she now lives. After Leonora's escape from France, Peggy Guggenheim intervened to facilitate your escape to the United States, and she may thus have saved your life. Later, in New York, she insisted, I believe, on marrying you, but it was also there in her art gallery that you met Dorothea Tanning. All these unforeseen and providential meetings now make your life in some respects sound almost like a picaresque novel.

ERNST: But these meetings are all in keeping with the character of our age. We always tend to attribute to chance what we cannot yet explain in a more rational manner.

E.R.: Patrick Waldberg noted that you borrowed this concept from your readings of Richter, who is one of the more neglected philosophers of German romanticism. I now have the impression that you have generally managed to follow the example of Machiavelli's ideal statesman, who manages to leap at the

right moment from one of Fortune's wheels, just beginning to descend, to another that is about to rise to its peak — in fact, you made the most of these unpredictable chances in that the most eventful years of your life, between 1922 and 1950, were also your most productive. Even when you were in one of the Vichy government's internment camps, you still managed to work.

ERNST: Well, in the Camp des Milles, not far from Marseilles, I had to share a tiny room with the painter Hans Bellmer. We spent most of our time drawing, if only to forget our hunger and our anxiety.

E.R.: I used to have hanging on my wall in Paris, until I sold it, a drawing by Hans Bellmer, a portrait of you that he drew in that camp. It's quite a realistic drawing that appears to have been a preliminary study for the portrait where he represents you as a kind of sculpture composed of bricks. Can you explain to me the significance of these bricks?

ERNST: The camp where we happened to be interned had once been an area of brick kilns and was full of broken bricks, shards and brick dust. We used to find this red dust even in the meager rations of food we received. Soon it began to penetrate the pores of our skin, until we felt that we too would disintegrate and fall apart while all our flesh turned to bricks and shards and red dust.

E.R.: Some of your wartime paintings are among those that I still find most disturbing.

ERNST: If, through work, you can manage to control your anxiety, it can be channeled into this work and enrich it instead of destroying you.

E.R.: In her memoirs, Peggy Guggenheim notes that before you had ever set foot in America you had already painted some landscapes that have a lunar quality and appear to be prophetic visions of those you were destined to discover in Arizona.

ERNST: This is quite true. Besides, when I first began to paint these landscapes, I had no idea of ever going to America; later, too, no idea of ever going farther west than New York. But when I left Peggy to live with Dorothea, we chose to settle in Sedona, Arizona; and it was there that I discovered landscapes of a kind that immediately seemed familiar, though I had always believed when I first visualized them

that they were purely imaginary. In Sedona, we built our house with our own hands. We had a grandiose view from it, and we often spent most of the day enjoying this view from our windows until we understood one day that we couldn't expect to do much work if we continued to live in the company of such a landscape. So we then bricked up these big windows and opened up other small ones, looking out onto a little garden on the other side of the house.

E.R.: This was in harmony with the principles of Alice Toklas, who, according to Gertrude Stein in *The Autobiography of Alice B. Toklas,* once said that she liked a good view, but preferred sitting with her back to it.

ERNST: For once, she was right.

E.R.: You sound as if you didn't have much respect for Gertrude Stein or Alice Toklas.

ERNST: They never thought much of us surrealists, and we in turn felt that these two women, after 1920, were already very old hat in their pretensions and affectations.

E.R.: How long did you keep your home in Sedona?

ERNST: When we decided to return to live in France, we gave the house to my son. Later, he in turn sold it.

E.R.: Your return to France was in many ways a triumphal return.

ERNST: On the contrary, we had to live at first rather modestly. You forget that I came back to France at a time when those whom you have just called the *terribles simplificateurs* were busy praising only abstract art and condemning surrealist art, especially if it was at all figurative, as too literary, so that it appeared to be irretrievably discredited.

E.R.: True, we were then being told at every turn that art should be pure or "other." But I was not thinking so much of immediate material success when I suggested that your return to France was triumphant. After all, you first came to live in France in 1922 without any residence permit — in fact, as a kind of illegal immigrant. For many years, you lived in Paris without any security, at least until your French friends were able to intervene with the authorities to regularize your situation. Then in 1939, this new status you had acquired with so much difficulty was undermined when the authorities remembered that you were still German — in fact, an enemy alien — and interned you in a

detention camp. Again, the poet Eluard and a few other French friends were able to exert their influence to obtain your release, after which the American Emergency Rescue Committee, with Peggy Guggenheim's financial assistance, obtained your visa for immediate emigration as a refugee to the United States. I'm told that when you reached the Spanish frontier, you were nevertheless nearly forced back into France, because your French exit visa was no longer valid.

ERNST: Yes, a French policeman told me that I should go back to Toulouse to get it renewed. But he then led me to the station platform between two trains. The one, he explained to me, would be going on to Spain, while the other would be going back to Toulouse. He then warned me not to board the wrong train, but very kindly left me standing there while he went back to the office where he checked passports; nor did he pay any further attention to me, so I took the hint and boarded the wrong train. Minutes later, I was safely in Spain.

E.R.: Ten years later, you were no longer a German citizen and were returning to live in France with an American wife and an American passport. Later, you decided to become a French citizen—in fact, a compatriot of this kind policeman who allowed you to escape from France.

ERNST: Actually, I came back to France because I feel that it's my real home. It's here that I've lived the happiest and most productive years of my life—I mean the years that allowed me to produce what I now believe to be my best work.

E.R.: Some time ago, you gave a show in Paris at the Galerie au Pont des Arts, mainly of recent works that consist of assemblages, the elements of which are mostly parts of dismantled bird-cages. All this seemed to me to be symbolic: in several of these assemblages, a single feather seemed to have been left there, like a visiting card from a bird, a former prisoner of the cage now free. I felt that this liberated prisoner was perhaps Max Ernst who, no longer afraid at the sight of a cage in which he might have lost his freedom and a few feathers, had now become so joyfully free that he can even play with the bars of a birdcage without awakening any painful memories. One of my friends, the American critic Jim Mellow, wrote in a New York art magazine on the occasion of an important

retrospective of René Magritte's paintings that surrealism interests the general public because of the sexual nature of many of the symbols that it uses and because it is the only art movement of the past half century that always brings our attention back to man, to the human body, and to what the human body can suggest to us, whether in dreams or in real life.

ERNST: I would tend to agree with Mellow. Art remains something created by man—in fact, an artifact that should always bear his mark. Nature too can produce things that we consider beautiful, such as patterns in a stone that suggest to us a beautiful landscape. But it was never nature's intention to create them as such. In nature's aesthetically successful creations, chance often plays a predominant part and man remains the final judge in interpreting and appreciating the aesthetic value of nature's creations. No bird will ever be fooled by them to the extent of discovering in the veins of a piece of marble the elements of a landscape or, to quote da Vinci again, the suggestion of a human face. If I too have allowed chance to play an important part in the creation of a number of my works, I did this, after all, in order to interpret these chance effects in my own manner—I mean in human terms and in terms of my own dream world, which is certainly personal and no other man's dream world.

E.R.: Because you have identified inspiration so often and so much in your work with such chance effects, I mean with "causes" or "reasons" that transcend our reason, your work seems to be founded to a far greater extent than that of most other painters of our age on what mathematicians would call "variables," as opposed to "constants." If one were, for instance, to translate each one of the typical works of Mondrian, Albers or Vasarély into a binary formula that no longer makes allowances for any ambiguity, and then express all these formulae in terms of data to be fed to a computer, the latter would be able to invent—on the basis of the information thus supplied—a whole series of new and original works that we would scarcely be able to distinguish from those of Mondrian, Albers or Vasarély which had, so to speak, "inspired" the computer. But your works would never lend themselves to this kind of reduction that excludes all possibility of ambiguity. On the contrary, the source of your

43

inspiration remains essentially an area of ambiguity that partakes both of the future and of the past, and is full of elements both of *déjà-vu* and of prophecy.

My little argument about computers amused Max Ernst. It was already late and I still had to return to Grasse and, from there, to Nice, where I would catch an evening flight back to Paris. We parted and that night I found in my mail a German periodical which contained an article about a computer which had been instructed to create, on the basis of informational input, some original works of art of its own in one of the many abstract styles which in recent years have been particularly successful with critics and art lovers. The obedient computer then created, in record time, a whole series of new and "original" works that could very easily be mistaken for some of the so-called "lyrical" calligraphies of Hans Hartung.

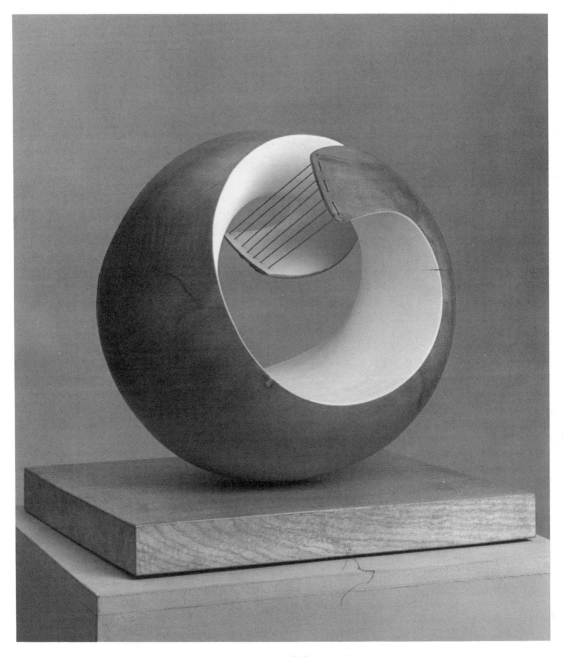

BARBARA HEPWORTH, *Pelagos*, 1946

Barbara Hepworth

The steep and narrow streets that lead up from the small Cornish harbor of St. Ives can appear, on a sunny day, disconcertingly Mediterranean. Is their Casbah-like intricacy a relic of the town planning of the Phoenician merchants and mariners who once established trading posts along this coast in order to export its tin ore? Are the white walls and bright blue shutters of some of these houses intended, as in Sidi-Bou-Said, near the ruins of ancient Carthage, to ward off the Evil Eye? The gardens behind some of the high stone walls of St. Ives, its houses built almost like fortresses, the intimate narrowness of its streets where the interplay of light and shadow can be so dramatic, all these remind one, at first, of St.-Tropez, of Ischia, of Hydra or of some eagle's nest of the Saracen pirates of the Barbary Coast rather than of the British seaside resorts, with their promenades, their bandstands and their piers, on which Osbert Sitwell has lavished his satire.

Long the home port of a small fishing fleet, then also an artist's retreat, St. Ives has only recently begun to be threatened with the vulgar prosperity of a trippers' paradise. Barbara Hepworth's house stands but a few yards from the waterfront where, during the season, the holidaying crowds ceaselessly flow past the espresso bars, hamburger eateries, fish-and-chip shops, "Studio" souvenir emporia stacked with the mass-produced wares of Birmingham and Clerkenwell workshops, and the bed-and-breakfast lodging-houses that seem to be dedicated to the cult of perpetuating the aspidistra displayed prominently in the parlor window. Just beyond the outer frontier of this absurd Cornish Disneyland, Barbara Hepworth's home faces the outside world, as many an artist's retreat in St.-Tropez and Ischia, with the austere exterior of a kind of fortress. Its pale blue doors and few narrow windows seem secretive; as one enters it, one is struck at first by the ordered economy of the rooms, which have a monastic and cell-like quality, until one reaches those that face the garden. Here one discovers a less reticent private

world, which one can contemplate from large windows and doors that open onto it as onto a patio. On the lawns, among the flowers and shrubs, a number of Barbara Hepworth's works of recent years are scattered, some of them in close groups like tombs in a strangely modern Moslem cemetery. An open-air studio reveals that the artist prefers to work, whenever the weather permits, in the light of nature. She derives from it a sense of freedom, no longer feeling constrained by artificial limitations of space.

Before calling on the artist for this interview, I had approached her over the phone, though I happened to be staying with her neighbor, the young sculptor John Milne. The informality of my now dropping in from next door helped us to get down to the job of discussion without any awkwardness, avoiding all time-consuming preliminaries. We sat in one of her studios or workrooms, in the one that overlooks her garden, facing the wall that separates it from John Milne's property. Over this wall, I had taken the liberty of peeking, a day earlier, at Barbara Hepworth's Moslem necropolis, which I now viewed from the opposite side. The artist's appearance, her gestures, her manner of speech, even her style of dress, suggested unusual poise and efficiency. Without being merely pretty, her features were beautifully modeled, as if her mind had sculpted her body from within. One cannot help feeling that she is exactly as she would like to be. Yet there is nothing odd about her, no histrionic Bohemianism, no flim-flam-flummery of facile protest. One would not be surprised to discover that such a handsome, pleasant and obviously intelligent woman is a brilliant physician or a successful politician rather than an artist. Yet she speaks of her art with a rare awareness of dedication, in a tone of authority and also of humility.

E.R.: What are the advantages, in your opinion, of working in the open air?

HEPWORTH: Light and space are the sculptor's materials as much as wood or stone. In a closed studio, you cannot have the variety of light and shadow that you find in the open air, where even the colors of the shadows change. I

47

"This is exactly what a sculpture should suggest in its relationship to its surroundings: it should seem to be the center of a globe, compelling the whole world around it to rotate . . . like a system of planets around a central sun."

feel that I can relate my work more easily, in the open air, to the climate and the landscape, whereas the light and the space of a closed studio are always more or less the same, and more or less artificial.

E.R.: In almost every explanation of your work that I have read I find that the word *landscape* occurs, obviously used with a very special meaning. Certainly, when you refer to the relationship of one of your works to a landscape, you are not thinking of a view such as one finds in a painting by Constable or by Turner.

HEPWORTH: Certainly not. I think of landscape in a far broader sense. I extend its meaning to include an idea of the whole universe.

E.R.: The landscape of one of your works might thus be interpreted as its ecology — I mean its relationship to nature.

HEPWORTH: Yes, I suppose that would be a correct interpretation of what I mean by landscape.

E.R.: But the relationship of a sculpture, as a man-made object, to its natural surroundings might be based either on harmony or contrast.

HEPWORTH: That would depend on the artist's response to a specific landscape. A sculpture, as I conceive it, is for a specific landscape. My own awareness of the structure of the landscape — I mean the individual forms, too, that contribute toward its general quality — provides me with a kind of stimulus. Suddenly, an image emerges clearly in my mind, the idea of an object that illustrates the nature or quality of my response. This object, once I have created it as a sculpture, may harmonize with the landscape that inspired it, in that its form suggests those that I have observed in nature. On the other hand, the form of the sculpture may also contrast with the forms of the landscape. But, whatever the formal quality of this relationship, the sculpture remains, in my mind, so closely associated with the landscape to which I originally responded that I often try to perpetuate this relationship in the title that I choose for the work.

E.R.: Do you mean that you give your works specific titles like those that landscape painters choose? I mean like the titles of paintings of Constable or Whistler?

HEPWORTH: Not exactly, since I'm always thinking of landscape in a broader and less specific sense. For instance, one of my sculptures is entitled *Pelagos,* meaning "the sea." Well, from my studio, I could see the whole bay of St. Ives, and my response to this view was that of a primitive who observes the curves of coast and horizon and experiences, as he faces the ocean, a sense of containment and security rather than of the dangers of an endless expanse of waters. So *Pelagos* represents not so much what I saw as what I felt.

E.R.: Do you believe that it is possible to explain or justify in words such an individual response to a landscape?

HEPWORTH: No such explanation would be entirely satisfactory. It would always fail to convince some individual spectator. But the individual also remains free to repudiate my particular response and to affirm his own different response to the same landscape. Still, the violence of such an individual's repudiation of my response may also serve its purpose in clarifying his own response, whether to my own work or to the landscape that originally suggested it to me. . . .

E.R.: So you admit that different artists may conceive different forms as responses to one and the same landscape?

HEPWORTH: Certainly, and each different form, each different response, is valid as a kind of testimony. My own testimony represents the sum total of my own life and experience, in that particular moment, as a response to that particular experience.

E.R.: In terms of Platonic philosophy, your works should thus be defined as imitations of something that occurs in your own mind rather than of nature as it is or as it might ideally be.

HEPWORTH: Yes — an imitation of my own

past and present and of my own creative vitality as I experience them in one particular instant of my emotional and imaginative life.

E.R.: Would you say that you set out to impose upon your material a very clearly conceived form, or that you allow your material, as you work on it, to suggest to you the final form of the sculpture?

HEPWORTH: I must always have a clear image of the form of a work before I begin. Otherwise there is no impulse to create. The kind of sculpture that I indulge in is hard work, and I would always hesitate to start doodling with a mass of wood or stone as if I were waiting for the form to develop out of the work. Still, the preconceived form is always connected with material. I think of it as stone, or as bronze, or as wood, and then I carry out the project accordingly, imposing my own will on the material. The size of the sculpture is also important, in my first clear image of what I want to do. I can see the material that I want to work on, and also the exact relationship of the object to its surroundings — I mean its scale. I hate to think of any of my works being reproduced in a smaller format.

E.R.: You mean as a kind of pocket edition reproduced in ceramic and tucked away on the shelf of a bookcase, in front of a row of cookery books?

HEPWORTH: Yes — that might well be one of my nightmares.

E.R.: But doesn't the material, as you work on it, ever suggest to you any modification of your original image?

HEPWORTH: Of course it does, and that is the great temptation. Halfway through any work, one is often tempted to go off on a tangent. But then one knows that there can be no end to such temptations, such abandonments of one's plan. Once you have yielded, you will be tempted to yield again and again as you progress on a single job. Finally, you would only produce something hybrid, so I always resist these temptations and try to impose my will on the material, allowing myself only, as I work, to clarify the original image. At the same time, one must be entirely sensitive to the structure of the material that one is handling. One must yield to it in tiny details of execution, perhaps the handling of the surface or grain, and one must master it as a whole.

E.R.: It sounds rather like the art of mastering a thoroughbred horse.

HEPWORTH: I've never ridden a horse, but I can well imagine that this is a good simile.

E.R.: As I look around your studio and see all these samples of your work, I feel that you have an awareness of what I would call the different epidermis of bronze, stone or wood. Your bronzes, for instance, have a rougher surface that is peculiar to them, whereas your stone and wood sculptures achieve as smooth a "skin" as the grain of the material can allow.

HEPWORTH: It requires an extra effort, some additional strength, to discover the wonderfully individual quality of each material. In the case of bronze, this problem of the finish is particularly subtle, as the model which I send to the foundry is of an entirely different material. I have to visualize it, as I work on it, as if it were bronze, and this means disregarding completely its own material qualities. That is why I find it necessary to work with a foundry that has an artistic understanding of the quality of finish and of color that I want to obtain in the bronze. I enjoy working for instance with Susse Frères, the great Paris foundry. They are artists and masters and I can always trust them to interpret my ideas. Look at the color, for instance, of that bronze, which came back from Paris only recently. The blue-gray quality of the shadows, on the interior surfaces, is exactly what I wanted, though I had never seen it before in any bronze. It turned out exactly as I had visualized it when I was still working on the plaster model.

E.R.: This awareness of the specific qualities of various materials is what strikes me as lacking in most nineteenth century sculpture.

HEPWORTH: Many sculptors then tended to misuse clay, wax or plaster. In handling something that is soft and yields, they would forget too easily that their model was to be reproduced in stone. Generally, it was another man, a craftsman rather than an artist, who carried out in marble the model that the sculptor had entrusted to him.

E.R.: The French poet Léon-Paul Fargue once referred to this kind of art as "noodles camouflaged to look like steel." I suppose that is why so many marble figures of that period look as if they had been squirted out of a toothpaste tube, then hastily and quite easily licked into shape and allowed to cool off and harden.

HEPWORTH: That sounds rather revolting to

me. But so many of these human figures of the nineteenth century are like petrified humanity, as if they had been injected with a chemical that immediately transformed living flesh into bronze or stone.

E.R.: The Greeks were already aware of the dangers of this kind of naturalism. Medusa, the gorgon, could turn human beings to stone by merely looking at them, and the legend horrified the ancient Greeks.

HEPWORTH: Well, I share their horror of a living being that has been overcome by a kind of *rigor mortis*. I feel that a work of art should always reflect to some extent the peculiar kind of effort that its material imposed on the artist.

E.R.: May I interrupt you here to say how much I am enjoying the aptness and articulate quality of everything that you have said to me about your art? I've had the occasion of interviewing, in recent months, quite a number of artists, whether in English, French, Italian or German. Some of them, I found, were quite inarticulate, except in their own medium. Others, when they spoke, were almost too articulate, so that I felt that they often failed to express, in their particular medium, all that they claimed, as they spoke, to have set out to achieve. In your case, I find that your verbal explanations apply very aptly to your actual sculpture.

HEPWORTH: It is important for an artist never to talk about his ideas until he has made them concrete as works of art. In explaining what one intends to do, one always wastes or loses some of the energy or force that is required to achieve the work of art. I suppose I am able to explain only those works which I have already completed. I don't think I would ever want to talk about an image or an idea that is still in my mind, or that I haven't yet made fully concrete.

E.R.: Brancusi was never very eloquent about his own sculpture.

HEPWORTH: No. I visited him twice in Paris, in his studio, before the war. It was wonderful. He simply pulled the dust sheet off each sculpture in turn, and there it was, something that needed no explanation because it was already as much a part of the visible world as a rock or a tree.

E.R.: For Brancusi, the act of creation was something as simple and as self-explanatory as the act of procreation among animals. But he could also be articulate whenever he discussed the work of another artist. I happened to meet him shortly before he died, when I called one afternoon on a young American painter who lived in Paris and occupied a studio next door to Brancusi's. That day, I didn't recognize Brancusi at once as I hadn't seen him for more than twenty years. My American friend, Reginald Pollack, is a figurative painter who had settled in France in order to study the techniques of the great French post-impressionists and Fauvists, from Bonnard to Dufy — which is scarcely the kind of art that one generally associates with the name of Brancusi. Well, here was Brancusi, carefully analyzing his young neighbor's recent work and giving him very specific advice on how to solve certain problems of color and texture that Pollack was still trying to solve.

HEPWORTH: That doesn't surprise me at all. There was an essential humility in Brancusi. He knew very well what he wanted to achieve, but this did not exclude the other aims which other artists might set themselves. Within the scope of his own field of creation, he could achieve the perfection of form that he sought. At the same time, he was aware of other types of expression which other artists might achieve.

E.R.: I seem to detect a great affinity between your own work and that of a few Continental sculptors — I mean Brancusi and Arp. But I also feel that your work, like that of Henry Moore, has contributed very decisively toward establishing the notion of a specifically English school of contemporary sculpture. I would even say that England and Italy are now the only two European countries that have a national style of contemporary sculpture.

HEPWORTH: It is safe for you, an American, to make this kind of remark. On my lips, it might sound almost too chauvinistic, though there may be some truth in it.

E.R.: Until 1939, English artists tended, I feel, to follow almost too closely the directives of the School of Paris. When they were cut off from Paris by the war, they became aware of their own power and of their own potential style.

HEPWORTH: It is an awareness that we developed as a group rather than as individuals. After the First World War, we became conscious of all the values of our civilization that we were called upon to defend. We then realized that sculpture, as a stonecutter's art, had been

widely and successfully practiced five centuries ago in England.

E.R.: I suppose you are referring to the masters who carved such figures as those that one sees on the façade of Exeter cathedral.

HEPWORTH: Yes. But this stonecutter's art had been abandoned and forgotten. In the twenties, we began to seek a return to the fundamentals of our art. We recoiled at last from the kind of reproduction of a reproduction which had satisfied the sculptors of the Victorian era. Sir Jacob Epstein, Eric Gill and Gaudier-Brzeska had cleared the decks for the sculptors of our generation — I mean Henry Moore, myself and others. We then rediscovered the principles of Anglo-Norman sculpture, too. I remember how, during the war, a bombing once led to the accidental unearthing of a carved Anglo-Norman capital in which the artificial coloring of the stone had somehow been preserved. I was able to see how the cavities of the reliefs had once been colored with a bright terra-cotta red, and this was exactly the kind of effect that I too had been seeking from 1938 onward, in some of my own works. What I had considered an innovation thus turned out to be a lost tradition in English sculpture.

E.R.: Of course, there had also been at one time a specifically French school of modern sculpture, from Carpeaux, Degas and Renoir in the generation of the impressionists, to Rodin, then Bourdelle, Maillol and Despiau in our own age. But the great sculptors of the School of Paris, in recent years, have generally been foreigners — I mean Brancusi and Modigliani, Lipschitz, Zadkine and Arp, who had been active in German artistic movements before his native Alsace, in 1919, became again a French province.

HEPWORTH: The English sculptors of my generation still owe a great debt to these artists of the School of Paris. They have taught us the basic principles of form in its relationship to the surrounding space. But we also had to solve a problem of our own. I mean that we had to deal, in our relations with the English public, with that very English characteristic of always seeking a literary explanation for every work of art. In France, the impressionists had solved that problem decades earlier. But we had to remind England that a sculpture need not be a monument to the dead, or a reminder of a great work of Michelangelo. On the contrary, a sculpture should be enjoyed for its own intrinsic qualities.

E.R.: That had already been the basic doctrine of Oscar Wilde's campaign against the "anecdotage" of Victorian art. But Oscar Wilde had been so eloquent in his praise of French art that most English artists, from 1890 to 1940, looked to France for their directives.

HEPWORTH: In 1940, we were then cut off from France and suddenly realized that everything that we really needed, for the time being, was available here. In sculpture, painting, architecture and music, everything that we stood for, that we had to defend in the war, was here. We realized that contemporary English art and music could indeed be as rich and varied as contemporary English literature. It was up to us to forge ahead and prove it.

E.R.: I think you, in particular, have proved it very eloquently.

HEPWORTH: I sometimes feel now that we are beginning to be threatened by a certain chauvinism. People would love to return to the comfortably insular or English ways of thinking. Now we have to combat this danger. We must avoid contributing toward the establishment of a new kind of specifically English academism.

E.R.: So you feel that you are now committed to defending the kind of nonfigurative art which is considered most controversial.

HEPWORTH: No, not necessarily. I have not always been a nonfigurative artist, and I may very well, one day, feel the urge to return to a more recognizably figurative style of art. Besides, we are already having to cope — I mean those British artists who have long been pioneers of abstract art — with a kind of placid academic recognition that is at times quite disconcerting.

E.R.: When did you first begin creating abstract forms?

HEPWORTH: Around 1931, I began to experiment in a kind of organic abstraction, reducing the forms of the natural world to abstractions. Then, in 1934, I created my first entirely nonfigurative works. But it was in 1931 that I began to burrow into the mass of sculptured form, to pierce it and make it hollow so as to let light and air into forms and figures.

E.R.: Is there any connection between this idea of an inner surface — I mean of a hollow mass that is penetrated by light — and the concave-

convex ambiguity of certain cubist paintings — it's actually a kind of optical punning — where objects that are convex in real life are depicted as concave, or vice versa?

HEPWORTH: No, I don't think there is any such play, in my work, with the ambiguities of optical impressions. I think this development, in my sculpture, was a response to an organic sensual impulse. I believe that the dynamic quality of the surface of a sculpture can be increased by devices which give one the impression that a form has been created by forces operating from within its own mass as well as from outside. I have never seen things, even inadvertently, in reverse, though I have often observed that some other artists tend to suggest that they have seen in relief what is actually hollowed out, or vice versa. In my own work, the piercing of mass is a response to my desire to liberate mass without departing from it.

E.R.: This is indeed a curiosity of the senses rather than of the intellect. It suggests a desire, on your part, to explore the inside of a mass with your fingertips rather than with your mind. But the cubists were more intellectual, as artists, than sensual; besides, they invented and tested most of their devices, even those that suggest sculptural effects, in paintings rather than in sculptures.

HEPWORTH: Still, there is an element of intellectualism in my sculpture, too. I feel that sculpture is always, to some extent, an intellectual game, though the sculptor generally obeys sensuous impulses. The sculptor sets out to appeal to all the senses of the spectator, in fact to his whole body, not merely to his sight and his sense of touch.

E.R.: In most cubist sculpture, I seem to miss, above all, this appeal to the spectator's sense of touch, except when the cubist sculptor sets out to fool the spectator by offering him a convex form where one expects a concave one.

HEPWORTH: But there is a certain amount of fooling of this kind in all art. You are perhaps right when you suggest that the cubists refrained from appealing to our sense of touch, except perhaps when they set out to deceive us. But my own sculpture also sets out, at times, to deceive the spectator. I thus try to suggest, in my forms, a kind of stereoscopic quality, but without necessarily allowing the spectator to touch these forms. The piercing of masses, by allowing light to enter the form, gives the spectator a stereoscopic impression of the interior surfaces of this mass, too. I set out to convey a sense of being contained by a form as well as of containing it — I mean of being held within it as well as of holding it — in fact, of being a part of this form as well as of contemplating it as an object. It is as if I were both the creator of the form conceived and at the same time the form itself, and I deliberately set out to convey this ambiguity to the spectator, who must feel, as I did, that he is part of this sculpture, in its relationship to space or landscape.

E.R.: This would indeed be the ideal of communication between artist and spectator. But it requires a kind of contemplative approach to the work of art, on the part of the spectator, that has become almost impossible in our overcrowded world where one often feels that there is already standing room only. In the Museum of Modern Art in New York, for instance, the modern sculptures are so crowded that one can sometimes see a detail of a César through a hollow in a Henry Moore. I found that very disturbing, like a vision of skulls and bones piled up promiscuously in a charnel house.

HEPWORTH: To me it sounds quite macabre. Besides, it is contrary to the basic idea that underlies most sculpture ever since that of ancient Greece. A human figure, set in the daylight and in a landscape, should give us there the scale of everything. If you wish to suggest a deity that dominates nature, a colossal figure will do the trick. But if you crowd together, in a single space, a lot of figures conceived on different scales, you deprive them all of their aesthetic purpose and reduce them to the status of "ancient remains" — I mean of objects of interest to an antiquarian. In the case of modern sculpture, too, this overcrowding in galleries and museums deprives each work of its intended relationship to space — I mean of its ideal landscape. Once, when I was in Greece, I became intensely aware of the relationship that a single human figure might bear to a whole vast landscape. It was on Patmos, and I was coming down a mountainside when I saw a single black-robed Greek Orthodox priest standing beneath me in a snow-white courtyard, with the blue sea beyond and, on the curved horizon, the shores of other islands. This single human figure then seemed to me to give the scale of

the whole universe, and this is exactly what sculpture should suggest in its relationship to its surroundings: it should seem to be the center of a globe, compelling the whole world around it to rotate, as it were, like a system of planets around a central sun. That is why each sculpture should be contemplated by itself.

I slipped my ballpoint pen and my notebook into my pocket and we then strayed into the garden together. Later, Barbara Hepworth also showed me, in another house in the same street, another studio, a huge room that is more convenient for larger works. Here, too, individual works seemed to conflict, each one interfering with another's aura or landscape. To create, for each work, its own ideal space, a sculptor must indeed be purposeful enough, or obsessed enough, to block out of his own field of vision all the other works that surround him in his studio.

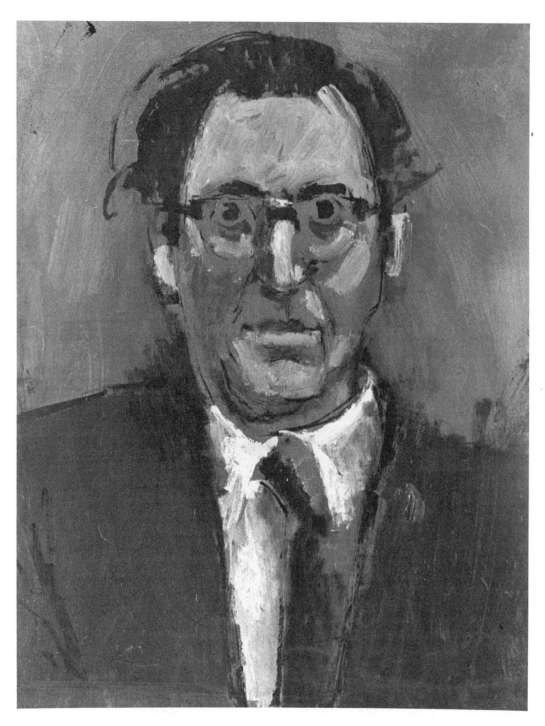

JOSEF HERMAN, *Portrait of Edouard Roditi*, 1960

Josef Herman

*T*he circumstances of my first acquaintance with the work of Josef Herman were particularly felicitous. Herman's London dealers, Messrs. Roland, Browse and Delbanco, went to considerable trouble to satisfy my curiosity about his work by showing me a great number of his paintings and drawings. I was immediately impressed by the monumental and at the same time painterly qualities of his oils, by the almost sculptural solidity of his draughtsmanship; even more, by the humanism that characterizes his approach to what seemed to be his favorite subject, men at work. In a decade that generally eschewed figurative representation, Herman's world, which had been that of Jean-François Millet, Jozef Israels, Gustave Courbet and Camille Pissarro in the nineteenth century, had been now abandoned almost exclusively to the Communist devotees of Socialist realism.

My discovery of Herman's work was all the more important to me because, in my analysis of the various trends prevalent in the emancipation of Eastern European Jewish painters from the traditional religious ban on "graven images" and, by extension, on nearly all figurative art, I had already come to the conclusion that the folkloristic "Yiddish" humor and pathos of Chagall and other more famous Jewish painters of Russian or Polish origin represented but a picturesquely National aspiration, of the same general nature as the one which, in literature, had given us Sholem Aleichem's Tevya the Milkman and, in the theater, the antics of all those Jewish comedians whose fantasy has culminated in the Hollywood "nuttiness" of Harpo Marx. To the devotees of modern art in Western Europe and America, all this seemed delightfully irrational, colorful and poetic, often suggesting, in its poignant mixture of fantasy, humor and pathos, a kind of Jewish analogue of Petrouchka. But there also existed, I felt, another trend among Eastern European Jewish painters, less particularistic or exotic in its folklore, more consciously humanistic in the universal application of its inherent Socialism. It had failed, however, to enjoy,

in the Western world, the same popularity as Chagall's more cheerful and colorful memories of his childhood in Vitebsk or as Issachar Ryback's elegiac vignettes of life in an old-fashioned Ukrainian Shtettl. Yet this other trend had inspired Lasar Segall's infinitely more stark and tragic series of lithographed memories of his native Vilna as well as the work of numerous Jewish artists who emigrated from Poland or Russia to France, England or America.

Herman's London studio was at that time a convenient place to work rather than a home which might express his tastes and personality. He was then spending much of the year in Ystradgynlais, the mining village in South Wales that has come to mean so much to him, or traveling the Continent, generally in France, in Italy or in Spain. From the windows of Herman's Swiss Cottage studio, one looked out onto a rather desolate and abandoned back garden. In spite of the many paintings and drawings that were framed on the walls, placed on easels or stacked at random against the furniture, the room itself was as typically middle-class English, as impersonal as any large furnished room in an old-fashioned suburban or provincial house that had obviously seen better days.

Josef Herman himself might well puzzle anyone who meets him for the first time without knowing much about his background. For a relatively recent immigrant he spoke remarkably fluent and correct English, though with a recognizable Polish or Polish-Jewish accent, that of a man whose mother-tongue was Yiddish rather than a Slavic language. His fair skin and light-colored hair, the structure of his cheekbones, his features and his short and stocky build, however, are more Slavic than Jewish. His manner, besides, is that of a provincial rather than of a Londoner, and one feels at once that he would be more at ease among working-class Polish Socialist intellectuals than among the more sophisticated francophile intelligentsia of prewar Warsaw, in Antwerp or Brussels rather than in the literary and artistic salons of Paris, and in Glasgow or Wales rather than among the glittering celebrities of a London cocktail party.

*"Human labor is not a trifling matter. We are conditioned
to labor. We have no choice. This is the tragic aspect of it. And
to express this aspect, this inevitability of a fate that leaves us
no choice, it does not matter whether one uses as a symbol a
peasant or a worker, an archaic ox or a modern tractor."*

*I began by questioning Herman about
his childhood.*

HERMAN: I was born in Warsaw, in 1911, the
eldest of three children. My father was a cob-
bler; my mother, just a typical Polish-Jewish
mother. I can only say of my childhood that it
was happy, in spite of its drab surroundings
and of the poverty of my parents. It was an ordi-
nary Eastern European urban working-class
childhood. My parents were kept busy trying
to make both ends meet and I was left very
much to myself. But I was never lonely. Even if
I was alone, everything came to life in my com-
pany, and anyone who had enough patience to
chat with me became at once my friend. Though
I was never shy, I was quiet and generally
waited for others to make the first advances.
The lives of children who are brought up in the
crowded slums of big cities are often rather
quiet, scarcely bright in a technicolor sense.

In contrast to my childhood, my youth was
more eventful and adventurous, though my
adventures were mainly in the twilight realms
of literature. I was a voracious reader. After
completing my elementary schooling, I began
studying for matriculation and, perhaps, for
admission to the university. Besides, I read for
my pleasure, and soon became acquainted with
most of the major classics. Dostoyevski and
Walt Whitman, Tolstoy and Balzac were among
my favorites. One of my mother's secret ambi-
tions was that I should become a physician. But
my father was undecided, and my own plans
remained for a long while very vague. My pas-
sion for reading may have been one of the
causes of this indecision, for I still read some-
what indiscriminately and for a long while I
remained a very unpractical youth. I remember
my father saying, to a friend who had remarked
that I was a rather gifted boy: "Believe me, a
gifted son is a curse for a poor cobbler." Nor
can I blame my poor father. In those days, I

changed jobs quite often, and my family was
never sure that I would be able to earn my keep
and contribute my own share of our household
expenses. At one time, I was an apprentice com-
positor in a printing press, at another time an
office boy; I also tried my luck in a workshop in
one of the metal trades, and as assistant sales-
man in a shop that sold imported tweeds and
soon went bankrupt. When I look back on those
unsettled days of my youth, I seem to see a star-
less night. . . .

E.R.: When did you first feel the urge
to paint?

HERMAN: It began to dawn on me when I was
eighteen that I wanted to draw and to paint. I
was already earning a precarious kind of living
and began slowly to buy all the art magazines
that I could find, which was something that I
had never done before. I also began to attend,
in the evenings, lectures that were given in War-
saw by the spokesmen of the various modern
movements which were being widely discussed
and that the Polish press still tended to lump
together under a single denomination as
"futurists." I thus came to accept one theory
after another, swallowing each in turn as if it
were gospel truth. Not that I was too shy to
criticize anything that I heard, but I still allowed
myself to be rather easily convinced by the
sheer eloquence of an argument and, in the heat
of the discussions that often followed these lec-
tures, I soon learned to throw in a few argu-
ments of my own. But all this was still very
innocent, mere nonsense and chatter. Many a
painter who made his first steps as an artist in
the late twenties of our century underwent simi-
lar experiences, and very few of them indeed
have ever recovered from this feverish and often
unhealthy passion for argument and theory.

E.R.: But when did you actually start
to paint?

HERMAN: Well, I had already begun to try
my hand a bit at drawing and even at painting

56

during this first period when I was so busily attending lectures and discussions about modern art in my spare time. But the first man from whom I got something that might be called an artistic training or schooling was, surprisingly enough, an old academic painter, a tall old Polish gentleman with a long white beard, a Mr. Slupski. In his youth, he had studied art in the nineteenth century academies of Munich and, when he took his first look at my drawings, he seemed actually shocked. All he could do was to murmur: "Nonsense. . . .But all this is very bad. . . . Still, young man, you can draw, but what you need is discipline. . . ." Again and again, in the course of his instruction, he repeated to me a long story about the nineteenth century German painter Adolf von Menzel who, he insisted, had never ceased, even at the peak of his career, to draw from plaster casts of Greek statuary, so as never to relax from this previous discipline. . . .

E.R.: There is a quite apocryphal legend about Menzel, who was one of the great draughtsmen of his age, an artist of much the same caliber as Ingres or Degas. Actually, Menzel nearly always had a sketchbook in his pocket, when he went out on his errands in the streets of Berlin, and often stopped in the middle of a busy thoroughfare to sketch some person or incident that caught his fancy. The great German realist cartoonist Zille was a pupil of old Menzel, and many of the early drawings of Käthe Kollwitz also reveal his influence. But academic painters like your old teacher Slupski would only remember, of course, that Menzel drew or painted, in his old age, a few scenes of corners of his studio, where he still had the plaster casts that had been part of the furnishings of the studio of any painter in his generation.

HERMAN: Old Slupski never mentioned to me Menzel's sketching of street scenes, and I finally gave in to his precious arguments about discipline. He impressed me so much with his talk about "solidity" and "the science of composition" and especially about the art of Raphael that it took me some time to realize that all he really meant was a kind of routine. Anyhow, I went on drawing systematically and, a year later, when I at last enrolled in the official Warsaw art school, I already knew at least what to avoid, including the advice of old men with white beards. I had also learned to differentiate

between brilliant and provocative theory and the humble crumbs of real knowledge that can be gained only through hard work and experience. But these years of schooling as an artist were a hard struggle. I had to earn my living meanwhile as a designer of posters, of book jackets, or as the paid assistant of more successful commercial artists.

E.R.: When did you first exhibit any of your work?

HERMAN: I had my first one-man show in Warsaw in 1932, in the small shop of a framemaker who was also a bit of an art dealer on the side. There were only two art dealers, at the time, who had galleries in Warsaw. One of these expected painters to pay for their exhibitions and was very expensive; the other was willing to risk his own money on the artist. Of course, I chose the frame-maker who took risks.

E.R.: What kind of paintings did you exhibit in this first one-man show?

HERMAN: Most of them were large-sized watercolors, painted in somber blues and browns, with rare flashes of red. My subjects were mainly derived from the life of Polish peasants, and my style was a vague kind of expressionism. This style was indeed my only claim to originality, as most of the younger Polish painters were still under the spell of Bonnard's postimpressionist palette, and of his bourgeois interiors. But I was already beginning to feel the urgency of what the great Norwegian painter Edvard Munch had written in his diary, when he first began to revolt against the style of the later French impressionists: "No more painting of interiors with men reading and women knitting! They must be living people who breathe, feel, suffer and love. I will paint a series of such pictures, in which people will have to recognize the holy element and bare their heads before it, as though in church." I remember repeating this exhortation again and again to my Warsaw colleagues.

E.R.: It is interesting that you should have instinctively chosen, as basic principle for your art, an idea that had been formulated by Munch. Several of the younger German painters who were later destined to become leaders of the expressionist movement had already begun, around 1900, to prefer the work of Munch, together with that of van Gogh, Gauguin and Lautrec, to the more established and typically

French and bourgeois styles of the older impressionists, such as Manet, the earlier Monet, Pissarro and Sisley. These German painters, especially Emil Nolde, were anxious to express a more specifically Germanic or Nordic personality in their work, and a more deeply rooted revolt against the values of an urban middle-class culture. It seems to me that you have also felt, from the very start, a need to emancipate yourself from the metropolitan and bourgeois tastes of Paris, and to formulate a style that would be more consistent with the climate and the society in which you lived, whether in Poland, in Belgium or in England. I mean that you have always been much closer to the expressionist painters of Central and Northern Europe than to the impressionist and post-impressionist painters of Paris.

HERMAN: This is all so very true that, in 1936, I established in Warsaw, with an older Polish painter, Zygmunt Bobovsky, a group of artists, called The Phrygian Cap, which deliberately set out to portray, in a style that was more expressionistic than post-impressionist, scenes of the everyday life of working people rather than of the middle class. The more active members of our group spent all their summers in the Carpathian mountains, among the peasants whom we portrayed in monumental and poster-like forms, but in somber colors. Three years later, however, I left Poland to study in Belgium. Not only was I attracted to that country by the realism of some of its great painters, especially Breughel, but I also felt oppressed in Poland, under its Fascist regime, both as a Liberal and as a Jew.

E.R.: Did you find it difficult to establish yourself as an artist in Belgium?

HERMAN: Not at all. I settled in Brussels and soon became acquainted with the work of the Flemish expressionists. I was particularly impressed by the paintings of Constant Permeke and Fritz Vandenberghe, though my closer contacts were mainly with a lesser-known member of this group, with Fernand Shirren. The year of my arrival in Belgium, I was already able to exhibit there a selection of my more serious or ambitious efforts. Though I met with some response and anticipated staying happily in Belgium, I was forced to flee to France in 1940, when the Germans invaded Belgium, and from France I then escaped, in June, to Britain.

Later, freed from the Polish Army, I settled down for about two and a half years in Glasgow, where I exhibited, for the first time in Britain, in 1942, which was also the year of my marriage. A year later, I exhibited in London and settled there with my Scottish wife.

E.R.: In these first exhibitions, in Scotland and in London, did you already show paintings that depicted mainly characters and scenes drawn from the British working class?

HERMAN: No. Most of my pictures of that period were fantasies based on childhood memories, and they were painted generally in rather dreamy harmonies of blue. I was obsessed for a long while, during my first years in England, with images of the Polish-Jewish world which was then being so ruthlessly destroyed by the Nazis. I knew that it was a doomed world, one that would never survive the disaster that had overtaken it, and I was drawn to depict all that I could remember of it, as faithfully as a chronicler, though always in colors and scenes that also expressed my own nostalgia for a vanishing past and my deep sense of sympathy for the millions of Jews who had remained in Eastern Europe and who were then being systematically starved, humiliated and exterminated. Many critics, of course, came at once to the conclusion that I was something of a lesser Chagall. Perhaps I may be allowed now to pay my humble tribute to an artist who, almost single-handed, discovered our folklore, the lore of the Yiddish-speaking Jew. I said "almost," for I believe that it was largely an effort of a generation and that each artist came with his own, perhaps smaller but nevertheless quite genuine, contribution. Folk singers care very little whether they are absolutely or only slightly original.

E.R.: Your compositions such as *My Family and I* seem to me to be far more elegiac or tragic than Chagall's joyfully lyrical memories of Vitebsk. I would rather be tempted to compare your works on Jewish themes to those that Lasar Segall painted when he revisited Vilna in 1916, during the German occupation of his native city in the First World War, or else to Issachar Ryback's lithographed memories of his native Elisavetgrad, which he designed after the pogrom in which a band of Cossacks had murdered his father, or to certain paintings on Jewish themes of Yankel Adler. . . .

58

HERMAN: You are probably right. Adler was my closest friend and he influenced me at one time, in 1936, after we first met. But not in the way in which the word "influenced" is usually understood. I never had much sympathy with Adler's artistic self-consciousness, his preoccupation with style, his willfully modern trend of mind. How often he used this phrase: "We must be of our time." We took long walks along the banks of the Vistula, this wonderful river flowing through golden sands and silver birches. During these walks, talk would carry us sometimes into the rose hours of the morning. Adler's voice was pleasant to listen to. Unlike my young self, he never hurried his thoughts; they seemed to follow the accompaniment of the river. And just at a time when I needed it most, he made me realize that studying is not a one-time business and done with, and that a true painter proves himself by his capacity for assimilating new ideas. Talking of ideas, he would explain that they do not mean at all the same thing to a painter as to a metaphysician. To a painter "idea" means an image in its totality and not a thought squeezed into an image. "Thus painting" — I would add as though continuing his line of thought — "involves a continuous process of visualizing."

"Yes," Adler would say, "but not only. . . . The picture I saw this morning on your easel, think of it, the color is good, but is this really all that one can get out of the material?" And I would be worried. You must admit that all this was very stimulating for a beginner. When we met again in Glasgow, it was a different story and my turning to Jewish themes had nothing, as far as I can see, to do with my personal contact with Adler. It came to me as a shock, when I found myself doing the first set of drawings of a subject I had never touched before or, I should add, since. It may perhaps have been, as a psychoanalyst friend at the time suggested, that I felt lost in this new environment and was looking for an imaginary home. Perhaps. The nostalgia for my background, a background from which I had at an earlier stage run away, was driving me almost mad. The nights were anxious, with the air-raid terrors of an up-to-date reality. But in daytime and at the easel, I dreamed pleasantly. The pictures came as a torrent. In any case, thinking of them in terms of artistic development, you may be right, they were perhaps an effort to link up with a national tendency rather than with a single artist.

E.R.: Still, you might easily, as many other Jewish painters, have whiled away most of your life as an artist in such dreams and memories of your childhood in Eastern Europe. What made you suddenly shift to an entirely different kind of subject?

HERMAN: Well, whenever I stopped dreaming, I also stopped painting dreams. Besides, the realities of the war years were not exactly conducive to dreaming, and a crisis then occurred in my work, as I longed for something more constructive, less dependent on individual moods, on memories of a vanished past. It was not an easy time to solve so purely personal a crisis. The more the earth was shaken by the convulsions of warfare, the more a voice seemed to cry out within me for a new belief in human dignity. For me, art and morality have never seemed very far apart. Then, in 1944, chance led me to this mining village of Ystradgynlais, in South Wales. The serene simplicity of its life, the constructive grandeur of the landscape, above all the monumental dignity of its men and women, all these at once set my imagination to work. For almost three years, I worked there for my next exhibition, which took place in 1946, in the London gallery that still handles all my work.

E.R.: I have been particularly interested in reading again the reactions of the Marxist critics to your exhibitions of recent years. The Communist *Daily Worker*, in one mood, wrote that it was "great proletarian art"; but, in another mood, their art critic was more aggressive and admitted that he had "many grumbles with Mr. Herman," who failed "to see here the tremendous individuality of the miners, their wit, homeliness and courage." As a Communist this critic was "bothered" by your "feeling of depression," which, he felt, is "foreign to the majority of Welsh miners and to the spirit of the valleys." Well, you said a few minutes ago that art and morality are always closely associated in your mind, and in the words of this particular Communist critic we see morality, or certain aspects of life, trying to override art completely. The Marxist critic John Berger, in *The New Statesman and Nation*, was a bit more intelligently explicit when he objected to what he calls, in your work, "a repetitive passivity, a certain

sense of hopeless endurance." As I read Berger's article, I felt that he allows no scope for the virtue of fortitude in his aesthetics of Socialist realism. His main objection, however, seems to have been, to quote him, that you paint miners "as if they were peasants instead of one of the most lively and militant sections of the proletariat. . . . For him, as for Millet, the symbol of the strength of labor is the peasant. . . . But miners need leaders, not consolation." It seems to me that we have here, in these few remarks of John Berger, a basis for a very lively discussion of your views on Marxist Socialist realism.

HERMAN: Of course, I have always been interested in depicting men at work, and that is why, when I was still a beginner in Poland, I joined Zygmunt Bobovsky's Phrygian Cap school of art and spent my summers, with the other painters of this group, among the peasants of the Carpathian mountains. Later, when I was in Belgium, I likewise spent some time painting in the Borinage mining country, where van Gogh and the Socialist sculptor Constantin Meunier had already worked. All this was part of my revolt against the sheltered *intimisme* of the leisured classes which was derived from Bonnard and Vuillard and seemed to dominate most of Polish painting between the two wars. But I had also been brought up in an urban Jewish working-class home, in an atmosphere of constant discussion of Socialism, Anarchism, Communism and Zionism, so that my approach to my subject matter — I mean that of men at work — is quite naturally tinged to some extent by my original background, that of a nation which was not yet fully industrialized, where peasants and artisans still represented the majority of the workers.

The French painter Millet once wrote: "I want the people I represent to look as if they belonged to their station and as if their imaginations could not conceive of their ever being anything else." Well, what Millet then wrote in a letter to a friend expresses perfectly what I feel about my own work, and I have probably chosen to paint miners, rather than factory workers, because miners, like peasants, have this deep attachment to their work and its surroundings — although at first sight, like many other types of worker, the miner seems to me to be more impressive and singular, like a walking monument of labor. Unlike many factory workers, he rarely thinks of changing his job or his surroundings — I mean of moving to another part of the country where he might find easier and more remunerative work. That is why a crisis in the coal industry is always such a tragedy; if a pit closes down, a migration of its miners and their families, and their resettlement in another part of the country and in other jobs, even under the best conditions, poses almost insoluble problems. In our generation, the miners of South Wales, except in brief periods of prosperity, have lived under the constant threat of such migration and resettlement projects, but this is not to explain the "gloomy" aspects of my work to which some Marxist critics have taken exception. I do not think my pictures gloomy, but I do think that sadness plays an inherent part in serious feeling, and I feel only revulsion in front of Stalin-Prize-winning pictures depicting smirking miners in spotless and hygienic mines, in what might well be called an optimistic style of petty-bourgeois academism that tries to flatter the workers. Nor am I particularly impressed with the bright colors and École de Paris formalizations with which some Italian Socialist realists try to cheer themselves up. Neither of these two styles of Communist art is any way progressive or deserving of serious consideration, whether in its artistic or its political aspirations. It may be true that miners need leaders rather than consolation, but no serious painter is out to supply either.

Human labor is not a trifling matter. We are conditioned to labor. We have no choice. This is the tragic aspect of it. And to express this aspect, this inevitability of a fate that leaves us no choice, it does not matter whether one uses as a symbol a peasant or a worker, an archaic ox or a modern tractor. However, I do not like to engage in a dispute with the priests of Socialist realism. My main objection is to the gospel itself. By invoking Courbet but following Meissonier, by employing words such as "decadence" and "imperialist style" as insults rather than as terms embodying critical precision, Socialist realism has put itself outside the broader humanist trend which obtained a new meaning in the arts since the nineteenth century and which is as much present in Courbet as in Cézanne, in Millet as in Rouault. In any case, some miners have better instincts than doctrinaires would grant them.

E.R.: And how do your neighbors in South Wales react to these paintings?

HERMAN: You have probably read that I set up my studio in Ystradgynlais, to begin with, in a room of an old local pub which I have converted. My neighbors soon acquired a habit of dropping in there to see me and to chat with me, and many of them enjoy posing for me in their spare time as models. Most of them seem to understand, far more readily than "arty" people, what I have set out to achieve. Looking at a portrait of a miner called Mike, one of them thus said: "You want to paint not only the portrait of one Mike, but of all the Mikes." And that is exactly what I want to do. I want my studies of miners to be more real than portraits. I am not trying to convey, as in some of Wystan Auden's early poems, the abstraction of derelict pits and the wasted face of an industrialized landscape, but a synthesis of the pride of human labor and of the fortitude, the calm force, that promise to guard its dignity. All this I have felt and have tried to convey in my work. I like the miners and I like living among them. In their warm humanity and their expressive occupational poses, the way they squat, the way they walk and hold themselves, I find the embodiment of labor as a human rather than a merely industrial force—in fact, the basic humanity that I have always sought and tried to express. The miner has thus become, for me, both incidental and symbolic. Incidental, in that I am not interested in him merely as a representative of a particular industry; symbolic, in that I see, in his monumental appearance, the very drama as well as the dignity of human labor.

I believe that I now face, in my work, no other formal problems than those implied in achieving an adequate plastic expression of this idea. Technical problems, of course, are an entirely different matter, and I don't enjoy discussing the recipes of this kind of "cuisine" of art. I just sort them out, these technical problems, as they come along.

E.R.: Would you include color among technical problems?

HERMAN: Yes, to a certain extent, except insofar as color also conveys atmosphere and mood, the quality of the world depicted and the reactions of the artist to this world. For this, however, the pre-Renaissance way of coloring rather than the naturalistic way of painting suits my purpose. Also I am an ardent admirer of the icon painters. By this I do not mean to suggest that I am interested in their decorative achievements, as the Fauves were, but in their use of color to give fuller meaning to the expressiveness of the form. Of all contemporary painters, Rouault and perhaps Permeke seem to me to have something of this austerity and grandeur, though they, too, are sometimes disturbed by the histrionic ambition to paint rather than to color. Actually I rely a great deal on drawing. I would like to add that I have no hard and fast theory of differentiation between a black-and-white drawing and a painting. The idea matters above all. Color thus remains, for me, a means of making my message more intense. But I view the whole art of making pictures as a moral responsibility, a kind of rhetoric rather than an aesthetics. It should be true to experience and to the will to communicate this experience rather than to detailed observation, description and taste. To be truly relevant, art must provoke thought and stimulate feeling rather than delight the senses. I think that today an independent artist, free of the aesthetic self-consciousness of the abstract movement and the bureaucratic narrowness of the Socialist realists, finds himself inevitably a middle-of-the-road man. I do not mind my work, in the context of our contemporary scene, being viewed as such.

Later, as I went through my notes and drafted a first version of my discussion with Josef Herman, I was reminded, by much that he had said, of the social philosophy of several of the greatest Jewish painters of the past hundred years—I mean of the letters of Camille Pissarro to his son and the opinions expressed by Josef Israels, whose paintings of men at work, little though they may now be appreciated by the snobs of the art world, once influenced van Gogh so profoundly. John Berger, in discussing Herman's work, had detected in his early ink drawings the influence of Rembrandt but failed to understand that memories of Rembrandt had haunted a whole school of Jewish artists of the past hundred years, ever since Israels first reverted to Rembrandt's chiaroscuro technique and to his habit of painting portraits of his neighbors in the old Jewish quarter of Amsterdam. After Israels, Jewish painters throughout Eastern Europe became interested both in Rembrandt's technique and in his

inherent humanism. Israels, Millet, Courbet and Pissarro remain indeed powerful influences among those rare artists, in our age, who are interested in moral rather than aesthetic problems. They were among the very first painters, in the nineteenth century, to approach the theme of men at work in a spirit of populist humanism, if not yet Socialism, and to purge this whole range of subject matter of the sentimentalism of all those petits maîtres who, since the age of Diderot, Greuze, Morland and Sir David Wilkie, had degraded it to a happy hunting ground for painters of mere genre scenes.

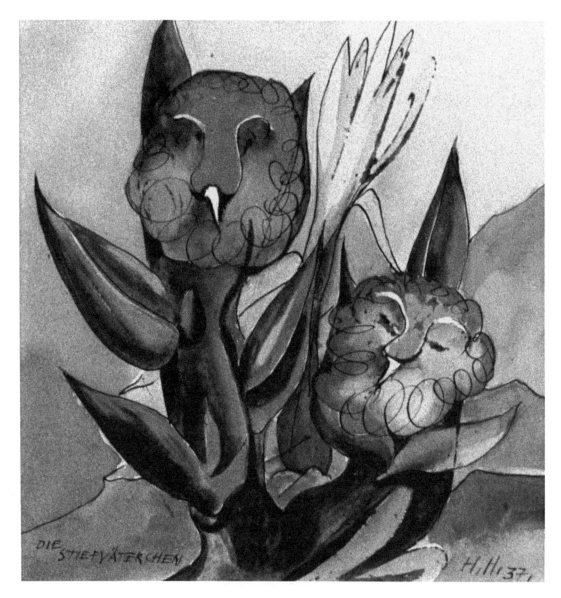

HANNAH HÖCH, *Die Stiefväterchen*, 1932

Hannah Höch

I had ventured into West Berlin's northern suburbs beyond Reinickendorf at most a dozen times when I decided, in June 1959, to interview the painter Hannah Höch, once a leader among the Berlin Dadaists, in her Heiligensee retreat. Our meeting thus occurred a few days later in July, and it took me over an hour to reach her house by bus from the Bahnhof Zoo to Schülzendorf, changing lines at Wittenau, then on foot through a maze of deserted streets lined on both sides by comfortable but modest villas, each one of them set in its own private garden.

Beyond the beautifully restored façade of Schloss Charlottenburg, the Ultima Thule of Berlin's more familiar landmarks on a hyperborean expedition undertaken in a heat wave, I was fascinated by the great variety of vistas gradually discovered from this bus in which the temperature, as I learned the next day in my morning paper, had reached, in the early afternoon when I was on my way out to Heiligensee, the unprecedented record of forty-five degrees Centigrade. These vistas ranged at first from an exquisite view of the rear of Schloss Charlottenburg, discovered beyond its park that spread to the opposite bank of the picturesque canal that the Tegeler Weg follows, to the impressive new Siemens factories, surrounded by their modern workers' settlements, and the huge military compound, formerly the Hermann Göring barracks of the Luftwaffe, but now the headquarters for the residual military government of the French sector of West Berlin and its diminutive garrison, a few listless specimens of which could be seen loitering around neighboring bus stops and beer gardens. They looked indeed for all the world like a cut-price version of the American G.I.s that haunt the slightly less bleak southern suburb of Lichterfelde. Farther north, I then discovered some remnants of traditional Brandenburg village architecture in Alt-Wittenau, Alt-Tegel and Schülzendorf, where a few old-fashioned, one-storied houses, like those of farms, are still grouped around an almost English green that spreads, beneath its venerable lime trees, around a diminutive old stone church. Beyond Tegel, in the heart of a forest such as one would never find within the city limits of any metropolis but Berlin, I was barely able to discern from the road a few details of the castle and park that are still the home of the descendants of Alexander von Humboldt, who once commissioned the great architect Schinkel to remodel the otherwise severe façade of what has now become one of West Berlin's half-dozen historical monuments.

When I at last reached the section of Heiligensee where she lived, I found that Hannah Höch's modest bungalow was almost entirely concealed from the street by the summer profusion of the garden's fruit trees and flowers. On this very hot day in early July, the whole neighborhood, between three and four in the afternoon, seemed to be as fast asleep as in a fairy tale. Hannah Höch, a lively, slender and gray-haired woman in her late sixties, ran down the garden path to open the gate as soon as I rang. She seemed to have concentrated in her slight figure all the energy of this whole drowsy Heiligensee and Schülzendorf area. I was over half an hour late, having miscalculated the time that I would require to come here by bus from the Bahnhof Zoo. A huge bowl of strawberries freshly gathered from the garden awaited me on a table in the cool veranda. Unlike most artists of her historical importance in Paris or New York, Hannah Höch seemed to me to be quite unaffected, almost surprised to be worthy of a foreign writer's curiosity. As we sat down for refreshment without any further ado, she remarked that she had feared, for the last half hour, that I might have lost my way in this little-known neighborhood.

HÖCH: Even Berliners, unless they actually live here, scarcely seem to know our whole northwestern area.

E.R.: Very few of my Berlin friends had any idea how to get here, when I asked them for advice. I was even warned by some that it would be unwise to try to visit you in Heiligensee; they insisted that it is already beyond the limits of West Berlin, in the Eastern Zone.

HÖCH: What nonsense! It's actually because

"We . . . shocked people by affecting not to take our own movement seriously. Theo van Doesburg . . . called his dog Dada, and some people argued that an art movement which calls itself by the same name as the dog of one of its leaders can scarcely be intended to deserve serious attention."

this part of Berlin is so quiet and so little known that I moved to Heiligensee in 1938, just before the war. Under the Nazi dictatorship, I was much too conspicuous and well-known to be safe in Friedenau, where I had lived for many years. I knew that I was constantly being watched and denounced there by zealous or spiteful neighbors, so I decided, when I inherited enough money to buy a little house of my own, to look around for a place in a part of Berlin where nobody would know me by sight or be at all aware of my lurid past as a Dadaist or, as we were then called, a Cultural Bolshevist. I was fortunate enough to find this little house, which had been a guard's house at one of the entrances to an air field built in this neighborhood in the First World War. I bought it at once and moved all my possessions here, and that's also how I managed to save them. If I had stayed in Friedenau, my life's work would have been destroyed in an air raid.

E.R.: But didn't you feel very isolated out here?

HÖCH: In those years, I would have felt lonely anywhere in Berlin. Those of us who were still remembered as having once been Cultural Bolshevists were all blacklisted and watched by the Gestapo. Each one of us avoided associating even with his oldest and dearest friends and colleagues, for fear of involving them in further trouble. Most of the former Berlin Dadaists had in any case emigrated by 1938. Hans Richter and George Grosz were in America, Kurt Schwitters had emigrated to Norway, Raoul Hausmann was in France. Of the really active members of the old Berlin Dada group, I was the only one still here.

E.R.: How and when did the Berlin Dada group first begin to be active?

HÖCH: We held our first exhibition in 1919, but we had already been working together as a group for a couple of years before actually adopting the same name and program as the Zurich Dadaists.

E.R.: Was it really the same program? It has always seemed to me that the Berlin Dadaists, as a group, were far less aesthetically and much more socially subversive than the Zurich Dadaists. This is perhaps because of your closer contact with Moscow artists like Lissitzky during the years of the Russian Revolution, perhaps also because of the more disturbed or revolutionary atmosphere in Germany, perhaps too because of the more political nature of the satirical genius of such Berlin Dadaists as George Grosz.

HÖCH: You are probably right. The situation here, in 1917, was not at all like that in Zurich, a neutral city, whereas Berlin was then the capital of an empire that was tottering as it faced defeat. I myself had come to Berlin before 1914 from a very bourgeois family background in Thuringia. At first I studied art under Orlik, who was to some extent a disciple of the French impressionists. When the war broke out, all art schools were closed for a while and I returned to live with my family. But I came back to Berlin in 1915, and it was then that I first met Raoul Hausmann. We were both in those days enthusiastic admirers of Herwarth Walden's Der Sturm Gallery. But Hausmann remained until 1916 a figurative expressionist, a close friend and disciple of Haeckel and at the same time an admirer of Robert Delaunay and Franz Marc, whereas I had already begun in 1915 to design and paint abstract compositions in the same general tradition as those Kandinsky had first exhibited a couple of years earlier in Munich.

E.R.: Were there any other abstract artists of significance in Berlin as early as 1915?

HÖCH: On the whole, most of the Berlin avant-garde was still figurative, either expressionist or Fauvist. Painters like Ludwig Meidner, for instance, were still working in the same tradition as Haeckel and other artists of the Dresden *Brücke* group or as Kokoschka, whereas other Berlin painters, like Rudolf Levy, were more in tune with the Paris

Fauvists. Among our own friends, the only abstract painter of any prominence was Otto Freundlich, who had returned to Berlin from Paris in 1914. But Freundlich, who had been living at one time in Montmartre with Picasso and some of the Paris cubists, was still painting mainly figurative compositions. It was only after his return to Paris in 1924 that his work gradually became exclusively abstract.

E.R.: Was Freundlich ever associated with the Berlin Dada movement?

HÖCH: Otto sympathized with us from the very start, because he shared our pacifist views, those of the *Monistenbund*, and also our determination to reject all the moral and aesthetic standards of the existing social order, which then seemed to us to be doomed. But he was much too serious and earnest to participate in any of our youthfully scandalous manifestations. We were a very naughty group, all of us still very wild, whereas Freundlich belonged already to a more established community of nonconformist writers and artists, all regular contributors to Franz Pfemfert's *Die Aktion*.

E.R.: If I remember right, the contributors to *Die Aktion* included Gottfried Benn and Johannes R. Becher, Freundlich and Meidner, Yvan Goll and Hermann Kazack — in fact, all sorts of writers and artists who, in the light of their later political or intellectual evolution, would now make very strange bedfellows. . .

HÖCH: The same might now be said of our own group of Berlin Dadaists. When we held our first exhibition in 1919, the *Erste Internationale Dadamesse* in Dr. Otto Burckhard's gallery at Lutzowufer 13, the catalogue included the names of George Grosz, Dadasoph Raoul Hausmann and Monteurdada John Hartfield. But John Hartfield and his brother, the writer Wieland Herzfelde, later founded the *Malik Verlag*, which remained for many years the leading German communist literary publishing house, and they are now both living in Eastern Germany and are still active in all sorts of communist organizations, whereas George Grosz, Walter Mehring and most of the other Berlin Dadaists of 1919 soon ceased to associate at all with communists or to be in any way politically active.

E.R.: Nevertheless, the Berlin Dadaists were originally quite closely associated with some communist intellectual and artistic groups.

HÖCH: You sound like a Grand Inquisitor!

E.R.: God forbid that I should! I myself would be the first to admit that, until the Spanish Civil War, I associated as freely with communist intellectuals and artists as with Theosophists, anthroposophists, pacifists or vegetarians.

HÖCH: So did we, between 1915 and 1925. We were very young and politically inexperienced, and communism itself, in those days, appeared to be much more liberal and freedom-loving than it does today. During the First World War, we were all pacifists and thus found ourselves in close sympathy with other pacifists, some of whom happened to be communists. Besides, we were still quite naively enthusiastic about anything that appeared to be opposed to the established order, and some of us even pretended to maintain close personal contacts with the enemy. To assume an English or American pseudonym, as Hans Herzfelde did when he called himself John Hartfield, was already an act of provocation in the eyes of German Nationalists. George Grosz also claimed to be American in some mysterious way and spelled his name George instead of Georg, affecting at the same time an American manner and style of dress. As soon as the War was over, we were among the first German artists and writers to establish contacts with similar avant-garde groups in New York, Paris and Moscow. In 1922, the German Dadaists even held an international conference in Weimar, attended by Theo van Doesburg and El Lissitzky, representing Mondrian's *De Stijl* group from Amsterdam and the Moscow Constructivists, and Tzara and Hans Arp, representing the Zurich and Paris Dadaists.

E.R.: Today, to have once been a close associate of Lissitzky is more compromising in Soviet Russia under the dictatorship of the Socialist realists than it would be in New York, or Paris or here, where all sorts of highly respected painters and sculptors like Chagall, Pevsner and Gabo are known to have been at one time close friends or associates of Lissitzky and of other ill-starred Russian avant-garde artists of thirty years ago. The Suprematists and Constructivists were indeed blacklisted or deported to Siberia, under the Stalinist regime, long before the Dadaists were threatened here.

HÖCH: Very few people can understand today

how innocent and truly unpolitical our connection with the communists had once been. In 1917, we were living in a social order that approved the declaration of a disastrous war which even the Socialist Party had failed to condemn. In the next few years, it began to look as if this whole order were about to collapse under the impact of military defeat and of the rising discontent of the masses on the home front. There were mutinies in the armed force, then revolts of the workers here in Berlin and elsewhere in Germany. As young people who had never believed in the justice of the German cause in the war, we were still idealistic enough to found our hopes only on those doctrines that seemed to be entirely new, to be in no way responsible for the predicament in which we found ourselves, and to promise us with some sincerity a better future, and a more equitable distribution of wealth, leisure and power. For a while, we thus believed in the slogans of the communists. You can see some of our own slogans and those of the communists here on the walls, in this photograph of our first Berlin Dada exhibition.

E.R.: And now, for the past thirty years or more, you have been saddled with such compromising evidence of your political past as these photographs.

HÖCH: Yes, these are the sins of our youth that we are never allowed to forget. But you must admit that our slogans were effectively shocking. Of course, today they would no longer seem so very novel, and I'm afraid that nobody would now take them as seriously as the respectable Berlin bourgeoisie of 1919 did.

E.R.: This slogan might still get you into trouble today.

DADA
steht auf
Seiten des revolutionären
Proletariats

DADA
stands on
the side of the revolutionary
proletariat

But most of those that I can distinguish on the walls of the gallery, in these few photographs, seem pretty harmless today:

Sperren Sie endlich
Ihren Kopf auf
Machen Sie ihn frei
für die
Forderungen der Zeit

Nieder die Kunst
Nieder die
Bürgerliche Geistigkeit

Die Kunst ist tot
Es lebe die neue
Machinenkunst
Tatlins

Open at last
your head
and make it free
for the
demands of the age

Down with art
and down with
bourgeois intellectualism

Art is dead
Long live the new
machine-art
of Tatlin

Or else:

DADA
ist die
Willentliche Zersetzung
der
Bürgerliche Begriffswelt

DADA
is the
voluntary destruction
of the
bourgeois world of ideas

HÖCH: Those few slogans were indeed evidence enough, in the Nazi era, to have us all tried and condemned as communists. I sometimes wonder today how I was courageous or foolish enough to keep so preciously all this incriminating material in my own home during those dreadful years. There was enough concealed in that cabinet, where I keep all my drawings, to condemn me and all the former Dadaists who were still in Germany. That is why most of them began, after 1934, to cover

68

up their tracks and to destroy all such souvenirs of their youthful follies. But I could never believe that the Third Reich would last, as it claimed, a thousand years, nor could I ever bring myself to destroy all these works of my friends — Hausmann and Schwitters — and all my precious souvenirs of the days when we worked together so enthusiastically as a group.

E.R.: It's very fortunate that you should never have destroyed or lost in an air raid this unique collection of documents and relics of the heyday of the Berlin Dada movement. But it would interest me to know, since you alone seem to possess enough of this material to be able to look back on the whole movement objectively, what you would now describe as the Berlin Dada movement's most original and lasting contribution to modern art.

HÖCH: I believe we were the first group of artists to discover and develop systematically the possibilities of photomontage.

E.R.: How did you first discover this technique?

HÖCH: Actually, we borrowed the idea from a trick of the official photographers of the Prussian army regiments. They used to have elaborate oleolithographed mounts, representing a group of uniformed men with a barracks or a landscape in the background, but with the faces cut out; in these mounts, the photographers then inserted photographic portraits of the faces of their customers, generally coloring them later by hand. But the aesthetic purpose, if any, of this very primitive kind of photomontage was to idealize reality, whereas the Dada photomonteur set out to give to something entirely unreal all the appearances of something real that had actually been photographed.

E.R.: Of course, the camera is a far more objective and trustworthy witness than a human being. We know that Breughel or Goya or James Ensor can have visions or hallucinations, but it is generally admitted that a camera can photograph only what is actually there, standing in the real world before its lens. One might therefore say that the Dada photomonteur set out to falsify deliberately the testimony of the camera by creating hallucinations which seemed to be machine-made.

HÖCH: Yes, our whole purpose was to integrate objects from the world of machines and industry in the world of art. Our typographical

collages or montages also set out to achieve similar effects by imposing, on something which could only be produced by hand, the appearances of something that had been entirely composed by a machine; in an imaginative composition, we used to bring together elements borrowed from printed books, newspapers, posters or leaflets, in an arrangement that no machine could yet compose.

E.R.: The collages of the Berlin Dadaists would therefore seem to be conceived according to principles which are not at all the same as those of the collages of the earlier Paris cubists, where a piece of newspaper in a painted still life represents a newspaper, or has been inserted for its texture, like any other artist's material, rather than to create an illusion of the same kind of those of a Dada montage. At the same time, these montages of the early Berlin Dadaists seem to be quite different, in their principles, from the *Merz* compositions of Schwitters, who salvaged the elements of his compositions from the dust bin, the wastepaper basket and the junkyard, creating objects of artistic value out of materials that were considered quite valueless — in fact, "a thing of beauty and a joy forever" out of elements that would scarcely be expected ever to suggest beauty or joy. The montages of the Berlin Dadaists represent an extension, in the realm of art, of the mechanical processes of modern photography and typography.

HÖCH: That is why they continue to be a source of inspiration to so many photographers, typographical artists and advertising artists. Even today, I sometimes find myself staring at a poster in a Berlin street and wondering whether the artist who designed it is really aware of being a direct disciple of Dadasoph Hausmann, or Monteurdada Hartfield or of Oberdada Baader.

E.R.: Who were, in your opinion, the most imaginative or creative among the artists of the Berlin Dada movement?

HÖCH: At first our group consisted only of Hausmann and myself, Johannes Baader, Hartfield, Grosz, Deetjen, Godyscheff and a few writers, such as Wieland Herzfelde and Walter Mehring. I'm leaving aside those who — like Schmalhausen, who was the brother-in-law of George Grosz — were only intermittently active as artists or writers in our group. I would say that the most active and productive artists

in our group were Grosz, Baader, Hartfield, Hausmann and myself. Godyscheff was very gifted, but he soon dropped out of our group and I have no longer seen any of his work or heard from him for many years.

E.R.: Would you be able to define the individual style that distinguished the Dada productions of each one of these artists?

HÖCH: Grosz was of course more of a moralist and a satirist than any of the others, a caricaturist of great genius even in such an early Dada collage as his *Dadaisten besteigen einen Pudding*, where the heads which he had added to his comical figures were actual photographs of his fellow Dadaists.

E.R.: But wouldn't you agree that Hartfield was also a satirist?

HÖCH: Certainly, though he was always more doctrinaire in his political intentions, a communist who tended to be didactic and orthodox rather than truly free in his fantasies and humor. But Hausmann remains in my eyes the artist who, among the early Berlin Dadaists, was gifted with the greatest fantasy and inventiveness. Poor Raoul was always a restless spirit. He needed constant encouragement in order to carry out his ideas and achieve anything at all lasting. If I hadn't devoted much of my time to looking after him and encouraging him, I might have achieved more myself. Ever since we parted, Hausmann has found it difficult to create or to impose himself as an artist, though he still continued for many years to provide his friends and associates with an inexhaustible source of ideas. As for Baader, he was our Oberdada, the very incarnation of the spirit of the Berlin Dadaists of 1919 and 1920. He had thrown himself quite recklessly into our movement, without any consideration of the consequences of his commitment, much as I, too, had thrown myself into my seven years of friendship with Raoul Hausmann. Later, Baader became a kind of anachronism, a survivor of a period and a movement that no longer had any reality except in a context of history. He was never able to mature or to develop as an artist, whereas I, after parting from Raoul, was still able to experiment in other styles and other kinds of subject matter.

E.R.: Have any of the other Dadaists achieved any importance as artists?

HÖCH: Godyscheff, as I said before, was very gifted but seems to have completely vanished. Deetjen also continued for many years to work as an artist, but she somehow failed ever to achieve a very distinctive style or a lasting reputation. As for Schmalhausen, I can now remember only one of his Dada works, a plaster death mask of Beethoven to which he had added a moustache and a crown of laurel leaves. But Dada was a lot of fun, and several of our friends who had no real ambitions as artists participated in our exhibitions with objects and ideas that had been suggested to them by our activities or by the spirit of the times.

E.R.: Did any important artists join the Berlin Dada movement after 1920?

HÖCH: Certainly, such major Dadaists as Kurt Schwitters and Moholy-Nagy, who both came to Berlin after our first two Dada exhibitions, and of course Hans Arp, who was often with us in Berlin after the war, and Hans Richter, who was mainly active with Viking Eggeling in making experimental Dada films, and some Russians, such as El Lissitzky, who then returned to Soviet Russia, and Pougny and his wife, who both settled later in Paris. But our Dada movement also began, after 1922, to develop along lines similar to those of the Paris surrealists. Around 1925, our Berlin Dadaism then ceased to be of much significance as a movement. Each one of us began to develop independently as an artist, or joined other movements, as Moholy-Nagy did when he became associated with the Weimar Bauhaus. Only Schwitters and I continued, for a while, to pursue more or less the same objectives. Besides, we were closely associated, after 1920 with Theo van Doesburg and some of the Dutch abstract artists of *De Stijl*. I even lived several years in Holland, shortly after the war, and was a close friend of Mondrian and most of his associates, though I never shared their philosophy of art. To me, it seemed to be rather pedantic and to have narrowed the scope of painting to such an extent that it had become almost impossible to avoid repetition.

E.R.: Would you care to define briefly your own evolution as an artist?

HÖCH: It is sometimes rather difficult for me to distinguish my style as an individual artist from my enthusiasms and my friendships. As I said earlier, I began experimenting in abstract black-and-white compositions as early as 1915,

but I was still experimenting in this field, in a slightly different manner, as late as 1926. Here is one of my 1926 black-and-white designs, reproduced as an ornamental tailpiece to Ernest Hemingway's "A Banal Story" in an old issue of the American *Little Review.*

E.R.: It's much more abstract than strictly Dadaist.

HÖCH: Certainly, but every artist tends to revert, every once in a while, to an earlier style which has meanwhile been modified to some extent by later experiments and achievements.

E.R.: When would you say that you first began to experiment in a style that one might call specifically Dadaist?

HÖCH: I suppose that was in 1917, with Raoul Hausmann, when we both began to develop a Dada style of our own. It was already to some extent surrealist and also had something in common with a few of those puzzling paintings of Giorgio De Chirico.

E.R.: Do you mean those of his *pittura metafisica* period?

HÖCH: Yes. Hausmann and I were trying to suggest, with elements borrowed from the world of machines, a new and sometimes terrifying dream world, as in this 1920 watercolor of mine, *Mechanischer Garten,* where the railroad track follows an impossible and nightmarish zig-zag course. Here's a photograph of another watercolor of mine in this style, *Er und sein Milieu,* which I painted in 1919.

E.R.: It's a very haunting interpretation of an individual's relationship to a world that includes objects derived from real life as well as elements which seem to be projected out of a private world of hallucination. The perspectives, both here and in *Mechanischer Garten,* have the same agoraphobic effect as in some of the metaphysical landscapes of Chirico and Carrà, but the whole of *Er und sein Milieu* also has something mysterious in common with Chagall's *Mon Village et Moi* and with Ludwig Meidner's *Ich und die Stadt*—I mean a kind of haunting expressionist ability to view one's surroundings with a feeling of total alienation.

HÖCH: This feeling of alienation was very much in the air, here in Berlin, between 1917 and 1922. We were then living in a world that nobody with any sensitivity could accept or approve. But I have always been of an experimental turn of mind and I soon began, in 1922

and 1923, to try my hand at *Merzbilder* too — I mean at the same kind of collages as those of my friend Schwitters, who reproduced one of my works, for instance, in the seventh issue of *Merz.* After 1924, I then returned to a more traditional kind of painting, though my compositions of that period still used many of the tricks of photomontage. Here, for instance, in this *Bürgerliches Brautpaar* of 1927, everything is drawn and painted very realistically and smoothly, as if the whole painting were a montage of details borrowed from photographs and then arranged to produce very realistically something quite unreal. Later, in 1928, I returned to photomontage, which I have never really abandoned since 1917; but at this time I worked in a museum and photographed examples of primitive art which provided me with some of the elements, as in this one, of an entirely new series of photomontages, in a style that was entirely my own. Then I began, after 1930, to live in ever-increasing isolation. I had lost touch with the Berlin art world while I was living in Holland, and the atmosphere in Germany, on my return, was scarcely conducive to any very enterprising activity. Still, I continued to paint and to create photomontages on my own, without associating with any other artists and without exhibiting much. My style had become increasingly abstract, though I occasionally reverted, especially in photomontages but also in some oils, as in this one of 1949, to themes and forms of the same kind as those of my Dada period of 1920.

E.R.: Yes, I can recognize here the same crystals, with objects or figures imprisoned in them, as in *Er und sein Milieu.*

HÖCH: I suppose that every imaginative artist has some recurring obsessions.

E.R.: Perhaps you had been very much puzzled, as a child, by those glass paperweights that are shaped like balls or crystals and in which there is a little figure, or a model of the Eiffel Tower. But I would now like to hear you discuss some of your old friends and associates of the heyday of the modern art movement.

HÖCH: I thought I had already spoken of them.

E.R.: Yes, but I'm very inquisitive. I would like to know more, for instance, about George Grosz.

HÖCH: It's difficult for me to speak objectively

about him today, so soon after the shock of his death. Only this morning, after reading about it two days ago in the newspapers, I received in my mail this black-framed announcement from his family. I hadn't even seen Grosz since he finally returned from America, only a few weeks ago, to live in Berlin again. It seems to me now as if there had been something spooky about his return to the haunts of his youth, only to die there.

E.R.: That was my impression, too. He had been talking about returning to Berlin for the past five or six years, but kept on postponing his decision as if he were obscurely aware of having here a rendezvous with death. When he finally came to Berlin in June, intending never to return to live in America, he scarcely saw any of his old friends here or visited any of his old haunts. He seems to have spent the last weeks of his life like a sick animal that has returned to die in solitude and peace in familiar surroundings.

HÖCH: I'm glad I didn't see him again in this dreadful condition. He remains in my memory as he was in his most brilliant and productive years, an artist capable of feeling very deeply, but who preferred to conceal his sensitivity beneath the brittle and provocative appearance of a dandy. He sometimes even wore a monocle. . .

E.R.: Monocles seem to have been very fashionable among the Dadaists. I've seen photographs of Raoul Hausmann, Tzara, van Doesburg and even Arp wearing monocles and looking for all the world like young aesthetes of the generation of Oscar Wilde.

HÖCH: The very sight of a monocle in those days shocked the stuffed shirts who claimed to be progressive.

E.R.: It still infuriates most Americans.

HÖCH: People seemed to be particularly annoyed if a Dada dandy wearing a monocle appeared on a platform in a meeting of communist workers.

E.R.: The Berlin Dadaists were past masters in the art of annoying people.

HÖCH: It was part of our wanting to be entirely different.

E.R.: Did this attitude of alienation manifest itself in Grosz in any other ways?

HÖCH: Yes, in his insistence on some mysterious and probably imaginary American origins, and in his very carefully chosen clothes that always gave one the impression of his being American or English rather than German. But Hartfield and Hausmann were just as careful about how they dressed.

E.R.: I understand that Hausmann even designed and wore a new style of shirt.

HÖCH: We were all of us in favor of new styles and systems. Johannes Baader even invented his own Dada system of reckoning time and dates, and spoke of having a special watch constructed to keep time according to his own new system.

E.R.: It sounds as if Dada had been, in a way, a kind of parody of a typically turn-of-the-century German *Reformbewegung*. . .

HÖCH: Looking back on it now, I suppose it was. But we were trying to point out that things could also be done differently and that many of our conventional ways of thinking, dressing or reckoning are no less arbitrary than others which are generally accepted. At the same time, we also shocked people by affecting not to take our own movement seriously. Theo van Doesburg, for instance, called his dog Dada, and some people argued that an art movement which calls itself by the same name as the dog of one its leaders can scarcely be intended to deserve serious attention.

E.R.: Let's return to Grosz. I suppose he belonged, in 1919, to the more politically *engagé* left wing of the Berlin Dadaists, with Hartfield and Wieland Herzfelde.

HÖCH: Grosz was actually more *engagé* in the eyes of his critics and of the public than in his own work and opinions. He hated insincerity and injustice, especially the inhumanity of every kind of political or economic power or authority. His satiric representations of the established order of course served the purposes of the communists, for a while, but I don't remember his ever having been a doctrinaire believer in communism.

E.R.: Would you consider that Grosz was a painter of the same kind as Otto Dix, who was also at one time in sympathy with the German Communist Party?

HÖCH: No, there is always more fantasy, wit, humor or tenderness in the works of Grosz. He was never as grim as Dix. Besides, one only had to watch Grosz at work to understand the unbelievable spontaneity of his art. I have never seen an artist draw as fast as he could. The lines and

the very subject matter seemed to flow out of his pen, as if he never stopped to think at all.

E.R.: Dix is of course more ponderous, more premeditated. But did the Berlin Dadaists ever have much contact with Dix or with other groups of the Berlin avant-garde?

HÖCH: At first, very few such contacts. I think I have already said that Freundlich was one of our friends, and that Hausmann was a close friend of Haeckel. On the whole, very few of the German painters who are now famous were then living in Berlin. Most of them, around 1920, were in Dresden or Munich, or living somewhere in the country, except, of course, elder men like Liebermann and Corinth.

E.R.: Did you know Ludwig Meidner and Jacob Steinhardt, who had founded the *Pathetiker* group in 1912?

HÖCH: We knew them, but we had little in common with them. Meidner was a wild and obsessed painter, very difficult as a friend or as an associate. Steinhardt, on the other hand, was more affable; but he was deeply religious, a close friend, if I remember right, of the poetess Else Lasker-Schüler. To me, it seemed almost incredible that a modern artist should still find a source of inspiration in traditional religious beliefs such as those of orthodox Judaism.

E.R.: I'm not prepared to argue with you on this point, being the author of a series of English poems entitled *Three Hebrew Elegies*. But what kind of man was Kurt Schwitters?

HÖCH: Here, too, it's difficult for me to speak objectively. Kurt was a very close and dear friend of mine, an artist who, like Hausmann, was very moody and needed constant encouragement. For a while, we were nearly always together. He seemed to find it easier to work if I was working with him. Today, Schwitters is remembered mainly for his collages and his *Merz* compositions. But I can remember often going out with him on sketching expeditions in the country, for instance, near Hannover along the banks of a canal; and then we drew and painted quite naturalistic landscapes, both of us, as late as 1925. Of course, we never exhibited these works, which were like the five-finger exercises of a concert pianist who refrains from playing such things in public. But this is an aspect of Dada art that is never mentioned today. However subversive our aesthetic doc-

trines, we still believed in acquiring, by training, the traditional skills of an artist.

E.R.: The American poet John Peale Bishop and I once concluded that we were probably the last two American poets who had been taught, at school, to write verse in Latin and in Greek. You and Schwitters may likewise have been the last two modern German artists to go out sketching like any German romantic, a hundred years earlier, in Tivoli or in Subiaco. But Mondrian had also done a lot of outdoor sketching, before the First World War and before he became a cubist and, later, an abstract artist. How did you get along with Mondrian?

HÖCH: I knew him well but was never really at my ease in his presence, even after knowing him quite intimately over a number of years. Everything in his life was reasoned or calculated. He was a compulsive neurotic and could never bear to see anything disordered or untidy. He seemed to suffer acutely, for instance, if a table had not been laid with perfect symmetry. To go and eat a meal with him in a restaurant was a truly strange experience. I have always felt that as ordered a style of art as his could exist only in Holland, where even the tulip fields are planted in a fantastic order that is far beyond the scope of a German gardener. I could understand Mondrian's art, but I have never felt any need for as rational a style. I need more freedom and, though capable of appreciating a style that is less free than my own, have always preferred to allow myself a maximum of freedom. I have often suspected that an artist's concentration on his own self and on one particular style of his own that is always recognizable may lead more easily to popularity and success. But I still prefer to enjoy my own ability to develop, change and enrich my style, even if my constant evolution as an artist deprives me of many an easy success.

E.R.: Do you think that, under more auspicious circumstances, and in spite of this protean quality of your evolution, you might have been more successful and more famous? Do you feel, for instance, that the years of the Nazi regime have very much hampered you in your career?

HÖCH: That's a difficult question to answer. Thirty years ago, it was not very easy for a woman to impose herself as a modern artist in Germany.

E.R.: Gabrièle Münter made the same remark

73

to me when I interviewed her last summer in Murnau.

HÖCH: I'm not surprised. Most of our male colleagues continued for a long while to look upon us as charming and gifted amateurs, denying us implicitly any real professional status. Hans Arp and Kurt Schwitters, in my experience, were rare examples of the kind of artist who can really treat a woman as a colleague. But Arp is also one of the most inspired artists I have ever met.

E.R.: I don't suppose you feel that you have much in common with most of the Berlin painters of today.

HÖCH: I don't know many of them. Most of those whom I knew are either dead or have emigrated, and very few of the younger Berlin painters seem to know that I'm still alive or to want to come out here and see me. But I'm very fond of Heinz Trökes, who comes to see me whenever he's in Berlin, and I like his work. I also like some of the recent paintings of Hans Jaenisch. Otherwise, I lead a very quiet life out here, quite content to have been forgotten by most of the more popular German art critics of today.

E.R.: It seems to be the fate of a number of important German artists of thirty years ago to be more highly regarded today in America than in Germany. In 1948, nobody in Berlin was willing to buy any of the works of Schwitters, Freundlich and Jawlensky that were available here on the art market, and Will Grohmann is always surprised if I answer his polite enquiries about my work by announcing that I'll soon be publishing in America a piece on you, on Freundlich, on Marcus Behmer, on Meidner or on Jawlensky. . . . Germany seems to be still busy rediscovering and digesting its great painters of the generation of 1900 to 1915, I mean the expressionists of *Die Brücke* and the leaders of the Blue Rider — Klee, Kandinsky, Marc and Macke. I'm shocked, for instance, to see that

Freundlich remains almost unknown in Germany.

HÖCH: And I'm still shocked whenever I remember that poor Otto Freundlich and Rudolf Levy, two of our greatest modern painters, were both murdered in Nazi extermination camps. No amount of monuments to their memory or of retrospective exhibitions of their works can ever compensate this typically German outrage.

E.R.: The Athenians murdered Socrates, and the French murdered André Chénier and Lavoisier. . . .

HÖCH: In the history of every nation there are disgraceful pages, but the crimes committed here remain unique in their magnitude. I often wonder how I managed to survive that dreadful reign of terror. When I now look back, I'm surprised at my own courage or irresponsibility in preserving in my home all the "subversive" Dada art and literature that I've been showing you, as we talked, for the past couple of hours. But it never occurred to me, until it was all over, that I could still be considered a dangerous revolutionary. Here in Heiligensee, I had managed to disappear as completely as if I had gone underground. My neighbors out here are all very kindly people, devoted to their children, their pets and their gardens. After 1938, I lived here, as far as possible, as if I were a thousand miles away from the capital of the Third Reich. . . .

The dangerously revolutionary old lady of Heilgensee then interrupted our conversation to prepare some coffee, which we drank together in the garden, with cakes and more fruit, cherries that we picked together from her own trees. As we watched the sparrows coming to bathe in the spray of the hose that watered the lawn, it was difficult to believe that this gentle gray-haired artist, so perfectly at her ease in her suburban garden, had once been a scandalously subversive young woman in an art world that had flourished in the asphalt jungle of metropolitan Berlin between 1917 and 1925.

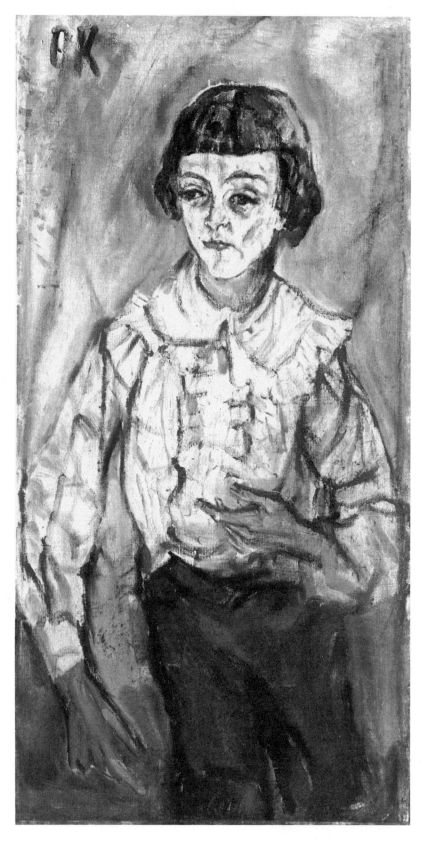

OSKAR KOKOSCHKA, *Portrait of the Composer Baron Jacques de Menasce as a Boy*, 1911

Oskar Kokoschka

*T*he Swiss Government's official Tourist Agency publishes, in three or four languages, a large number of illustrated leaflets to attract visitors to individual beauty spots, historic towns or cities and other points of interest situated within the Helvetic Confederation. The leaflet devoted to Villeneuve concludes its description of this picturesque coast town at the far end of the Lake of Geneva as follows: "Many painters have appreciated the incomparable charm of this part of the country between lake and mountains, which is the present residence of the famous painter Kokoschka."

My work as a conference interpreter had kept me in Geneva until late in the evening before my scheduled meeting with Kokoschka, and I thus arrived in Villeneuve by the last local train, well after midnight. The whole town seemed to be fast asleep, beneath a steady downpour of rain. Only the hotel where I had reserved a room, and which I had warned by phone of my late arrival, still had a couple of lighted windows, as if to guide me from the station, which was about to close down for the night. The stationmaster, on his way home, showed me a shortcut through the town to my hotel, which was situated on the lakefront. We were the only living souls in the deserted streets of Villeneuve. No stray cats would have deigned to go marauding under such torrential rain.

On reaching my hotel, I enquired, before retiring for the night, how far I would have to walk, the next morning, to reach Kokoschka's house. The proprietress had never heard of him, so I produced my printed leaflet about Villeneuve and explained that I had come all the way from London to visit the town's most famous resident. She read about him with skeptical interest: "If you're interested in interviewing artists, you should write about me. I paint flowers on porcelain and sell a lot of my work to tourists. I'll show you a few things tomorrow morning."

The next day, I was up early. It was still raining steadily. *As I breakfasted, I asked several members of the hotel staff how I could get to Kokoschka's house. None of them had ever heard of him. Finally, a young Italian maid had a bright idea: famous men are generally old and frail and are known to the local pharmacy as good customers. So she phoned a friend, who worked for the pharmacist, and obtained the necessary information.*

When I found myself at long last in Kokoschka's entrance hall, I was dripping wet, and my plastic raincoat threatened to flood the place. But Kokoschka and his wife greeted me without dismay, as if river gods were indeed the kind of visitor with whom they most often had to deal: "Whether here or in Salzburg, all our friends from abroad seem to call on us in pouring rain. As refugees from the much-maligned London weather, we have chosen to live in the two rainiest spots in all of Europe!"

Throughout our conversation of the next few hours, it continued to rain so relentlessly, with such spectacular persistence, that it was difficult to avoid referring, every once in a while, to the weather which, like a badly disciplined child, took great pains to attract our attention. Kokoschka was worried, with good reason, about his garden, where the spring flowers were taking a cruel beating.

KOKOSCHKA: You cannot imagine today how lovely the view and the flowers can be, when the weather chooses to be fine. But I seem to have bad luck. As soon as the weather begins to improve here, I have to go away, each year, to Salzburg, where I teach art classes in the summer school. Here it rains all winter and all through the spring; in Salzburg, it then rains all through the summer.

He began to speak with enthusiasm about his teaching. I try to teach my students how to see. Artists no longer take the trouble to use their eyes in looking at the outside world. Most of them have become Puritans, iconoclasts, as if it were a sin to reproduce any aspect of reality, of the objective world. In Salzburg, we now have

*"Though my faith in humanity is sorely bruised, I still hope
that, after the present period of nebulous dreams, the
spirit of Europe may become manifest in works of art which
are more poignantly human than anything that an electronic
brain can imagine or create."*

one of the few art schools where students are taught to observe, to see, and to paint what they see. Not that we try to inculcate an academic style of art or any theories of realism or mannerism. On the contrary, academic art is also a rejection of reality, an escape from the world of objects. Instead of painting what he sees, an academic painter generally imitates existing works of art and offers us only trite memories of the world as other generations of painters have experienced it. But painting remains a visual art, and a painter who refuses to see and to observe is voluntarily impoverishing his art. Goethe once wrote: "We know of no world except in relation to man, and we do not want a kind of art that is not a reflection of this relationship." I interpret these words of the poet as meaning that art must express the artist's relationship to a visible world.

E.R.: Would you then exclude, from the domain of art, all imaginary worlds, all that is unreal in visions or dreams?

KOKOSCHKA: Not at all. True dreams and visions should be as visible to the artists as the phenomena of the objective world. The test of the truth of such a vision or dream is its compelling visual reality, and that is why many merely academic allegories remain, in art, so deplorably unreal, simply because the artist has never been able to visualize them properly, to see and observe them as a prophet observes his dreams and his visions, with accuracy, with all the spontaneous emotional impact of a real experience.

E.R.: Would you therefore reject, as subjects for the artist, all more intellectual abstractions, such as those of Mondrian, which no longer concern themselves with man's relationship to the outside world?

KOKOSCHKA: To me, Mondrian remains a kind of architect of a world lost to man rather than a great painter. He is too exclusively concerned with only one aspect of art, with the problem of proportions. He is a Puritan, a Cal-

vinist, an iconoclast. The subjective world that he communicates to us appears, in my eyes, tragically dull and uninteresting. I am still far too much interested in the visible world to want ever to escape from it. As an artist, I seek no evasion from the present, from the world of here and now. I am passionately devoted to life as man experiences it, with his eyes and other senses, with his emotions as he apprehends the visible world. But mankind seems to be losing its interest in this here and now. When I read the papers, I see that the most important news is about rockets aimed at the moon, and I am told that people are already trying to book seats on the first space-travel ships. I am still interested in travel only on this planet, and God forbid that I should witness its destruction! All this talk of a scorched earth or a scorched moon horrifies me.

E.R.: So you are proclaiming, in your work, your allegiance to a more traditional conception of art and of its relationship to reality than most of the great painters, since Picasso and Klee, have chosen to expound. Does this mean that you disapprove of the work of Klee, for instance?

KOKOSCHKA: No, I am not prepared to condemn Klee, whom I consider a true visionary, except that I am not always satisfied with the material quality of his works. I often feel that these are a bit sketchy, sometimes even amateurish, as if he had limited himself to a kind of hasty or almost absentminded doodling.

E.R.: I have also felt that Klee refrains at times from allowing himself to develop his ideas or his visions fully as finished works of art. Still, Klee's attitude to his art has preserved, in much of his work, a kind of private and spontaneous quality that is generally lacking in the work of masters like Poussin or Manet, except of course in their sketches.

KOKOSCHKA: When we look at many of Klee's works, we experience the same delightful feeling of eavesdropping as when we read the private

diary of a gifted writer, his notes and impressions that were never intended for public consumption. It is a very subjective and private art and teaches us more about the working of the artist's mind than about the nature of Art or the nature of nature.

E.R.: Your own art has also been called, by some critics, a very subjective art. Would you care to distinguish your own subjectivism from that of Klee or of some of the younger action painters?

KOKOSCHKA: I suppose my own subjectivism limits itself to expressing my emotional reactions to what I see, whether my subject matter is chosen from the objective world or from a world of dreams or of visions. Klee, on the other hand, is more solipsistic. He plays around with his dreams and visions and seems to invent them to fit his moods and emotions. He functions, so to speak, in reverse, projecting these moods and emotions as visions, not deriving them from what he sees or visualizes.

E.R.: But some action painters go even further than Klee. They seem to be satisfied with the reality of their own moods and emotions, without ever concerning themselves at all with the visible world, without trying to project these moods and emotions in terms of forms borrowed, even as remotely as some of those of Klee, from the visible world.

KOKOSCHKA: Yes, Klee still meets his audience, in much of his work, on a common ground of recognizable forms; to this extent, his art is still a language of communication, whereas that of some of the younger action painters no longer communicates anything but the intensity of their own emotion. Their work tends to become pure self-expression of the moment and tells us no more about the artist, about the world in which he lives, or the world of his visions and dreams, than a fever chart tells us about a patient in a hospital bed.

E.R.: Some of my readers will find us both very harsh in our condemnation of action painting. One has become accustomed, in recent years, to hearing it praised by all but a few diehard Royal Academicians or less reputable Philistines of the daily press.

KOKOSCHKA: The action painters and their friends have established a kind of Reign of Terror in the world of art criticism, and many of the great critics of the past few decades no longer dare condemn something that is so new or obviously iconoclastic that they fail to understand it. These critics are so afraid of losing their following among the younger artists — in fact, of compromising themselves by appearing at all conservative — that they now behave like certain hysterical old women who are terrified of losing their charm and accept the advances of any man, as if each man in turn might be their last chance. In German, we have a word for this kind of hysteria. We call it *Torschlusspanik*: the panic that breaks out before the final closing of the door. But I feel that the art critic should not be irrevocably committed to novelty or to what is generally believed to be progress in the arts. On the contrary, he should be committed only to *quality,* and we all know, from our studies of art history, that a great period may be immediately followed by one of shocking mediocrity. It is foolish to assume that everything new must inevitably be better. This may be true of gadgets, of machinery, but not necessarily of art.

In the last few decades, some of the most influential art critics seem to have had no other purpose than to encourage a constant lowering of the standards of art. By praising indiscriminately every kind of primitive art, they have created a market for the pseudo-primitive and corrupted the truly primitive artists of our age. We thus have phoney *peintres du dimanche* and African artists who pretend to be less sophisticated or more primitive than they really are. In the same way, art critics have corrupted the art of children, so that we now have art teachers in our schools who often rebuke the children in their classes for producing works that are not childish enough. With action painting, this process has gone one step further, and the art critics are busy corrupting the natural devices of self-expression of chimpanzees, and already condemn the works of a more sophisticated or skilled animal as not sufficiently bestial. But they forget that a real chimpanzee, in wild life, would never dream of painting. Only in a cage or in a zoo have these chimpanzee–artists been forced to paint. As for any action painters who might deliberately set out to emulate these chimpanzee–artists or be willing to allow comparisons between their own works and those of animals, well, I need only refer you to the parable of the Gadarene Swine, in the Bible, to let you know what I think of them.

E.R.: Do you have any theory of your own to explain this trend in modern art which you condemn as decadent?

KOKOSCHKA: Art has always been a craft rather than an industry, producing handmade objects which bore the mark of the personality of the artists even more recognizably and distinctively than those produced by mere craftsmen who were not artists. Now that the crafts have almost disappeared because everything is machine-made, the arts find themselves divorced from the infrastructure of handicrafts and the artist is losing his awareness of a real relationship between his own activity and the many other productive activities of our economy. Instead of emulating the craftsman and surpassing him, he is tempted to emulate and surpass the machine, or anything else that can produce forms or patterns, such as our chimpanzee–artists. Gradually contemporary art is thus abandoning its human standards and ceasing to be humanistic. For a long while, European civilization, in the Western world, resisted this trend and remained a repository of terms designating mental facts which can be expressed by images. Modern art can be likened to modern language, losing the means of expressing the more subtle relations and connections between thoughts that can strike a responsive spark in the human mind. But our European civilization is now doomed. It can no longer compete with the technical civilizations of America and Russia, except by borrowing their techniques of production. What we are witnessing, in the new styles of art of the last few years, whether in Europe or in America, is the final stage of this decay, in which action painting and other extremist innovations are but the death throes of the art of the Western world — I mean the humanistic art that we have inherited from ancient Greece. Exhibitions like the Venice Biennale are, so to speak, the Armageddon of Western art.

E.R.: But would you condemn all art that is abstract or nonobjective?

KOKOSCHKA: No, because everything we see can be reduced to some kind of abstraction. Like Rembrandt, Titian, another great genius, had been neglected for centuries. Now we realize that it is not subject matter, but the abstract painting *per se* which matters in Titian's work and makes it divine. There is abstract painting, as I fully acknowledge, in every square inch of the pattern of Titian's great art. But the abstract or nonobjective art of today is often the art of an ostrich that refuses to see the world as it is. At the same time, it presupposes the existence of an extraordinarily rich, varied and worthwhile subjective world, that of the artists. Wouldn't you agree that most of these abstract or nonobjective artists of today are very ordinary men who reveal to us, in their works, only the extreme poverty of their own ideas, sentiments and emotions? I am shocked, when I visit some exhibitions of this sort, by the platitudinous nature of the statements made by many abstract or nonobjective artists, and by the terrible oversimplifications and conformist ideas that they seem to communicate. I often feel that an eighteenth century craftsman like Roentgen, who made exquisite rococo furniture, had more imagination and a richer temperament, as a sheer artist, than some of the latter-day disciples of Mondrian or of the Bauhaus. As craftsmen, too many of these abstract artists have degraded themselves, like Circe's lovers in the *Odyssey,* by emulating the nonhuman. They have stooped to emulate animals or machines, and now their minds and souls function as if they were computers already without a soul or a mind. Man should always emulate only man or some higher order of beings, never machines that he himself has created. Now that man has even invented electronic brains which, we are told, are capable of composing original music, of writing poetry or of creating works of art, we must be careful to avoid emulating these robots.

Though my faith in humanity is sorely bruised, I still hope that, after the present period of nebulous dreams, the spirit of Europe may become manifest in works of art which are more poignantly human than anything that an electronic brain can imagine or create. If art has any future at all, it must seek inspiration from the great art of the past, in the works of all those artists who remained faithful to the humanistic Greek tradition, rather than in the work of cave dwellers, primitive and exotic art, or in the art of children or in psychopathic doodles. I mean, for instance, that an artist must now seek to achieve, in each of his works, something unique from a human point of view, like Piero di Cosimo's *Death of Procris,* which represented a peak of Renaissance neopaganism

after the mystic or cabalistic gnosticism of the disputing theologians of the Dark Ages, or like Seurat's *La grande jatte*, which transforms a Sunday view of Paris suburbia into a vision of the divine light as seen by the artist in spite of the optical theories and the scientific materialism of his contemporaries. An artist should even refrain from settling down to the repetitive routines of his own particular manner or style, which may blind him to the freshness and novelty of a world which never repeats itself. . . .

E.R.: I suppose you mean the kind of repetition that one finds, for instance, in so many of the works of Fernand Léger, as if a whole series of them had been fed into an electronic brain instructed to produce more of the same kind, but each one only slightly different from the original information supplied and from the other products of the series now produced artificially.

KOKOSCHKA: Perhaps you are now being a bit harsh on Léger, as I too was harsh on the action painters. But that is exactly what I mean. Rather than compete with the machine, the artist must try to transcend it. Only thus can the artist preserve his freedom, a freedom of the individual. . . .

E.R.: Do you feel that our age offers sufficient guarantees for this individual freedom of the artist?

KOKOSCHKA: No, we are living in what I would call *die grosse Zeit der Gleichschaltung,* the great age of leveling down to the lowest common denominator. Never have the masses felt such an urge to follow a leader like sheep. Most men now seek security rather than freedom and prefer not to think or feel with their own minds and emotions. Instead, they accept vicarious experiences and prefabricated thoughts and withdraw into their homes to indulge in orgies of television rather than go out and face reality.

E.R.: I recently came across an eloquent illustration of this reliance on machinery as a substitute for thought and emotion. I was on a holiday and, though I'm not much good as an artist, I decided one afternoon to do some sketching. Suddenly, a young man who was watching me as I painfully tried to formulate my impressions of the landscape asked me why I took so much trouble. Condescendingly, he produced his camera and photographed the view. He then asked me to give him my name and address and promised to send me a print as a souvenir. It

was quite difficult for me to explain to him that the mental process of sketching allows me to integrate what I see far more thoroughly, as an experience or a memory, than merely photographing it and later referring back to a mechanically produced memory, filed away in an album, whenever I might want to relive that particular moment of my past.

KOKOSCHKA: Now that is exactly what I am trying to teach my students in the Salzburg summer school. When I was a young man, fewer people could afford to travel, but the proportion of those who took sketchbooks with them on their holidays was as high as that of those others who now carry cameras. Nor did all those who sketched have ambitions as artists or illusions about their talents. On the contrary, sketching was considered to be part of the fun of travel, a device for enhancing and integrating one's visual experiences. I feel that many of the tourists of today who carry cameras with them, wherever they go, are mentally, if not physically, quite blind, or rather that their eyes no longer function as human organs, only as a kind of accessory to their cameras.

E.R.: To me the effort of sketching can be an essential element in the experience of enjoying a view, just as the effort of climbing a mountain on foot, instead of sleeping in a cable car that carries you up, can be an essential element in the experience of travel. That is why the sketches of quite anonymous and unskilled nineteenth century travelers often tell me more about Italy and what it could mean to them than most of the photographs that so many tourists now bring back from the same places. I own, for instance, a view of Taormina, painted by a minor German Romantic, and have often wondered how the artist could possibly have climbed to the spot from which he has depicted the ruins of the Greek theater; at the same time, I feel that the picture also expresses some of the triumphant sense of achievement of a man whose experience of this beautiful view included a certain athletic prowess.

KOKOSCHKA: Still, I think it would be wrong to insist that art should always be a trial of strength, as if it were a kind of weightlifting. The element of effort, in art, is often concealed, and the artist's virtuosity consists in giving us the impression that he achieves his feats of skill and strength with ease. The world of experience,

81

as it is revealed to our sense and our understanding, is always chaotic. Each one of us must seek to organize so many conflicting facts, impressions or sensations in some kind of understandable synthesis, I mean in a *Weltanschauung* which will allow one to face the world as an individual, without being overwhelmed by the kaleidoscopic flow and swirl of phenomena. *Die Welt muss stündlich neu geschaffen werden*: the world must be created again in every hour, by each one of us, if not in every minute and second. It is the task of the artist to illustrate this process, to organize the chaos of the visible world in patterns from which some meaning can emerge. Each artist, of course, specializes in certain patterns, and thus suggests particular meanings and emotions rather than others. . . .

E.R.: Your own panoramic views of cities, especially of cities situated on rivers that are spanned by bridges, somehow convey to me the individual character which you seem to detect in the tangle of architectural details and of geographical features. Like Greco's *View of Toledo,* your views of Prague, Florence, Dresden, London, Hamburg or Paris are each time the fruit of a successful search for the character of a community, and you interpret it to us as a sum total of the city's past, revealed to us in its present appearance. In some of your portraits, too, I can detect a similar ability to see, in the facial expression of a man or a woman, the culmination of a whole life of joys and sorrows, of hopes and fears. Rembrandt had the same kind of psychological insight, whereas most portrait painters, even such great artists as Frans Hals or Reynolds, tend to depict their models exclusively in the present, without interpreting their immediate appearance as a visible fragment of a kind of huge submerged iceberg.

KOKOSCHKA: It is most important that an artist should always face what he depicts, at least in the beginning, with a sense of sheer wonder. However ugly a face may be, we can discover some beauty in it if we first experience wonder before it and then begin to understand it, too.

E.R.: Géricault's series of portraits of inmates of an insane asylum are particularly brilliant examples of this kind of understanding, which can transform something horrible or frightening into something beautiful.

KOKOSCHKA: Yes, but such a task requires an effort of charity or pity, of humility and of wisdom or prudence. *Caritas, humilitas et prudentia*: these must be the virtues of an artist who seeks to discover the hidden beauties of a chaotic world. Without these virtues, he might easily produce works that are merely macabre.

It was no longer raining as obstreperously, and I felt that I might soon risk returning to my hotel without too much discomfort. Before we parted, Kokoschka took me over to the window, again apologizing for the weather, and began pointing out to me the beauties of his garden and of the view of the lake and the mountains.

KOKOSCHKA: If the weather permits, I enjoy working in the garden. Nature is like a tremendous kaleidoscope, and there is no end to its appeal, to the variety of its forms, its colors and its patterns. . . .

I was about to leave, when Kokoschka produced a folder of watercolors which he began to show me. They were exquisite studies of details of his garden, of the effects of light and shadow on flowers and shrubs. One could feel that they had all been painted in a completely relaxed mood, with the mastery achieved at the climax of a life devoted to drawing and painting, but also with the wonder and delight of a child or a mystic. As I turned toward Kokoschka and observed the expression on his face, the eager and youthful eyes, the smile transfiguring the ravaged features, I was reminded of the Latin term used by certain medieval mystics to describe their ideal. Kokoschka is indeed a puer senex, *a white-haired boy, and the watercolors that he was showing me had the same quality of wisdom and of wonder as those of a whole school of mystical painters of the Far East, the Taoist and Zen artists of China and Japan who were able to discover, as he, order and beauty in the confusion of natural appearances.*

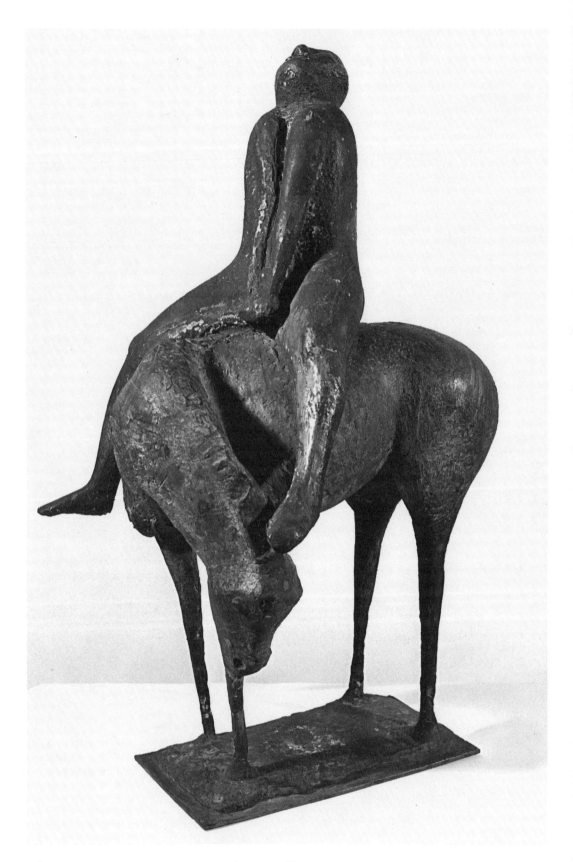

MARINO MARINI, *Horseman*, 1947

Marino Marini

I *had noticed in recent months the sporadic publi-cation of a number of news items and features, in the Italian press, about the progress of the huge sculpture on which Marino Marini had long been working. Each time, the reporters had tried to give their readers some new details concerning this monument. They all agreed that the great Italian disciple of the art of preclassical antiquity and of the Middle Ages had inaugurated a new phase in the evolution of his style. The mysterious sculpture to which Marino Marini had devoted most of his time for the preceding two years was thus described by some critics as more expressionistic than his previous works, but by others as more abstract. On the other details, there was less agreement. Some referred to the monument as a new bronze horse, but without the usual rider. Others affirmed that Marini was again producing an equestrian figure, but conceived accord-ing to a novel formula. Some declared that the horse would be five yards high; others, only two yards. It was sometimes said that the monument had been commissioned by the municipality of Rotterdam, sometimes by that of Amsterdam, once by that of Groningen.*

As I happened to be for a few days on other busi-ness in Milan, I decided to investigate the matter myself and took the liberty of phoning Marini for an appointment. I was fortunate enough to find him at home. He had returned only the day before from a visit to his wife's family in Switzerland. He asked me to call the next morning at his apartment.

I found my way there in fog and rain, in weather more suggestive of London than of any Italian city. Marino Marini lived on one of the upper floors of a modern apartment house in the center of the city. When the door was opened to me by the maid, I was led into an elegant living room, decorated and fur-nished in a kind of cultured "movie-set" style, like the house of a fastidious industrial tycoon. On the walls, there were several of Marini's own paintings and drawings; on a few tables and other low pieces of furniture, some of his more famous bronzes, of which

I had seen other copies in museums and galleries. It was like the home of a wealthy Swiss or Italian art patron, with nothing that might suggest the inevita-ble dust and disorder of a sculptor's studio.

As soon as Marino Marini had joined me and greeted me, I began to ask him about his new work, quoting the discrepancies that I had noticed in the Italian press. He laughed, then began to explain to me the facts about his work.

MARINI: It's an equestrian figure. Some papers have already published photographs of the plaster model. But a few of these pictures, as a consequence of a faulty perspective, have suggested some misunderstandings. The rider is leaning back, almost lying on the horse's hindquarters. When one looks at the model from the front, the shadow of the horse's head some-times blots out the rider, or confuses it with the horse's mane. That is why so many people have believed that the horse had no rider. As for the other details, the whole monument will be some six yards high and has been commissioned by the municipality of The Hague for one of the new "satellite cities" that are being built as suburbs of the Dutch capital.

The business of noting Marini's explanations dis-tracted me throughout our conversation from watch-ing his unusually mobile expressions. His face had a sculptural quality, like that of a figure in a painting by Piero della Francesca. His forehead was broad beneath the receding line of graying hair, but the face was still young, relaxed and open in spite of a curious sadness in the eyes, that of a prophet who has no longer any illusions rather than an embittered or sick man. As I questioned him in French, Marini formu-lated his answers carefully in the same language, which he spoke almost faultlessly, with only a slight Italian accent. Once in a while, if he seemed unable to find the right word, I encouraged him to express himself in Italian. His Tuscan was unusually pure, though he spoke without that guttural quality which renders the speech of many Florentines so unmusical.

E.R.: What difference is there between your

*"My equestrian figures are symbols of the anguish that
I feel when I survey contemporary events. Little by little, my
horses become more restless, their riders less and less
able to control them."*

new equestrian statue and all those that you had already created since 1945?

MARINI: I think it would be wrong to state that a clear break can be detected in the evolution of my style, in the last two years. On the contrary, the monument on which I'm now working — and I'll show you the model later in my studio downstairs — illustrates only the latest phase of this evolution, the meaning of which may already be clear to you. Each one of the equestrian figures that I have created since 1945 represents a different phase of this evolution.

I asked Marini to explain to me his ideas about the increasingly apocalyptic character of his riders, each one of which, in turn, seems to have been struck more brutally by some catastrophe, whether as witness or as victim.

MARINI: Equestrian statues have always served, through the centuries, a kind of epic purpose. They set out to exalt a triumphant hero, a conqueror like Marcus Aurelius in the monument that one still sees on the Capitol in Rome and that served as model for most of the equestrian statues of the Italian Renaissance. Another example is the statue of the French king on the Place des Victoires in Paris. But the nature of the relationship which existed for centuries between man and the horse has changed, whether we think of the beast of burden that a ploughman leads to the drinking trough in a painting by one of the brothers Le Nain, or of the Percherons ridden by the horse traders in Rosa Bonheur's famous picture, or again of the stallion that rears as it is spurred by one of the cavalry men painted by Géricault or Delacroix. In the past fifty years, this ancient relationship between man and beast has been entirely transformed. The horse has been replaced, in its economic and its military functions, by the machine, by the tractor, the automobile or the tank. It has already become a symbol of sport or of luxury and, in the minds of most of our contemporaries, is rapidly becoming a kind of myth.

The artist is often a bit of a prophet and, almost a century before the invention of the automobile, some of the Romantic painters, especially Géricault and Delacroix, no longer painted their horses with the same objectivity as the portrait painters of the eighteenth century. Especially in England, these painters had often been more exact in their rendering of a favorite horse than in their somewhat idealized portrait of its aristocratic human owner. The Romantic painters were already addicted to a cult of the horse as an aristocratic beast. They saw in it a symbol of luxury and adventure rather than a means of transport or beast of burden.

From Géricault and Constantin Guys to Degas and Dufy, this cult of the horse found its expression in a new attitude toward sport and military life, an attitude that is best exemplified by the nineteenth century dandy. In Odilon Redon's visionary renderings of horses and later in those of Picasso and Chirico, we then see the horse become part of the fauna of a world of dreams and myths.

E.R.: All this had already struck me last summer, when I visited, in Western Germany, a special exhibition entirely devoted to the theme of the horse in the history of art. Though this exhibition had devoted almost a whole room to your own work, I left it convinced that the nineteenth century remains, from Géricault to Degas, the great age of the horse as an artistic theme.

MARINI: I suppose I came along in the immediate aftermath of this great age, after Degas, but still as a contemporary of Dufy as well as of Picasso and of Chirico. My own work has followed a general trend in its evolution, from representing a horse as part of the fauna of the objective world to suggesting it as a visionary monster arisen from a subjective bestiary.

E.R.: I don't remember ever having seen, except as photographs in catalogues and art publications, any of your horses of the first

86

period of your own evolution, the one you have just called objective.

MARINI: They are mostly early works, not as well known as some of my more recent sculptures. I had been fortunate in renting a studio, when I was a beginner, in Monza, near Milan, where my neighbors owned a big livery stable. I made the most of the opportunities offered me and drew and modeled horses almost every day. But these horses were still far from symbolizing to me anything subjective or apocalyptic. All my work—I mean my human figures, too—remained for a long while very classical, somewhat reticent and realistic, too, in its style. Until the end of the Fascist era and of the war, I continued to hark back to the sober realism of the artists of the Etruscan funerary figures, or of the sculptors of some Roman portraits, especially the earlier ones. My own way of reacting against the imperialist pathos of official Fascist art continued, until 1944, to consist in identifying my art very consciously with my private life, so that I never allowed myself any form of expression that might seem too blatantly public. That is why I continued to produce so many portraits which might seem as anonymous as those funerary busts of unknown Romans which strike us, twenty centuries later, as human documents, stripped of all historical pathos. My nudes of that period also have, I believe, this classical quality of anonymity. I have tried to express in them no personal sensuality of my own. I wanted to exclude from them the autobiographical element that allows us to recognize, in some sculptures of Renoir and even of Maillol, the artist's own mistress or at least a particular contemporary type of feminine beauty that appealed to the sculptor more immediately than an eternal type of classical beauty.

E.R.: When I see your nudes of before 1945, I feel that I am rediscovering in them an idea of beauty that remains perfectly anonymous and timeless, as if set beyond the frontiers of history. In some of your portraits of these earlier years, I have also felt a kind of presence that is not that of the artist but truly of his model. It is the same kind of presence as might be felt in many of those funerary sculptures of Roman and Etruscan antiquity. So many of them reveal to us a personality that is often nameless and whose biography remains unknown; but this personality is still complete and faces us like someone raised from the dead and answering our call: "Here I am!"

MARINI: That is just what I tried to suggest in those portraits that are founded on a different sculptural tradition. My nudes seek to revive the tradition of Greek classical sculpture. But my portraits are founded on Etruscan and Roman art, as you pointed out, and also on the realistic art of the Christian Middle Ages as we discover it in the portraits of kings and queens and bishops lying in state on their cathedral tombs, or in the equestrian statue of Bernabò da Visconti. I suppose you know that masterpiece of Bonino da Campione, here in Milan in the Castello Sforzesco Museum.

E.R.: I went to see it yesterday morning, and it again reminded me of some of your works of recent years, if only because it somehow contrasts with them.

MARINI: Bonino da Campione was still directly inspired by the figure of Marcus Aurelius on the Roman Capitol. In the Middle Ages it was venerated as a portrait of Constantine, the first Christian Emperor. But I am no longer seeking, in my own equestrian figures, to celebrate the triumph of any victorious hero. On the contrary, I seek to commemorate in them something tragic—in fact, a kind of Twilight of Man, a defeat rather than a victory. If you look back on all my equestrian figures of the past twelve years, you will notice that the rider is each time less in control of his mount, and that the latter is each time more wild in its terror, but frozen stiff, rather than reared or running away. All this is because I feel that we are on the eve of the end of a whole world.

E.R.: I suppose you mean the world of the humanism that provided the foundations of all Western art, from the romanesque Carolingian pre-Renaissance to the birth of contemporary abstract art.

MARINI: I would prefer not to develop my ideas on this subject in the form of a polemical statement. It is a feeling, deep within me, that must be related to what some Romans felt, in the last years of the Empire, when they saw everything around them, a whole world order that had existed for centuries, swept away by the pressure of barbarian invasions. My equestrian figures are symbols of the anguish that I feel when I survey contemporary events. Little

by little, my horses become more restless, their riders less and less able to control them.

Man and beast are both overcome by a catastrophe similar to those that struck Sodom and Pompeii. So I am trying to illustrate the last stages of the disintegration of a myth—I mean the myth of the individual victorious hero, the *uomo di virtù* of the humanists. I feel that soon it will no longer be possible to glorify an individual as so many poets and artists have done since classical antiquity and especially since the Renaissance. Far from being at all heroic, my works of the past twelve years seek to be tragic.

E.R.: If I understand correctly, your equestrian figures, whether in sculpture or in your drawings, began to follow this evolution around 1945. I hope you will not be offended if I compare this development to that of an animated cartoon which tells us the story of your mythical rider. I have seen, for instance, some of your drawings of the end of the war, representing your horseman standing beside a rather massive and peaceful horse, like the horses in some of the paintings of Paolo Uccello. Then there came drawings in which your horseman mounted the horse, followed by others where we see him mounted, the man still as massive and peaceful as the horse, as in the statue of Bernabò da Visconti. After that, little by little, the horseman and the horse ceased gradually to communicate to us this heroic or epic quality of classical equestrian statues.

MARINI: Yes, and this decline and fall began in my horseman of 1945, which I actually finished in 1947. It is now in Pittsburgh, in the garden of the house that Frank Lloyd Wright built there for Edgar Kaufmann. I called this statue *Resurrection*. It represents a horseman, seated on his mount with arms outstretched and staring straight ahead; it is a symbol of the hope and the gratitude that I felt shortly after the end of the war. But developments in the post-war world soon began to disappoint me, and I no longer felt any such faith in the future. On the contrary, I then tried to express, in each one of my subsequent equestrian figures, a greater anxiety, and a more devastating despair.

E.R.: Is that why your horses appear increasingly tense, as if they had stopped suddenly on the brink of an abyss? And why each rider seems to have been stricken more brutally,

till we now see the rider lying like a dying man who has been struck down on his horse?

MARINI: In my studio I'll show you one of my latest works, an equestrian figure with the horse prostrate on the ground, and the rider lying beside him as if they had both been suddenly overcome by a tempest of ash and lava like the one beneath which were found the petrified victims of the last days of Pompeii. The horseman and the horse, in my latest works, have become strange fossils, symbols of a vanished world or rather of a work which, I feel, is destined to vanish forever.

E.R.: Some critics have argued in recent years that your evolution tends toward a conception of sculpture that is less classical or archaic. It has even been said that you are becoming an expressionist, or that your art is about to become abstract. I suppose these writers are all analyzing your evolution as it can be observed from the outside, that is to say without considering what you are trying to communicate. . . .

MARINI: As soon as sculpture is conceived on a monumental scale, larger than life, it becomes architectural and tends to appear more abstract. But as soon as it seeks to express anxiety, sculpture also wanders away from the ideas of classicism.

E.R.: I suppose you mean that it then abandons the canons of Winckelmann in order to adopt those of Lessing's *Laocoön*.

MARINI: But I am no longer trying to formulate a stylized version of anxiety such as we find in the *Laocoön* group and in so many other sculptures of the Silver Age of antiquity. I feel that these works are always a bit too melodramatic. If you really want to find the sources of my present style in antiquity, I must confess that you will find them in the remains of the life of the past rather than in those of its art. The fossilized corpses that have been unearthed in Pompeii have fascinated me far more than the *Laocoön* group in the Vatican. If the whole earth is destroyed in our atomic age, I feel that the human forms which may survive as mere fossils will have become sculptures similar to mine.

E.R.: Your apocalyptic pessimism expresses itself in what I might call a "Hiroshima" style. But this style has much in common with that of the sculptors Alberto Giacometti and Germaine Richier, whose human figures likewise seem to be fossils or hideously disfigured victims of a

catastrophe, and also with the vision of a Decline of the West that one finds in the works of some abstract sculptors, such as César in France, Paolozzi in England, and Stankiewicz in America—I mean those "near-abstract" artists who construct their sculptures out of "prefabricated" elements, odd pieces of scrap metal and old machinery salvaged from junkyards and then welded together. . . .

MARINI: I expressed my whole philosophy on this subject to Pierre Matisse, my New York dealer, when I once said to him that I had been born in an Earthly Paradise from which we have all been expelled. Not so long ago, a sculptor could still be content with a search for full, sensual and vigorous forms. But in the past fifteen years, nearly all our new sculpture has tended to create forms that are disintegrating. Here in Italy, the art of the past is part and parcel of our daily life in the present. We live among the monuments of the past. I, for instance, was born in Tuscany, where the rediscovery of Etruscan art, in the past fifty years, has been something of great importance in contemporary local life. That is why my own art was at one time so often founded on themes borrowed from the past, like the equestrian figure, which remains a reminder of utilitarian relationships between man and the horse, rather than on more modern themes, like the relationship between man and the machine.

E.R.: I remember seeing in Paris a number of public monuments that can give us a good idea of what representations of the relationship between man and the machine can give in art. There is, for instance, in the Parc Monceau, a wonderful Chopin monument, with the composer strumming a waltz, I presume, on a stone piano that is fortunately shown only in relief; and César Franck, in the Square Sainte Clotilde, is represented playing a stone organ. But Paris has even more wonderful statues of this kind, such as the eternally motionless stone automobiles of the monuments to Panhard and Serpollette, the one at the Porte Maillot and the other at the Place Saint Ferdinand. Before the war, at the Porte des Ternes, there was also a fabulous bronze balloon that seemed to defy all the laws of gravity as it rose into the air, from its stone pedestal, with bronze passengers gesticulating in the bronze cockpit. It commemorated, if I remember right, an incident of the siege of Paris, during the Franco-Prussian War; and that is why the Germans scrapped it during the Occupation of France. All these monuments are a bit absurd. . . .

MARINI: Of course, because machines change their style so rapidly. If one tries to reproduce them in art as realistically as man and the horse in classical art, one immediately lapses into a kind of anecdotic or documentary art, like that of old engravings representing fashions for women. A balloon or an automobile will appear, in art, as silly as a bustle. Only the stylization of a painter like Léger could integrate the machine as the subject matter of art. Here in Italy, the futurists, before 1914, attempted a similar integration of the machine. I don't know the work of the American sculptor Stankiewicz, but I have seen some of César's work. César creates, with elements borrowed from industry and the world of machines, sculptural fossils that appear to have survived the same kind of catastrophe as my own figures. But I would like to show you now, in my studio, my latest fossils. . . .

Marino Marini led the way out of the apartment, down the stairs and across the yard, into his huge ground-floor studio. As we entered it, we faced the enormous plaster model of the monument commissioned by the municipality of The Hague. It is a gigantic yellowish horse, tense with horror like the horse in Picasso's Guernica. *The horseman, as if struck by lightning, falls back. The whole sculpture is constructed in terms of planes, with almost flat surfaces, rather than in the round, as Marino Marini's earlier and more classical works had once been constructed.*

At the back of his studio, he then showed me another horse that lies on the ground, as if struck down by the same catastrophe, with its horseman lying beside it, though not thrown off, only fallen with the horse. Among these fossils that Marino Marini had created in the last few years, his sculptures of before 1945 looked like relics of another civilization.

As I left the sculptor's studio, I went back to the Castello Sforzesco to think over all that he had said and contemplate again the statue of Bernabò da Visconti. When I came out of the museum, I found, in the yard of the Castello, a group of English tourists to whom a woman was explaining something. I approached them and listened.

Through the gate of the Castello, the guide

pointed out, at the far end of the park, the great triumphal arch that was built after 1866 to commemorate the assistance given by Napoleon the Third in the reunification of Italy. "As you look at this arch," she explained, with a slight Cockney accent, "you are turning your back on the one that you saw a few days ago in the Forum in Rome. And if you had walked straight ahead, in a straight line, all the way from Rome, you would have passed through the arch in the Forum and through this gate, on through this arch here in Milan. If you still walk ahead in a straight line, you would then pass first under the Arc de Triomphe in Paris, and after that through the Marble Arch in London. All four of these archways were built by the same man. . . ."

This wonderful confusion of geography and of twenty centuries of architectural history failed to elicit any protest from the guide's listeners. Yes, Marino Marini was right. We are living on the eve of a catastrophe, though this catastrophe may turn out to be but the triumph of sheer ignorance and nonsense.

JOAN MIRÓ, *Equinox,* 1968

Joan Miró

B audelaire once compared the artist's lack of grace, in his bearing as an ordinary citizen in daily life, to the awkward gait of the albatross, a bird that compels our admiration and wonder when we see it soaring gracefully in the air but appears ridiculous to us when we see it waddling on dry land. I was painfully reminded of this simile throughout my very pedestrian conversations with the great surrealist painter Joan Miró.

When I first went to interview Miró in his Paris hotel, I found that I had to deal with a man who was articulate only in his art. If pressed to discuss his work, he remained notoriously vague and inexplicit, barely able to explain his activity as eloquently as a farmer might talk of his crops, a cobbler who is no Hans Sachs of the shoes that he mends. Miró's appearance was moreover that of a conformist Spanish businessman: short, stocky, gray-haired, he dressed very correctly and might more readily have been identified as a prosperous orange exporter than as one of the most revolutionary living painters.

Miró had come to the French capital from his home in the Balearic island of Majorca, to complete and supervise the work on the huge ceramic panels which he had been commissioned to execute for the garden of the new UNESCO building in Paris. Like many other successful artists, writers, publishers, literary agents, dealers in rare books, antiques or paintings and interior decorators, he had chosen to stay at the Left Bank Hôtel du Pont Royal, in the rue du Bac. It was there, in the somewhat conventional but luxurious lounge, just ritzy enough to satisfy the prestige needs of its Madison Avenue clientèle without at the same time sacrificing all its Left Bank charm, that I found myself face to face for the first time with this extremist among the painters of the previous thirty years.

How we had failed to meet before remains a mystery. In the heyday of surrealism, thirty years before, I had been one of the American contributors to the Paris expatriate periodical transition

who participated in a great number of surrealist activities. But Miró, even in his less conformist youth, had never been very gregarious. As we now met for the first time, he proved at first to be, like many surrealists, somewhat suspicious of me as a mere stranger, almost provincial or parochial in his aloofness. It took him quite a while to adjust himself to the idea that I was not a reporter from the daily press, trying to extract from him some sensational obiter dicta.

I saw Miró three times, in the lounge of his hotel, in less than a week. In several hours of uneasy discussion, I was finally able to obtain from him about as much information as from Chagall in half an hour. Often, I had to force Miró to express an opinion: "Do you believe that. . . ?" If I had formulated my question simply enough, his answer came as a monosyllable, without any qualification: "Yes," or "No." After that one syllable, I remained each time as if stunned, then had to dream up another leading question. Each time, as I pretended to take lengthy notes but was actually planning my strategy, there was an awkward silence: whole processions of angels seemed to pass through the lounge of the Hôtel du Pont Royal. Once, we were interrupted when Miró was called to the phone; a lengthy conversation in Catalan then ensued as Miró explained to his wife, in a veritable torrent of words, what an ordeal he was going through, and in what restaurant they would later meet to dine. I pretended not to have understood his Catalan.

E.R.: Is it your first experience of designing this kind of ceramic panel?

MIRÓ: Yes.

E.R.: Do you do all the work yourself?

MIRÓ: No.

E.R.: So you have an assistant?

MIRÓ: No. I paint the panels myself, but a qualified ceramist prepares the colors and later attends to the baking in the kiln.

E.R.: Charles Demuth at one time made a hobby of painting on porcelain. Technically, I suppose, your work is much the same.

*"When I first came to Paris, I felt that impressionism and
Fauvism were both dead, and that cubism was already
moribund. Only Dada seemed to me to be really alive."*

MIRÓ: Who is Demuth?

E.R.: A famous American painter, now dead.

MIRÓ: Never heard of him.

E.R.: Well, he isn't very well known in
Europe. But are your own panels only painted,
or are the designs also in relief?

MIRÓ: There are two large hollowed-out
forms in the panels, and I did that work, too.

E.R.: What are the dimensions of the panels?

MIRÓ: The first is fifteen meters by three; the
second, seven and a half meters by three.

E.R.: Are you working exclusively on these
panels for UNESCO while you are here
in Paris?

MIRÓ: No. I'm also supervising the printing
of my illustrations for Paul Eluard's poems
A toute épreuve.

E.R.: Is this an unpublished posthumous
work of your great friend Eluard?

MIRÓ: No. These poems had already been
published, but without illustrations.

E.R.: Is this to be like other books that you
have illustrated in the past?

MIRÓ: No.

E.R.: What will be the difference?

MIRÓ: These are my first woodcuts.

E.R.: How many are there?

MIRÓ: Eighty in all.

E.R.: Very few Paris artists of the past fifty
years have tried their hand at woodcuts. I
remember that Dufy once did a few, but
woodcuts seem on the whole to have been more
popular in Germany, above all among
the expressionists.

MIRÓ: *Tiens!*

*Miró was plainly surprised, if not pained. He
had apparently fancied himself almost as the dis-
coverer of a lost art. At this point, in despair, I
tried another approach.*

E.R.: A few months ago, a Dutch publisher
asked me to translate into English a book that
is entitled *Mondrian or Miró.*

MIRÓ: *Tiens!*

E.R.: The author, a Dutch critic, argued that

Mondrian's style is more universal in its appeal
because it remains faithful to a few "pure"
geometrical figures or forms which are arche-
types of aesthetic experience. He seemed to be
a believer in the psychology of Jung, and objected
to your kind of abstraction because he found it
too strictly personal or autobiographical — in
fact, too cryptic to enjoy any very broad validity.

*Miró's face expressed a puzzled surprise, if not
actual distress. As if I were a Grand Inquisitor
before whom he was afraid of committing a fatal
blunder, he refrained even from saying* Tiens! *I
resumed my monologue, though in a slightly less
aggressive tone.*

E.R.: Of course, I feel that Mondrian's
geometrical abstractions allow too little scope
for the human element which we are accus-
tomed to find in artistic expression. What do
you think of Mondrian?

MIRÓ: I have the greatest respect for him as
an experimental artist.

Miró was obviously playing safe.

E.R.: But do you believe that his art can lead
anywhere beyond what he himself had achieved?

MIRÓ: Well, it is a kind of dead end.

E.R.: In America, Mondrian has had several
disciples, many of whom only repeat what he
has already achieved, with at most but slight
variations or innovations. Do you think that his
importance may have been overrated?

MIRÓ: No. His work remains unique in the
art of his generation.

E.R.: But its very uniqueness makes me
sometimes wonder whether it is still art in the
same sense as the works of most of his contem-
poraries. Whereas the latter generally believed
in self-expression, Mondrian followed an ascetic
path of his own, always disdainful or suspicious
of any individualistic element of self-expression.
Would you consider yourself an abstract artist
in the same sense as Mondrian?

MIRÓ: No.

E.R.: Would you say that your work is at
all abstract?

94

MIRÓ: No.

E.R.: But many critics claim that your work of the past twenty years is abstract. When did you first begin experimenting in this style?

MIRÓ: Toward the end of the twenties. I have often been called an abstract painter, but it has never been my intention to be abstract.

E.R.: I suppose your designs might be called ideograms, like those of Chinese writing, rather than abstractions.

MIRÓ: Yes, they *are* ideograms.

Miró was visibly pleased with this definition. I felt that he was filing it away mentally for future use. At last, I seemed to have established what psychologists call "rapport" with this recalcitrant "patient."

E.R.: I remember one of your paintings of the twenties that impressed me particularly when I first saw it, and that I still consider a very important work. I mean your *Dutch interior.* I immediately recognized it as a kind of derisive parody of a Vermeer or a Jan Steen. It would interest me to know if my guess was correct.

MIRÓ: Yes, I had been on a vacation in Holland and had brought back to Paris some postcard reproductions of pictures that are in Dutch museums.

E.R.: Do you remember which particular Dutch painting you had in mind when you painted your own *Dutch interior*?

MIRÓ: No. I just had a lot of postcards and I suppose I must have chosen one of them.

E.R.: But your *Dutch interior* interested me as one of the earliest, finest and most explicit examples of a kind of derisive attitude toward the art of the past which has become increasingly important in some schools of modern art. Of course, one finds many examples of this attitude in the work of Picasso, in his compositions, for instance, on themes borrowed from the Turkish interiors of the eighteenth century Swiss painter Liotard, with their harem lovelies whom Picasso has transformed into dancing monsters. And Dubuffet has also, in recent years, developed a ribald style that is a derision of every style of art that has ever been claimed to be beautiful. But your own *Dutch interior* represents a more specifically Dada or surrealist kind of derision. I remember also an early Max Ernst painting that has a similar quality, though with a more literary or anecdotic content. It represents a very classical madonna, with the Child on her lap, but turned over for a spanking that she is administering diligently with her raised hand ready to strike.

MIRÓ: Yes. It was one of Ernst's Dada works.

E.R.: I suppose it was intended to shock in much the same way as the *Mona Lisa* to which Marcel Duchamp had added a moustache.

MIRÓ: Yes.

E.R.: But the derisive quality of your own work is no longer Dada, nor even strictly surrealist. I feel that you are very Spanish as an artist, and that your humor is often of the same kind as that of Goya. Spanish painters sometimes have a peculiarly fatalistic sense of humor. They seem to believe that the mere fact of being human — I mean our "human plight" — is in itself ridiculous and at the same time tragic.

MIRÓ: Yes, that is very Spanish.

E.R.: It is what disconcerted French classical critics in Spanish drama of the Golden Age. They objected to its mixture of tragic and comic elements. *Don Quixote* is also both tragic and comic.

MIRÓ: Yes.

E.R.: In France, Don Quixote is rarely considered a tragic figure, and the book is generally published as a comic work, a classic for children rather than adults.

MIRÓ: But it is a tragic work, too.

E.R.: I find a similar tragicomic quality in your famous *Dog barking at the moon.*

MIRÓ: Yes.

E.R.: Allowing for differences of style due to historical and personal reasons, it might well be considered a kind of *Capricho* like those of Goya.

MIRÓ: Yes.

E.R.: Of course, it is still one of your relatively early works and much more unequivocally figurative — in fact, more anecdotic — than your later works which have been called abstract. One might conclude that, in becoming less anecdotic, you have also become less strictly surrealist. In recent years, most other surrealist artists have no longer relied on their individual subconscious but have drawn more and more heavily on Freudian literature or on anthropological sources. Only you and Arp have chosen this path of near-abstraction, whereas Dali now gives us allegories rather than dreams.

MIRÓ: Do you plan to interview Dali, too?

E.R.: No.

MIRÓ: I would not like to be interviewed in a series that would also include Dali.

E.R.: I don't plan to interview Bernard Buffet either.

MIRÓ: That's good.

E.R.: But I do plan to interview Max Ernst.

MIRÓ: That's good.

E.R.: And Larionov.

MIRÓ: Never heard of him.

E.R.: Well, he's an elderly Russian painter who was one of the first to experiment in abstract art.

MIRÓ: I wouldn't know of his work if he doesn't live in Paris.

E.R.: But he has lived in Paris for more than forty years. To return to Dali, you nevertheless approved of his work at one time.

MIRÓ: Yes, when he was still a member of our surrealist group.

E.R.: That was the period of his soft watches, which were an authentic symbol, I suppose, of his own fears of impotence. Later, Dali seems to have overcompensated these fears by accumulating allegories and symbols which he borrowed from all sorts of other sources rather than from his own dream world. Then he became a latter-day symbolist, a painter in the same tradition as Arnold Boecklin, Max Klinger or Gustave Moreau, if not an outright pre-Raphaelite who had the misfortune to turn up a hundred years too late. But have you had occasion to see much of Dali in recent years?

MIRÓ: No. . . .

E.R.: When did you become a member of the surrealist group?

MIRÓ: In 1925.

E.R.: Did you participate actively in any surrealist demonstrations?

MIRÓ: I attended a few of their gatherings, such as their banquet in honor of the old poet Saint-Pol Roux, who came to Paris for the occasion from his retreat in Brittany. He seemed very bewildered among the surrealists. But I used to spend only half the year in Paris, at that time, and always went back to Spain, to spend the other six months in the country.

E.R.: Where did you live, when you first came to Paris?

MIRÓ: I stayed at first in a hotel, near the Bourse, to which I had been recommended by friends in Barcelona. The owner had relatives there, and most of the customers were Catalan businessmen. Later, I moved to the rue Blomet, on the Left Bank, where I occupied the studio of the sculptor Gargallo, who also spent half the year in Spain. I used to share it with André Masson, when Gargallo was away.

E.R.: Did you associate with Gertrude Stein and other American expatriates, as Picasso did in those years?

MIRÓ: No, but I met several of them casually.

E.R.: Why did you feel particularly drawn toward the surrealists?

MIRÓ: Painting had become a bit too restricted, in its style and subject matter, after the so-called heroic era of early cubism.

E.R.: I suppose you knew Juan Gris.

MIRÓ: Yes, I was often in his studio in Boulogne, on the outskirts of Paris. I saw him the last time only a few days before his death.

E.R.: What do you think of his last works, those that were exhibited for the first time only recently?

MIRÓ: I find them a bit frigid.

E.R.: Was Gris very enthusiastic about his own work, when he died?

MIRÓ: No, he was very perplexed and discouraged. But most of the cubists seemed to have lost their faith, in the early twenties.

E.R.: That was when former cubists like Le Fauconnier, Metzinger and Hayden abandoned cubism and tried their luck in less formalistic styles, reverting even, at times, to Fauvism and to a kind of post-impressionism. It was then, too, that Picasso went through his classicist period. But you were never tempted to adopt any of these more traditional styles.

MIRÓ: No. When I first came to Paris, I felt that impressionism and Fauvism were both dead, and that cubism was already moribund. Only Dada seemed to me to be really alive.

E.R.: Had there been any Dadaists in Spain?

MIRÓ: Only a few poets, Alberti, Guillermo de Torre, and the Chilean poet Huidobro, among others.

E.R.: Did you ever meet García Lorca?

MIRÓ: No. We always missed each other, whether in Paris, Barcelona or Malaga.

E.R.: Who were your closest friends among the surrealists?

MIRÓ: The painter André Masson, with whom I shared Gargallo's studio, and the poets Robert Desnos and Paul Eluard.

E.R.: If I remember right, Desnos also lived

in that studio, at number 45 of the rue Blomet. I called for him there one evening, and we went to the Bal Nègre with a whole group of friends.

Miró seemed quite surprised that we should ever have had any friends in common. It upset all his preconceived notions of me as an American journalist who had no roots in Paris and was more interested in news than in art.

MIRÓ: So you knew Desnos?

E.R.: I translated some of his poems for *transition.*

MIRÓ: *Ah!* transition. *C'était la belle époque!. . .*

As we reached the end of the third and last of our talks, I may have unwittingly expressed my sense of relief, perhaps in an indecently audible sigh. But Miró was visibly even more relieved than I. When we parted, he had the air of a visiting Spanish businessman who had just been quizzed by an over-inquisitive reporter from a trade paper. He had done his duty, had avoided giving any unnecessary information, and would be able to report the whole incident satisfactorily, on his return home, to his Chamber of Commerce. Later, as I went through my notes of our talks and prepared the final draft, it occurred to me that he had perhaps been interviewing me. One thing was clear: to those who fail to find a satisfactory explanation of Miró's art in his actual works, no more explicit verbal explanation can ever be expected from the artist himself. Miró remains one of those rare artists to whom the magic of their own creative activity poses no problems. They accept it as something that requires no discussion, no explanation. It is their only way of being articulate, as natural to them as speech is to most of us.

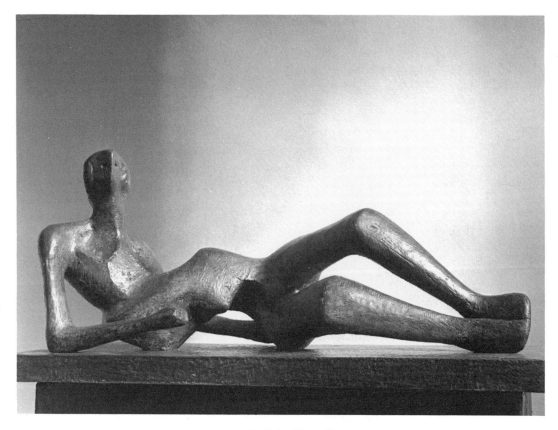

HENRY MOORE, *Reclining Figure No. 2*, 1953

Henry Moore

*I*f art, in our age, has followed an evolution similar to that of industry and concentrated power or prestige in the hands of an oligarchy of "captains," then Henry Moore deserves, with Picasso and one or two other painters and sculptors, to be called indeed a "captain of art." Though friendly and accessible by nature — in fact, unaffected and sociable as most of the Yorkshiremen whose literary spokesman J. B. Priestley had long been — Henry Moore soon found himself involved in such a multitude of activities that it required weeks, if not months, to obtain the necessary audiences with him, between a trip to Poland where he had been invited to join an international jury to select the prize-winning project for a monument to be erected on the site of the former Nazi extermination camp in Auschwitz, and the numerous trips he also had to make to Paris, in order to complete his assignment for the new UNESCO building, or to Italy where some of his figures were being cast. Throughout Europe, all available foundries seemed to be busy casting bronzes for Henry Moore; bottlenecks in this production again and again called for his "executive action," and Moore's forthcoming New York exhibition even had to be postponed in order to allow more time for its multiple and complex preparations. When, in the course of our interviews, I casually mentioned a small West Berlin foundry that had once worked for Gerhardt Marks, its name was promptly noted by Moore's secretary, who was instructed to find out if it could still accept orders.

I had already been impressed by this tremendous activity in the course of the phone calls and correspondence that prepared the way for our actual meeting; this impression was only strengthened by my two visits to Henry Moore's home and his studio in Perry Green, near Bishop's Stortford, in Hertfordshire. The sculptor's efficient and devoted secretary worked full time answering his voluminous mail, filing new photographs of him and his work, selecting them out of these files for forthcoming publications, while Mrs. Moore ran the large house equally

efficiently. Whether Moore was at home or away on one of his trips, his secretary continued to work, while his own production continued unabated, with the help of assistants either in the indoor studio that was a separate building next to the house or in a large semi-outdoor studio that one reached beyond the bottom of the garden after crossing an expanse of meadow dotted with occasional works of the master. As one wandered around the meadows that Moore was gradually transforming, all around his house, into a new kind of park, one encountered a number of these sculptures, set among the lawns and the trees according to principles that seemed more intuitional than rational, as if Henry Moore, whether consciously or unconsciously, were emulating the Zen landscape gardeners of classical Japan rather than the kind of jardin à la française that Lenôtre devised for the royal parks of Versailles, Saint-Germain-en-Laye, Marly, Saint Cloud, the Tuileries and the Luxembourg, or the less formal achievements of Capability Brown in the park at Chatsworth Hall.

When I was at last fortunate enough, between my own occupations and the sculptor's numerous trips abroad, to arrange for an interview, Moore had just returned from a trip to Paris, and we began discussing his figure for the new UNESCO building. He admired the latter for its spatial conception of architecture and its monumental quality.

E.R.: The London press has in recent weeks quoted or misquoted you very widely and stated that, before starting work on your UNESCO assignment, you spent three or four months meditating on the meaning of UNESCO. Some years ago, when I obtained my first assignment as a free-lance interpreter for UNESCO, my mother was surprised that a Rumanian violinist should require the services of a full-time interpreter. I hope you began your meditations on the meaning of UNESCO more auspiciously than my mother. . . .

MOORE: The press has very much exaggerated this aspect of my approach to the UNESCO

99

"[A sculpture] should always give the impression, whether carved or modeled, of having grown organically, created by pressure from within."

assignment. My friend Julian Huxley, the first Director General of UNESCO, told me what he considered to be the purpose and meaning of UNESCO, and this was, of course, a help to me in first formulating my thoughts on the subject.

E.R.: To me, it all sounds like a nineteenth century assignment to design an allegorical group to be set above the main entrance of the building. I mean something like: "The United Nations coordinating the efforts of Education, Science and Culture and guiding Mankind in its search for Peace." I'm quite surprised that you didn't finally plump for a draped figure with a lantern held high, at arm's length, above its head.

MOORE: Eventually, after discarding many preliminary studies, I decided on a reclining figure that seeks to tell no story at all. I wanted to avoid any kind of allegorical interpretation that would now seem trite. This particular reclining figure has perhaps turned out to be one of those that Sir Philip Hendy has called my "wild ones."

E.R.: How would you define your "wild ones"?

MOORE: Well, they are sculptures which are inspired by general considerations of nature, but which are less dominated by representational considerations, and in which I use forms and their relationships quite freely.

E.R.: Your "wild ones" are in a way what Goethe might have called your more "dionysiac" sculptures.

MOORE: I suppose so. I enjoy working in the open air, and I have always regarded sculpture as an "outdoor" art. That is why I make most of my larger sculptures in the open, and often set them up in the garden, so that I may also judge them from various distances. It is quite difficult to imagine, in the more or less artificial light of a well-planned studio, what outdoor light can do to a sculpture. A dull cloudy day with a diffused light demands a contrast in direction and size of masses and planes in a

sculpture, all the more so since details and relief effects will hardly show. In England, in particular, where we have so many sunless days, this is, for outdoor sculpture, a primary consideration. But it only means that sculpture is three dimensional, and such principles apply to smaller works, too, though they will perhaps be seen only indoors. Besides, a piece of sculpture that looks well in a poor light will always look better in a good light. I generally work on my smaller figures in the studio near the house. It's a converted stables building, and I also use it for patinating and finishing some of my larger works, and for storing unfinished projects. The larger outdoor studio is more convenient for work on major projects.

E.R.: With so much work on hand, you must keep several assistants busy.

MOORE: I have only one full-time permanent assistant, but right now I'm also employing a student from the Slade School for the duration of his holidays and two others as well on a temporary basis.

As we spoke, Moore led me out of the house into the smaller studio. Though crowded with examples of his work of the previous few decades, with unfinished projects and sketches, with all sorts of odds and ends, it was surprisingly tidy. On a series of shelves, for instance, I saw a strange assortment of curiously formed pebbles, bones of animals, odd pieces of driftwood. Henry Moore picked one up absentmindedly and began to finger and feel it; obviously, the curves of these smooth surfaces shaped by nature fascinated him and such natural objects are to be counted among his sources of inspiration. On a table, a number of photographs of his work were scattered. He selected a few of them and began to show them to me.

MOORE: Here you can see what I mean when I say that I enjoy working in the open air and creating figures that are intended to be placed in natural lighting and natural surroundings. This is a picture of my *King and Queen* group as it has been set on a moor near Dumfries, by a

Scottish collector. The figures are standing on a natural rock base. The same collector also has my larger *Cross* and several other monumental figures, all out on the moors that surround his Dumfriesshire farm. Such open-air sculptures must be understood as three-dimensional forms, in terms of changing lights and shadows on their surfaces, and not solely as outlines standing out against the sky, though of course the silhouette also matters.

E.R.: But don't you find it difficult to work all through the year, in the British climate, in an open-air studio?

MOORE: Adrian Stokes once wrote to me in a letter that I am the only sculptor who has come to terms with the English weather. . . .

E.R.: In that respect, you're a bit like the legendary Hassidic rabbi who decided, contrary to all the prescriptions of the Jewish faith, to travel on a Sabbath; to his left and to his right, it was Sabbath; ahead of him, it was Sabbath, too; behind him, it was again Sabbath. But he managed to walk ahead in a tiny sphere of non-Sabbath that he had miraculously created around himself. I suppose you achieve a similar miracle and create a tiny world of weather that isn't English, like a cocoon of sunshine around your open-air studio.

MOORE: On the contrary — I work out of doors throughout the whole year and never attempt to ignore the English weather, but rather to use it. Here you can see the model of the figures of the *Four Elements* that I did for the Time and Life building in Bond Street. In this model, they are movable. I had planned to place them on pivots, so that they could be turned every once in a while, which would have allowed them to be seen from changing aspects, thus emphasizing their three-dimensional quality. But the London County Council seemed to think that this was dangerous. They objected that the figures might fall on passers-by, so they were finally made immovable.

We had already wandered out of the studio, across the garden and into the meadows, where Moore had placed several of his larger sculptures. We paused in a kind of bower, where his huge bronze nude, entitled Seated Woman, *was surrounded by young trees and shrubs. Henry Moore caressed the back of the bronze figure, almost absentmindedly or ritualistically.*

MOORE: You know, whenever I see this figure I am reminded of a boyhood experience that contributed toward the conception of its form. I was a Yorkshire miner's son, the youngest of seven, and my mother was no longer so very young. She suffered from bad rheumatism in the back and would often say to me in winter, when I came home from school: "Henry, boy, come and rub my back." Then I would massage her back with liniment. When I came to model this figure which represents a fully mature woman, I found that I was unconsciously giving to its back the long-forgotten shape of the one that I had so often rubbed as a boy.

E.R.: It is a phenomenon of tactile memory very much like the remembered taste of the *madeleine* dunked in tea that inspired Marcel Proust's *Remembrance of Things Past.*

MOORE: Tactile experience is very important as an aesthetic dimension in sculpture. Our knowledge of shape and form remains, in general, a mixture of visual and of tactile experiences. A child learns to judge distance by touching things, and our sense of sight is always closely associated with our sense of touch. That is why a blind man learns to rely more exclusively on the use of his hands. A child learns about roundness from handling a ball far more than from looking at it. Even if we touch things with less immediate curiosity, as we grow older, our sense of sight remains closely allied to our sense of touch.

E.R.: I used to know a German Orientalist, the late Professor Erwin Rumpf of Berlin, who was reputed to be one of the very rare Westerners to have an instinctively true appreciation of Japanese art. He once explained to me that the aesthetics of the Japanese Netzuke figures — those little carved ivories that were used as buttons — required that the whole object be understood or read by feeling as explicitly as by seeing, and that Japanese art lovers fondle them and comprehend the whole sculpture with the use of one hand.

MOORE: Blind persons have been known to model sculptures which are visually exciting. Still, there are limitations to the proportions of a blind artist's sculpture. Size would pose a great problem, and it would be almost impossible to conceive a very large figure, with a proper integration of the relationships of its masses as parts, without ever being able to have recourse to one's sight. Some people, misunderstanding

the nature of tactile values, and perhaps wishing to be fashionable, will often say: "I love touching sculptures." That can be nonsense. One simply prefers to touch smooth forms rather than rough ones, whether these forms be natural or created by art. Nobody can seriously claim to enjoy touching a rough-cast sculpture, with its unpleasantly prickly surface that may be nonetheless good sculpture. No one likes touching cold and wet objects, for example. A sculpture may thus be excellent according to quite a number of different criteria and still be unpleasant to touch. But the tactile element remains of primary importance in the actual creation of most sculpture.

E.R.: Berenson has already discussed at great length the tactile qualities of a certain kind of painting, especially of the more sculptural art of Piero della Francesca or of Mantegna. But painting can suggest a whole range of tactile qualities, not only a sculptural awareness of roundness of relief that is suggested by Mantegna and Piero della Francesca, but also the awareness of texture that is suggested in a Courbet still life, where the feathers of a pheasant and the fur of a hare can almost make your fingers tingle. . . .

MOORE: But these last tactile qualities of painting can also degenerate into a kind of cheap illusion, like that of a performing magician. They exist, in a way, in sculpture, too — for instance, when a marble or bronze suggests the silky texture and the softness of human flesh. Actually, this is fairly easy to achieve, and many an outstanding sculptor is popularly admired for the finish that his assistants have given to his works.

E.R.: I have often been struck by the essentially tactile nature of certain distortions of the human form in your sculpture. It has seemed to me that these are sometimes inspired by tactile illusions of feeling, as opposed to the optical illusions that inspire most distortions in art.

MOORE: You are right. I believe that there can be distortions, tactile rather than visual in origin, which can make a sculpture much more exciting, though they may give an impression of awkwardness and disjointedness to an art lover who is more accustomed to the distortions of painting. Sculpture with such tactile exaggerations can be so much more exciting than the smooth and merely pictorial ease that characterizes most bad nineteenth century sculpture.

E.R.: I have often felt that only Carpeaux, Rodin and Medardo Rosso, in the whole second half of the nineteenth century, really understood the purposes and the principles of sculpture.

MOORE: Rodin, of course, knew what sculpture is: he once said that sculpture is the science of the bump and the hollow.

E.R.: I was interested to observe, when I visited recently the great retrospective show of works of Jacques Lipschitz in Munich, that this one-time master of cubist sculpture seems now to have reverted to a style in which I could feel a profound sympathy with Rodin.

MOORE: Lipschitz is, of course, a good sculptor. I would include some of his cubist works among the best sculptures of his generation.

E.R.: To me, cubist sculpture has always seemed a bit illogical. After all, the great innovation in cubist painting consisted in introducing certain sculptural effects and principles into the two-dimensional world of the canvas. In borrowing this sculptural style from painting, cubist sculpture becomes a kind of *reductio ad absurdum*. Lipschitz seems to have been aware of this when he created his bronze still-life panels that are like paintings deprived of color. . . . But I would like to ask you now what you think of the so-called Renaissance of sculpture in England today. It has been frequently observed that England has never had so many outstanding sculptors, and that Italy and England, since 1945, are the only European nations to have a "native" School of Sculpture. A few weeks ago a Yorkshire museum was even able to organize an exhibition of five contemporary Yorkshire sculptors that included you, Barbara Hepworth and Armitage. . . .

MOORE: I suppose that the success of one sculptor may inspire others. One young sculptor told me that he was planning to be a doctor when he chanced upon an article about me and changed his mind. When Epstein and I achieved a certain international reputation, I suppose this fact encouraged some young people to turn to sculpture. After all, it's in a way like tennis playing or dancing. If a local boy makes good, then all the ambitious local mothers want their boys to make the same career, and then you suddenly have a local tradition or

a local school of art. Nevertheless, I believe that Yorkshiremen also have a very direct and realistic attitude toward life that can be useful to a sculptor. A sculptor must be practical. All day he is handling materials and tools that require truly practical skills. He must also be able to supervise the casting and handling of his works. Coping with this UNESCO assignment was thus a major physical undertaking. It made me realize that the great Renaissance painters and sculptors were often men of terrific power and energy as sheer workmen. Some were builders, designing whole rooms before decorating them with murals. Besides, they had to make and mix all their own colors, and the physical effort of working on high scaffoldings, to paint vaulted ceilings, must have been tremendous.

E.R.: The physical effort required of a sculptor may explain why, in the past, there have been so few famous sculptresses. Chana Orloff was probably the first important non-amateur woman sculptor. This reminds me of one of Humbert Wolfe's poems:

> Queen Victoria's
> Portrait is
> The work of her daughter
> Beatrice. . .

I think this sculpture, by a Royal amateur, still stands in Kensington Gardens. But what do you consider the most important aspect of sculpture?

MOORE: Sculpture, for me, must have life in it, vitality. It must have a feeling for organic form, a certain pathos and warmth. Purely abstract sculpture seems to me to be an activity that would be better fulfilled in another art, such as architecture. That is why I have never been tempted to remain a purely abstract sculptor. Abstract sculptures are too often but models for monuments that are never carried out, and the works of many abstract or "Constructivist" sculptors suffer from this frustration in that the artist never gets around to finding the real material solution to his problems. But sculpture is different from architecture. It creates organisms that must be complete in themselves. An architect has to deal with practical considerations, such as comfort, costs and so on, which remain alien to an artist — very real problems that are different from those which a sculptor has to face.

E.R.: I once read in a history of ancient art that the pyramids were originally conceived as artifical mountains by a race that had migrated from a mountainous area, where it performed its religious ceremonies on mountaintops, into a region of plains. Even the most abstract or least practical kind of architecture, it seems, was originally conceived for a practical purpose.

MOORE: Yes, some architecture may be an imitation of nonliving nature, whereas sculpture derives from living nature. Even my most abstract forms, my stringed figures of 1938, are based on living creatures. This one, for instance, has a head and a tail. It's basically a bird.

E.R.: What other qualities do you require of a sculpture?

MOORE: A sculpture must have its own life. Rather than give the impression of a smaller object carved out of a bigger block, it should make the observer feel that what he is seeing contains within itself its own organic energy thrusting outward — if a work of sculpture has its own life and form, it will be alive and expansive, seeming larger than the stone or wood from which it is carved. It should always give the impression, whether carved or modeled, of having grown organically, created by pressure from within.

It was already dark as we returned from the outdoor studio to the house. I had ordered a cab to take me back to the station in time for my train to London. The cab was there. We parted rather hurriedly. In the train, I thought that few artists, in our age, are as completely conscious of their aims as Henry Moore, as naturally explicit.

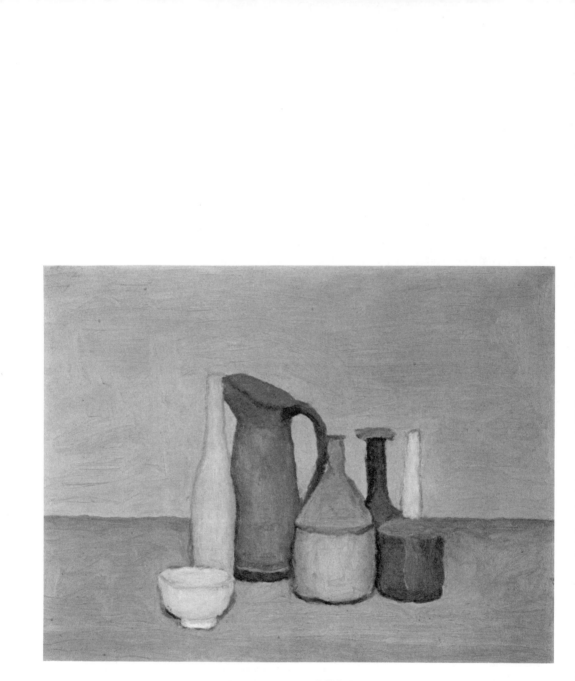

GIORGIO MORANDI, *Still Life,* 1952

Giorgio Morandi

1958

*M*any of the more important artists of our age, such as Picasso, Braque and the majority of the younger abstract or nonobjective masters, have generally communicated to us their subject matter, however private or cryptic, in an idiom that is strikingly public, if not rhetorical or declamatory. Paul Klee has been, in this respect, a notable exception.

Among the less cryptic modern artists whose works describe a recognizably objective world, Giorgio Morandi seemed to be committed to a kind of modesty or privacy very similar to that of Klee. For many years, Morandi remained almost unknown, even in his native Italy. Only since 1948, when he suddenly acquired an international reputation, did collectors and dealers throughout the world begin to add their names to a long waiting list for the four or five pictures that he managed to finish each year. A veritable legend about Morandi's strangely retiring manner then spread from Bologna, where he lived, as far as California, Brazil and Japan.

When I met him in 1958, Giorgio Morandi was sixty-eight years old. A tall, lean, gray-haired and scholarly man, he avoided, in his dress and manner, everything that might suggest an artist's reputedly Bohemian way of life. True to the traditions of the North Italian middle class of the provincial cities, he was leading the same kind of restricted social life as most of the older university professors and professional men of his native city, but with an additional touch of purely personal modesty, shyness and asceticism that marked him at once as an eccentric in his own quiet way.

Morandi lived nearly all his life in the same old-fashioned apartment that had once been the home of his parents, in one of the narrow arcaded streets of the ancient heart of Bologna. He had never married; neither had the three elderly sisters with whom he shared his home and whom, however experienced and respected they might be in their profession as teachers, he always treated as if they were still very young women in constant need of his guidance and

protection. To reach the room that he used as a studio, he went through those where his sisters slept and spent much of their spare time. He always knocked on their door and paused a while, to avoid disturbing them, before daring to enter his studio or to return from it to the front part of the apartment.

In his small living room and dining room, both furnished in a very conventional late nineteenth century style, a few remarkably fine paintings hung on the walls: a small Jacopo Bassano, one of those scenes from the Scriptures that the Venetian master depicted entirely in terms of the rustic life of his own region and age, and two of those studies where Giuseppe Maria Crespi, the Bolognese Baroque painter, so successful in obtaining commissions for large and melodramatic religious compositions, also proved his real talent as a precursor of Greuze and the eighteenth century French "intimist" or "bourgeois" artists whom Diderot loved so dearly. One of Morandi's Crespi studies represented rather charmingly in oils a young woman, viewed from the rear as she sat at her dressing table, with her face reflected in a mirror. The very choice of these few paintings revealed Morandi's preference for an art that is neither too aristocratic nor too public. Like the great French impressionists, he remained committed to the standards and tastes of a stable middle class, a firm believer in the aurea mediocritas of the poet Horace. In our age of mass culture, an old-world charm, in fact, a certain informal courtliness about his modesty and discretion, characterized Morandi's manner and way of life, those of a vanishing class.

There was an element of discretion, of scrupulous exactitude, even of formality, in the very manner of our interview. We faced each other, as we sat at the dining room table in the otherwise deserted apartment, and Morandi allowed me, as we spoke in Italian, as much time as I might need to note in full what he had said. Later, he was very scrupulous, too, about revising the draft of my interview which I submitted to him in English, but which he asked a friend to translate into Italian before he returned it to me, many months later, with all his corrections.

At first, I explained to him how I had already

"I believe that nothing can be more abstract, more unreal, than what we see."

interviewed other artists, such as Marc Chagall and Marino Marini.

MORANDI: It would be difficult for me to speak to you, as Chagall apparently did, in auto-biographical terms. I have been fortunate enough to lead, unlike Chagall, an uneventful life. Only on very rare occasions have I ever left Bologna, my native city, and the surrounding province of Emilia. Only twice, for instance, have I been abroad, once when I crossed the frontier into Switzerland, a couple of years ago, to see an art exhibition in a resort on the shores of one of the Swiss–Italian lakes. Besides, I speak only my native language, as you see, and read only Italian periodicals.

E.R.: So you are perhaps the only major living artist who has never felt the urge to go to Paris . . .

MORANDI: Don't misunderstand me, please. When I was in my early twenties, my highest ambition was to go abroad and study art in Paris. Unfortunately, the material difficulties involved were too great, and I was obliged to remain in Italy. Later, I had too many respon-sibilities, with my teaching and my family, and never managed to go abroad.

E.R.: Do you think that your evolution as a painter might have been different, had you been able, as a younger man, to study art in France?

MORANDI: No. If anyone in Italy, in my gener-ation of young painters, was passionately aware of new developments in French art, it was I. In the first two decades of this century, very few Italians were as interested as I in the work of Cézanne, Monet and Seurat. . . .

E.R.: You seem to insist very much on the element of privacy in your life. Is that why you have never been active in any group or school of modern art?

MORANDI: You might think that I have delib-erately avoided every direct contact with the main currents of the contemporary art world, but this isn't really true. I am essentially a painter of the kind of still-life composition that

communicates a sense of tranquility and pri-vacy, moods which I have always valued above all else.

E.R.: This intimate quality of your still-life compositions has prompted several critics to call you the Chardin of Italy.

MORANDI: No comparison could flatter me more, though my favorite artist, when I first began to paint, was actually Cézanne. Later, between 1920 and 1930, I developed a great interest in Chardin, Vermeer and Corot, too.

E.R.: In a book of reproductions of your works, I saw recently that some of your earlier paintings are composed in a much less personal style — in fact, in a style very reminiscent of that of Cézanne and those early cubists, especially Juan Gris, who had begun by imitating his later manner.

MORANDI: An artist's early works are nearly always five-finger exercises which teach him the principles of the style of an older generation of artists, until he himself is mature enough to formulate a style of his own. That is why you have been able to detect in my works of between 1912 and 1916, some recognizable influ-ences of the early Paris cubists and, above all, of Cézanne.

E.R.: In the same book of reproductions of your works, I also noted that you then painted still-life compositions, between 1916 and 1919, with lay figures, or rather milliners' busts, like those that one also sees in some of the *pittura metafisica* compositions of Carlos Carrà and Giorgio De Chirico.

MORANDI: But my own paintings of that period remain pure still-life compositions and never suggest any metaphysical, surrealist, psychological or literary considerations at all. My milliners' dummies, for instance, are objects like others and have not been selected to suggest symbolical representations of human beings of legendary or mythological characters. The only titles that I chose for these paintings were conventional, like *Still Life*, *Flowers* or

Landscape, without any implications of strangeness or of an unreal world.

E.R.: In a way, you might then be called a Purist, as the painters Léger and Ozenfant called themselves in Paris, around 1920.

MORANDI: No, there is nothing in common between any works of mine and those of the Paris Purists. The only kind of art that has continued to interest me, ever since 1910, has been that of certain masters of the Italian Renaissance — I mean Giotto, Paolo Uccello, Masaccio and Piero della Francesca — then also that of Cézanne and the early cubists.

E.R.: Have you always preferred to paint still-life compositions?

MORANDI: In that book, you surely saw that I also continued for a long while to paint occasional flower-pieces and landscapes, too. Besides, I have also painted three or four self-portraits. . . . I suppose I remain . . . a believer in Art for Art's sake rather than in Art for the sake of religion, of social justice or of national glory. Nothing is more alien to me than an art which sets out to serve other purposes than those implied in the work of art in itself. . . .

I believe that nothing can be more abstract, more unreal, than what we actually see. We know that all that we can see of the objective world, as human beings, never really exists as we see and understand it. Matter exists, of course, but has no intrinsic meaning of its own, such as the meanings that we attach to it. Only we can know that a cup is a cup, that a tree is a tree. . . .

E.R.: . . . Is there any connection between your own philosophy of art and your apparent reluctance to produce as many works as most other contemporary painters of your international standing?

MORANDI: I suppose my works are less numerous, but this is a fact which I have never pondered and which does not really interest me. All in all, I must have produced by now some six hundred paintings, and only four or five a year now that I am having so much trouble with my eyesight.

E.R.: This means an average of barely one painting a month, if you began your career at the age of twenty.

MORANDI: But there is another problem involved here. I have always concentrated on a far narrower field of subject matter than most other painters, so that the danger of repeating myself has been far greater. I think I have avoided this danger by devoting more time and thought to planning each one of my paintings as a variation on one or the other of these few themes. Besides, I have always led a very quiet and retiring life and never felt much urge to compete with other contemporary painters, whether in terms of productivity or of exhibitions.

E.R.: Would you now advise a younger artist to follow the footsteps of the masters of contemporary nonobjective art, or to return, as some painters now propose, to a more figurative conception of art?

MORANDI: When I was young, I never felt the need to ask anyone for advice of that kind. My only source of instruction has always been the study of works, whether of the past or of contemporary artists, which can offer us an answer to our questions if we formulate these properly. But those younger painters of today who really deserve this appellation as well as our attention would refuse, quite properly, to accept any gratuitous advice of the kind that you seem to suggest. I respect the freedom of the individual and especially of the artist, so that I would not be of much use as a guide or instructor, nor have I ever wanted to be one, even when I have been asked to undertake the job. When most Italian artists of my own generation were afraid to be too "modern," too "international" in their style, not "national" or "imperial" enough, I was still left in peace, perhaps because I demanded so little recognition. My privacy was thus my protection and, in the eyes of the Grand Inquisitors of Italian art, I remained but a provincial professor of etching, at the Fine Arts Academy of Bologna.

E.R.: You said just now that you had never been very willing to accept the responsibilities of teaching and giving advice. Yet you taught etching for many years.

MORANDI: I accepted to teach etching because it implies exclusively the teaching of techniques.

E.R.: In our discussion, you have mentioned so far only great painters, never any of the recognized masters of etching. Would this mean that you have always considered yourself a painter rather than an etcher?

MORANDI: For me, it's all the same thing, the

only difference consisting in the actual techniques of expression.

E.R.: I suppose, however, that the teaching of etching does not generally imply the same kind of discussion of the nature and objectives of art as the teaching of painting. In most academies, etching is taught as a kind of sideline — I mean as a technique rather than as a style.

MORANDI: That is exactly why I preferred to teach etching.

E.R.: Still, I suppose that there are some masters of the craft of etching whose works you particularly admire.

MORANDI: Of course, and I prefer those who were also painters, *les peintres graveurs,* especially Rembrandt and Goya, whose etchings are as great works of art as their paintings. As for myself, I have etched mainly between 1912 and 1915, then again from 1921 until quite recently. My last etching is of 1956. I did it for the catalogue of my complete etchings which was published by Einaudi in Torino a couple of years ago.

As I was about to leave, Morandi offered to show me his studio, after taking the usual precautions so as not to disturb his sisters. But they were not in their room, when he knocked on the door, and I passed through it as I might have passed through a deserted harem, almost on tiptoe and without daring to look to right or left. In the studio, a few unfinished paintings were hanging on the walls. Some very dusty household utensils, the familiar bottles and glasses and boxes, were grouped here and there on tables, in still-life arrangements. One or two of the unfinished paintings were surprisingly bright-colored: in a finished Morandi, there are layers of concealed colors, bright reds and blues that give a warm glow to the grays and whites of the surface, just as there might exist bright colors, beneath the thick fuzz of neutral dust that covers them, on the actual porcelain or glass objects that Morandi painted.

As we parted, a few moments later, I was again reminded of a line of Horace: Integer vitae scelerisque purus. *Since I had last nibbled, somewhat tremulously, a digestive biscuit over a cup of tea with T. S. Eliot in his office on Russell Square two years earlier, I had not experienced again this feeling of being in the presence of a sage, if not of a saint. Later, when I wrote to Morandi to obtain his approval of the written version of our talk and spent many hours translating into English the scrupulously considered corrections, improvements or additions that he had written into an Italian translation of my original English draft, I was reminded again and again of the atmosphere of these rooms in Bologna where everything, however small or unimportant in the eyes of others, seemed to have in his own eyes meaning and value, if not dignity, too.*

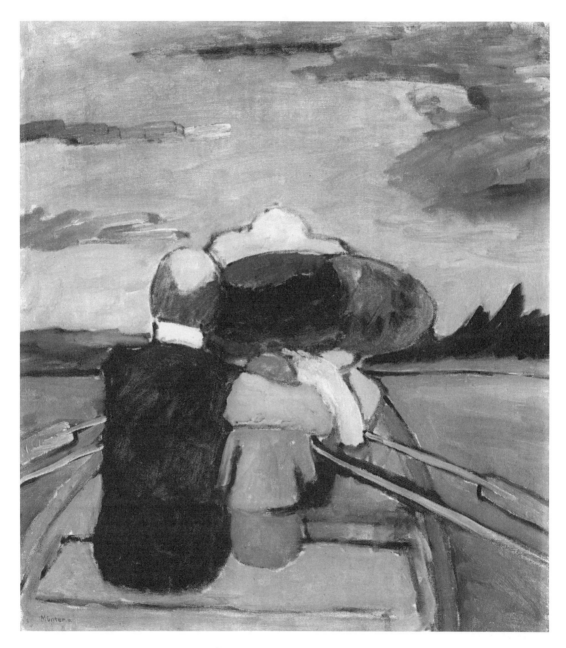

GABRIÈLE MÜNTER, *Kahnfahrt*, 1910

Gabrièle Münter

Munich celebrated on a grand scale, in 1958, the presumed eight-hundredth anniversary of its somewhat legendary foundation. Among other attractions planned to draw every kind of tourist to the capital of the former Kingdom of Bavaria, an exhibition of modern art, in the Haus der Kunst, set out to stress the city's contributions, as an international center, to the great movement which began about a hundred years ago with the realism of Gustave Courbet and the French painters of Barbizon, and has now reached, in an unprecedented swing of the pendulum of taste, the opposite extreme of abstract, nonobjective or non-formal art.

Accustomed to the values and tastes that are currently respected by most museum directors, critics, historians, dealers and collectors throughout the Western world, many a visitor from abroad may have made, in this Munich exhibition entitled Aufbruch zur modernen Kunst, some unexpected discoveries. For instance, Gustave Courbet, when he came to Munich in 1869 as one of the foreign guests of honor of the city's First International Art Exhibition, had immediately found, in the German painter Wilhelm Leibl's circle of associates and pupils, a school of kindred spirits who set themselves the same ideals and aims as he and his French followers. Courbet's own exhibits, Les casseurs de pierres and L'halali du cerf par temps de neige, indeed roused less antagonism in Munich than his realist works currently did in Paris, where such academic painters as Franz Xaver Winterhalter and Jean-Léon Gérôme were among the only artists to receive official recognition. After being awarded, together with Camille Corot, a decoration offered by the Bavarian State, Courbet wrote a number of surprisingly ungrammatical if not altogether illiterate letters to his Paris friend Castagnary, to whom he pointed out that the Bavarian monarchy apparently granted to a jury of artists more freedom than "government action" could tolerate in Napoleon the Third's police state.

Nor had Courbet's friend Wilhelm Leibl, with Wilhelm Trübner, Hans Thoma, Karl Schuch and the other disciples whom Leibl had attracted, established in Munich but a group of isolated or freakish local geniuses. These artists had found their way to the Bavarian capital from almost every region of Germany and soon included in their ranks even a couple of gifted young natives of distant America, the painters Frank Duveneck, from Kentucky, and William Merritt Chase, from Indiana. For all their devotion to the beauties of the South Bavarian Alpine landscape and their interest in depicting local peasant types, the Munich realists remained indeed an international rather than a regional school of art, and their contacts with other schools of the same general persuasion ranged from Leibl's personal friendship with Courbet to an awareness and an understanding, among his followers, of the aims of the French Barbizon painters, of the Tuscan Macchiaioli such as Fattori, Lega, D'Ancona and da Tivoli, of the Milanese group gathered round Mosé Bianchi, and of the Dutch painters of The Hague, such as Jan Hendrik Weissenbruch, who were later destined to number Vincent van Gogh among their disciples. In Munich, in Barbizon, in Holland and in Northern Italy, four different schools of realist painters were then practicing the same kind of plein-air painting as the French impressionists are often believed to have initiated. In the works of all these realists, one can detect the same interest in sheer painting as opposed to academic smoothness, and in everyday life as opposed to the tableau-vivant historical reconstructions of the later Romantics — in fact, in those qualities of painting that French critics now call matière and intimisme. Whatever their national origin, the realists were guided by a passionate reverence for the truthfulness and sobriety of such old masters as Rembrandt and Franz Hals in Holland and Velasquez and Zurbaran in Spain. Many a portrait painted in Munich by Leibl is thus of the same rare quality as those that Monet was then beginning to paint in Paris, and many a landscape by Hans Thoma or a still-life by Karl Schuch has the same luscious sensuality of color

"My pictures are all moments of my life . . ., instantaneous visual experiences, generally noted very rapidly and spontaneously. When I begin to paint, it's like leaping suddenly into deep waters, and I never know beforehand whether I will be able to swim . . . it was Kandinsky who taught me the technique of swimming."

and of texture as some of the less rhetorical master-pieces of Courbet.

Munich continued moreover to be one of Western Europe's most creative art centers for a good half century. After being the home of the German realists, it saw the emergence of the so-called New Dachau School of contemporaries of the later Paris impressionists. The importance of their leading spirit, the painter Adolf Hoelzel, as one of the first practitioners of abstract art, if not the actual source of some of Kandinsky's theories, has begun to be appreciated, even in Germany, only in recent years. The 1958 Munich exhibition very judiciously stressed Hoelzel's significance as a link between the earlier realists and some later schools that became increasingly idealist or abstract in their styles. In addition, it devoted due attention to two other remarkable movements which flourished in and around Munich between the turn of the century and the collapse of the Weimar Republic: the Munich School of Jugendstil, which overshadowed for a while the Viennese Sezession as well as the art nouveau of Paris, and the Blue Rider School which, in the works of Klee, Kandinsky, Jawlensky and a few of their friends, has now influenced the art of a whole generation of younger painters in France, England, the United States and even distant Japan.

The Munich retrospective exhibition of works of the Blue Rider School may have been disappointing in that it included few of the more famous masterpieces of Klee, Kandinsky, Jawlensky, August Macke or Franz Marc, so many of these being scattered among museums and private collections which could not easily be persuaded to part with them for a period of several months. But it made up for this deficiency by including, in addition to important works by these artists, loaned mainly by local collections, an unusually representative and almost unprecedented choice of works of the many other painters who constituted the rank and file of the Blue Rider group. The biographical notes, in the catalogue, were particularly instructive; they revealed, for instance, that the Blue Rider School

shares, with that of the Paris cubists, the honor of having been the first truly international school of modern art, drawing almost as many of its members from Russia as from Germany and including several artists who had been born in America or had at least spent some of the formative years of their youth in the United States. Besides, the Blue Rider painters maintained close contact with the more experimental Paris cubists, especially Robert Delaunay, who for a while had tried to establish a separate school, that of the short-lived Orphists.

The Russians among the Blue Rider artists included Kandinsky; Jawlensky; the latter's unduly neglected friend Marianne de Werefkin; the ill-starred Russian–Jewish sculptor Moishe Kogan, destined later to be deported by the Nazis from Paris and to die in an Eastern European extermination camp; the painter David Burliuk and his brother Vladimir; and the painter Vladimir de Bechtejev. Both David Burliuk and Bechtejev subsequently emigrated to the United States, where their former association with so epoch-making a German group of artists failed, for a long time, to earn them the kind of recognition that they deserved. Though the American painter Lyonel Feininger became an associate of Kandinsky only later, when he joined him on the faculty of the Weimar Bauhaus and, together with Klee and Jawlensky, too, exhibited with him in a group called The Blue Four, there had already been some American elements, before 1914, in the Blue Rider group: the German painter Adolf Erbslöh, one of the more strictly Fauvist artists of the group, had been born in New York; the American painter Albert Bloch was for a while a close friend of Kandinsky; Marsden Hartley likewise associated for a while with the Blue Rider group in Munich; and Gabrièle Münter, Kandinsky's companion, though born in Germany, was the daughter of German–American parents and had spent part of her adolescence in the United States. Gabrièle Münter shared moreover the honor, with Marianne de Werefkin, Erna Barrera Bossi and Elisabeth

*Eppstein, of being a rare pioneer, in Germany, as a
woman among the modernists. Berthe Morisot
and Mary Cassatt had already attracted attention
among the Paris impressionists, and Nathalia Gon-
charova was well known in the avant-garde of St.
Petersburg as one of the founders of the Rayonnist
movement, but women were rarely encouraged in the
German art world, where the Dresden Fauvist group
known as Die Brücke, for instance, included
no women at all, and Paula Becker-Moderssohn,
the mainstay of the Worpswede artist colony, was
long looked upon as a kind of freak. Even in Paris,
Marie Laurencin, Sonia Delaunay and Maria
Blanchard, in the cubist Bohemia of Montmartre,
were often hailed, by the poet Apollinaire and
his friends, as Muses rather than as colleagues and
equals of Picasso, Braque and other males in
their group.*

*In 1958, when the city of Munich decided to
organize so important a retrospective of the art of the
Blue Rider, Gabrièle Münter, already over eighty
years of age, was the only surviving member who still
resided in Germany. In America, David Burliuk,
Vladimir de Betchejev and Albert Bloch were still
alive; in Austria, just across the border from the
Bavarian frontier city of Passau, Alfred Kubin was
also living, but in a state of health that would not
permit him to face the strain and excitement of the
interview which I requested. To my telegrams pressing
for an appointment, his companion replied laconi-
cally: "Arteriosclerosis of brain makes Kubin
interview pointless." With the assistance of Dr. Hans-
Konrad Röthel, curator of Munich's Lenbackhaus
Museum, which houses the long-forgotten collection
of early Kandinsky paintings that Gabrièle Münter
had so dramatically salvaged from oblivion and
given to the city of Munich two years earlier, I was
then able to visit her in her home in Murnau, a
delightfully situated small town in the lake district of
Southern Bavaria.*

*I arrived at Murnau in the late afternoon, and
was immediately struck by the colors of the land-
scape: the unmodified bright green of the pastures, the
equally flat blue tones of the distant mountains, all
justified the technique of those early landscapes of
Kandinsky, Jawlensky and Franz Marc in which
juxtaposed areas of contrasting colors, without any
glazes or effects of brushwork, suggest receding planes
rather than perspectives. At the inn where
I chose to stay, I enquired that evening where
Gabrièle Münter's house might be; I was surprised to
discover that it is still known locally as the House*

*of the Russians, because she had lived there, before
1914, with Kandinsky, Jawlensky and Marianne
de Werefkin.*

*In spite of her great age and her physical dis-
abilities, Gabrièle Münter had almost a youthful
manner, that of a woman accustomed to great
independence, when she received me in her study the
next morning. In some ways, she reminded me of
those spry pioneer grandmothers whom I had often
met in the Western states of America twenty years
earlier, rare survivors, even then, of the era
of the covered wagon. This impression was con-
firmed when Gabrièle Münter began to question me
about the United States, to tell me of her own
memories of life in Arkansas and in the Texas
Panhandle between 1898 and 1900, and to show me
some of the pencil sketches which she had brought
back from this girlhood visit in the home of her Amer-
ican cousins. Though she no longer spoke much
English, she still understood the language and occa-
sionally used, when speaking to an American, Amer-
ican words, which she pronounced without a foreign
accent.*

*"I still have many cousins over there," she
explained to me, using the American word
"cousins," as she spoke German, rather than the
German word "Vettern." "In those days," she went
on, "St. Louis was to a great extent a German city,
and we spoke German there most of the time. I also
visited New York briefly, and met many Germans
and German–Americans there. In Moorefield,
Arkansas, and in Plainview, Texas, of course, it
was different: we associated with American-born
families and always spoke English, except
at home."*

E.R.: If I understand correctly, both your par-
ents were German–Americans.

MÜNTER: Not exactly. They had both been
born in Germany but emigrated very young to
the United States, where they subsequently met
and married. My father came from Westphalia,
where most of his relatives were in the civil ser-
vice or the Protestant clergy. He must have been
a very fiery and idealistic young man, an
enthusiastic believer in the liberal ideas of 1848.
Shortly before the March Revolution of that
year, he got into trouble for his political ideas
and activities and, to avoid the scandal of his
arrest and imprisonment, was packed off to
America by my grandfather. He arrived there
with very little money and started off as a

huckster, but soon made good and met my mother and married. During the Civil War, the young couple then found business increasingly difficult in the Southern States, where they had settled. As traders, the German immigrants were not committed to the plantation economy. Most of them, besides, had come to the States as political refugees and believers in the Rights of Man; they were often suspected by their neighbors of sympathizing with the Northern Abolitionists. So my father decided, in 1864, to bring his family back to Europe, where he settled in Berlin. I was born there in 1877, as the youngest of his children.

E.R.: How did you come to make your trip to America in 1898? Surely such an expedition, for so young a girl, was very unusual in those days.

MÜNTER: Well, my father died in 1886, then my mother, too, in 1898, and our relatives thought it might be good for my older sister and me to spend a couple of years with our American cousins.

E.R.: Had you studied art at all before going to America?

MÜNTER: I had taken some drawing lessons, as many girls did in those days, but I had also attended an art class for a couple of months in Düsseldorf, which still had a great reputation as an art center. I found the teaching of its Academy, however, very uninspiring, still dominated by the ideas and tastes of the later Romantics; besides, nobody there seemed to take seriously the artistic ambitions of a mere girl.

E.R.: Did your family encourage you much as an artist?

MÜNTER: No. The cultural interests of my relatives were rather in the fields of theology, philosophy, literature and music than in that of art. When I came to the United States, I filled my sketchbooks with drawings, very much as any educated girl of my generation might have kept a diary. But nobody attached any more importance to my drawings than they might have done to a diary.

E.R.: Still, many a future writer's career has begun with the keeping of such a diary.

MÜNTER: In those days educated men and women nearly all kept diaries or sketched what they say when they traveled. It was not like today, when every traveler has a camera, even if

he has no ambition of ever achieving the skill and the status of a professional photographer. My American sketches were private notations of visual experiences which I wanted to fix on paper as a personal memento.

E.R.: But this little sketch of Plainview, Texas, with its farmhouses and artesian wells outlined against the sky, is now an interesting document, if only from the point of view of cultural history. I'm sure that an American museum in the Southwest would be proud to own it.

Among the other sketches of America that Gabrièle Münter was showing me as we chatted, I noted a colored-crayon drawing of a woodland scene, a souvenir of Moorefield, Arkansas, and a charming sketch of an intense and very young girl, seated awkwardly and revealing a surprising expanse of lanky legs, like those of a filly. This last drawing was entitled Listen to the graphaphone, *reminding me of the days when Americans were still unsure of the names under which some strange modern inventions would finally become popularly known to us.*

E.R.: Would you be offended if I say that these drawings seem to me to be very much in the tradition of those of the German Romantics? They express the same respect for nature, the same concern with sheer draughtsmanship, with line and outline, and the same *Innigkeit* — I mean a kind of spiritual or psychological intensity or empathy.

MÜNTER: I'm not at all offended. As a child, I devoted much of my leisure to drawing sketches of relatives and friends, familiar sights and scenes, a view that suddenly moved me or appealed to me. I always concentrated on depicting nature as I saw it or felt it, in terms of line, and on obtaining a kind of psychological likeness which would convey the personality of my model or the mood of the moment. In this girl, for instance, I tried to convey the unconscious boyishness of one of my young cousins, who spent so much of her time with her brothers and with other boys that she was almost unaware of being a girl. You can see that in her pose and her expression, I hope. There is nothing defiant or hoydenish in her boyishness, and her attitude and pose are not at all immodest, just naturally boyish.

We were interrupted, at this point, by Gabrièle Münter's houseguest, a somewhat younger but already elderly Danish woman who entered the

room bearing a tray with a bottle of wine, three glasses and some biscuits. As we partook of this refreshment, the artist asked her friend to show me, on an easel that was produced from a corner of the room, some of her paintings. These included a number of earlier works, strikingly Fauvist in feeling but composed in a recognizably German rather than French idiom. There were also many more recent flower studies, painted in oil on paper, all surprisingly youthful in their freshness of vision, brilliance of color and sureness of design. I was reminded, as I saw them exhibited here in quick succession, of a similar experience that I had known a year earlier in Paris, when I visited Nathalia Goncharova in the apartment that she shared, in the rue Jacques Callot, with Michel Larionov. But Goncharova and Larionov lived for forty years in the increasingly catastrophic disorder of their cavelike dwelling, where they appeared never to have intended, as Russian exiles, to establish themselves on a permanent basis and to have only allowed themselves to be slowly submerged there under an accumulation of old newspapers, art magazines and exhibition catalogues proliferating around them as the years went by. Finally, when I visited them in Paris, they were like nomads who had been forced to become sedentary because they had accumulated in their camp too many possessions to be able to move any longer. They wandered around laboriously among stacks of paper and of paintings that littered the whole floor, leaving them almost no available space for living and for working.

No such chaos was apparent in this house in Murnau where Gabrièle Münter had lived intermittently since 1909. On the contrary, everything here was neat and tidy and could easily be found, if needed. But this elderly German artist seemed to me to share with Goncharova a curiously eternal youth.

Again and again, in the course of the two clear autumn mornings that I spent in Murnau with Gabrièle Münter, I was surprised by some impetuously youthful expression or intonation in her speech, though she received me each time upstairs, in a room where she now spent most of her time resting rather than working. In the last couple of years, she had experienced, as she admitted to me, great difficulty in moving around. An infirmity of the semicircular canals made her lose her sense of equilibrium very easily, but her eyesight was still excellent and her hand firm enough to allow her to draw and paint. Among her recent works, there were again a few abstractions in which she reverted to her experimental style of 1912. But Gabrièle Münter admitted to me that she had always expressed herself more spontaneously in figurative compositions. Only between 1912 and 1914, when she was working in close association with Kandinsky, and again in the last few years, had she felt the urge to paint abstract "improvisations." As I spoke to her, I could contemplate, through the window that I faced beyond her, the Murnau landscape that she and Kandinsky and Jawlensky had so often painted. Again and again, I was able to observe that the bright flat tones of her landscapes were truly those of the countryside that she had depicted.

E.R.: When did you first come to Murnau with Kandinsky?

MÜNTER: We came here together, on a brief visit, for the first time, in 1908, in June, and we were both delighted with the town and its surroundings. In August, we then returned to Murnau for two months, with Jawlensky and Marianne de Werefkin. The following year, we heard that this house was for sale. Kandinsky fell in love with it and said: "You must buy it for our old age." So I bought it and we then made it our home until he returned to Russia in 1914. Jawlensky and Marianne used to stay with us here, and the people of Murnau called it "The House of the Russians," though I actually owned it. I'm glad I bought the house, even if it is a bit big for me now that I am alone. But I only occupy these rooms upstairs. During the great housing shortage of the years of the war and its immediate aftermath, the lower part of the house was requisitioned and I had to make room there for tenants. That was when I had to store away all my early works and those of Kandinsky that I am reported to have "rediscovered" a couple of years ago. Of course, I knew that I had them, but I always seemed to postpone taking them out of storage. Now I would prefer to live downstairs, but it is difficult for me to evict my tenants. If I wanted to work more, I would have very little space up here.

E.R.: When did you begin to work with Kandinsky?

MÜNTER: I met him shortly after my return to Germany from the United States. At first, I lived for a while in Bonn, where my sister had married a professor. A year later, in 1901, I decided to move to Munich, but still found very little encouragement as an artist. German painters

refused to believe that a woman could have real talent, and I was even denied access, as a student, to the Munich Academy. In those days, women could study art, in Munich, only privately or in the studios of the *Künstlerinnenverein*, the association of professional women artists. It is significant that the first Munich artist who took the trouble to encourage me was Kandinsky, himself no German but a recent arrival from Russia.

E.R.: Was Kandinsky still considered an outsider by most of the Munich artists?

MÜNTER: Not exactly. He had come from Russia in 1896 and studied at first, together with Paul Klee and the young German painter Hans Purrmann, under Franz von Stuck, who was then at the height of his fame. Kandinsky and Klee both had a high opinion of Stuck as a teacher and had already made many friends among German artists of the Schwabing avant-garde.

E.R.: Purrmann mentions their admiration for Stuck in some memoirs that he published a couple of years ago in a German magazine. It is now difficult for foreigners who lack a knowledge of the Munich art world of 1900 to realize that Klee and Kandinsky should both have been pupils of Stuck. But it is no more surprising than that Matisse and Rouault should have been pupils of Gustave Moreau. Both as a painter and as a teacher, Stuck had much in common with Moreau. In the *Aufbruch zur modernen Kunst* exhibition that I visited yesterday in Munich, there were several examples of Kandinsky's early *Jugendstil* style. But they suggest an affinity with Léon Bakst rather than with Stuck. Did Kandinsky ever mention Bakst to you as having been, in Russia, one of his masters?

MÜNTER: He rarely spoke of his earlier Russian associations. It was as if he wanted to forget Russia and to make a fresh start in Munich, perhaps, too, because he had been unhappily married in Russia and had left his wife there. Still, he did mention Bakst from time to time, especially in his arguments with Jawlensky and Marianne de Werefkin. But Kandinsky never, as far as I can remember, said he had been a pupil of Bakst.

E.R.: I feel that he must have known much of Bakst's work. In Kandinsky's earlier compositions on traditional Russian fairy-tale themes, there is a quality of folkloristic decorative art that reminds me often of certain works of

Bakst. Even in such large compositions as *Die Bunte Welt,* which Kandinsky painted as late as 1907, I can still detect a specifically Russian style of *Jugendstil* that he shares only with Bakst and Roehrich, far more theatrical than that of Munich. To me, *Die Bunte Welt* is typical of the Russian art nouveau of the St. Petersburg *Mir Iskusstva* or "World of Art" groups: the canvas is transformed into a kind of stage setting, with the figures disposed according to the choreographic principles of a ballet, whereas the Munich *Jugendstil* artists tended more generally to create a two-dimensional world, treating even their canvases as if they were designs for posters or book illustrations.

MÜNTER: You seem to attach considerable importance to this *Jugendstil* element in Kandinsky's early work.

E.R.: I feel that it is the element in his work that has been least studied in recent years, and I believe that we may yet discover the sources of his early abstract style in some of the theories of the *Jugendstil* artists whom he knew in St. Petersburg before 1896 or in Munich between 1896 and 1910. After all, he had painted quite naturalistically at first.

MÜNTER: As a student of Stuck, he still continued for a while to paint quite naturalistically. He admitted to me that he had always loved color, even as a child, far more than subject matter. Form and color were his main interests. To me, he often remarked that "objects disturb me." But he could paint portraits, too.

E.R.: I have seen several of his portraits. In the Munich Lenbachhaus, I saw for instance his little 1903 portrait of you, the *Gabrièle Münter* painting that is executed in a very post-impressionistic style of plein-air painting. But I have also seen in New York a portrait of a woman that he painted in 1902, if I remember right, in an entirely different style of studio painting, with an elegant bravura similar to that of fashionable artists such as Hugo von Habermann or Giovanni Boldini.

MÜNTER: Kandinsky pretended that he had painted only two portraits, one of his father, in Russia, and the one of me that you saw in Munich. But I have seen other portraits that he had painted before 1905.

E.R.: When did he paint his first abstract or nonobjective compositions?

MÜNTER: Between 1908 and 1910. He had already expressed a great interest in abstraction when we visited Tunisia together in 1904. The Moslem interdiction of representational painting seemed to stir his imagination and that was when I first heard him say that objects disturbed him.

E.R.: Had Kandinsky associated in Munich with the abstract *Jugendstil* artists Hans Schmithals, Hermann Obrist and August and Fritz Endell? They had begun to create, as early as 1898, abstract designs that were inspired mainly by natural forms, those of plant life, for instance.

MÜNTER: Kandinsky knew Obrist well and appreciated his ideas. At one time, we were often invited by Obrist and his family and we thus had occasion to see several of his abstract designs and sculptures. But they were always more decorative, in their intention, than Kandinsky's abstractions. Besides, Kandinsky never allowed himself, after 1902, to be influenced to any appreciable extent by the styles of other artists. Between 1900 and 1910, he began to rely increasingly on his own theories of art, which many of his friends could understand only with great difficulty.

E.R.: Did Jawlensky and Klee share his ideas?

MÜNTER: They were constantly arguing about art and each of them, at first, had his own ideas and his own style. Jawlensky was far less intellectual than Kandinsky or Klee and was often frankly puzzled by their theories. My 1908 portrait entitled *Zuhören* (Listening) actually represents Jawlensky, with an expression of puzzled astonishment on his chubby face, listening to Kandinsky's new theories of art. Jawlensky had many friends in Paris and had spent, with Marianne de Werefkin, almost more time in France than in Munich. He was a great admirer of Matisse, van Gogh and especially Gauguin. For a while, Jawlensky always kept his studio very dark when he painted; this was a habit that he acquired in France. Like many great painters of the School of Paris, he was a consummate craftsman and artist rather than a theorist.

E.R.: One of the characteristics of your own painting as well as of the art of Kandinsky and Jawlensky, in their Murnau period of 1909, is the use of flat areas of bright color, sometimes

placed in contrasting juxtaposition, sometimes set like pieces of colored glass in a stained-glass window, in heavy darker outlines. Would this technique have been derived from Gauguin and some of his pupils in Pont-Aven?

MÜNTER: Not consciously. As far as I am concerned, I learned this technique from Kandinsky and, at the same time, from the glass paintings of the Bavarian peasants of the Murnau area, who had painted for centuries in this style.

E.R.: As a matter of fact, other German painters were also using this technique around 1900 — I mean Adolf Hoelzel in Dachau and Paula Becker-Moderssohn in Worpswede.

MÜNTER: But we had no contact with the painters of the Dachau and Worpswede Schools. It was only much later, for instance, that we discovered that Hoelzel had already been experimenting with nonobjective compositions as early as 1908. We were only a group of friends who shared a common passion for painting as a form of self-expression. Each of us was interested in the work of the other members of our group, much as each of us was also interested in the health and happiness of the others. But we were still far from considering ourselves as a group or a school of art, and that is perhaps why we still displayed so little interest in the styles of other groups or movements. I don't think we were ever as programmatic in our theories, as competitive or as self-assertive, as some of the modern schools of Paris.

E.R.: Yet you did finally decide to establish yourselves as a group or school — I mean when Kandinsky published in 1912 the first issue of *The Blue Rider.* Had this originally been Kandinsky's idea, or had it been a collective project?

MÜNTER: Of course, there was a lot of discussion in our group before the book was actually ready for publication. I have now forgotten who was responsible for the original idea, perhaps because I have never been particularly interested in theory.

E.R.: If I understand correctly, the idea of exhibiting as a separate group was more or less forced on you.

MÜNTER: Yes, the *Neue Künstlervereinigung* didn't approve of Kandinsky's ideas in 1911 and rejected his *Composition No. 5* as too big for their show. So Kandinsky withdrew from the association, and Franz Marc, Kubin, Le

Fauconnier and I followed his lead. It was then that Kandinsky began to write the book that became *The Blue Rider.* Franz Marc, who was one of his pupils, managed to interest a German publisher in the project, and everything suddenly began to crystallize. But the title of the book was still undecided, till Franz Marc insisted that a name for the book and for an exhibition of works of our group be found at once. That evening, Kandinsky said to me suddenly: "We'll call it *The Blue Rider.*" You know, of course, that this had already been the title of one of his canvases in 1903.

E.R.: Yes. Blue seems to have always suggested some secret meaning to Kandinsky. In 1908, he had also painted a *Blue Mountain,* and both his *Blue Rider* and his *Blue Mountain* belong to the same kind of legendary world as Maurice Maeterlinck's *Blue Bird* and also, perhaps, the *Blue Rose* after which a group of Russian symbolists in St. Petersburg, around 1905, had named their exhibition.

MÜNTER: I remember that Kandinsky sometimes mentioned the *Blue Rose* group, but I myself never knew much about it.

E.R.: Was Kandinsky in touch with Goncharova and Larionov or any other artists of the St. Petersburg avant-garde?

MÜNTER: Not exactly, though many of them turned up every once in a while in Munich and dropped in to see him. Jawlensky was much more sociable, more in touch with other Russian artists. But Kandinsky was very much interested, at one time, in the work of Larionov and Goncharova.

E.R.: What was the basic factor, in your opinion, in the ideas or the style of the Blue Rider group?

MÜNTER: I think we were all more interested in being honest than in being modern. That is why there could be such great differences between the styles of the various members of our group.

E.R.: It has always surprised me that two such different artists as Kandinsky and Kubin should have been close friends — in fact, members of the same school or group.

MÜNTER: They had great faith in each other. I think that each of them knew that the other, as an artist, was absolutely honest. Whenever Kubin came to Munich from his nearby country retreat, they spent many hours together,

and I wish I had been able to take down in shorthand some of their conversations. Their ideas about art and life were so different. I was never interested in being just modern — I mean in creating a new style. I simply painted in whatever style seemed to suit me best. But Kandinsky was a thinker and had to express his ideas in words, so he constantly formulated new theories of art which he liked to discuss with Kubin, who was also a thinker, though in an entirely different vein. Kandinsky was an optimist; he had been interested, at first, in fairy tales and legends and chivalrous themes of the past, but he then became increasingly interested, after 1908, in formulating what he called the art of the future rather than in indulging in romantic visions of the past. Kubin, on the other hand, was a pessimist, always haunted by the past and suspicious of the future. This basic difference in their temperaments made their discussions all the more fruitful, and their friendship was the more intense.

E.R.: Would you say that Jawlensky was one of the optimists or one of the pessimists in your group? Was he interested in the art of the future, like Kandinsky, or in that of the past, like Kubin?

MÜNTER: I suppose he was a middle-of-the-road man. In some respects he was very conservative, not at all interested in ideas or theories. He often disagreed with Kandinsky. On several occasions they even became estranged. Jawlensky and Marianne de Werefkin, for instance, remained at first with the *Neue Künstlervereinigung* and refused to secede with us when we formed our new Blue Rider group in 1911. Later, they patched up their differences.

E.R.: I understand that Jawlensky also disapproved later of Kandinsky's activity as an artist in Soviet Russia. Jawlensky was always deeply religious and believed that the Bolshevists were truly the Anti-Christ. I have been told that he was quite shocked when he first heard that Kandinsky, after his return to Russia in 1916, had become, for a while, a believer in the Revolution.

MÜNTER: I don't think that Kandinsky was ever really a communist. He just happened to be in Russia and to become involved in some revolutionary artistic activities because of his reputation as a revolutionary in the arts. In any case, he left Russia as soon as an opportunity arose. But we had parted, by that time, and

I prefer not to express any opinion on Kandinsky's later ideas and beliefs, with which I was never familiar.

E.R.: Did Kandinsky ever share Jawlensky's religious interests?

MÜNTER: He was never at all religious-minded, but he shared Jawlensky's admiration for Rouault. They both believed that Rouault was one of the most important Paris painters of their generation, though they also admired Matisse very much.

E.R.: It is interesting to learn that Kandinsky, a revolutionary former pupil of Franz von Stuck, who had so much in common with Gustave Moreau, should instinctively have preferred, among the more revolutionary Paris painters, those who had been pupils of Moreau. But I somehow feel that Jawlensky was much more interested in Rouault and Matisse than Kandinsky ever was.

MÜNTER: Jawlensky and Marianne de Werefkin were much more involved in the politics of modern art, in those years, than Kandinsky and I; they had both lived in France and had many friends among the Fauvists as well as in other groups of advanced painters abroad.

E.R.: I have never had occasion to see much of Marianne de Werefkin's work.

MÜNTER: Most of it seems to have vanished since her death. I often wonder what her heirs did with it. Of course, her nephew may have stored it all away in an attic somewhere in Italy.

E.R.: I saw a couple of her works in Munich, in the Blue Rider retrospective exhibition and in the Municipal Museum. She seems to have been both a Fauvist in the French sense and a painter of landscapes and still-life compositions of the same kind as your own Murnau works of about 1912.

MÜNTER: Yes, we shared very much the same tastes and ideas, when we lived together in this house. She was extremely perceptive and intelligent, but Jawlensky didn't always approve of her work. He often teased her about being too academic in her techniques, and too intellectual and revolutionary in her ideas. He used to pretend that she had never managed to liberate herself entirely from the academic teachings of the Russian master under whom they had once studied together, the old painter Ilya Riepin. Suddenly Jawlensky would pick on some tiny detail of one of Marianne's best and most origi-

nal pictures and exclaim: "That patch of color, there, is laid on much too flat and smoothly. It's just like old Riepin." Of course, it was nonsense and he was only saying it to annoy her. But Jawlensky really was a devotee of the *touche de peinture* of the French Fauvists, rather than an innovator, a believer in a new kind of art of the future.

E.R.: If I understand correctly, Jawlensky and Marianne de Werefkin were, until the First World War, the painters who associated most closely with you and Kandinsky.

MÜNTER: I suppose so. They often lived here in our Murnau house. But Paul Klee and Franz Marc were also close friends, and August Macke, too, whenever he was in Munich.

E.R.: What part did Klee play in formulating the theories of the Blue Rider group?

MÜNTER: Klee was never as active a theorist, in those years, as Kandinsky or Marianne de Werefkin. Besides, it took Klee much longer to become a truly and consciously modern artist. When he first came to Munich as a student, from Switzerland, he was still a very timid Romantic. You can see that in his earliest paintings, many of which were small portraits that strove to achieve the quality of intense perception or of intimacy that we Germans call *Innigkeit*.

E.R.: Yes, but I was surprised to see that he also seemed to be an imitator of Arnold Boecklin, in a way.

MÜNTER: Well, Klee was then one of Stuck's pupils, together with Kandinsky, and that is where they both learned to paint. Then Klee abandoned painting, for a while, and concentrated on drawing.

E.R.: That was the period, I suppose, of his *Jugendstil* drawings and etchings which are often in much the same style as those of Kubin or even of his near-namesake Kley.

MÜNTER: It has never occurred to me that there was any similarity between Klee and Kley. After all, Kley was practically a commercial artist — I mean a newspaper cartoonist.

E.R.: Yes, but he also drew grotesques, and I once saw one of his signed grotesques exhibited abroad, out of sheer ignorance, as an early work of Paul Klee.

MÜNTER: How absurd! Anyhow, Klee achieved freedom, as an artist, only very slowly. He developed his interest in the drawings of children, for instance, only after many years of

study and of experiment here in Munich. As you can see in my portrait of Klee, which I painted in 1913 — I mean the one where he is seen seated in one of the rooms here downstairs and wearing white summer slacks — he was not very communicative. That is why I depicted him all hunched up and tense, as if he were constraining some mainspring within himself. In my eyes, it was almost a portrait of silence rather than of Klee, and for many years it no longer occurred to me that he had been my model. But Klee was always a close friend of ours, and Kandinsky and I both had great confidence in his talent and his future, though he was not yet very active as a leader or a theorist in our group.

E.R.: Was Feininger also one of your group?

MÜNTER: No, I don't remember ever meeting him. I believe he came much later. His association with Kandinsky began at the Bauhaus, after the First World War.

E.R.: Was the American painter Albert Bloch a member of the Blue Rider group?

MÜNTER: Yes, Bloch was at one time one of our closest friends. But I never hear from him now. Has he been very successful in America?

E.R.: I'm afraid his work has been rather shockingly neglected by most American critics and collectors. He has never been active in any American group of artists, and has always lived very much alone. What were your group's contacts with the Paris painters — I mean the cubists and the Fauvists — before 1914?

MÜNTER: Kandinsky and I had made several trips to France, though we never associated there with many artists. Most of the time, we were content to visit galleries or, as soon as the weather was fine, to go out on sketching and painting expeditions. But some Paris painters, especially Delaunay and Le Fauconnier, exhibited in our group's shows in Munich. I don't remember meeting most of them personally here. Macke and Marc, of course, were great friends of Delaunay, whom they had met in Paris. They were both enthusiastic about Delaunay's Orphist theories of form and color. Delaunay was jealous, however, of their devotion to Kandinsky. Marc once told me that he had insisted that Kandinsky was an inspired painter, and that Delaunay was then rather offended and had replied: *"Vous dites qu'il a de l'inspiration. Mais, moi aussi, j'en ai. . . ."*

[You say that he has inspiration. But I, too, have it.]

E.R.: You have said that Kandinsky was the first artist to take your work seriously and to give you any real guidance. Would you care to explain this in greater detail?

MÜNTER: Well, when we first met, Munich was still very much a center of plein-air painting, and Kandinsky himself was a plein-air painter, too, to some extent. We used to go out sketching and painting together in the countryside, and he painted a picture of me sketching, and I also did one of him. That was a long time ago, in 1903. It was only some ten years later, when he painted his first improvisations, that he began to work exclusively in his studio. You have probably understood that I had always been mainly a plein-air painter, though I also painted portraits and still-life compositions. At first I experienced great difficulty with my brushwork — I mean with what the French call *la touche de pinceau.* So Kandinsky taught me how to achieve the effects that I wanted with a palette knife. In the view from my window in Sèvres that I painted in 1906, when we were together in France, you can see how well he taught me. Later, of course, here in Murnau, I learned to handle brushes, too, but I managed this by following Kandinsky's example, first with a palette knife, then with brushes. My main difficulty was that I could not paint fast enough. My pictures are all moments of life — I mean instantaneous visual experiences, generally noted very rapidly and spontaneously. When I begin to paint, it's like leaping suddenly into deep waters, and I never know beforehand whether I will be able to swim. Well, it was Kandinsky who taught me the technique of swimming. I mean that he taught me to work fast enough, and with enough self-assurance, to be able to achieve this kind of rapid and spontaneous recording of moments of life. In 1908, for instance, when I painted my *Blue Mountain,* I had learned the trick. It came to me as easily and naturally as song to a bird. After that, I worked more and more on my own. When Kandinsky became increasingly interested in abstract art, I also tried my hand, of course, at a few improvisations of the same general nature as his. But I believe I had developed a figurative style of my own, or at least one that suited my temperament, and I have remained faithful to

it ever since, with occasional short holidays in the realm of abstraction.

E.R.: Did your association with Kandinsky continue during the years of his teaching at the Bauhaus?

MÜNTER: No, we parted in 1914, when Kandinsky, being an enemy alien, had to flee from Germany to Switzerland, as did Jawlensky and Marianne de Werefkin, too. I then went to Denmark and Sweden, which were neutral countries, hoping that he might join me there, and it was in Stockholm that he visited me briefly, in March 1916, on his way back to Russia. There, during the Revolution, he was at last able to obtain a divorce from his first wife, but he also met in Moscow a woman who was able to hold him in a firmer grip than I and whom he married. I never saw him again, and I met her for the first time in Munich, long after his death, in 1949. Ever since we parted in 1914, I have worked mainly by myself. After the First World War, here in Munich, we found that our Blue Rider group had broken up. Marc and Macke had both been killed, Kandinsky, Jawlensky and Marianne were no longer here, Bloch and Burliuk were in America. Those of us who were still in Munich remained friends, of course, but each one of us had learned to work by himself rather than in a group. Besides, as I told you before, we had always been individualists and our Blue Rider group never had a style of its own as uniform as that of the Paris cubists.

I spent two more days in Murnau, after my conversation with Gabrièle Münter, and went on several excursions around the lake or into the blue mountains beyond it. Everywhere, I discovered views of the Bavarian countryside that had exactly the same bright colors and curious lack of perspective as the paintings of the more Fauvist artists of the Blue Rider group. These landscapes indeed had no vanishing point, but seemed to be disposed in receding planes. I thus understood how important the Munich tradition of plein-air painting had been in the development of Kandinsky's later style. It had liberated him from all that was too purely decorative or calligraphic in his earlier Jugendstil art, when he had first adopted the fashionable modernism of the more urban Munich aestheticism, which he inherited also from Bakst and the Mir Iskusstva painters of St. Petersburg. Plein-air

painting, with Gabrièle Münter in Murnau and elsewhere, then weaned him away from all that was too literary or constrained in this art, still of much the same nature as that of Aubrey Beardsley; and this made it possible for Kandinsky to develop his own style in abstract improvisations, especially after 1912, when he returned to indoor studio work after a fresh-air cure as a landscape painter.

Two different artistic traditions of the Munich avant-garde thus contributed toward Kandinsky's later abstract styles. On the one hand, he developed in these the theories of a nonobjective art that had first been formulated in Munich, as early as 1898, in the writings of the Jugendstil sculptor Obrist, and that had later been applied to painting, in Dachau, by Adolf Hoelzel. On the other hand, by then achieving a synthesis of the indoor modernism of the Jugendstil draughtsmen and colorists and of the older plein-air painting of Leibl and the Munich contemporaries of the French painters of Barbizon, Kandinsky had vastly expanded the scope of abstract art so that it ceased to be merely decorative or playful and was at last able to cope with major tasks of artistic self-expression. His first improvisations, often composed in the same Fauvist colors and with the same kind of brushstrokes as his Murnau landscapes painted a couple of years earlier, are really landscapes of the mind or of the emotions. They remain, I feel, his greatest works. To what extent should we attribute this daemonic exuberance, in Kandinsky's abstract improvisations of before 1914, to the encouragement and friendship of Gabrièle Münter or to the constant prodding of Marianne de Werefkin, whose recently discovered and published diaries prove that her ideas were often more original and more advanced than her actual painting? After they parted, Kandinsky's art seems to have hovered again and again on the brink of the merely decorative or of the excessively schematic. He remained a magnificent theorist, a wonderful teacher. But his most creative period, that in which he covered the most ground and matured the most rapidly, was between 1900 and 1914, in the years that he spent with Gabrièle Münter and Marianne de Werefkin, whether in Munich and its surroundings or on their numerous trips to foreign countries.

A few weeks after my conversations with Gabrièle Münter, I chanced to call on Dr. Clemens Weiler, the scholarly curator of the Art Museum in Wiesbaden. I had reviewed, a few years earlier,

his first book on Jawlensky, in the American Journal of Aesthetics. *He now began to discuss with me some of the fruits of his recent research in the history of the Blue Rider movement. Among other things, he had discovered, among Jawlensky's papers, a collection of photographic reproductions of works by Russian painters of the turn of the century. Jawlensky had kept them preciously for close on half a century: they proved his respect for the art of Riepin, Serov, Vrubel, Levitan and others whose influence on modern painting is no longer suspected. Dr. Weiler also showed me extracts from the remarkable diaries that Marianne de Werefkin had kept in French, from 1898 until her death during the Second World War. Here she had noted, before 1900, that she felt herself "devoured" by abstraction. As a convinced anthroposophist and believer in the color theories of Rudolf Steiner, she had constantly urged Kandinsky to desert, in his art, the objective world.*

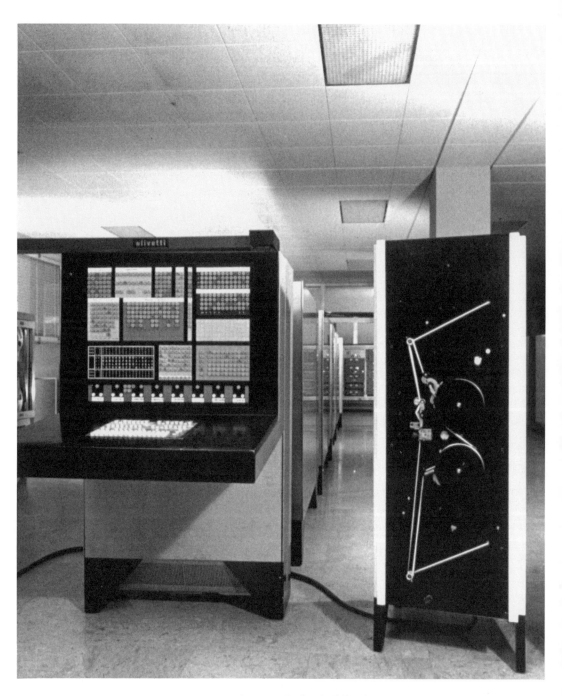

ETTORE SOTTSASS, *Computer Design for Olivetti,* 1959

Ettore Sottsass

*I*first met Ettore Sottsass, now a world-famous
designer, as early as 1952 as the husband of
Fernanda Pivano, the Italian translator of
such outstanding American writers as Ernest
Hemingway, Gertrude Stein and, some years later,
Jack Kerouac and Allen Ginsberg. The Ford Found-
ation had asked me to propose to Fernanda that she
edit the Italian version of its new periodical Perspec-
tive USA, which was to be published in English,
French, German and Italian editions. In the follow-
ing couple of years, I was in Milan every few
months to discuss with Fernanda whatever problems
arose in translating the texts already selected for the
original English-language edition. On one such
occasion, I found myself assisting the great Italian
poet Salvatore Quasimodo, who later won the Nobel
Prize in Literature, in the almost impossible task of
translating some of the poems of e. e. cummings.

After my day's work with Fernanda or some of the
Italian translators who needed my guidance, I gener-
ally dined with her and Ettore. Sometimes we were
joined by a few of their literary or artistic friends.
My acquaintance with Ettore Sottsass and his work
and our conversations on the occasions of my various
visits to their home soon led me to have a truly pro-
phetic faith in his future as a designer. When I began
in 1958 writing my interviews with major European
painters and sculptors, I planned to include in
Dialogues on Art an interview with Sottsass, too.
But my publishers objected that he was not an artist
in the same sense as Chagall or Miró, and that he
was in any case still unknown beyond the frontiers
of Italy.

For twenty-five years this interview remained
unpublished and even forgotten in a file of old type-
scripts. Recently, it surfaced again in the course of a
thorough job of housecleaning. As I read it after a
quarter of a century, I felt that everything that
Sottsass had then said to me has now been amply
illustrated in the work that earned him in recent years
his international success as the initiator of the Mem-
phis style of Italian design.

When I first met Ettore, he was already considered
one of Italy's most progressive young architects and
designers. With his wife, he lived in the heart of the
old patrician quarter of Milan, on one of those nar-
row stone-paved streets that are still lined with some
of the baroque palaces that once delighted the great
French novelist Stendhal and have somehow man-
aged to survive wartime bombings and the depreda-
tions of postwar real-estate developers. Ettore had
transformed the whole top floor of one of these dig-
nified older buildings into a modern penthouse which
served as both his home and his office.

He was then a very experimental young architect,
almost too experimental to obtain many commis-
sions. His apartment was full of models of houses
that looked a bit like mushrooms grown by Hans Arp
or cactuses designed by Anton Pevsner. Many of these
models were indeed biomorphic, more like products
of nature than of art. A painter as well as an archi-
tect, Ettore was still creating new forms rather than
houses in which one might be tempted to live. His
architecture seemed almost too sculptural. At the
same time, he was also experimenting as an abstract
expressionist and nonformal or nonobjective painter,
associating with a group of younger Italian artists
who called themselves Spazialisti and were propo-
nents of what was already known among Italian
critics as pittura nucleare. Among these Spazialisti,
Capogrossi and a couple of others later achieved an
international reputation, and the two Pomodoro
brothers, who were their close friends, are now world
famous as sculptors.

Slowly but surely, though not always consciously
or in a premeditated program, Ettore Sottsass was
developing a very personal philosophy of form, color
and total design. Every few months, when I visited
him and Fernanda in Milan, I found him enthu-
siastic about some new phase in his evolution as
an experimental and creative artist rather than
as a practical designer. Suddenly, in 1958, Ettore
and Fernanda phoned me in London, where I was
then living.

They were visiting England with a team of
designers for the Olivetti typewriter and business-

"We can measure our success as designers by the response of the public to the machines as mythical creatures, as 'film stars' of the technological world rather than as average citizens in it — as merely useful objects."

machine firm, on important Olivetti business. Ettore had suddenly fulfilled all my expectations and become a full-fledged designer, already recognized in Italy as one of the most original, controversial and promising younger designers employed in Italian industry, which was beginning to enjoy a worldwide reputation for daring innovations in design. The Olivetti firm recognized Ettore's unusual talent because of its own particular flair for responding to everything creative and novel in the field of design — everything, in fact, that was destined inevitably to appeal to the public because it was at the same time practical and pleasing.

Since 1945, the Olivetti concern had attracted attention, at first only in post-war Italy, then throughout Western Europe and now all over the free world, as a great industry that not only produced excellent typewriters and office equipment but proposed a new style or pattern of life — in fact, a philosophy of industrial relations, of community organization and of what Germans call Lebensgestaltung. Olivetti company towns were organized and built according to a recognizable Olivetti pattern; they were both more liberal in their social, economic, educational and other policies and more beautiful than the towns of most other great industries. Olivetti posters were as bright and pleasing and as novel and intriguing as many an abstract painting exhibited in a museum. In any street, the Olivetti outlet store immediately caught one's eye. Whether in Istanbul or Manchester, Bari or Barmen, Copenhagen or Marseille, whatever the style of the building leased for the store, the façade was remodeled according to a pattern that was recognizably Olivetti's.

In interviewing Sottsass in Italian, I was not so much seeking to find out from him the principles of this Olivetti style of life and design as to discover what ideas of his own might have aroused the interest of so progressive an organization.

He was still relatively young. His handsome, slightly Germanic North Italian looks betrayed, as does his name, his Alpine origins as a scion of one of those small Romanche-speaking communities that are tucked away in the upper valleys leading from Italy into the Engadine region of Switzerland. Always exquisitely dressed in a style that was not obtrusively Italian but almost American or English, he had the appearance of a rather thoughtful dandy who might, a few years earlier, have been an athlete, too. His physical appearance, style of dress and manner were those of a twentieth century equivalent of a North Italian uomo di virtú of the humanist Renaissance, and it required little effort of one's imagination to visualize Sottsass as a light-haired, light-complexioned "gentleman of Verona" in a fifteenth century portrait.

The twentieth century had added, however, an ingredient of its own to his physical and psychological character. As a recalcitrant beneficiary of the educational policies of the Fascist era, he had developed an almost exasperated individualism, an oversensitive watchfulness in everything that affects personal freedom, whether of thought, taste, opinion or action. As a result, his facial expression was often thoughtful if not somewhat careworn, and he seemed to be easily discouraged in some matters or frequently depressed; yet it required little to make him laugh with the spontaneity of a much younger man. A true artist, he could be both more serious and more playful than most men of his age, so many of whom tend to be dull rather than serious, and vacant rather than relaxed. We discussed his philosophy of design in his newly installed office, in itself, together with his apartment, an excellent illustration of his theories and tastes, since most of the furniture of these rooms had been specially built for him, after his own designs, within the preceding few months.

E.R.: It came as rather a surprise to me to see you suddenly blossom forth as an industrial designer — I mean as a colleague of such older men as Raymond Loewy, who already began in the twenties to propose to industry a kind of Art Deco style of streamlining for its products,

especially for cars and railroad engines. I had always thought of you, ever since I first met you, rather as a pure artist.

SOTTSASS: I scarcely consider myself a true industrial designer; in fact, I refuse to accept that definition. I'm a designer who happens to work for industry but who also continues to work for craftsmen and, as an artist, to design sometimes for his own pleasure.

E.R.: How would you define the concept of industrial design?

SOTTSASS: Its meaning has been vastly expanded in the last few decades as a result of the expansion of industry and of the increasing complexity of the problems that a highly competitive industry must solve. Industrial design now includes, for instance, the "interior decoration" of plants and factories in order to make them seem less prisonlike to the workers, more conducive to good industrial relations and to the kind of mood or poise that encourages a relaxed productivity. At the same time, industrial design sets out to make the products of industry appeal to the eye and the emotions of the prospective customer in terms of a specific philosophy of taste or of aesthetics.

E.R.: Would you care to discuss this philosophy of taste or of aesthetics in greater detail?

SOTTSASS: In the nineteenth century, the Western world experienced, as a consequence of the Industrial Revolution, a tragic divorce between art and industry. In the eighteenth century, there had been no industry in the modern sense, no mass production. Everything was still produced by craftsmen rather than machines, and the style and design of objects made by such craftsmen were determined, on the one hand, by the limitations of their materials and technical equipment and, on the other hand, by sheer fashion which, to a great extent, was still dictated either by artists or by very enlightened patrons.

E.R.: I suppose that typical examples of this happy marriage of art and industry in the eighteenth century would be the exquisite porcelain of Meissen, designed by such artists as Johann Joachim Kandler, or the more soberly classical ware produced in the factories of Josiah Wedgwood.

SOTTSASS: Certainly. These objects were all designed in terms of the best that contemporary technology could produce, and they managed to satisfy the demands of the most sophisticated customers. When the Industrial Revolution began to mechanize production, it set out at first to produce only cheap copies of what these earlier artists and craftsmen had once produced, yet it was already using different tools. Instead of bastardizing the devices and styles of the earlier craftsmen, these tools might well have been used to achieve new forms or styles which nobody was yet interested in investigating. The relationship between many nineteenth century manufactured articles and the wares of earlier craftsmen was like that between a cheap Victorian oleolithograph colored reproduction of the Sistine Madonna and the original.

A crisis in designing occurred when it became increasingly obvious, after 1850, that the forms of the objects produced by industry no longer corresponded at all to the possibilities inherent in the new technology. In France, for instance, the Manufacture de Saint-Etienne, which was turning out excellent modern firearms and machine tools, was at the same time producing, by means of the same modern casting techniques, candelabra designed in a bastard gothic, Renaissance or rococo style. Their elaborate design and ornamentation would have been justifiable only if these had still revealed the virtuosity of a craftsman and offered scope to the delicacy of his workmanship.

E.R.: Still, I wouldn't be prepared to condemn all the industrial designing of the early nineteenth century. In the Musée des Arts et Métiers, in Paris, I have seen, for instance, some very beautiful pieces of nineteenth century machinery that betray in a few decorative details the influence of Gothic Romanticism.

SOTTSASS: Certainly, but generally in those parts of the machine that are still castings designed and made by craftsmen who were often employed in other crafts, too, such as that of the silversmith, which had not yet been industrialized.

E.R.: Yes, you're right. As a matter of fact, I experienced quite a revelation in this field of industrial style and design when I visited a couple of years ago one of the famous old breweries in Kulmbach, in Franconia. The building itself, a great mass of brickwork, had been conceived in a very functional style of nineteenth century *Backsteingothik* that didn't lack sobriety or elegance. Actually, it might have been designed by a pupil of the great neoclassical

Berlin architect Karl Friedrich Schinkel, who had initiated a rather gaunt neogothic style of his own for red brick churches. When I entered the brewery, however, I was even more delighted and surprised. It was still operating to a great extent with its old machinery of some eighty or a hundred years ago. All of it was in excellent condition and functioning perfectly, constructed to last a hundred years or more and designed very elegantly in a kind of sober Second Empire style, with here and there some ornate castings in iron or some highly polished wrought brass that gave the whole installation the air of an exquisite period piece, a kind of rare industrial *bibelot.*

SOTTSASS: I can well imagine your surprise and delight. Somewhere in my library I have a book on the history of mechanical designing. In the illustrations, one can guess the period of a machine without necessarily having any notions of technology. Some eighteenth century machines are still neoclassical or rococo in their morphology; those of the early nineteenth century are then Empire or Regency in their style, and so on.

E.R.: That's why there already exist collectors of old machines, not only of eighteenth century clockwork automats but also of phonographs, typewriters, cameras and automobiles of fifty years ago. Still, only a museum can afford the space and the maintenance costs of a collection of old railway engines and early models of airplanes. In Paris these are exhibited hilariously enough in a disaffected late-gothic church that is part of the Musée des Arts et Métiers.

SOTTSASS: Now we have entirely new forms in industry, determined by its own technology and no longer by that of related crafts. In fact, the process has been reversed: instead of the craftsmen imposing on such parts of a machine as its castings the style and designs still current in crafts which use the same skills, we now find industry imposing designs and forms on crafts which are not at all produced by means of the same technological devices and skills.

E.R.: I suppose you are referring to what Raymond Loewy considered a heresy — I mean the streamlined baby carriage and the streamlined hearse, to say nothing of the streamlined ashtray and the streamlined toilet basin — in fact, the streamlining of all those objects that are either motionless or should on no account need to be propelled forward at a great speed.

SOTTSASS: Yes, in a way, but even this streamlining of motionless objects isn't really such a heresy. We now work as designers in terms of a familiar idiom of new forms that are applicable to all arts and crafts as well as all products of industry. A streamlined toilet basin like Gio Ponti's is no more absurd today than an ormolu rococo candelabra that imitated the forms of vegetation but was never likely to blossom or to wilt. We now design all sorts of objects in this streamlined style, simply in order to make them harmonize with other objects which have been designed in this same style for practical or functional reasons. Our problem is no longer the one that faced William Morris when he first set out to reform and purify the style of the products of the Industrial Revolution. Nor do we face the problems that once preoccupied the Weimar Bauhaus, when it first set out to formulate the functional style of modern industry. Now that this style has been formulated and generally accepted, it is based to a great extent on the more successful experiments of the Bauhaus, rejecting its less practical or more extreme suggestions. We now need only to adapt this existing and generally accepted style to industrial products which have either not yet been redesigned or are new on the market. Ponti's new toilet basin is thus an object that will look less out of place in an otherwise modern bathroom, among bathroom fixtures and appliances which are all new and bear the stamp of our own era, than an old-fashioned toilet still built in the style, not yet streamlined, of an earlier epoch. Our job is now to achieve unity of style rather than to create new styles.

E.R.: How would you define this general style?

SOTTSASS: To begin with, it is an idiom of forms which are all in harmony with those produced by industry in its most rational and efficient phases, with the greatest economy of effort and materials. At the same time, these new forms now affect the works of craftsmen, too. But when I refer to economy of efforts and materials, I don't mean the kind of niggardliness that consists in turning out cheap products which are not reasonably durable; I mean, on the contrary, producing the best, without wasting good effort or the best available materials.

E.R.: I suppose that this definition implies a condemnation of the sheer waste of materials

involved in the making of some of the more gigantic American automobile models of recent years — I mean those huge hearses which may well satisfy one's prestige needs as a mechanized dandy, but which one spends half one's time trying to park in any city, and which are streamlined for speeds never permitted anywhere or chromium-plated to the point that thirty maids with thirty chamois-leathers could be kept polishing them for half a year.

SOTTSASS: Yes, I would condemn that kind of industrial designing as a heresy, though it does serve a purpose as an adjunct of salesmanship in a highly competitive market. My ideal in industrial designing would strike a happier balance between the real requirements of technology and the makeup, I might almost say the cosmetics, which render the product attractive to the customer.

E.R.: Raymond Loewy's dictum that ugliness does not pay seems now to have led American industrial taste to swing in some fields too far in the opposite direction. Some automobile models have become too beautiful to be truly practical, and too expensive, too . . .

SOTTSASS: That may be one of the reasons that determine what I would call the new trend in industrial designing. Today, the industrial designer is no longer expected, as he was in the era which began with William Morris and ended with Raymond Loewy, to be a kind of *arbiter elegantiarum*.

E.R.: I rather like this idea of the industrial designer as a new sort of Oscar Wilde telling industry how to be artistic and refined, muttering "beauty, beauty, beauty" in the assembly plants . . .

SOTTSASS: Now the industrial designer is expected on the contrary to have undergone some training in the field of a specific branch of technology, such as electronics. This is relatively reasonable, but not entirely. As designers, we are still employed to create forms, without necessarily considering the machines which we design from the point of view of their actual functions in production. We have to view these machines, in a way, as persons — I mean as entities intended to play a part in the lives of people and to fit into the general pattern of our culture. These machines are of course perfectly capable of performing their functions satisfactorily without our help. All that we can do is to doll them up, so to speak, and make them pleasing, more appealing, more popular. We can measure our success as designers by the response of the public to the machines as mythical creatures, as "film stars" of the technological world rather than as average citizens of it — as merely useful objects.

E.R.: What do you mean when you refer to machines as mythical creatures?

SOTTSASS: Well, I suppose that the best way of explaining it would be to quote a concrete example, such as those gigantic American automobile models of recent years which we were just discussing, with their unnecessarily lavish chromium plating and their streamlining like that of an interstellar space rocket. Their design is no longer dictated by actual requirements of speed but by fashion. They are designed to harmonize with the American dream, and they are sold to drivers who imagine themselves, more or less consciously, to be piloting space rockets in some epic of science fiction. Besides, there exists, in all designing, a kind of law like Gresham's law in economics. As soon as a majority of the best designers of a nation are employed in a specific field of industry, the products of this field dictate the general tone of the design of most other industries, imposing forms on them which are not necessarily functional. In America, for instance, many of the best designers have been engaged, in recent years, almost exclusively in research tending to reduce, through streamlining, the resistance and friction encountered by rockets and experimental space-travel devices. The styles or forms thus devised then spread to other industries in which they are not necessarily functional and in which, in any case, there is no such concentration of creative designing or talent. Here in Italy, on the other hand, we're much more modest and, in our designing trends, more democratic. Many of our best designers are employed in the typewriter industry, the motor scooter industry or in the designing of small cars.

E.R.: Would it be correct for me to conclude, from all that you have said, that the myth which dominates much of recent American designing would be that of space travel, but that the myth which dominates most recent Italian designing is that of a modestly chic and comfortable utopia which ought to be accessible very soon to the common man?

SOTTSASS: Certainly, and that is why I suggested just now that it was, in my opinion, a more democratic myth. In a world where more than half of mankind is still undernourished and underprivileged to a shocking extent, it is absurd to believe that the average man may be able to afford in the near future the luxuries of space travel in a privately owned flying saucer. But it is not absurd to believe that all those who want an attractively designed motor scooter may be able to own one within a few decades.

E.R.: In using such a term as "attractively designed," what do you really mean?

SOTTSASS: That kind of question might involve us in an endless discussion. But I think a few concrete examples can be useful. Compare, for instance, the modern table-telephone models, which are available everywhere, to the models of fifty years ago, which were so hideous that everyone agreed to conceal them.

E.R.: I remember one New York interior decorator of the twenties who used to ransack Europe for antique sedan chairs which he then installed as telephone booths in the Park Avenue living rooms of his clients.

SOTTSASS: Well, the telephones and typewriters of fifty years ago were all uniformly ugly and black. Nobody had yet considered designing them as objects which might be considered attractive. Now they are offered on the market in a variety of designs and colors, all intended to appeal to the customer as particularly pleasing or practical — in fact, as objects which can fit into his own private world. The customer can then decide which model he finds most attractively designed. The very variety of available models of typewriters is proof of a more competitive and personal approach to designing, and the individual customer can choose a typewriter of a design that appeals to him or of a color that suits his temperament. Some people, for instance, like living in a room where everything — carpet, curtains, upholstery, telephone and typewriter — matches in color. They feel, whether rightly or wrongly, that a particular color or harmony of colors suits their personality.

E.R.: I remember recently engaging, through an agency, a free-lance typist-secretary for a few days. She turned up very smartly dressed in a harmony of blues, wearing blue-rimmed Harlequin glasses and carrying a portable typewriter of the same tint of blue. It was obviously all planned to project in her professional life a specific personality which she expected to be more pleasing and successful. It would have been impossible, twenty years ago, for her to choose a machine that suited her personality in its design and color, but I can well remember how carefully the rare women drivers of Paris society used to select, in the twenties, the design and color of the body of a new car. Often a whole year's wardrobe depended on such a choice.

SOTTSASS: But the bodies of some of those cars of the twenties were still being designed as craft products intended for the few, not as mass-produced industrial wares for the many. You were quite right to suggest that close relationship in the twenties between the luxury models of the automobile industry and the *haute couture.*

E.R.: Certainly, the *petite robe simple* of Mademoiselle Chanel could be worn in an open Bugatti, whereas a Lelong model was more suitable for driving a closed Delage coupé.

SOTTSASS: Now the task of the designer is to make it possible to offer to the customer a whole range of different mass-produced models of an article. The customer can then select a typewriter as a personalized object, no longer alien to his own life or world, much as he might select a tie or a pair of slippers.

E.R.: How would you explain the evolution of the forms of such a typewriter?

SOTTSASS: At first, of course, its forms — I really mean its shape — depended entirely upon an empirical approach. The relationships between the various parts were determined either by the functional requirements of the machine or by those of the machine tools used in manufacturing its parts. The whole design was thus determined by the machine, or by machines, not by the tastes of the potential customer. Now we try, as designers, to transform these interpersonal relationships of forms. But this generally leads also to a greater concentration of the relationships between the parts as forms.

E.R.: If only because they are designed more thoughtfully and artistically, many modern machines seem to me to be like good prose, less diffuse. They achieve their ends more economically, more laconically.

SOTTSASS: In that respect, I'm very much a

modern. Whatever I design, I try to be as concise as possible. But I'm also very old-fashioned and European in that I'm not so very deeply impressed by technology as some of my American colleagues. I'm naturally suspicious of the rhetoric of modern industry and, in my eyes, there's nothing mysterious or mythical about technology. Even electronics is only a field of applied science that can be studied and mastered, and I'm not prepared to worship anything that I know I can learn or understand at the cost of rational effort. Because I'm not unduly impressed by any so-called mysteries of technology, I'm never ready to make any concessions to it as a designer. When studying designs for a new model of a machine, I may feel that a specific improvement in its form would make it more attractive. But I'm then prepared to argue about it with the engineers, and I expect them, if they disagree with me, to produce good technical reasons for not accepting my proposed improvements in form and design.

E.R.: Would you care to discuss the relationship between the aesthetics of industrial design and those of modern art? I mean, can you relate the style of the best industrial designing to any specific style or school of modern painting or sculpture?

SOTTSASS: In general, the designer works today for high-level industries which are producing the most characteristic machines of our age. As I said before, the actual forms of these machines are dictated to a great extent by technical requirements. But the forms of the machines which enjoy the most prestige in the public eye tend to influence the forms of many of the less characteristic products of our age. In America, as we agreed, the designs for rockets and space-travel devices thus influence the designs for automobiles and even baby carriages. In Italy, the typewriter, the motor scooter and the espresso coffee machine dictate the style of household furniture, ceramics and an infinity of other objects. Right now, throughout Europe, whole homes are being decorated and furnished in a style which has actually been created for the modern bathroom or the labor-saving kitchen, with panels of Formica and other laminated plastics in the living room, where they are scarcely necessary, and with television sets and even pianos designed, for some

strange reason, along the same principles as refrigerators.

E.R.: But surely there is also some relationship between these styles or forms and those of modern art—I mean between the style of good up-to-date industrial designing and cubism, Fauvism, expressionism, Dada, surrealism, formal abstraction or nonformal abstraction.

SOTTSASS: Certainly, but rather with formal abstraction, I mean with the trend that developed out of cubism, through purism and neoplasticism, to the formal abstraction of Mondrian and the Constructivism of Eli Lissitzky. After all, we are dealing with three-dimensional objects that require simplified design. Their outer appearance is to a great extent determined by the modern techniques of presses for metals or plastics. Industrial designing therefore borrows its idiom of forms, whenever it seeks inspiration in art, from the same general language as much as modern sculpture—I mean from architecture. This is only logical. Fauvism, expressionism, surrealism and nonformal abstraction, on the other hand, influence modern industrial designing almost only as surface decoration, as illustration. Such styles lend themselves particularly well to the designing of ceramics and textiles. One can also create decorative three-dimensional surrealist objects such as odd-looking lamp stands or ashtrays out of glass, ceramics or plastics. I often have a lot of fun designing such objects, but they scarcely represent a significant trend in modern design.

E.R.: Actually, they are the *bibelots* of our age, playthings which are still in the tradition of those once produced by hand in the era of craftsmen, even if they are now produced entirely by machine. But would what you have just explained mean that the abstract style of purism or neoplasticism, as applied to industrial designing, is unlikely to change at all significantly? I mean, is it here to stay?

SOTTSASS: That is rather a blunt question and I can answer it only with a lot of qualifications. A style changes through the years almost unconsciously. Very few artists or designers are at any time fully aware of the evolution of their own particular style or of the general style in which they are working.

E.R.: Most artists and designers of the Baroque era, I agree, were probably quite

unaware of the trend that they were following as they gradually became rococo artists. But can you detect any similar trend in the style of contemporary industrial design?

SOTTSASS: Certainly. I can see a constant evolution. One would have to be blind to notice no evolution of style from that of industrial products designed in the "Liberty Style" or art nouveau of 1900 to that of objects designed in the Bauhaus style of 1930. Yet the Bauhaus designers had been the conscious heirs of the earlier art nouveau pioneers, and their neoplasticism was in many respects the logical outcome of art nouveau. Not only was Henry Van de Velde, the great art nouveau designer and architect, much admired as an artist and teacher by such Bauhaus leaders as Walter Gropius, but some of the teachers of design and art at the Bauhaus, such as Kandinsky and Klee, had actually been pioneers of *Jugendstil* or art nouveau art around 1900. Today, we can see the style of the Bauhaus and that of art nouveau in a certain historical perspective that makes it easier for us to observe the evolution of style which occurred in those thirty years. Now a similar evolution has been occurring since 1930 and is still continuing.

E.R.: How would you define this evolution?

SOTTSASS: I think it may be necessary first to define the evolution from the designing of the art nouveau or *Jugendstil* period to that of the Bauhaus period. Art nouveau began to derive its forms from the study of organic structures, mainly those of the realm of botany, but it viewed these structures generally in a two-dimensional context as a kind of calligraphy. Hence its concentration, in decorative design, on structures such as those of the veins in a leaf. Such designers were not so much interested in color, light or mass as in the line which holds the leaf together, so to speak, and determines the principles of its growth. All modern architecture now derives from this principle, first proclaimed by such masters of art nouveau or *Jugendstil* as Henry Van de Velde, Adolf Loos and Oskar Strnad. But when the Bauhaus was founded by pupils of these pioneers, another dimension was added, whether consciously or not, to this conception of design. The function of an object began to be considered as seriously as its basic structure, and this alone gave the products of the Bauhaus a kind of three-dimensionality which art nouveau and *Jugendstil* often lacked. A building by Le Corbusier or Gropius is thus designed in terms of its functions, in terms of units of space, of masses. An art nouveau or *Jugendstil* building, on the other hand, was often designed mainly in terms of an interesting two-dimensional façade.

E.R.: I can understand how this evolution affects design in architecture or even in teapots. An art nouveau teapot thus offers often an interesting new silhouette but no real functional improvement on the traditional teapot, whereas a Bauhaus teapot, by suppressing the long spout which usually breaks all too easily, may be both interesting in design and more practical. But I don't understand how this evolution affected the designing of machines.

SOTTSASS: Let me quote again a few concrete examples. In the design of a traditional bicycle, according to principles that were current around 1900, color served the purpose of stressing only the outline or design. Later, different colors began to be used to differentiate between the functions of the various parts of the bicycle, some being chromium-plated, others being painted. Actually, there is no reason why mudguards should not be chromium-plated or handlebars painted red. But it was felt that some differentiation was necessary, for aesthetic purposes, and that it was more practical to paint the mudguards, which are made of lighter, less expensive and less durable metal, and to reserve chromium-plating for the more expensive and durable metal of the handlebars. In shipbuilding, too, we have a similar differentiation, with black or gray being frequently used for the hull of a ship whereas the superstructure is painted white. These principles of differentiation of functions by color or by form had been recognized and applied long before the Bauhaus was founded, but the work of the Bauhaus then consisted mainly in rational research in the formulation and application of such principles of design.

E.R.: But has designing now progressed beyond this rational philosophy of the differentiation of functions, materials or masses?

SOTTSASS: Certainly, in that designers now tend to invest all forms with symbolical meanings or with an emotional appeal. We no longer find it interesting to conceive a form only as a rationally understood unit. We want to make it

attractive, too, something that the customer instinctively admires or wants to caress, something that will seem to him to be, however novel, exactly as he always knew that it should be.

E.R.: Do you now propose to design machines in terms of what I would call Jungian archetypes—I mean principles of form that have survived in man's subconscious ever since those prehistoric or archaic civilizations which produced neolithic, Cycladic or Minoan art?

SOTTSASS: That is exactly what I mean. Many of these forms suggest symbolic meanings which appeal to specific emotions, and this is where design helps salesmanship.

E.R.: Does this mean that a man would decide to buy a typewriter because of its deliciously feminine curves?

SOTTSASS: Certainly, and why not? We live in an age when it can be said that most products of the same kind, produced also in the same price range, are, within very slight limitations, equally practical and priceworthy. Our choice between these different brands and types is therefore dictated, to a great extent, by aesthetic or emotional considerations and should even seek to provoke them.

E.R.: But this leads us far from the technical training which has until recently been advocated so widely for prospective industrial designers. You lead me now to believe that a good industrial designer should study archaeology and psychoanalytical theory, art history and anthropology, rather than engineering.

SOTTSASS: Perhaps he should. After all, we are not consulted as engineers and we generally leave it to the engineers to perfect new types of machinery from the point of view of their construction and functioning. We are consulted to make these machines pretty and popular—in fact, to bridge the psychological gap between technology and human nature. That is why it remains essential that we should have an original and valid philosophy of human nature.

E.R.: How would you say that you have acquired your own philosophy of human nature?

SOTTSASS: No man who is still young can offer a satisfactory answer to that kind of question. I must admit that I've learned a lot, as every man does, from arguing about my problems with my friends. But one also learns a great deal about human nature by simply living among human beings and being naturally sensitive to

their different characters, moods and reactions. I would never dare, however, to formulate a program intended to train a designer in this field of the understanding of human nature. Some designers are quite blind to certain aspects of human nature, and any such training as I might plan would be wasted on them. That is why I prefer to discuss, for what it is worth, my own training and evolution as an artist and designer.

E.R.: I suppose you first underwent, as an architect, the usual academic training that was offered to young men of your generation during the last years of Fascism and immediately after the war.

SOTTSASS: Yes, and I revolted against it as many more sensitive or imaginative students did in those years. The classicism, neoclassicism and functional classicism of the Fascist era was like a blind alley. We seemed to suffer from a kind of claustrophobia, because all problems appeared to have been satisfactorily solved in such a manner as to offer us no openings for experiment and research in design. That is why nonfigurative and nonformal art—what we called *Spazialismo* and *arte nucleare* for a while—played such an important function in my own development. It liberated me from classicism and neoclassicism which are represented, in Italian painting, by the art of the survivors of the Fascist era—I mean painters such as Sironi or Campigli—and it liberated me too from the dry functional classicism or abstraction of such formerly futurist artists as Balla, Magnelli and Prampolini. I was thus able to experiment more freely in form and color and to rediscover color as a problem of physics and chemistry. As for my research in form, it has been guided to a great extent by my interest in primitive and exotic art, and in recent years especially by studies of classical Japanese art. Here I seem to find, more than elsewhere, the creation of forms as reflections of a subjective world, not conceived from the analysis of the geometry or structure of an object but as a result of the designer's concentration on his own sensitivity, on his pleasure in seeing or handling the object that he creates.

E.R.: There seems to be a paradox in this close affinity which you suggest between the styles of some primitive or ancient arts and the style of the most advanced kind of contemporary

industrial designing. But it might lead us too far to investigate here the causes of this surprising evolution.

When I first suggested to Ettore Sottsass that I interview him on the subject of industrial design, I never suspected that our talks would lead us into these realms of speculative aesthetics, history of art and artistic theory. Perhaps our many years of friendship created, between us, an atmosphere of confidence which proved conducive to creative thought. Twenty-five years later, when I read again the text of my old interview drafted from notes taken while we talked that evening in Milan, I was surprised to see how much ground we had covered. I even felt as if I had forced him, by my few questions, to formulate a complete new aesthetics of industrial design.

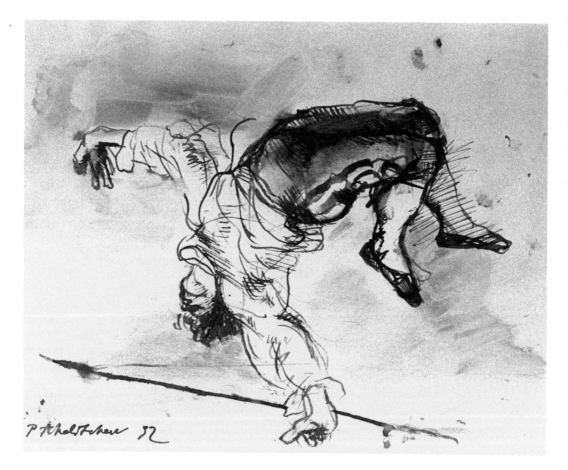

PAVEL TCHELITCHEV, *The Australian Tight-Rope Artist Con Colleano Rehearsing His Act at the Cirque Medrano in Paris*, 1932

Pavel Tchelitchev

When I first met Pavel Tchelitchev, I was still a naive and easily amazed eighteen-year-old near-surrealist poet. But I already shared, with Charles Henri Ford and Paul Frederick Bowles, the honor of being numbered among the very youngest contributors to transition, a now legendary Paris–American publication in each issue of which James Joyce was publishing a new installment of his Work in Progress, later known as Finnegans Wake. Sylvia Beach had been kind enough to think of inviting me to Edith Sitwell's reading of her own poems in the Shakespeare et Compagnie bookshop in the rue de l'Odéon, where the "expatriate" avant-garde of England and America used to foregather. I came there, that evening, compulsively early, and drifted, as the crowd increased around the door behind me, toward the reserved chairs in the front row. This may have been, on my part, a serious breach of etiquette, as I was certainly one of those younger men who, in a crowd, are expected to stand at the back of the room, leaving the chairs to older and more famous guests. But sins and errors, it seems, are sometimes rewarded richly, and I soon found myself close to Gertrude Stein, who was holding court in the front row; she struck me, that evening, as looking like one of my father's American–Jewish business associates who might suddenly have gone mad and appeared in public wearing his mother-in-law's clothes, his own wife being too chic, too much of an Edith Wharton character of that "Age of Innocence," to wear the kind of timeless "practical" garb that the author of The Making of Americans affected.

Gertrude Stein was accompanied by a lively and less strikingly masculine younger man who spoke English and French with equal fluency, though always with a slight Russian accent. He switched constantly from one language to another, often in the middle of a sentence, with grammatical and syntactical pirouettes that betrayed a rare linguistic virtuosity. When Edith Sitwell, another formidable figure, at last appeared and greeted Gertrude Stein, their encounter was like a late-gothic painter's representation of "A visitation of Saints." They were soon joined by others, among whom those who spoke French addressed each other familiarly as "tu," indicating a degree of intimacy which set them in a veritable empyrean of celebrity, far above the outer circles of the avant-garde heaven where such obscure neophytes as I still groveled.

Edith Sitwell's appearance was even more striking than that of Gertrude Stein. As an English eccentric, she managed to synthesize, much as Nancy Cunard did, too, four or five foreign, obsolete or exotic styles of dress and ornament in as unmistakably insular a "native costume" as that of a London Pearly. Edith Sitwell's headdress, that evening, was a bottle-green skullcap turban, a personal improvement on those that the Paris modiste Agnès had recently launched; but this particular turban also suggested both the blue headdress of the Vermeer portrait of a girl that hangs in the Mauritshuis in The Hague and the more formal sugar-loaf hairdo of a Benin bronze. Her necklace of heavy and dark amber beads might have been an heirloom from a Mandarin uncle but was supplemented with odd pieces of antique Russian or Italian filigree and enamel-work that transfomed her ample, ageless and somewhat monastic dark gray robe into a garment of almost sacramental splendor. All this, combined with her stature, her commanding bearing and her junoesque proportions, made her look like the twin sister of a Guards officer disguised as a Madonna for a religious pageant held in eighteenth century Portuguese Goa.

After the reading of her poems, I found myself too dazzled from this world to think of forcing my way through the crowd to the door and escaping from the crush of celebrities as modestly as my self-consciousness might have required. Marooned close to Edith Sitwell, Gertrude Stein and their loquaciously bilingual companion, I was graciously introduced to them by Sylvia Beach, but remained speechless with terror and respect. Their companion turned out to be Pavel Tchelitchev, and it never occurred to me then that I would one day be so close a friend of his that our

"One is haunted by certain ideas, images or patterns which one manages to bring to the surface, at first only by accident, in occasional moments of vision or of luck. Gradually, one learns to exorcise those spells — whether images, ideas or patterns — that seem most meaningful, and gradually, too, one learns to express or communicate them more immediately or with more skill."

meetings, our polyglot exclamations, our use of the second person singular in French, German or Italian, and our peculiarly European exchanges of kisses on the cheek would, some thirty years later, perplex younger American poets as much as Tchelitchev's and Gertrude Stein's meeting with Edith Sitwell had dumbfounded me, that evening, in 1929.

I then met Tchelitchev again, by chance, a couple of days later in Montparnasse, where he was seated at a café-terrace with the poet and novelist René Crevel, whom I knew quite well. Tchelitchev then turned out to be a close friend of Maurice Sachs, Christian Dior, Christian Bérard and other unknown young men who are now celebrities and who were my day-to-day companions. Tchelitchev and I met frequently in the ensuing years, in Paris, London or New York, though our paths often failed to cross for several years at a time. The last time I saw him, in Paris, in November 1956, I had just returned from Berlin, where I had undergone some surgery. It was the last evening of his one-man show at the Galerie Rive Gauche. He had entertained great misgivings about the fate of this exhibition, but was satisfied that he had successfully achieved a rather remarkable but well-deserved comeback, after neglecting, since 1939, to indulge in the kind of intrigues that ensure an artist a great reputation on the Paris market. As he was leaving the next day for Rome, where he subsequently fell ill and died, I had made a special point of meeting him at the Galerie Rive Gauche after dinner, though I was still hobbling around with two canes. There was something poignant in our meeting, as if we both felt how very nearly we might never have set eyes on each other again, and it was then that we decided that I must interview him and write what might turn out to be his artistic credo and testament. During the ensuing months, I wrote many letters to Tchelitchev, and he answered them whenever his failing health allowed him the effort. Shortly before his death, he sent me

a mass of notes, drafted in English, French, Italian or German, which he asked me to study so as to be ready to interview him as soon as his health would allow him to come to Paris. But he never returned to Paris and, when I learned of his death a couple of weeks later, I understood that his notes gave me the answers to all the questions which I raised in my letters and to most of those that might still have occurred to me had we met again. I therefore wrote my interview of Pavel Tchelitchev on the basis of his polyglot answers to my questions, now rewritten in a single language and completed with memories of earlier conversations, as if some Spiritualist miracle were allowing me to communicate with him beyond death.

E.R.: Many of your old Paris friends and admirers seem to have been a bit disconcerted by the astronomical or mathematical nature of the works that you have just exhibited here. But I remember that you have often been tempted to interpret the real world in terms of a very personal and mystical geometry, as if all living things and phenomena were constellations revolving in infinite space.

TCHELITCHEV: Mathematics fascinate me. As a young man, my father had obtained his doctorate in mathematics and later devoted much of his time to studies of the philosophy of numbers. This may explain why I have always been aware of geometry, of numbers, and of the value of forms and figures as signs that convey hidden meanings. I have the feeling that the whole visible world can be reduced to mathematical formulae or geometrical figures, which develop before our eyes like those colored Japanese pills that one drops into a glass of water to make them slowly unfold as artificial flowers. The Jewish Cabalists believed that the world had been created out of the letters of the Hebrew alphabet, which are also used as numbers. In thus reducing the world of

appearances to its basic numbers or geometrical forms, we probe the very mysteries of Creation. But I have never been at all brilliant in arithmetic or geometry. On the contrary, I always remained content with being puzzled by the mysteries of mathematics and never wanted to solve them or to put them to any practical use. Mathematics remain, for me, a kind of contemplative exercise.

E.R.: Can you remember your first conscious display of interest in mathematics or geometry?

TCHELITCHEV: I was born in Russia on September 21, 1898, which was also September 8 according to the Old Calendar of the Orthodox Church. Anyhow, I must have been nine months old when I was given one of those boxes of wooden cubes with which a child can compose six different pictures by selecting the elements of each picture from the various sides of each cube. I could play for hours with these cubes, and each time I had completed one picture I remained mentally so very much aware of the five other possible pictures concealed within the one which I had composed that I could visualize them as if I were actually seeing them all at the same time, through the one picture which was there before my eyes. I thus learned that a cube has three dimensions, but also six sides, and that each one of these six surfaces can appear to lead a life of its own, offering us a different image of the world and suggesting to us a different meaning. But all these six different pictures are somehow related, though there may seem to be no logical connection at all between them. Imagine, for instance, a set of cubes with which you can compose the portrait of the Gioconda, a Watteau love scene in a park, a patriotic battle scene painted by a Russian nineteenth century academic painter, a Dutch still life with fruit, fish and vegetables, the Sistine Madonna, and the famous Millais picture of *Bubbles*. And then imagine a child who knows perfectly well that this Dutch still life can be transformed at will into a patriotic battle scene or the pictures of *Bubbles*, to say nothing of the three other possibilities offered. There you will find the key, I suppose, to my whole conception of art as a kind of science of metamorphosis — I mean as a magic which can transform any visible object into a whole series of other objects.

E.R.: The kind of geometry that you have just explained to me is a far cry from that of Cézanne and the cubists.

TCHELITCHEV: Certainly. I might add that I see geometry as something basically dynamic, never static as it is in so many cubist compositions. And I can explain this in terms of another childhood memory. Of course, you know those cardboard marionettes whose arms and legs are activated by an ingenious arrangement of strings that one can pull. I remember being taught to walk by being shown the movements of such a cardboard harlequin, and I then believed that I was also being manipulated, or could even manipulate myself, by means of similar strings, though they might be invisible. I still feel, in fact, that we are all guided, in our movements, by invisible strings. Later, when I designed the sets and costumes of Nicolas Nabokov's ballet *Ode* for Serge de Diaghilev, I developed this idea in terms of choreography, and I am sure you have detected memories of it in many of my paintings of the late twenties and early thirties.

E.R.: I happened to be present at the first night of *Ode*. It was in Paris in 1928, shortly before our first meeting. Your designs seemed to me to interpret the world as a kind of cat's cradle in which we live as if our movements were all governed or predetermined by shifts of tension within this web of strings. But was *Ode* your first experience of designing for the stage?

TCHELITCHEV: No. I had long been devoted to the theater, esecially to the ballet. As a child, I had been brought up in the country, on my father's estate near Kaluga, till I was sent at an early age to a boarding school in Moscow. Puppet shows on market days in the nearby town, mountebanks at animal fairs, all the traditional entertainments of the Russian peasantry fired my imagination. Once in a while, I would be allowed, as a great treat, to go to a Moscow theater. When I came to the University of Moscow in 1917, I spent most of my spare time either attending classes in art schools or going to see plays, operas and ballets. In the early years of the Revolution, I found myself, in 1918, in Kiev, with a group of other art students. Kiev was at that time the capital of an independent non-Communist Ukrainian government, and we managed to earn our living designing and painting scenery for theaters. In 1919, I then

managed to escape to Constantinople with some French friends and got a job there as a stage designer for a Russian ballet company with which I traveled to Bulgaria, Vienna and Berlin.

E.R.: Immediately after the First World War, Berlin seems to have been the inflationary Mecca of the refugee Russian avant-garde. Chagall was also there, for a while.

TCHELITCHEV: Yes, but I had little contact with Chagall and his circle. My own associates were mainly in the theatrical world, and none of us had ever had much to do with the Communist regime in Russia, where Chagall had been Commissar for Fine Arts in his native Vitebsk and also worked for the Moscow theaters. In Berlin, from 1921 to 1923, there were two main groups among the Russian émigrés: those who, like myself, had never expected any mercy or favors from the Communist regime and been dispossessed by it, and those others who, at first, had hoped somehow to fit into the new order. Among the latter, many had even managed like Chagall to be successful for a while as artists in Soviet Russia, or, like the writers Ilya Ehrenburg and Karl Radek, were still sitting on the fence and constantly traveled back and forth between Moscow and Berlin.

E.R.: Did you work in Berlin exclusively for Russian theatrical ventures?

TCHELITCHEV: Not at all. It was in Berlin that I experienced my first European successes, when I designed sets and costumes for German theaters, even for the famous Berlin Staatsoper's production of *Le Coq d'Or*. And it was in Berlin that I held my first one-man show, in Alfred Flechtheim's gallery on the embankment of the Landwehrkanal.

E.R.: Flechtheim was one of those dealers to whose faith and efforts modern art owes many of its earliest commercial successes. But he exhibited, with a few German exceptions, almost exclusively artists of the School of Paris. In selecting you, he seems to have made a kind of prophetic exception to his general policy.

TCHELITCHEV: Flechtheim always spoke French to me, as if I were a Paris artist, though I had never yet been to Paris, and it was he who first advised me to abandon my theatrical work and concentrate on sheer painting. So I moved to Paris in July 1923, when Serge de Diaghilev suggested that I join him there. At first Diaghilev may have been a bit disappointed by

the somewhat limited interest that I displayed in working for his ballet company. But he was a man of unusual insight and soon realized that I was not wasting my time, so that he too began to encourage me to concentrate on easel painting. In fact, I owed Diaghilev many of the contacts that assured me my first Paris successes, including those that facilitated my first Paris exhibition, after only a year of work in the French capital.

E.R.: Was it already a one-man show?

TCHELITCHEV: No, it was a rather modest group show, and you will probably be surprised to hear that the two other young Russian artists who made their first bow to the Paris public in the same show in the Galerie Henri, on the rue de Seine, in 1924, were Terechkovitch and Lanskoy. Today, Terechkovitch is popular as a kind of decorative or illustrative and very Russian postimpressionist, and Lanskoy is reckoned among the more esoteric Paris abstract expressionists, whereas I remain a lone wolf, always exploring new visionary but figurative worlds of my own. It must be difficult to imagine that the three of us could ever have had enough in common to be classed as a group. . . We were all three very young and still very Russian in a kind of folksy way, relying to a great extent on traditional Russian themes, perhaps as an expression of our natural homesickness as exiles. Each one of us, however, was destined to achieve a different kind of adjustment and to steer a different course in art.

E.R.: When did you first begin, in your opinion, to steer this course and to paint in a distinctive style of your own?

TCHELITCHEV: An artist who is destined to develop a distinctive style has the elements of it at his disposal from the very start. I remember, for instance, one of my earliest watercolors, a *Head of Medusa* that I painted, as a boy of ten, in 1908, when I was still at school. In 1946, I was surprised to find myself painting it again, of course with far more skill and in a more complex form, when I was working on *The Lady of Shalott* that now hangs in the Edward James collection. One is haunted by certain ideas, images or patterns which one manages to bring to the surface, at first only by accident, in occasional moments of vision or of luck. Gradually, one learns to exorcize those spells — whether images, ideas or patterns — that seem most

meaningful, and gradually, too, one learns to express or communicate them more immediately or with more skill. . . .

E.R.: Still, you must feel that your own personality as an artist began to mature more specifically at some given moment in your career.

TCHELITCHEV: That moment probably came toward the end of my first year in Paris—in fact, immediately after the exhibition that I shared with Terechkovitch and Lanskoy. It was then that I met Gertrude Stein and exhibited, in the 1925 Paris Salon d'Automne, my *Basket of Strawberries,* which is now in the John Hay Whitney collection in New York. I had begun to emerge from my almost exclusively Russian émigré group of artists and intellectuals. The French surrealist poet and novelist René Crevel—I had first met him in Berlin through Flechtheim—was soon one of my closest friends. You remember how selflessly generous he could be. He introduced me to all his Paris friends and, by 1926, I was already exhibiting with a more specifically Parisian group of artists, though there were still several Russians among us. This group came later to be known as the neohumanists or neo-Romantics and included Christian Bérard, Eugène Berman and his brother Léonid, Paul Strecker, Léon Zack, Hosiasson and a few others whose critical spokesman was our dear friend Waldemar Georges. A few months later, I met Edith Sitwell, too, and our friendship prevented me, through the years, from ever becoming rooted in a kind of Parisian provincialism, like that of many Russian artists who divested themselves on the Left Bank of their Russian provincialism only to become *paysans de Paris,* real moujiks of the *Quinzième arrondissement.* Gertrude Stein and Edith Sitwell taught me to feel at home in England and America, too. But my first Paris success was my 1926 Exhibition, before I had become so intimate with either of them.

E.R.: And it was a couple of years after your 1926 show that our paths began to cross. By that time, you were already a celebrity, one of Diaghilev's protégés, whereas Bébé Bérard and the other painters of the neohumanist group were still but brilliant beginners. Christian Dior, among our friends, was still far from dreaming of revolutionizing the *haute couture.* He was then but an enthusiastic young salesman

in Pierre Colle's Gallery, where you all exhibited. Maurice Sachs, in his diaries, noted one day in 1928 that he had met, at the Galerie des Quatre Chemins, a whole new crowd of bright young men among whom he listed Dior and me.

TCHELITCHEV: You make me feel as if I had already been, in 1928, some kind of hoary elder statesman of the art world. . . . But this whole business of so-called artistic generations is such nonsense. . . . As the years go by . . . we select our friends on the basis of spiritual affinities and common tastes and experiences rather than of mere age. . . .

E.R.: Does this imply that you condemn the whole school of Paris nonformal, abstract expressionist or Tachist art in which Lanskoy and Hosiasson achieved such prominence?

TCHELITCHEV: If I believed in it, I would be producing that kind of art, too. But I condemn it as a trend, without wanting to condemn the work of individual nonformal painters. . . . I view this whole movement as a kind of aberration, a real denial of art or rather of certain human and artistic values that still mean so very much to me. But this is no war of religions and I myself am by nature no zealot. Though I reject the theology of the new iconoclastic movement and refuse ever to identify myself with it, I can still admit that some of its neo-Puritans are honest men and artists of real talent.

E.R.: What do you mean when you refer to human and artistic values?

TCHELITCHEV: I mean that much of the abstract art of recent years seems to me to be too subjective, too solipsistic. I was educated in a liberal milieu of the Russian aristocracy, but was still taught to believe, though without any prejudice, in some traditional cultural and religious institutions. . . . We have all inherited from the past much that is still meaningful, whether as members of a nation, a cultural minority, a religious group or even a family. In my case, this heritage included pagan Slavic myths, more or less apocryphal legends of the lives of Russian saints, and fairy tales that had reached us from all parts of the world. Later, the heritage of other religions enriched this lore, and a miraculous Hassidic rabbi now means as much to me as a crucifix does to Chagall. To this vast, complex and often confused or contradictory heritage I owe the strength, the faith and the courage which have allowed me,

throughout the ghastly revolutions, massacres and wars that I have survived, to go ahead in my work as a painter, concentrating all the while on a few artistic and emotional problems which I have felt that it was my destiny to formulate or to solve.

E.R.: This very singleness of purpose means, in the long run, that you must exclude from your preoccupations as an artist many subjects and styles for which you were gifted but which seemed to you less urgent or less meaningful.

TCHELITCHEV: Life is too short for most artists to try their hand at everything. We cannot all hope to achieve the universality of Leonardo da Vinci, Dürer or Michelangelo. Many a great artist must remain content with the destiny of a Caravaggio, a Corot or a Manet.

E.R.: Would you be able to define what you believe to be your own destiny or vocation as an artist?

TCHELITCHEV: Yes, though it has been in a way a twofold pursuit. On the one hand, I have always been interested in problems of light and darkness, in the sheer lighting that gives a picture its life and its truly magical quality. As a child, I was spellbound when I chanced to see a rainbow, or frost on a lighted window in winter, or a sunset or a sunrise, or to peer into a kaleidoscope. Sheer light transforms the atmosphere, the crystals of frost, the clouds in the sky, the pieces of glass in a kaleidoscope, into seemingly quite different materials, lending them a different kind of solidity or mass, often suggesting a kind of volume or perspective that is perhaps illusion but remains nevertheless a real optical phenomenon. I have tried, in my own paintings, to achieve this kind of mirage by experimenting with light and shadows and, in my latest work, with perspective, too. The ambiguity of concave and convex, when one cannot really make up one's mind whether an object is hollow or rounded, seems to me to give a far more convincing impression, both of the concave and of the convex, than an unequivocal style of presentation in which a convex object is obviously and only convex, a concave one obviously and only concave. This has been one of the more important problems that I have tried to solve in my work.

E.R.: But your work has always suggested other preoccupations, too, with subject matter and meaning rather than with the technical devices of draughtsmanship and lighting, perspective and *chiaroscuro*. I suppose that this has been the other aspect of your twofold pursuit.

TCHELITCHEV: Such problems of subject matter have been like obsessions — images that haunted me sometimes for years before I was at last able to understand what they really mean to me or could be made to mean to others.

E.R.: Like Millet's famous theme of the farm laborer pushing a wheelbarrow through a half-open door into a shed. All through his life, Millet felt compelled to add this element to other pictures or to draw it again and again, as if it were a childhood memory that haunted him without his ever being able to unravel its true meaning in a single picture which would develop it fully and independently and thus solve it as an emotional problem.

TCHELITCHEV: Yes, that is exactly how an image haunts an artist. It is some emotionally charged element of a dream or a remembered experience, a detail of the world of illusion of the goddess Maya — I mean the realm of natural phenomena which we must accept as real. After years of concentration on such a detail, one may suddenly understand what it means in terms of spiritual or emotional values. Only then can one integrate it properly in the world of one's own art and beliefs which remain, after all, one's only reliable record of the reality of all that one sees and dreams.

E.R.: How does your preoccupation with mathematics fit into this somewhat more psychological philosophy of life and art?

TCHELITCHEV: When I was nineteen — that was during the Russian Revolution — I suddenly found myself intrigued, perhaps as a consequence of my exposure to certain cubist, Suprematist or Constructivist theories of art, by the relationships which exist between geometry and painting. But my father had been a mathematician, and I knew from him that geometry had originally been conceived as a practical science. . . . Then I also understood that the famous shortest way from one point to another — I mean the basic straight line of geometry — is after all but an illusion, a very useful convention in a practical science. On the surface of our planet, every line between two points is inevitably curved to some infinitesimal extent, being always but a section of the circumference of a vast circle. I then decided that it was absurd to

try to emulate in art the mere conventions of an applied science. I therefore began to try to develop, in my own work, a kind of artistic geometry analogous to the real geometry of the universe, so much more mysterious than Euclid's. I also began to understand that all the things that we see can, in the last analysis, be reduced to figures or mathematical formulae, but this does not simplify matters or condemn the universe to a greater monotony. On the contrary, there is as much variety in these mathematical formulae, with their laws and exceptions, as in the immediate appearances of the world which we call real. But an understanding of a mere inkling of this mathematical or geometrical nature of appearances is essential to the artist: it helps him to achieve those proportions, in his work, which give it the appearance of reality. . ., the more intense reality that makes it possible for a still-life painting to appear more real, more charged with meaning and emotion, than a clutter of real fruit and vegetables on a real kitchen table.

E.R.: How did you set about achieving, as an artist, this kind of mathematical imitation? If I understand you correctly, the artist's quest is destined to remain, in the long run, almost fruitless. Unlike the scientist, he should never come up with some formula, joyously crying: "Eureka! I've found the answer to my question!" Instead, he seeks a reason for his wonder rather than an explanation for natural phenomena.

TCHELITCHEV: My enquiries into the real nature of the outside world, in all these early years of my quest, always brought me abruptly to the same ultimate question: what is there, what exists, at the bottom of this or that, of this object in itself, this subject in itself? And this question always brought me back, from the object or subject of enquiry, to the ultimate subject of all questioning: to myself and to the world that exists within me, to the structure and mechanism of my own body and mind, of all that seemed to add up to my own individual existence. I was thus led to check on myself all the knowledge that I brought back from my investigations of the outside world, and all these investigations finally seemed to center on the problem of form in art.

E.R.: Perhaps you could explain more fully what you mean by form. It surely cannot mean to you the same thing as to a painter like Léger, who reduced everything to a sort of massive architecture, or who, like Mondrian, has developed a kind of basic geometry of aesthetics.

TCHELITCHEV: To me, there exists a great difference between a form or a shape as we see it and one that we remember or create in thought. At the same time, I have never believed, as an artist, in the need to break up the forms of the natural world, as certain cubists have done. . . . To be reborn of its own ashes, a phoenix must first burn of its own fire.

E.R.: But what is this fire? . . .Shall we agree that this mysterious fire is the intensity of the artist's emotion and vision, the moment in which, whether as image, idea or memory, the observed object or detail of the outside world transcends itself and becomes part of the artist's own inner world?

TCHELITCHEV: I think you are right — and that moment is a kind of *verklärte Nacht*, a transfigured night, a blinding darkness, a white night that we cannot explain or explore. After that, the form, in memory or thought, no longer corresponds to the original form that had been seen. My job, in my quest, was to define this imagined or remembered form and to discover how I could transform it again into an object, a work of art that had a life of its own in the outside world, in time and in space. To be able to define such a form, I had to explore it from within and from without, so as to know all its surfaces and properties and understand how they are interrelated. It is like wanting to paint an imaginary moon in an imaginary sky. Well, if that painted moon, which is an object in the real world, must look at all real, then the artist must at least know that his imagined moon is a sphere. Unless he can suggest, in his picture, that it also has another side, however mysterious, his painted moon will look as flat as a silver sixpence. Nor will it help the artist much to break up his moon into component parts and then put it together again as best he can. He might then create, in his painted sky, some strange kind of cubist lantern that has nothing at all lunar about it.

E.R.: Would you then agree that the forms which the artist creates as objects must have an integral or organic quality? In fact, that they must come into being as complete as a child at the moment of its birth, though still capable of a growth which will make them more viable as

objects, less dependent on whatever interpretations or explanations the artist might still need to provide in order to make them fully self-contained?

TCHELITCHEV: Yes, I think you have formulated my beliefs correctly. There is a moment of birth, and the artist is then like a mother nursing a child till the work of art no longer needs his help and care. . . .

E.R.: Like the mother bear in the old bestiaries, the artist has licked his little bundle of living fur into shape. . . . Now what would be, in your opinion, the basic difference between a real object, as the artist or anyone sees it, and a form created by the artist—I mean the same kind of object as it appears again in a work of art as another kind of object?

TCHELITCHEV: You mean the difference between the pears that you eat and the pears that Cézanne painted?

E.R.: Yes.

TCHELITCHEV: Well, the pears that you eat are there to be eaten and should have the taste of a good pear. But you would be a fool to peck, like the birds in the story about the Greek painter Apelles, at the pear that Cézanne painted. Cézanne's pear should only suggest to you the texture or the flavor of a real pear; but it should also communicate to you, as directly as a real pear communicates to you its natural taste, the flavor of Cézanne's mind, the reality of his life and of the world as he experienced it. If art consisted merely in reproducing the real world as it is, I would long ago have abandoned such a dreary pursuit. It is industry's task to duplicate useful objects and to supply whatever a demand requires. Van Gogh's chair was not painted because there was a shortage of chairs in the house, nor to match an existing chair. To me, as an artist, the world of objects has always been rather disappointing, if considered only from the point of view of supply and demand. Everything in such a world is more or less useful or useless, but I have always been concerned with other values or criteria. Of course, these values and criteria remain, even today, something mysterious, almost unknown and ineffable.

E.R.: Perhaps because science, for many centuries, has taught us more about the outside world than about man. We know today far more about the atom or the basic living cell than about the soul, and there's more agreement about what

constitutes a good internal combustion engine or good plumbing than about what constitutes a great work of art or about the treatment that should be prescribed for a sick soul.

TCHELITCHEV: Yes, man remains the great question mark, often a *terra incognita* even in his own eyes. A man may speak about himself and honestly affirm — as an ancient map says *hic sunt leones* — that such an area of his personality is inhabited by wild beasts or monstrous fish-eating savages; then you go and explore that area, and find no lions and no savages there at all. Man knows very little about his own soul, and even our body often plays mysterious tricks on us, proving to us how little we can know and control it. Man's real nature, his ego, is like a prisoner within an unknown world, a mysterious universe which, in my own case, I call my own body. The soul is a bird that sings in this cage. . . .

E.R.: Let's return to a definition of the work of art as an object.

TCHELITCHEV: Well, a painting is an object, like any other object in the real world—I mean a chair, a table or an apple. But a painting is more like a chair or a table, in that it is man-made, than like an apple, which grows by itself on a tree. At the same time, a painting is a dream or an illusion — in fact, a deliberate piece of trickery. It is as if the artist were a magic lantern, capable of projecting onto a wall, as deceptive shadows, the images that haunt his mind. Still, a painting has more objective reality than a magic lantern's projected images. . . . How can an artist give to his inner life this tangible form in a three-dimensional world where the work of art must be as real as any other object? A three-dimensional object must have an independent entity of its own in time and space, and thus becomes subject to the same laws as other objects, which have not come into being out of the artist's own ideal world. The work of art as an object can even age. . . . In becoming a part of the changing world of physical appearances that is governed by time and space, it has also accepted, so to speak, the fate of all things that exist in this changing world; it has acquired a kind of mortality of its own.

E.R.: Such considerations must lead you, I suppose, to formulate a philosophy of time and space, too.

TCHELITCHEV: A painter is less concerned with time than a poet, a novelist or a musician,

and more concerned with space. Within the limited and framed space of a picture, the artist creates a kind of window onto another world, and must be able to suggest in his picture the quality of space, light and textural reality of this imagined world. I have already explained to you how I learned, as a child, that my game of wooden blocks could compose six different pictures, each one of them endowed with a different quality of reality. . . . Now I sometimes compose paintings which seem to represent different objects or scenes as one contemplates them from different points of view or at different moments. I am primarily concerned, as an artist, with this magic of illusion, because I consider a work of art to be, first and foremost, a masterpiece of magic and illusion, at least in its more technical aspects.

E.R.: Hasn't this made your work of recent years acquire a puzzling ambiguity that certain critics have defined, in the case of the works of Arcimboldi, as anamorphosis, and that Salvador Dali has called paranoid art?

TCHELITCHEV: Technically, I suppose my work uses the same rhetorical devices of ambiguity as Arcimboldi or as Dali. . . . I try on the contrary to stress some mysterious but intrinsic relationship between the various objects that my forms can suggest.

E.R.: You have defined the task of the artist as that of a demiurge whose technical magic translates into the terms of reality his own visions as a more purely contemplative mystic or dreamer.

TCHELITCHEV: But let's return to my various attempts to solve for myself the problems of art. We can certainly agree that the artist is not a creator of really living forms: he does not create a living world; nor again as *natura naturans* creates herself out of herself. When I realized this, I abandoned for a while my investigations of the formal nature of the objects which I depicted in order to investigate more thoroughly their potential metamorphoses or changes in time. And that is why, around 1928 and 1929, I began to depict things as transparent cages, like those French wire salad baskets. . . . I no longer tried to communicate the real form of the objects which I had in mind; instead, I began to study objects from the points of view of their various identities, in the light of the metamorphoses to which my "magic" or my imagination

subjected them. For the time being, I still limited myself, however, to a three-dimensional world. It was as if I were trying to invent, in my art, a game similar to those wooden cubes with which I had played as a child. But now I wanted the six possible pictures to be somehow connected, not chosen at random. . . . I wanted to suggest, in my pictures, the same kind of coexistence of various surfaces, but with some justifiable relationship between the different realities depicted on these surfaces.

E.R.: But might not this preoccupation also lead you to abandon painting in favor of sculpture?

TCHELITCHEV: That is the painter's problem: to achieve, within the two dimensions which assure him so much freedom, a kind of stereoscopic realism, too. But time can also be a valuable tool in achieving this realism. To begin with, the artist can recount, in a single picture, as some Italian primitives have done, several incidents of the same story, with the same characters appearing again and again within the same limited space, as if three or four acts of the same play were being performed simultaneously on one stage by different but identical sets of actors. Or else, the artist can present the same object or person or scene simultaneously from several different points of view, for instance, in three different perspectives, as if seen from above, from below and from a third point facing the picture. A judicious use of these three different perspectives can endow a painted image with a stereoscopic quality of mass, as if one were seeing three different surfaces of it, not so much simultaneously as in the quick succession of one's awareness of each surface in turn. It is then as if the object were actually moving, revolving on its own horizontal axis, or as if the still spectator were moving around the motionless object.

E.R.: And thus you have reached, in art, what T. S. Eliot has called "the still point of the turning world," in the center of the wheel where the motion which can be measured so easily on the outer circumference can no longer be measured at all — in fact, where motion ceases to be motion and stillness ceases to be stillness.

TCHELITCHEV: It is also the moment of pause between two states of being, the interval in a metamorphosis when the prince who is turned into a toad is no longer a prince and not yet a

toad. In my composition *Hide and Seek*, now in the New York Museum of Modern Art, I tried to determine the rhythm of recurrence of such intervals in the act of a reality which is a kind of quick-change artist. I believe I achieved in *Hide and Seek* a continuity in the discontinuity of metamorphosis and change. Such a continuity is to be sought, above all, in the spectator's interest, in a human element of curiosity roused by the mystery of the composition which derives much of its life from this human effort to understand and solve it as a riddle; and the human element, the curiosity, the effort and pleasure of understanding, add the life-breath of time to a composition that is basically organized only in two dimensions of space.

E.R.: I think you have just given me the most ingenious interpretation of the magic of a work of art that I've ever heard from the lips of an artist.

TCHELITCHEV: Perhaps it is too ingenious. Perhaps I was trying, in *Hide and Seek*, to achieve a kind of magic that relies on too much abracadabra, too much trickery. After painting it, I felt compelled to concentrate on much simpler themes — in fact, on the human figure and the human head as standards or central elements of all art. I was no longer interested in storytelling, as in *Hide and Seek*, but in investigating and explaining the nature of the hero of the story. This was the most difficult phase of my evolution as an artist, a phase that I have just completed after many years of study and meditation.

E.R.: It has also been a period in which you isolated yourself more and more as an artist from all the schools of contemporary art in which so many of your friends are active as leaders. No longer at all neohumanist or neo-Romantic, you have transcended the dream-anecdotes of surrealism and all the learned or esoteric paraphernalia of postsurrealist mannerism as we discover in the work of Dali or of Leonor Fini. On the other hand, you have also transcended every kind of expressionism, whether figurative or abstract, and all the merely graphic or geometric preoccupations of pure abstraction. Some of your recent works even suggest to me that you may have reached a point where art ceases to serve primarily its own traditional purposes — I mean the pursuit of the Beautiful — and concerns itself almost as much with the purposes of Science and Religion — I mean the pursuit of the True and the Good. You appear to be carrying out some vast project of anatomical, biological or astronomical research, investigating the nature and properties of beings that are human only by analogy. These human beings may be gods, angels, demons or constellations endowed with a human form, but at the same time with an organized collective life similar to that of certain colonies of unicellular beings such as we find in the lower orders of biology.

TCHELITCHEV: You have defined these beings correctly. They are allegories of human nature, which I see as something situated halfway between the infinitely small of these lower forms of biological life and the infinitely great of the constellations. At either extreme, the individual star and the individual unicellular being also leads an autonomous life of its own, being self-sufficient or complete in itself. But man remains, as a being, a single unit that cannot be broken up into component parts which might survive independently. At the same time, man remains the point where all knowledge converges, the measure of the universe as he conceives and understands it. That is why I now seek to represent man in his relationship to the whole of the created world, which forms part of his own inner landscape insofar as he is aware of its existence. I therefore began by trying to paint allegories of this inner landscape, depicting man's body as if it were a microcosm, reflecting in its nature and properties the microcosm of the infinitely small world of biology. In some of my pictures, the five senses are symbolically identified with the five basic elements. The nerves of the body, painted in a vivid yellow that exhales a halo of magenta red, represent fire or the ambiguity of all that burns, whether hot or cold. The veins and arteries are blue and represent the air and sky, through which flows the lifeblood of light; for the lymph, I chose a green that also suggests water; for the bones, a deeper yellow that suggests rocks and earth; for the soft tissues of the body, the flesh that is like the empty spaces beneath the stars, I chose white to symbolize the ether.

E.R.: Actually, this is a kind of cabalistic physiology, and some of your ideas were not alien to such medical philosophers as Paracelsus in the Middle Ages.

TCHELITCHEV: But I was not seeking a scientific explanation, nor trying to discover any principles of therapy. As an artist, I am concerned only with meanings and values, with elucidating and illustrating beliefs that haunt my own mind and the minds of others, whether factually true or false. Their existence as latent beliefs or superstitions makes it necessary for us to try to know and understand them. As I progressed in my investigations of these beliefs, I seemed to find the universe less and less mysterious and opaque, increasingly luminous and translucent. I hoped, in this manner, to discover the answer to the ultimate question, the *summa sapientiae*, the sum of all wisdom rather than of all knowledge. But the confused tangle of beliefs within me, this jungle of contradictions and doubts, seemed on the other hand to become increasingly opaque. It became clear to me that my ideas were leading me into complete chaos. I had to find another method of approach. So I abandoned my considerations of matter—I mean this transcendental biology—and returned to a study of forms—I mean to a kind of dynamic geometry.

E.R.: This is represented in the very latest phase of your art, in those wonderful linear bodies that you have designed in the last couple of years in Rome, as opposed to the anatomical studies which you painted during your last years in America.

TCHELITCHEV: Yes. In these last works, I am no longer concerned with the material nature of man or of my universe, with the chemical or biological composition of all that I imagine or depict, but with the laws that govern these beings as sheer structures. It is as if I were observing a crystallized world, investigating how it comes into being, how and why and where it refracts and reflects light, how it can magnify or reduce things in its transparency. A single spiral line proved to be the most adequate tool in this research: such a line, seeming to have no beginning and no end, is already a symbol of eternity and infinity, undying and always live. I then remembered the bird cages and salad baskets of my earlier still-life compositions and began to design human heads that were constructed like cages or like transparent vases, but sensed by the artist and the onlooker rather than viewed, though both from within and from without, so as to convey to the

onlooker an impression of being contained within these forms as well as of being kept out by them. A face thus became a surface that is concave as well as convex, as if we could also see ourselves from within, not only from without as when we contemplate our reflection in a mirror. Finally, I achieved a true ambiguity in the *trompe-l'oeil* of my human forms, a kind of reversible quality in the masses that I created. As one contemplates them, one follows a movement of doubt, seeing them convex, then concave, and this very movement of the mind endows the forms with a semblance of life. Such forms are generally suggested against a dark background, in linear arrangements of colors that suggest light. The space of the picture is stated in terms of a perspective which creates a cube, and the picture itself has the quality of a mirror reflecting a real world while endowing it at the same time with an unreality, with something dreamlike or visionary, as in those fairy tales where a magic mirror reveals an incident of the past or of the future, or something that is happening elsewhere or that might conceivably happen but is still only hoped or feared. I believe that these recent works of mine are founded on two different principles of movement. Firstly, the whole space of the picture suggests the infinite revolving movement of the universe, that of the wheel within a wheel which the prophet Ezekiel saw in his vision. Secondly, the movement of the object depicted is that of something that moves forward and recedes, too, within the picture, as one hesitates to decide whether it is concave or convex. But the center of the revolving universe and the vanishing point of this ambiguous perspective are one and the same point, which seems to generate both movements, palpitating with the life of the whole design. I have attained, at long last, what I wanted, and in a basic form, I mean in the human figure. Now I should set about constructing according to the same principles a whole world, until my art becomes a true *speculum naturale,* reflecting in its forms the infinite variety of nature's forms.

E.R.: But would a man's life-span suffice for such a task?

TCHELITCHEV: Is that sufficient reason for an artist to lose his faith and courage? Does Arachne, the nature goddess in whose infinite spiderweb all creation is contained, abandon

her ceaseless weaving now that man has invented the atom bomb? The task of creation is always subject to interruption. . . .

Pavel Tchelitchev was not destined to progress beyond the threshold of this infinite world which he still proposed to create. Perhaps such a task is in any case better suited to an artist who has been freed from the shackles of time and who can dispose of all eternity in order to create and recreate a world of his own. I can imagine him now, in Elysian fields rather in a Christian paradise, studiously following his plan, blessed at last with the ataraxia, *the liberation from all haste, disturbance and anguish, which was the ideal of all the sages of antiquity.*

Many months after Tchelitchev's death, as I drafted the present record of his notes, and of our conversations and correspondence about the problems that he raised, I began to understand the philosophical or mystical meaning of the works which he had produced during the last period of his creative life. By concentrating on a very limited number of themes, almost exclusively on the human head and the human figure, he had achieved great variety within a very narrow scope. A few months before our last meeting, I had visited, in the monasteries of Mount Athos, the Greek Orthodox monks who are the last heirs to the tradition of the Mystics who once painted Byzantine icons which were often believed to have dropped from Heaven, not seeming to have been created by human hands. The monks of Byzantium endowed their work with an intensely visionary or hieratic quality by painting again and again the same icon, each time with a slight but significant difference which seems to regenerate the whole picture, saving it from the

automatism of a merely repetitive art. This art, peculiar in the Western world to the Greek Orthodox Church in its heyday, had much in common, in its disciplines and intensity, if not in its techniques, with that of some Zen mystics of Japan. In all of contemporary Western art, I can think of only two painters who followed this almost forgotten Byzantine tradition, whether intentionally or by accident. Both of them had been brought up as believers in the Russian Orthodox Church: Alexis de Jawlensky, who spent the last years of his life painting an apparently never-ending series of nearly abstract Veronica-images or heads of Christ, and Pavel Tchelitchev, whose faith was more humanistic than religious and who concentrated all his thought and emotion on the one theme of the appearance of man.

In repeating again and again the same picture, an artist can produce variations on one theme as significant as those of a Chinese calligrapher whose various renderings of the same ideogram express each time a different mood, a different degree of emotional, intellectual or spiritual intensity. But Tchelitchev's last interpretations of the human figure as a kind of constellation revolving in an infinite space were also transfigured versions of the lightning sketches which I had once seen him paint quite naturalistically in watercolor, nearly thirty years earlier, while we had spent an afternoon together in the Paris Cirque Medrano and watched the great tightrope dancer Con Colleano rehearsing his amazing act. For all its diversity, Tchelitchev's art, if only as a constant pursuit of an impossible ideal, displays a basic unity, though this unity cannot always be detected at once and remains, without his explanations, almost beyond the scope of the understanding of most art lovers.

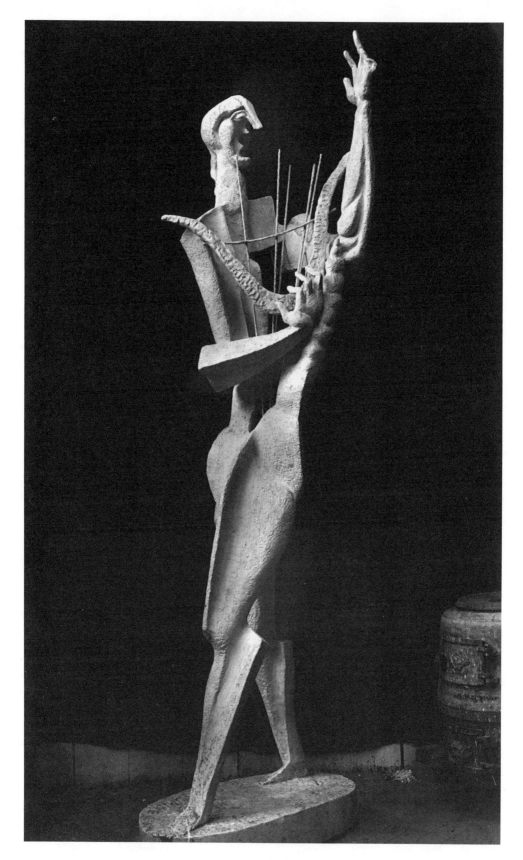

OSSIP ZADKINE, *Orphee*, 1948

Ossip Zadkine

E ver since the poet Guillaume Apollinaire first began to write about his cubist friends, artists from the School of Paris have tended to enhance their prestige in the eyes of an often uncritical public by deliberately borrowing the tricks of poetry in order to create around themselves a somewhat artificial aura of mystery or divinity. In the court etiquette that illustrated the Byzantine empire's constitutional law, the rulers similarly relied on illusions suggested by stagecraft. An elaborate machinery had thus been devised to transform the state appearances of the emperors into visions of a Christian Paradise. Petitioners from far-flung provinces and ambassadors from abroad were introduced to a throne room where they could see at first only an empty throne at the far end set on a magnificent dais. Suddenly, the throne would disappear in a cloud of incense wafted onto the dais by means of silent bellows concealed beneath the floor; when the cloud dispersed, the emperor was revealed, seated on his throne like God the Father depicted in an icon, with the empress beside him in a costume and an attitude that suggested the Virgin Mary, while their young son and heir appeared in the guise of the Son of God. After a while, another cloud of incense would envelop the dais, allowing the imperial family to retire through concealed doors as soundlessly and mysteriously as it had first appeared.

Many Parisian art critics have made a practice of writing enthusiastic and meaningless prose about living artists whose works they admire; in a language that apes the imagery of poetry or the vocabulary of the more hermetic philosophies, they create but clouds of verbal smoke in the midst of which the artist or his works are revealed only in vague and mysterious terms if at all. Most of the major artists of the School of Paris are now so thoroughly accustomed to this ceremonious sleight-of-hand that, if one chances to ask them a simple question, they are either offended or answer only in portentously ambiguous phrases. Mystification thus thrives

today in a land that was once reputed to be incurably Cartesian in its devotion to reason.

When I decided to interview the Paris sculptor Ossip Zadkine, after having spoken to a dozen major contemporary artists in other European art centers, I was afraid he might dish out the kind of poetical and metaphysical gobbledygook I had become accustomed to hearing from other Paris artists whose insignificant utterances I generally refrained from publishing.

Fortunately, I had known Zadkine, if only superficially, for close on thirty years. We had first met in Paris in a Montparnasse café in the late twenties, when he would often interrupt his work, in his studio on the rue d'Assas, just off the Luxembourg Gardens, to relax briefly in nearby Montparnasse, generally on the café terrace of the Dôme. One of the few pioneer pipesmokers of the Paris art world, he would appear with his pipe in his mouth, as if this attribute were as integrated an element of his personality as the lyre of Orpheus, the grid with which Saint Lawrence is always represented, Saint Cecilia's organ or Saint Catherine of Alexandria's wheel. Even at the age of sixty-eight Zadkine appeared so boyish, in spite of the whiteness of his tousled hair, that his pipe added a necessary element of poise to his somewhat birdlike movements. As he filled it, lit it or emptied it again, his agile hands seemed less independent, less centrifugal; they appeared to be busying themselves like birds building a nest. As he spoke — and his speech was surprisingly eloquent and explicit, whether he expressed himself in French or English — he watched one, too, with the vigilant eye of a bird; I expected him almost to pounce at any moment and to peck. But he pounced only on ideas and pecked only at words. Few artists whom I have known have revealed, in conversation, as keen and quick a mind as Zadkine.

During the war years, we met frequently in New York, generally at Leo Lerman's incredible get-togethers, real subway crushes of talents of every nature and nationality. In spite of his fluent English, his many American friends and his

"I believe that an artist should avoid accepting, for any length of time, any specific formula of style. Whatever may at first seem novel or modern or personal soon becomes a dangerous trick of stylization, a shortcut that makes it easy for the artist to neglect thought, emotion, concentration, real creative work."

immediate success, Zadkine had never been really happy in New York, perhaps because he was too much at his ease there to inspire the kind of awe or pity to which other exiled artists owed their greater prestige. Not that America had been at all unkind to Zadkine; on the contrary, it welcomed him as if he were a native son and immediately granted him the status of an American artist, but in a decade in which even the most successful American artists enjoyed far less authority than more world-famous expatriates such as Léger and Chagall, Mondrian and Yves Tanguy. As soon after the liberation of Paris as possible, Zadkine returned by the first available ship to the one city where he felt truly at home, even though, in 1944, it happened to be a city near starvation.

After the death of Henri Laurens and Brancusi, with Jacques Lipschitz remaining in New York, Zadkine became the dean of the modern sculptors of Paris. But such an undisputed honor did not mean, as it did for Henry Moore in England, Gerhardt Marcks in Germany or Marino Marini in Italy, that Zadkine received a constant flow of official orders from the French state, or from institutions and municipalities throughout France. On the contrary, it is in Dutch cities that one now finds monuments conceived by Zadkine; and you might indeed go through France with a fine-tooth comb without finding a single example of his work in a public place except, very recently and belatedly, in Paris. In their frenzies of megalomania, the Third, Fourth and Fifth Republics of France have been careful to commission mainly such monuments as might, like Landowsky's monstrous war memorial in Algiers, provide a suitable setting for a near-Fascist putsch. Zadkine's monument to the Nazi bombing of Rotterdam is not the kind of sculpture that can lend itself as a rostrum to the rhetoric of a rebellious paratrooper, and his fine project of a monument to the great eighteenth century chemist Lavoisier was unceremoniously rejected by the Paris municipality.

I phoned Zadkine for an appointment in Janu-

ary 1959 in the course of my first clandestine visit to the French capital under the newly established Fifth Republic. I had been expelled from France on an unspecified and unproven political charge a year earlier, when the doomed and demented Fourth Republic, in the last months of its inglorious existence, was busily introducing Trojan horses into all its strongholds and disarming all those who might yet have been willing to defend it. Though technically still liable to arrest at any moment if identified, I had now entered the country illegally, and was living again quite openly in my own apartment, using every day my phone line that had been tapped so studiously for four years; I had already called on a former premier, lunched with a newly appointed minister of state, and been assured everywhere that I need fear no trouble. But nothing specific had yet been done to obtain an official cancellation of my expulsion order; as a matter of fact, as I left France two weeks later, I was erroneously identified and arrested at the Swiss border by an overzealous frontier guard, then released immediately without having to serve the prison sentence — a minimum of six months and a maximum of three years — provided by law for an expellee who reenters France before his expulsion order has been officially rescinded. When Zadkine received me in his studio on the rue d'Assas, I explained to him my situation; his face expressed as little surprise as that of the monumental carved-wood Prometheus that stood beside him.

Too many of our mutual friends of the past thirty years had been executed for being Jews, exiled for neglecting to become communists or Fascists, or imprisoned for trying to escape illegally from unjust and unjustifiable persecutions. My predicament, as a clandestine visitor to Paris, could no longer inspire more discussion than an unusually rainy day. Leaving aside the mere accidents of contemporary history as the individual can experience it from day to day, we were soon conversing about more substantial matters.

"I see that you are a chain-smoker," Zadkine

remarked, looking disapprovingly at my tobacco-stained fingers. "You're still a young man, but you'll soon begin to regret this self-destructive habit. If you must smoke, you should learn to smoke a pipe."

After proffering this piece of charmingly paternal advice, Zadkine settled down comfortably in an armchair and lit his pipe. My eye wandered from the pipe that he was lighting to the wooden flames that the great figure of Prometheus was bearing, a few yards to Zadkine's left and my right.

E.R.: I have often pondered the meaning of your ability to integrate the essential activity of your mythical figures, making it a part of their body, of their actual presence. When you create an *Orpheus*, his torso is a lyre. When you create a Prometheus, the flame that he bears is as much a part of his being as if it were a beard. Would you care to explain how you interpret this kind of identification of a mythical figure with his conventional attributes?

ZADKINE: The sculptors of the cathedral porches of the Middle Ages already knew that we can identify many legendary figures by their attributes, not their physical appearance. How is one to recognize Orpheus without his lyre, or Saint Lawrence without his grid? At the same time, it seems a bit absurd, in an art that claims to be realistic, to have Orpheus always carrying his lyre, like a German businessman his brief-case. There must have been moments when Orpheus and Saint Lawrence left their lyre or their grid at the checkroom — for instance, when they knew that they would need to have both hands free. Yet they remain as essentially Orpheus or Saint Lawrence as if they still carried their attributes. As a matter of fact, these attributes are their fate, no longer separate objects they can carry or leave at the cloak-room, but part of their actual presence. I try to signify this by reorganizing the objective form of such a legendary figure so as to create an allegorical form that is complete in itself, no longer requiring an attribute that must be carried like the German businessman's briefcase; the lyre becomes part of the poet's presence, its text written all over his body, as if tattooed on his skin. It is here in the text of one of Paul Eluard's poems, because Eluard remains, of all the poets that I have known, the most complete poet.

E.R.: I believe you have always been a great reader of poetry and have even written and published a number of poems in French. Do you think that there exists a close relationship between poetry and sculpture?

ZADKINE: It is in a sculptor's interest that there should exist a close relationship between his art and that of the poet. Otherwise, his sculpture may lack human or emotional content and become too strictly architectural. We sculptors pay a heavy price for the limited freedom that we enjoy as a result of our being able to create in three dimensions: we must sacrifice color and whole realms of subject matter, such as landscape, that scarcely lend themselves to a representation in three dimensions.

E.R.: Still, you can paint the surfaces of your figures as such masters as Veit Stoss did in the late Middle Ages or the early Renaissance. If I remember right, you have done this, too, in your woodcarving entitled *The Sculptor.*

ZADKINE: Yes, but even then a sculptor remains deprived of many of the riches that are at the disposal of any painter, however ungifted the painter may be as a colorist. Similarly, we are very restricted in our subject matter: even if we choose to create panels in relief, as did some sculptors of the Italian Renaissance, we can never enjoy as much freedom in poetic details of landscape as one discovers, through an open window or an arcade, in the background of a painting by Memling or Antonello da Messina. Because the scope of the sculptor's subject matter remains so limited, we must be careful to concentrate as much meaning or emotion as possible in the few forms that remain at our disposal.

E.R.: I suppose you mean that Paulus Potter, for instance, whenever he painted a cow, could suggest some of the animal's placidity in the background landscape, but that a sculptor's cow must contain in itself all that the sculptor can possibly say or feel about cows.

ZADKINE: Certainly, and this is where poetry can help the sculptor to remain intensely aware of all those other meanings that an object might fail to suggest by its mere form. Were I to concentrate exclusively on the body of Prometheus, I would be seriously limiting the scope of my rendering of the demigod; but because I concentrate also on the myth of Prometheus, on all that the great poets have written about him, I expand the meaning of the demigod's physical

form and try to communicate, in a sculpture that is deprived of a narrative's dimension of time or a painting's scope in scenery and color, the basic message of the legend of Prometheus, who stole fire from the gods and taught man to cook his foods, to smelt metal ore and to forge his tools and weapons. Technically, it may be more difficult to express all this in a painting, I mean to compose a landscape with figures as complex as those in which Piero di Cosimo, for instance, relates to us an ancient legend. But a sculpture which sets out to achieve the same ends demands an almost unbelievable effort of concentration. Practically none of the episodes or moments of such a legend really lends itself to sculpture, and the sculptors of the nineteenth century were often quite careless or foolish in the choice of the moment which they set out to represent. Their works could thus become cluttered with all sorts of narrative details which detract from the monumental quality of the whole; these details are often alien to sculpture but quite appropriate in a painting or a poem. That is why, in my *Prometheus,* I represent the fire as an integral part of the presence or appearance of the hero: he stands there before us in all his awe-inspiring grandeur, a human figure that seemed in the eyes of the men who first saw him to be actually consumed by the fire that he was bearing.

E.R.: Would you be prepared to say that this kind of integration is the basic principle of your style?

ZADKINE: I often wonder whether my style is really founded on any single basic principle. On the contrary, I believe that an artist should avoid accepting, for any length of time, any specific formula of style. Whatever may at first seem novel or modern or personal soon becomes a dangerous trick of stylization, a shortcut that makes it easy for the artist to neglect thought, emotion, concentration, real creative work. One should avoid every kind of repetition or monotony in art. A sculptor is never young enough to waste his time and creative means on repetitious works in which he only marks time.

E.R.: Does this mean that an artist, in your opinion, must always try his hand at something new?

ZADKINE: That would be almost impossible in an art like sculpture, which allows so very limited a scope but requires so much concentra-

tion. Besides, novelty is often an illusion, revealing only our ignorance of all that has already been attempted and achieved. In sculpture, there is almost as little novelty as proverbially beneath the sun. Instead of vainly seeking novel styles and solutions, a sculptor should rather alternate his aims. The novelty then comes to him of its own accord.

E.R.: Would you care to explain this in greater detail?

ZADKINE: We have already discussed the importance of poetry in my life and, to a great extent, in my sculpture, too. Nevertheless, there have been times when I refrained from allowing poetry or poetic meanings to play so important a part in my sculpture. Every once in a while, I take a kind of holiday from poetry and impose upon myself a more Spartan discipline of form. But this discipline never means any great sacrifice or discomfort to me. Some people really enjoy physical training. So I alternate my aims; at one time, I concentrate on poetry, on a more expressionist kind of sculpture; at other times on form—I mean on a kind of sculpture that concerns itself with formal relationships rather than emotions or ideas. I suppose that this principle of alternating my aims leads to a kind of oscillation in the evolution of my own particular style as a sculptor, but I feel that it prevents me from repeating myself—I mean from settling down to the monotony of a few routine tricks which I might be tempted to use again and again. . . .

E.R.: Do you simply decide at a given moment that you have been working long enough in a particular style and that it is high time for you to change your aims?

ZADKINE: I doubt whether any artist can be as rational as that in his self-criticism. Fortunately, a sculptor's style and aims are, to a great extent, dictated to him by his materials. To make a sculpture seem at all moving or inspiring, an artist must, of course, be gifted with a certain personality that speaks movingly through the subject and materials of his work. But he must select appropriate materials, and use them appropriately, too. One cannot express an idea or emotion in a woodcarving in exactly the same manner as in a block of marble or the plaster that one molds for casting a bronze. A sculptor therefore requires, in addition to his artistic sensitivity, a great knowledge

of his materials and tools, and of the kinds of lighting in which his work will be seen. My materials often dictate my change of aims, and I choose to work in a different material much as a man may suddenly feel an appetite for a change of diet. After a steady diet of molding models for bronzes, I enjoy returning to a discipline of carving stone or wood, and the wood or the stone inevitably suggests to me a shift of principles or aims.

E.R.: Yet you return again and again to themes in which the evolution of your style can be most easily detected. If I remember right, this last figure of Orpheus is your fifth.

ZADKINE: But my first *Orpheus*, which I carved in wood some thirty years ago, was a relatively conventional human figure as far as its anatomy and composition are concerned; the figure was simply playing an instrument. I allowed myself very little freedom and only formalized the figure in terms of a kind of post-cubist style of woodcarving that was inspired to a great extent by our fairly recent discovery of the beauties of African art. Only much later, on my return from New York, did I first attempt a bronze *Orpheus*, the first of a series of four in which the instrument is each time more thoroughly integrated as an element of the figure's anatomy. At first, I thought I had found in this second figure the perfect solution, but a surprise awaited me. One day my coal merchant delivered to me, here in my studio, some wood for heating; among these logs I found a rudimentary but completely mysterious wooden figure of a man. He seemed to be walking in great strides, his torso suggested by only two simple boards which, in their structure, were very much like an ancient lyre. I immediately began working on a new *Orpheus* in which the instrument had truly become part of the man. Still, I was not fully satisfied with it, and a couple of years later I began working on a fourth bronze *Orpheus*, a kind of stepping-stone between the third and fifth, the one which I have just completed and with which, for the time being, I am fully satisfied. But Orpheus has always haunted me, and I'm not so sure I've exorcised his spell on me. For all I know, I may yet be tempted to try a sixth or a seventh *Orpheus* in years to come. Besides, the scale of each figure makes it necessary to conceive it differently. You cannot simply reduce or enlarge the scale of a sculpture without revising it. So I may someday decide to work on a small-scale *Orpheus*, which will inevitably be different. My huge monument to the bombing of Rotterdam, for instance, was the third and final version of this figure. Once the model had been accepted in principle and the scale agreed upon, I began working on a new version of it, conceiving it to a great extent in terms of the effects of the changes of lighting in which such a monument would be seen in the open air. In the case of a smaller figure, these changes of lighting are not so important and, if the sculpture is destined to remain indoors, may even be ignored by the artist.

E.R.: Whenever I'm in Rotterdam, I make a point of calling on your monumental figure there. It has already become an essential element of the city's personality. I feel that it is one of the most successfully conceived public monuments of our age.

ZADKINE: If you can still visualize it now as you saw it in Rotterdam, you may be interested to see one of the small-scale versions of it. It's out there in the garden.

Zadkine led the way out of the studio. His garden was a mortuary of unfinished works, small-scale models of more monumental figures and works of his earlier periods that had been cast out and left in the cold. Several early wooden carvings stood there, slowly rotting in the wind and rain ever since the late twenties, when modern art suffered a serious commercial setback on the Paris market and even the most famous cubists could no longer store all their unsold works in their studios. We stopped in front of a small-scale early version of the Rotterdam monument. Though unmistakably representing the same figure, it was distinctly different. Its changes seemed to have been dictated almost exclusively by considerations of lighting. The final figure, as it now stands in Rotterdam, appears to play with the sky and the light of its environment. It has integrated its natural surroundings in its general composition, much as the lyre has been integrated in the body of the final versions of Zadkine's Orpheus. *In the earlier small-scale version of the Rotterdam figure, the sky and the lighting play no part; it is a piece of indoor sculpture, perhaps more monumental than most, but it might still be placed quite appropriately on top of a bookcase, on a piano, or anywhere else in a collector's home.*

When we parted by the garden gate, I decided to walk back to my apartment through the Luxembourg Gardens, so cluttered with the mediocre sculpture on which the municipality of Paris still squanders its parsimonious funds. I was greeted there by an academy of nineteenth century poets, most of them reduced to a pathetic afterlife as mere stone busts, deprived of any semblance of a human body from the waist down. Are they any more realistic than Zadkine's Orpheus, whose torso has become a lyre? Verlaine, in particular, now facing eternity like an armless and legless character in one of Samuel Beckett's works, seemed to be more thoroughly damned than most of his colleagues.

More than twenty years later, after last visiting Zadkine in his charming Left Bank Paris studio and interviewing him there in the midst of a random selection of his works of several decades, I had occasion in the summer of 1982 to go there again, when I had to write an article on the new Musée Zadkine for the Paris monthly L'Arche. The house and garden had only recently been opened to the public as a museum, after the death of Zadkine and, later, of his widow, the fine cubist painter Valentine Prax, thanks to her generosity in bequeathing the property and its contents to the city of Paris. Although she deserves to be far more widely known and appreciated as both an artist in her own right and a pioneer woman painter in the somewhat macho cubist group, Valentine Prax appears moreover to have stipulated, with exemplary modesty, that only a couple of her own paintings be displayed in the Musée Zadkine which, for so many years, had also been her own home and studio.

I had known Zadkine over a considerable number of years, both in Paris before the Second World War and during his years of exile in New York, but I had never yet had an opportunity to view, as now in the new Musée Zadkine, as vast and varied a collection of his works, illustrating as profusely every stage of the evolution of his personality as a major twentieth century sculptor. A great wealth of his works is now displayed throughout the garden and the house, and many of his earlier works appear to have been salvaged from attics and other odd corners where he had stored them so as to enjoy more space for living and for work.

In his early years as a more orthodox cubist,

he had been influenced, like many other avant-garde artists of his generation, by his discovery of African art. Some of his works from this period thus have much in common with those of his close friends Brancusi and Modigliani, and the Musée Zadkine now displays, among other more personal memorabilia that include a collection of Zadkine's almost legendary pipes, a small Modigliani drawing, a portrait of Zadkine as a young Montparnasse artist.

But Zadkine's far broader cultural interests very soon began to affirm themselves in the broader choice of his subjects, many of which were drawn more and more frequently from classical mythology. In this respect, Zadkine now proves to have been a humanist of much the same kind, in spite of the modernism of his style, as the great sculptors of the Italian Renaissance, who so often derived their themes from their readings of such classics as Ovid's Metamorphoses. At the same time, Zadkine constantly varied his manner, adapting it always to his subject. His Laocoön group in bronze is thus more overtly baroque than many of his other works of the same period, and the whole series of his various projects for the van Gogh monument for Auvers-sur-Oise displays an expressionist quality which is, of course, more appropriate to van Gogh's personality than a more strictly cubist manner might have been.

Because of this great variety of subjects and manners in which he handles them while still revealing, at all times, his own artistic personality, Zadkine's work will never appear to be as monotonously limited in scope as that of his contemporary Henri Laurens, whose sculptures are now as profusely displayed in several halls of the Musée National d'Art Moderne on the Avenue du Président Wilson. For the same reason, there will always be admirers for individual works of Zadkine, which must appeal variously to different tastes and artistic temperaments. This is already proven by the steady stream of interested visitors, both French and foreign, who come to the new museum. Because it is so much smaller than the Musée Rodin or the Musée Bourdelle, the Musée Zadkine communicates to a visitor a more intimate sense, in spite of the profusion of works displayed and the lack of most of the furniture that I had seen there during Zadkine's lifetime, of actually visiting a great artist's home that is still haunted by his presence.